Changing

Lucy R. Lippard, who has been a free-lance art critic since 1965, was born in 1937. She received her B.A. from Smith College and her M.A. from New York University. In 1968 Miss Lippard was awarded a Guggenheim Fellowship to prepare her forthcoming book called *Ad Reinhardt: Art as Art*. She is also the author of *The Graphic Work of Philip Evergood* (1966), *Pop Art* (1966), *Tony Smith* (1970, being published in Germany), and the editor of two companion volumes, *Surrealists on Art* (1970) and *Dadas on Art* (1970). Miss Lippard's critical essays have appeared regularly in the leading art journals as well as *The Hudson Review*, and from 1965 to 1967 she was a contributing editor to *Art International*. She has organized numerous exhibition catalogues, including *557,087/955,000/3,549,000* in Seattle, Vancouver, and Buenos Aires. She teaches at the School of Visual Arts in New York City.

Changing: Essays in Art Criticism is the second in the series of volumes called "Documents in Modern Art Criticism."

Changing

essays in art criticism

Lucy R. Lippard

A Dutton *Paperback*

New York

E. P. DUTTON & CO., INC.

1971

Published simultaneously in Canada by Clarke, Irwin and Company
Limited, Toronto and Vancouver.

Library of Congress Catalog Card Number: 71–87187

SBN 0–525–47243–6

FIRST EDITION

In memory of Eva Hesse
and Ad Reinhardt

Foreword

André Ferminier writes: "What has perhaps been most damaging to the art critic is the prodigious gobbledygook that with him takes the place of a vocabulary; and the prefaces to exhibition catalogs in particular would provide a classic anthology of the art of saying nothing." * While this quotation aptly describes much of what passes for art criticism today, the work of Lucy Lippard represents the opposite pole. Of all contemporary art critics, Lippard is undoubtedly the most perspicuous and pragmatic. However, lucidity alone does not result in intelligent criticism; an understanding of the identification of the craft is indeed a prerequisite for useful criticism. The pieces reprinted in this volume interest because they are strong and thought provoking, and because they are about issues and problems in recent art, rather than formal descriptions and analyses.

More importantly, however, Lippard deals with issues not usually taken for granted—issues that frequently possess the stature of sacred cows. Their debunking always results in lively reading as well as significant aesthetic insight. For ex-

* *Art and Confrontation* (Greenwich, Conn.: New York Graphic Society, 1970), p. 49.

ample, she notes: ". . . that the so-called cult of the new, with which artists and critics are constantly accused of being obsessed, is actually a self-imposed cult of the difficult." Lippard thus contradicts her own pronouncement: "If criticism really comes to grips with [difficult] ideas, it is not likely to be particularly entertaining."

Inevitably, Lippard confronts the nature and responsibilities of art criticism today. At the very start of the game she decides: "Criticism has little to do with consistency; for consistency has to do with logical systems, whereas criticism is or should be dialectical and thrive on contradiction and change." The broad variety of topics discussed within these essays fundamentally revolves around the artistic and aesthetic developments of the New York School during the latter part of the Sixties. They include discussions of major artists and exhibitions of the period and, even though some of the exhibitions with which she is concerned may not be exclusively about art of the period, they were organized and viewed according to the sensibilities and preoccupations of the period— a fact that Lippard appreciates. As a result, her discussions of these exhibits are of much greater interest to us today than they would have been had she simply prepared "reviews" according to an inflexible academic formula. Thus she demonstrates, in her own words, that ". . . flexibility . . . is a basic component of originality."

In the essay entitled "Rejective Art" Lippard explains why she chooses that label over "Minimal" or "Primary," and notes that the art it encompasses is ". . . founded upon a more negative premise than is usual." So the reader is prepared for the later developments of the "Conceptual" school discussed in the 1968 essay "The Dematerialization of Art," an essay that was the earliest and still one of the most perceptive critiques of this recent art development.

The enormous problems faced by the modern artist as he begins to assume a new responsibility—that of actually restructuring the sensibilities of the society—are also confronted by the critic who may be expected to alter dramatically his notions about the nature of his craft, as well as his responsibility to both artist and public.

The revolution in perception will necessarily be accompanied by a revolution in all communicative processes, including art and its criticism. Future volumes in this series on modern art criticism will include more works that expand conventional ideas about the function of criticism and at the same time offer positive alternatives to traditional practices. If, as Lucy Lippard points out, "Criticism, like history, is a form of fiction," then it is clear that the potential for new forms of criticism is infinite, and the development of experimental critical frontiers that can be enjoyed and valued by a revolutionary society is restricted only by the imagination of the critics themselves.

GREGORY BATTCOCK

Prefatory Notes

Reading over the essays included here I have wondered if any of them need see the light again. In less than five years of writing I have frequently changed my mind—not often about the stature of specific artists, but about the place of their work in the network of ideas and objects that constitutes current art. If there is a connecting thread in the contents of this book it is the relationship between internal and external change, my own seeing/thinking process and that of the art about which I write. The only reason to reprint these texts is in order to expose that flux, to read them again in a broader context, and to see how clearly, if at all, certain constant preoccupations (the dialectic between Dada chaos or ambiguity and rejective formal precision first among them) survive the changes.

*

Not very far beneath the surface of these essays is an almost daily frustration and doubt about the role of criticism itself. On the one hand, the core of the matter, the core at which the artist is working, usually evades elucidation; on the other, attempts at elucidation are clearly necessary, providing the art

audience, the artist, and the would-be artist with an arena in which to disagree and to clarify the issues. Recently I have seen vital, growing art scenes in other cities, bereft of good criticism, and the artists themselves are the first to complain, since they have the most to lose. I can bemoan the rapid pace forced upon a free-lance critic who does not want to teach, or write for the mass media. But the serious working critic (as opposed to the serious but less regularly writing curator or scholar) is subjected to the same pressures, insights, and quick changes as the artist, and as the art world in general; the resulting flexibility has a value not merely sociological, and a character not merely sensational or superficial. It can provoke an acute openness, an irregular but penetrating manner of seeing and writing about what is seen. The lines along which such a body of work is composed may seem irrational, but at some point its individual order must become apparent.

<p style="text-align:center">*</p>

I have no critical system, which should be patently obvious from the contents of this book. At times I wish I did, but then I think of the distortions that occur when a critic has a system and must cram all the art he likes into those close quarters. Criticism, like history, is a form of fiction. Moreover, so-called objective criteria always boil down to indefinable subjective prejudices, which are the plagues of writing about the immediate present. When cornered, I describe my own criteria as clarity, directness, honesty, lack of pretense and prettiness, even a kind of awkwardness (for which I have been chastised, since that is supposed to be the worst kind of romantic Americanism). But then, no one will admit that the work he likes is muddy, indirect, dishonest, pretentious, or pretty, so such word lists mean very little.

<p style="text-align:center">*</p>

Criticism as we have it now, as I write it now, often lags far behind the art it treats. Exclusive, judgment-oriented writing that experteases an all too willing audience of lay victims may diminish when that audience diminishes. The young are

involved in other things. This is not to say that art writing is obsolete. The more that artists write about their own work and ideas, the livelier the dialogue between artist and critic, work and words, is likely to become. And there will always be some sort of audience for explanation, "appreciation," and interpretation as well as for an information-oriented, perceptual, and speculative analysis, just as there will always be a decorative art coexisting with broader researches.

*

There are a lot of elusive ideas in the air today that vanish as soon as they hit the ground, or the page, but eventually reappear in more tangible form. Involved as I am right now with experience, or perception, with the ramifications of extending visual experience into new spaces, and perhaps to new audiences, more rapidly than has previously been possible, I should like to create a fragmentary criticism of cross-references. Instead of setting up more of the namable theoretical thickets that exist around experience, I should like to cut away some of the transitional undergrowth to expose more clearly the irregular tempo of art in 1970. Such an approach seems more specific, more like direct communication, than the traditionally unified methods depending on literary transitions. We are learning to make the jumps ourselves. I have written only one thing that utilizes such fragmentation, a randomly organized, and constantly reorganized, catalogue for an exhibition ("557,087/955,000"; Seattle and Vancouver 1969–70) in which my twenty text cards were shuffled in with the other eighty 4″ x 6″ index cards containing the artists' contributions and general information. I was less pleased with the content than the form, but found it stimulating to have to write in non sequiturs. Except for the last essays, however, the work reprinted here dates from 1966–67, and represents only the training ground for further attempts at such projects.

Lucy R. Lippard

New York City
January 1969/March 1970

On the Book's Form

I had originally planned to add extensive footnotes to each essay in which I would argue with myself on points concerning which I have changed my mind, but my complaints were too broad and I was too lazy to follow it through. And some of the issues I was then involved in now seem so irrelevant that they are better ignored than prolonged.

I have omitted essays on Ad Reinhardt and Tony Smith because both have served as the bases for books now in press. I also omitted the early pieces whose interest is largely chronological. For instance, "The Third Stream," written in the fall of 1964, was the first article published on Primary Structures, and in retrospect it is unbearably naïve, not only due to my own inexperience, but also because information about the new work at that early stage was insufficient for a discussion in depth. When this book's production was delayed, I added two recent essays.

I have done a minimum of editing: correcting factual and grammatical errors, cutting what are now extraneous details about installation or lists of participants in exhibitions, and adding a few footnotes (indicated by daggers) where updating seemed necessary, where I have changed my mind, or where

I could not resist comment. Otherwise, the texts stand as they were published.

I should particularly like to thank James Fitzsimmons of *Art International*, Robert Ryman, John Chandler, and Sol LeWitt for information, argument, and encouragement over the period most of these essays were written.

<div align="right">L.R.L.</div>

Contents

Illustrations

Changing

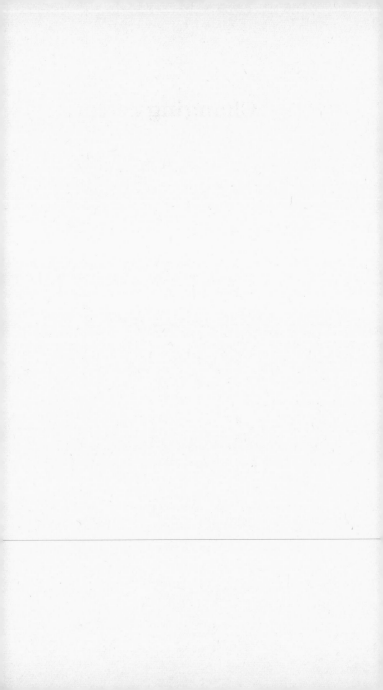

Change and Criticism:
Consistency
and Small Minds*

You could not step twice in the same river; for other and yet other waters are ever flowing on.

<div align="right">HERACLITUS</div>

The past should be altered by the present as much as the present is altered by the past.

<div align="right">T. S. ELIOT</div>

In the midst of the flux and transitional confusions that characterize advanced art, a contemporary art critic's major preoccupation must be how to establish criteria flexible enough to encompass rapid and radical change. He must decide how to handle a change of mind (his own as well as the artist's), how to distinguish between innovation and novelty, derivation and originality. The question "Is it art?" is no longer paramount. The ramifications and refinements of Duchamp's fifty-year-old assertion that anything is art if the artist says it is, have made the query beside the point. The question boils down to "Is it good art or bad art?" and also, perhaps, "Who are the artists?"

* Reprinted from *Art International,* Vol. XI, No. 9 (November, 1967).

The "tradition of the new," by now taken for granted, has drastically altered the roles of both critic and artist, and accordingly, the critic's relationship to the artist has also changed.

For example, today's emphasis on a highly conceptual art has produced more artist-writers than usual, and they often produce full-length essays rather than the traditionally isolated "statement" or autobiographical fragment. The writing artist is doing the same sort of thinking on paper that the critic does, employing the same sort of dialectical process through the same articulation and conscious understanding of the issues, though his *self*-criticism will lead to action. In his work, the artist reserves the right to change his mind; in his writing too, he can provide his own context and maintain a rare independence from the stream of critical opinion. There is a certain amount of competition involved, which can be hard on the critic. The artist's published material, out of the horse's mouth or not, must be rigorously dealt with by the professional writer, who must beware of taking all of an artist's assertions of purpose or influence at face value. It is, after all, forgivable for an artist not to know or care about his historical debts, but it is unforgivable for a critic not to recognize the exhausted or undeveloped form, the degrees of influence and originality.

T. S. Eliot wrote that the critic must have above all a "very highly developed sense of fact," and that interpretation "is only legitimate when it is not interpretation at all, but merely putting the reader in possession of the facts which he otherwise would have missed." [1] When the artist publishes his own intentions, the critic is spared a certain amount of interpretation, but since these intentions are part of the facts the critic must acknowledge (he need not approve the results), it is important for him to have some contact with the artist. There are dissenters who feel that the dangers of knowing an artist personally outweigh the advantages of a stimulating dialogue. Yet lack of such dialogue creates a highly artificial situation. The best that can be said for criticism—at heart a secondhand métier, entirely dependent on the works in question—is that

[1] The Eliot quotations used here are from two essays: "Tradition and the Individual Talent," and "The Function of Criticism," *Selected Essays* (New York: Harcourt, Brace, 1960), pp. 3–22.

it enables the practitioner to participate in, consider at length, and transmit or articulate the issues brought up by the art itself, rather than dumbly "appreciating" (or dumbly following the artist's lead either, for that matter). Straight man or not, the critic cannot be starry-eyed about the Creative Artist. On the contrary, the most valid reason for contact between critic and artist is that the critic becomes close enough to the art-making experience to understand and tolerate as well as admire the whole complex situation in which the artist operates; he becomes familiar enough to criticize instead of simply to like or dislike, to create his own ideas instead of simply to judge.

On a fundamental level, the critic's right to set himself up as judge should be questioned. What judgment he makes should be not on the values of the stylistic direction as a whole, which is out of his hands, but on the degree to which the individual work or concept furthers or alters that whole. Analysis and comparison of intention and relative achievement as well as of the works produced are invaluable. It is often said that a judge should be aloof, detached, objective, disengaged, not involved with criminals; but the critic must be immersed in the art underworld and know all the prevalent attitudes, events, relevancies, and irrelevancies in order to develop his "sense of fact" in relation to the current situation. For he records rather than reforms, discusses rather than disposes. His criteria depend on perception, not preconception. A judgment on contemporary art is *tentatively* true, like a scientist's law and unlike a legislator's law. The critic's judgments are entirely different from the court's. The courtroom judge decides whether a particular act has broken a prescribed law. But since the artist himself legislates as to what constitutes art, the critic's role is descriptive rather than prescriptive. Criticism has little to do with consistency; for consistency has to do with logical systems, whereas criticism is or should be dialectical, and thrive on contradiction and change.

Thus the contemporary critic's real task is not simply a superficial combination of the historian's and the aesthetician's. Categorization, placement, attribution, and the stabilization of universal criteria are secondary to constant adjustment, im-

mediate recognition of change within the art itself. The art under scrutiny should even be reflected in the critic's approach, whether or not it is wholeheartedly endorsed. It would be ridiculous to write a line-for-line, shape-for-shape formalist analysis of a Rauschenberg or a Dali or a LeWitt, or poetic paeans about a Judd. Rigid style, like rigid preconception, is a threat to perceptive criticism. One must approach new concepts without asking that they measure up to standards applicable only to their predecessors or their opposites. It is more dangerous to know what you like than what you don't like. Awareness of contemporary attitude, mood, issues, must be backed up by a set of working criteria, constantly in the experimental stage, which emerge and change, though not radically, with each new work confronted. If I could not enjoy very different kinds of art, based on very different values, if my criteria were fixed for once and for all, I would feel cheated. But such experimental criteria must be backed up by as much intellectual rigor as can be mustered, and that indefinable faculty, "a good eye," and, finally, must rest on a solid foundation of looking, of having looked at all kinds of art, not just what one expects to like. The critic forms his own ideas of recent history before the historians have their "distance."

Art history profits from, and is often patronizing about, criticism's mistakes. A contemporary critic takes risks, and sacrifices the possibility of eternal rectitude to the less dignified task of eternal revision. (Though it should be said that all history is in fact contemporary history because it is written in the present and is a product of all the interests and preconceptions of the present.) The rewards of contemporary criticism lie in the act of looking at art and allowing oneself time to experience and reexperience it, to think, consider, articulate, vacillate, and articulate again. Contemporary criticism is no place for someone who hopes to be right all or even most of the time. Bewilderingly rapid and not always significant change encourages an illogical criticism that sets up a dialogue between historical and visual fact and opinion in some sort of "open form," rather than establishing a pedantic system that allows for no variation and is perfect only in its restrictions. It is this endless self-correction that is the most interesting aspect of art

writing. Oscar Wilde called criticism the highest form of auto-
biography. I should hope it would not be autobiography, or
self-expression, but autodidacticism, a demonstration of the
learning process in print, and, ideally, a demonstration of the
extent to which the art discussed is stimulating.

The art scene itself is an endless self-corrective process; its
workings are more evident the more it accelerates and con-
denses. Today movements are just that; they have no time to
stagnate before they are replaced. Much current art is made in
reply to issues raised by previous art. This self-critical aspect
need not be strictly evolutionary, but can instead be seen as a
continuous lattice of interrelating unlike elements. The con-
necting grid consists of the ideas and articulations that a new
art can force from a constant observer—a substantiation of the
"ideas in the air," and their relation to the unlike objects—
the art. The critical lattice (a four-dimensional one, including
the time element) shows not only how the various arts looked
when they were first seen, but their interrelationships and pos-
sibilities at the time; it can chart the structural growth of
these possibilities.

A style or so-called movement emerges, crystallizes, splits
into several directions over this period. As it does, the critic
too finds himself divided. At the beginning of a "trend," simi-
larities are stressed. The critic's job is to document the emer-
gence of a common sensibility or style. As the style becomes
more widespread and visible, the *differences* between the works
and intentions become more important. It is not unusual to
have to revise or contradict oneself on points one knows to
have been correct when written but which have since become
elementary, irrelevant, or even inaccurate.

The issue is change and degree of change. The "sense of
fact" can be overdone. Teutonic scholarship is not necessarily
germane. Aesthetic value is not based solely on consistency, the
"mark of small minds," but on the flexibility that is a basic
component of originality. In the historical sense, everything is
derivative; immaculate conceptions are entirely absent from
art history. Yet a group of artists may begin to work spon-
taneously and independently in a certain direction, responding
to as yet undefined issues, *without* any conscious influence from

earlier movements. The best of the primary structures have been related to all strict, classical, geometric art of the past. And they do relate. Nevertheless, the rejective trend took more impetus from recent painting than from earlier sculpture, and the break made with earlier relational geometric art was actually radical. Again, a matter of degree.

From the other extreme, there are always isolated lesser artists who have, say, made target paintings years before Jasper Johns. But Johns's recognition of the target (and his number, letter, map paintings) as two-dimensional subject matter for a two-dimensional surface, and all the attendant ambiguities, was innovatory. Before Johns, the target as a design could be traced to innumerable prototypes back through ancient times. After Johns, the target became an idea to be reckoned with, and as it turned out, a fertile one, formally and conceptually. The new, even when it is not tremendously valuable in itself, always contains the possibility of significant change.

Change of course is not necessarily progress. This too must be a critical preoccupation. Immediate acceptance of the new for the sake of novelty alone is condoned only by journalists whose interest lies in the sensational. In fact, there comes a time for all critics (usually after they have been writing prolifically for some time) when they confront a trend to which they are congenitally unsympathetic and to which they cannot respond. No one critic, no matter how well informed and catholic in taste, can develop standards that will prepare him for all aesthetic events.

Yet I must admit to a conviction that if something is new, "catches on," and becomes relatively widespread, it is likely to be valid, and will probably have unforeseen and positive results, even when the initial manifestation seems superficial or dangerously exciting. When a new idea resolves or stimulates ideas already held by a number of other artists, then it is probably an innovation and not mere novelty. While there is no infallible test for originality, one of the best indications is a work's ultimate influence on the art that succeeds it. Originality could be called novelty that endures through influence and provides enduring aesthetic or intellectual satisfaction in itself.

Thus the artists themselves are generally the best judges of innovation; if a contribution is picked up and carried on (by means of opposition as well as acceptance), it is likely to acquire substance and become important to the continuity and eventually to the history of art. A gimmick, a mere novelty, exhausts itself quickly, often helped along by minor artists who recognize its capacity for easy adaptation. It is frequently alarming to find out what work does not survive a short period like five years, which artists can go no farther with their one original idea. Some may be resting on their laurels, others have been carried beyond their ability by a single situation.

Innovation can be corrupted, or hidden, too. Some potentially major contributions never become influential and are recalled long after the fact when related events occur, as prototypal. There are cases where an original work leads to other innovations that eventually overshadow and surpass it. It is not uncommon for a good, but not great, artist to make the original step which provokes several masterpieces by others and changes the course of history. Yet he will be "neglected" in favor of the real masters who not only perceived the originality of his step but understood and were capable of extending its consequences far more profoundly. Finally, only a masterpiece remains as satisfying in its originality long after the original aspects have been extended by other work. And masterpieces, perhaps for this reason, tend to come at the maturity rather than the inception of a trend or style.†

Originality not only can be but should be a basic criterion for aesthetic judgment. Effects and methods in art do get exhausted. Someone painting today like Rembrandt (who always seems to be the painter brought up by reactionaries, justifying Duchamp's note for a ready-made: "Make an ironing board out of a Rembrandt") is what Rembrandt would have been had he painted like Raphael. He would not have been Rembrandt, and the neoacademic painter today who retains some of Rembrandt's style is no one either, certainly not Rembrandt.

The element of originality is not always related to surprise,

† I realize now I could find examples both to prove and to disprove this statement. It is an impossible generalization.

but it often is. Surprise does not have to be shock or a *nouveau frisson*. At times it is part of that deeper satisfaction that results when something expected turns up in an unexpected guise, the best example being in music, when an anticipated final note is worked out in an unusual way; while the rhythm satisfies the expectation, the solution itself affords new pleasure. Within the system of radical change dominating the art world at the moment, the alert and well-trained observer is rarely surprised by the new or original in its general occurrence; the next logical step or reaction to current styles is usually at least vaguely predictable before it has become wholly visible. What is surprising is the specific manifestation. The artist's individual genius, his solution to that next step, no matter how logical it seems after the fact, never ceases to surprise me.

The novelty of Pop Art, for instance, has been so disturbing to some observers that they fail even now to see the originality achieved by several of its makers. The reversal of taste afforded by Pop and by the sensibility of which Pop was the first obvious manifestation is still good for an argument, is still touted as a distasteful aberration promulgated only by those critics whoring after the approval of collectors and Loose publications. This, in spite of the fact that anyone in close contact with the work of younger artists cannot help seeing its very broad effect on both abstract and figurative art. I have felt, in turn, that Op Art, prominently billed as Seitz for sore eyes, was an uninspired product of artificial insemination. Yet recently I have had to note that certain aspects of perceptual abstraction formulated by lesser Op artists are being rethought to more original ends by younger abstract painters and sculptors, which bolsters my conviction that if it seems new, it has a good chance of being valuable.

I am aware that in advocating change and novelty, I am setting myself up for all those timeless shots at contemporary critics as opportunists, faddists, public relations men, and historical illiterates. Actually, I should be one of the last to deny that knowledge of historical method and an eye to broad historical pattern are valuable for contemporary criticism. But utter dependence on historical method in a time of such great change encourages premature decisions and categorization and

results in intellectual stagnation. One cannot set up critical systems when the recent past is constantly altered by the immediate present.

Critical ambivalence toward change arises from the fact that it is easier and usually more satisfying not to change one's mind according to the changes in the art, but to retain fixed criteria, to mark out one area of study and bury oneself in it, continuing to discuss and explore minutely that single area, than to have to look up with new eyes as new works appear and subtly alter the boundaries of that area. The critic who out of moralist and loyalist zeal confines himself to one strain of art, remaining Fogg-bound from all other tendencies, is a masochist, resigned to looking at art he cannot allow himself to like (on top of the general limitations everyone has in view of personal capacity for enjoyment and stimulation). Worse still, he is likely to find the artists he has fixed upon departing from the status quo, outdistancing him, and forcing him to extremes of syllogism in order "logically" to defend his stance.

While I deplore the economic and social pressures of change on the artist, I cannot join the doom-sayers who seem to feel that Art has been destroyed by the present sensibility. Younger critics and artists have matured in a period accustomed to rapid change. Observers in and out of the art world complain about the speed and apparent heedlessness with which aesthetic decisions are made, demonstrated, exhausted, or continued into new manners. The person who suffers most is the artist, but it is also the artist who takes the responsibility, insisting upon a quality and intensity that is extremely difficult to maintain. The result of many complex factors within the art world, the so-called cult of the new is actually a cult of the difficult.† One artist around thirty feels that ten years is as long as such a pace can be kept up within the high standards he has set himself. While most don't go that far, the prevailing replacement of styles and concepts is a result of that pace.

Rapid change also produces its share of easy art—Good Design and retrograde potboilers with a vast area of attractive, unambitious art in between. A tremendous amount of medi-

† See pp. 112–119 of this book.

ocrity is publicly exhibited today, as often in the museums as in commercial galleries and tourist traps. And there is a ridiculous overemphasis on "names" in the center of the advanced art world, a willingness to forget that the best artists make some bad paintings, that a good painter is not necessarily a great painter. In this regard, formalist criticism, based on the impersonal analysis and comparison first advocated by literary critics like Hulme, Eliot, Richards, and Leavis, in the early part of the century, was particularly valuable when it appeared around 1960, for it called attention to the individual properties of works, artists, and periods, and forced the mind and eye to work together, omitting extraneous speculation and emotionalism and purging art criticism of most of the permissive lyricism and literary generalization of the 1950's.

Formalism's specificity did a good deal to clear the air and to bring the critical method closer to the antisentimental approach of the art, though its major drawback was a tendency to eliminate from its evolutionary systems an increasing amount of the better art being done. Ironically, after a brief flirtation with the hardest, coldest, most detailed formal analysis, most younger critics have moved back toward generalization and a broader approach, at times incorporating conceptions filtered in from other, extra-art realms. Much recent writing retains its art for art's sake backbone without expending much descriptive energy on the analysis of single works. Rapid change and preoccupation with the new encourages generalization because a general approach is more flexible. Flexible ideas, in turn, contribute indirectly to change by their openness.

One need not *like* the new. The well-informed, "well-seen" reader need only disagree intelligently. Yet far more common is the armchair amateur who comes to new art and its commentary bowed under preconceptions of unchanging definitions of Art and Beauty. He does not understand the new because he is voluntarily unequipped to understand, and he will rant about how the cult of the new is being put over on him, forgetting that only the ignorant are easily "put on." Such a reader prefers to swallow the word of anyone who supports his initial distaste for the new. Worse still, he loses sight of the fact that the crux of these issues lies not in what is written

about them, but in what has been accomplished in the work written about. Some of the most avid fans of *The New York Times*'s senior critic have never seen nine-tenths of the art he writes about. Such a reader will resist the invitation to dialogue implicit in good criticism; he will look for the passive entertainment he is accustomed to getting from the mass media rather than the active pleasure of participation in intellectual pleasures. As Wallace Stevens once wrote: "No one tries to be more lucid than I. If I do not succeed, it is not a question of my English nor of yours, but I should say of something not communicated because not shared."

I, for one, would rather supply an arena, in which my own and others' opinions can meet, than make taste. The kind of criticism I like is not "educational" in an all too common sense of "educational." That is, it does not tell people how to think, or how to act as though they have thought, but shows rather than tells and explains. Criticism should not have to interpret, except in Eliot's sense of interpretation as presentation of less accessible facts. Freedom from interpretation provides freedom for clearer statement, aimed at those who have looked at enough art and paid enough attention to read that statement. Unfortunately, Art Education and criticism geared to "appreciation," to the formation of its audience's taste, rarely meets the intellectual standards necessary to stimulate ideas of any profundity and endurance, ideas that will prolong and intensify the art experience for the viewer. Too much journalism and educational writing attempts to be enjoyable instead of thought provoking. It founders in superficiality and oversimplification; at the other extreme, much specialized criticism is confused, rhetorical, and heavy-handedly "scholarly." The ideal medium might be the "literary sensibility" which, unlike journalism, "is geared to the timeless. . . . It is willing and solicitous to allow things their complexity, and to respect the irreducibility of much of the best art to anything like simple statement or basic English; and it is really concerned with pleasing one reader only: its owner, with his uncompromising demands on his abilities." [2]

[2] John Simon, *The New York Times*, August 20, 1967, Sec. 2, p. 1.

How much the nonprofessional art audience gains from the most thoroughly considered discussion of specialized issues is another story. For, like the making of art, criticism is basically self-indulgent. The artist does not set out to change the visible world or reform taste; his expansion of how people see or his comments on the world are by-products of the initial impulse to make art. One of the casualties of a preoccupation with the new is Communication, as the word is understood by teachers and television moralists. The responsibility of even the most casual art observer and reader of criticism to think, to look thoughtfully, is practically unacknowledged. The burden is left on the critic's shoulders, and if the critic shrugs it off in order to settle down to serious work, he cannot be blamed. If he is to face issues directly and honestly rather than through a simplified veil of explanation to others, he will open doors only for those who want them opened enough to push a little. Difficult art generates ideas and issues difficult to articulate. If criticism really comes to grips with these ideas, it is not likely to be particularly entertaining. A committed, and even professional, audience is ultimately the committed critic's only audience.

Heroic Years from Humble Treasures: Notes on African and Modern Art*

To the contemporary eye and sensibility, traditional African sculpture is extraordinarily beautiful. We are blasé about its exoticism, or barbarism, having often surpassed these ourselves by now; we take for granted its plastic force, and cannot fully share the experience of the French artists around 1904 who were discovering it for the first time, any more than we can plumb its originally intended depths. But we can easily share the attraction to such a dramatic, nonnaturalistic rendition of natural forms, all the more so since familiarity with contemporary abstract art has accustomed us to its subtleties. The African artist is perhaps the purest exponent of "significant form," and while his choice of these forms is symbolically determined, it led away from the naturalism with which the Western artist had come to a dead end. It signaled the vitality of a formal tradition, broadening the possibilities of art. The greatest lesson primitive sculpture had to teach the European artist may have been the ability of abstract and geometric forms to convey emotional force.† A general rather than a spe-

* Reprinted from *Art International,* Vol. X, No. 7 (September, 1966).
† Although here in New York one has only to walk a block—from the Museum of Primitive Art to the Museum of Modern Art—in order to

cific lesson, it has since been much misunderstood. Any discussion of African and modern art must keep in mind the differences between the two as well as seeking out the similarities. One of the salient facts is that "whatever the type of distortion, and whatever its function, Negro sculpture is conspicuously wanting in what we should call 'romantic agony' . . . the distortions are so controlled that they also transmit a feeling of serenity." [1] As Robert Goldwater, the leading authority on the subject, has repeatedly pointed out, African art is founded on a "preoccupation with other things which does away with a subjective artistic personality." [2]

The relationship between African and early twentieth-century art is a confused one, usually overemphasized and oversimplified by the literature of instant art appreciation. In 1926 Paul Guillaume and Thomas Munro correctly cited the prime contribution of Africa as "a general method and a storehouse of materials; its way of building up a design from the dissociated parts of a natural object, and the array of actual designs it achieved by this method . . . are capable of infinite development." [3] Earlier enthusiasts had offered more extravagant claims, suggesting that "Negro Art" (both African and Oceanic) dominated modern culture. In 1916, Marius de Zayas could write that "Abstract representations didn't exist in Europe till acquaintance with African art," and abstract art is "unquestionably the offspring of Negro Art." [4] Max Jacob

draw this or conflicting conclusions, the following notes were prompted instead by two exhibitions in Houston, Texas. The first, "Humble Treasures," at the University of Saint Thomas, united some 200 choices of African tribal art; its breathtaking variety dispelled any notion of African styles being "all alike." The second exhibition, "The Heroic Years: Paris 1908–14," at the Houston Museum of Fine Arts, was a loan collection of important, often magnificent, and rarely seen works.

1 W. G. Archer and Robert Melville, *40,000 Years of Modern Art* (London, 1949), p. 21.

2 Robert Goldwater, *Primitivism in Modern Painting* (New York, 1938), pp. 124–25.

3 Paul Guillaume and Thomas Munro, *Primitive Negro Sculpture* (New York, 1926), p. 134.

4 Marius de Zayas, *African Negro Art: Its Influence on Modern Art* (New York, 1916), p. 41.

went only a little less far when he categorically stated in 1927 that "Cubism was born of Negro statuary," omitting all reference to Cézanne.[5] By 1920, the artists themselves were tiring of the legend that at times threatened to overwhelm their achievements. In an enquête in *Action*[6] on the subject, Picasso replied, "L'Art nègre? connais pas!" Jean Cocteau remarked that "the Negro crisis has become as boring as Mallarméen Japonism," and Paul Dermée, saying that Picasso had accomplished his revolution by the time he first saw African art, added: "In seventy centuries the Negroes have not produced a Picasso. Now it is too late."

Although known in Europe since at least 1600, African art had been considered an ethnographic curiosity until around 1900, when avant-garde artists in Germany, Belgium, and France, looking for an exit from the maze of Western tradition, began to discern the merits of alien cultures—prehistoric, African, Pre-Columbian, American Indian, ancient Near Eastern, and Oriental. Vlaminck gets the credit for being the first Parisian artist to acquire an African sculpture; he did so by trading two liters of Aramon for a figurine noticed behind a bar. Accidental discovery was the rule. Paul Guillaume, an early and influential collector and dealer in African art, saw his first example on his laundress's mantelpiece. It had been sent her by a son in the colonies. After a while, Heman's curio shop on the rue de Rennes became known as a good source. Derain and Matisse were among the first to appreciate the aesthetic ramifications of the "ugly little creatures," which appealed to the Fauves' anti-intellectualism, and Matisse appears to have introduced Picasso to African art, although a good many other stories exist, including Picasso's own.[7] Unlike the nineteenth-cen-

[5] "Souvenir sur Picasso," *Cahiers d'Art* (1927), p. 202.

[6] "Opinions sur l'art nègre," *Action*, No. 3 (April, 1920), pp. 23–26.

[7] Picasso says that he discovered African art for himself in the Trocadéro in mid-1907, though he knew and visited Matisse the previous year. Robert Goldwater wrote in 1938 that Derain introduced Picasso to African sculpture in 1906; Gertrude Stein wrote that it was 1906, through Matisse; John Richardson says it was early summer 1907, through Matisse; while Michel Georges-Michel says Picasso was shown a carving in 1906 but only realized its aesthetic force on a trip to the Trocadéro with Apollinaire.

tury romantic approach or the Fauves' welcome of the crudities
and exaggerations found in poor examples, the Cubists' appre-
ciation of primitive art was relatively analytical. Their interest
in its formal qualities has led to the "pervasive form" theory,
that is, the correct notion that modern art has been influenced
by primitive art through generalized rather than specific chan-
nels. Since all primitive art must be necessarily taken out of
its intended context, liberties are bound to occur. Around
1908, European artists read into African sculpture grotesque,
brutal, spontaneous, free qualities that hardly correspond to
the rigid stylistic and iconographical traditions to which the
tribal sculptor was subject. Such qualities were, more likely,
born of the French imagination in reaction to the refinement
and impending decadence of its own naturalistic tradition.
Picasso's great *Dancer,* 1907–08, actually depicts the destruc-
tion of tradition in process. Often taken as the ultimate in-
stance of African influence, in fact it demonstrates the relative
superficiality of Picasso's borrowings from the African. He
chose to absorb from African art, mainly that of the Ivory
Coast, its emphasis on simplified, geometric features and its
consequent emotional force, but form is still distinctly vehicle
for content, and that content was still to some extent a cliché
view of the primitive. Then, within a year, he wholly assimi-
lated such characteristics. The so-called Negro paintings of
1908–09 are as much Picasso (and Iberian) as African, and they
also contain echoes of Oceanic art and, above all, of Cézanne.
Kahnweiler contends that Gauguin's influence "suffices to ex-
plain the 'savage' appearance of that period falsely called
'Negro.' " [8] He also insists, rightly, I think, that the real ramifi-
cations of Picasso's attraction to African art are to be found
in the work of 1910–14 rather than of 1907–09. In the card-
board and wood constructions concave and convex are re-
versed, as in masks where eyes and mouth are seen as cylin-
drical projections rather than holes. African sculpture was also
important at that time in the development of an assemblage
aesthetic, undoubtedly encouraged by the use of extraneous
materials on masks and fetishes. A handsome horned mask

8 Daniel-Henri Kahnweiler, *Les Sculptures de Picasso* (Paris, 1948), p. 3.

from Ghana, for example, incorporates patches of a lettered tin kerosene can.

The *Dancer*'s relationship to African sculpture is symptomatic, and I am not convinced by the usual comparison to a "bowlegged" Gabon reliquary figure. The oval eyes, pointed chin, small mouth, long nose, and short legs find equally telling counterparts in, say, a beautiful little Wabemba ancestor figure, yet aside from their intensity, they have little in common. The African pieces are self-contained, impassive, closed and inner-directed; the Picasso is open, active, aggressive, with an eerie, wide-eyed glance. The flattening devices derive from Cézanne, but they are combined with modeled forms and a deeper, stagelike space. Despite remains of their sculptural sources, these forms are distinctly antisculptural by nature. Nevertheless, such inconsistencies add to the painting's effectiveness. While it lacks the clarity of a fully resolved concept, the bold abandonment of smooth transitions, harmonious rhythms, and logical space make this a major work, more unified than *Les Demoiselles d'Avignon*. It even predicts Futurism in the way the legs swing to the left but are reflected by their path of movement at the right.

Soon after his initial exposure to African art, and presumably before painting *Dancer,* Picasso carved several small wooden figures, some strongly suggestive of Iberian styles or of Gauguin's and Oceanic sculpture, two patently African in spirit. *Femme nue,* a bas-relief, reappears in a painting and has a large oval head and concave contour legs in common with *Dancer*. *Homme debout* boasts a long concave dish face with protruding eyes and large crescent ears in deep relief, a rigidly vertical stance and short, two-part legs with cylindrical thighs and swelling calves. The columnar figure and long face could refer to Easter Island idols, but it more directly recalls standing Baoule figures. These little carvings suggest that Picasso, realizing how irrevocably sculptural were the values of African, or primitive art, tried his hand at some sculpture in the spirit of experimental empathy, in order to feel out the foreign process. The fact that he did no more work in this vein and soon abandoned all direct reference to African art indicates that he had absorbed what he wanted for his own evolution and had little interest in mere reflections.

Few other Cubist painters assimilated more than an occasional mannerism. Léger's *Couseuse,* 1910, like certain Picassos of 1908–09, has geometrically blocky, stylized hands that could refer to works like a Dogon female ancestor figure with musical instrument, but it is altogether more Cézannesque than African.[9] The only other Afroid painting in the Heroic Years exhibition—Modigliani's *Caryatid* (1911–12)—is a Pygmalion rendition of an Ivory Coast statuette. A standing female, on rounded pedestal with folded arms, it looks rather like a costume sketch. The head refers directly to a Baoule mask type that was available in Paris at the time, but the only distortion is the short lower leg and a slight stiffness and stylization; lacking the sinuous grace of a classic Modigliani nude, it is far more elegant than any African figure. The ropelike hair, circular breasts, oval eyes, and triangular nose are obvious references to its source, but otherwise the effect is blunted in favor of prettiness supplying a noteworthy contrast to Picasso's *Dancer.* By sacrificing structural vigor to anecdotalism, erect verticals to languid curves, by rounding off edges and restoring realistic proportions to distorted elements, Modigliani evolved a style more Gothic than primitivist.

One of the more interesting areas of discussion in this period is the different results of African influences on advanced painting and on advanced sculpture. In painting, the separation of parts typical of African art provided a move toward eventual fragmentation and nonobjectivism, whereas in sculpture it led to greater clarification and concrete articulation. By 1910–14, it was the sculptors who understood and absorbed African art most profoundly, even if their styles were arrived at via Cubist painting. Only in the sense of contour, pattern, and dramatic expressionism is African art adaptable to pictorial ends. The piled-up volumes and the piercing of the mass by voids, which are generally agreed to be the most decisive elements of African influence, can only be communicated in

9 Léger undoubtedly was acquainted with African art at that time, since he knew artists who owned examples. His interest seems to have been minimal, however, and only came to the fore in the twenties when he studied African work for the décor of the ballet, *La Création du Monde.*

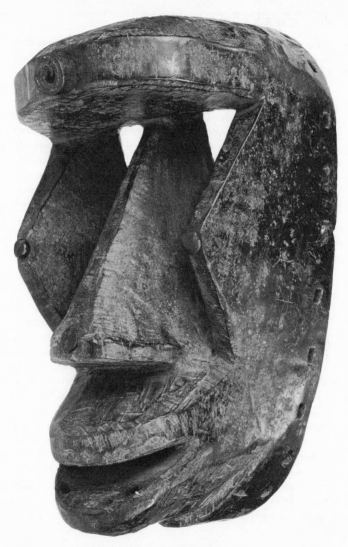

Mask with simian features from the Gio tribe. Poro society, area of Danane on the border of Liberia and Ivory Coast. Hardwood with metal and leather studs. 8½" high. De Menil Collection. Photograph courtesy of University of Saint Thomas Art Gallery, Houston.

three dimensions. The yearning and reaching quality possible in freestanding work becomes sentimental in two dimensions. Since the African sculptor seems to have been extremely sensitive to physical nature and change, his art was naturally sculptural (though the role played by European exposure to primitive ornament in the late nineteenth century must not be forgotten). Painters, more than sculptors, tended to overemphasize the evocative content of African art and since the sculptors came to appreciate it later, they were less romantic in their approach; their work is rarely raw or "spontaneous." Lipchitz, in 1920, voiced this attitude: "The art of the Negroes supplied us with a grand example. Their real comprehension of proportion, their feeling for drawing, their acute sense of reality made us glimpse, even dare many things. But it would be wrong to believe that our art has become mulatto. It is distinctly white." By 1962 he saw African art only as a "confirmation of our thinking," and rather fatalistically remarked that "a time came for voids, and so it came." [10]

The "Heroic Years" exhibition included three major sculptural monuments that can be more or less distantly related to African art: Matisse's *Jeannette V,* Archipenko's *Boxers,* and Duchamp-Villon's *Horse.* By 1909 Apollinaire could write that Matisse liked to surround himself with "those sculptures in which the Negroes of Guinea, Senegal, or Gabun have demonstrated with unique purity their frightened emotions." Fundamentally a traditional Western portrait bust, not a mask type, Jeannette's direct and regal aspect could as easily be traced to art of other cultures, but since Matisse was so knowledgeable in the field, it can be attributed to a familiarity with African art and to some sort of formal assimilation. Alfred Barr has noted the correspondence of the bulbous features of the Jeannette series with certain masks from the Cameroons in their haptic character,[11] though these were probably not available

10 *Action, op. cit.;* Rose-Carol Washton, *"The Influence of African Art Upon Sculptural Developments in Paris, 1906–1919"* (unpublished master's thesis, Yale University, 1962), Appendix B ("Interview with Jacques Lipchitz," March 27, 1962).

11 Alfred Barr, *Matisse, His Art and His Public* (New York, 1951), p. 141.

in Paris at the time, and Picasso's Cubist *Head* of the previous year must be taken into consideration. The fusion of finely modeled "Grecian" lips, sensuously protuberant "primitive" volumes, and the "Cubist" left eye, angularly faceted and flattened in contrast to the convex sphere on the right, all point to a highly sophisticated and modern solution.

Archipenko, who arrived in Paris in 1908, is a more complicated case. Apollinaire said he worked in the midst of a group of "fetishes," and we know he spent much time in museums and saw a good deal of Brancusi in those years. Yet in a 1962 interview Archipenko insisted that he was ignorant of African art around 1910; when asked if African forms had helped him arrive at his early sculptural solutions, he replied "nonsense." [12] (He also declared that he himself had influenced Duchamp-Villon, although the latter's *Horse* is intricately Cubist, owing more to Picasso and to Boccioni, just as *Maggy* owes much to Matisse's *Jeannette*.) While neither *Boxers* nor *Horse* bears more than a vague resemblance to any particular African piece, their freedom from representation translated into a European idiom, their use of expressive voids, and a certain pervasive solidity suggest a relationship. At the same time, their dynamism is foreign to the conventions of African sculpture, which derives its drama from subtle vertical emphasis rather than bold diagonals. *Boxers* is advanced for its time, displaying few references to visible reality and employing an assured abstract vocabulary. Its concave-convex cross-references recall many African works, but in his book, published in 1958, Archipenko pointed out that his use of these forms was very different, the African concave forming a "background" for projecting relief shapes while his own "symbolized the absent form and thus has creative meaning." [13] Obscure as this may sound, it makes sense in terms of the two triangular forms at the top of *Boxers,* which call attention to the cut-out concave area below from which they might have been extracted.

Brancusi is undoubtedly the most interesting artist to be

12 Washton, *op. cit.,* Appendix A ("Interview with Alexander Archipenko," February 27, 1962).

13 Alexander Archipenko, *Archipenko, Fifty Creative Years, 1908–1958* (New York, 1958), p. 51.

associated with primitive art in this period, both because he is such a towering figure on his own, and because there is such disagreement about the extent and even existence of an African influence. Jacob Epstein wrote that "African sculpture no doubt influenced Brancusi, but to me he exclaimed against its influence. 'One must not imitate the Africans.' " [14] Carola Giedion-Welcker contends that Brancusi was never the least bit influenced by African art, but that the primitive characteristics came from his own Romanian peasant background, the wooden beams and balconies of his native architecture and the squat forms and geometric patterns of folk art providing motifs that have since been confused with other primitive arts. He told her that Negro art was "dangerously charged with demonic forces," and in 1923 he had written: "Christian primitives and Negroes proceeded only by faith and instinct. The modern artist proceeds by instinct, guided by reason." [15] It is true that despite the natural aspect of Brancusi's sculpture, and while it is not lacking in humor or fantasy, his work is almost without exception devoid of the grotesque and the "demonic," even when the subject seems to demand it. Yet a great deal of the best African art also forgoes such extremes, concentrating on a moving expression of man's isolation and self-containment in the midst of hostile forces.

Going through the "Humble Treasures" show, one was constantly struck by some mysterious correspondence with Brancusi's art, not only in terms of natural surfaces, additive compositions, geometric forms, and elongated verticals, but also in the tremendous dignity that is at the heart of major tribal art. Specific instances for comparison are rare; Brancusi's *Wisdom of the Earth*, 1908, has been associated with African caryatids, but it is clearly derived from a more Western idiom, perhaps from the patient, crouching peasant woman, but also with a touch of Maillol. *The Kiss* has similarly been called "African" because of its schematic hair pattern and geometric solidity—

14 Jacob Epstein, *Let There be Sculpture* (London, 1940), pp. 63–64.
15 Carola Giedion-Welcker, *Constantin Brancusi* (New York, 1959), p. 33; M— M—, "Constantin Brancusi, a Summary of Many Conversations," *The Arts* (July, 1923), p. 16.

a feeble basis considering all of the other traditions which can claim these attributes, especially Greek archaic and folk art. Rose-Carol Washton cites a definite "African phase" of Brancusi's development with a peak in 1913–14, distinguishing it from the 1906–08 "primitivism." The former includes many of those wooden pieces, which do seem to us predominantly African in feeling, such as *Caryatid, Prodigal Son,* and, less so, *The First Step;* later, in the twenties, there is another group, *Adam and Eve, Chief, Socrates, Spirit of the Buddha.* Since none of these rough and exhilarating works was included in the "Heroic Years," show they fall outside the scope of these notes but Miss Washton does make a highly convincing comparison between the first version of *The Kiss* and a Baluba headrest supported by two facing figures joined by serpentine, embracing arms. For that matter, the oval domed head, lightly incised eyelids, and fine narrow nose of many Baluba figures and masks also recall the recurrent Brancusian head form found from 1908 on, in *Woman's Head, Sleeping Muse, Madame Pogany,* and *The First Cry.* Yet this might be traced back to certain seventh-century Indian Bodhisattvas, and it evolved from a gradual reduction in Brancusi's own work as much as from historical prototypes. *The First Cry* might also be compared, in the interest of purely visual analogies, to an Aduma mask in the "Humble Treasures" show, though it is unlikely that this type was available in Paris around 1913. The spade-shaped mouth frequently appears in Fang figurines, which *were* available.

It is no accident that Brancusi's wooden sculptures are far more reminiscent of African art than those in metal or stone. Like the African sculptor, he was a craftsman with high standards. He took great care with detail and many of the roughest tribal pieces were once covered with metal or skin, or retain a texture of magical substance applied for religious reasons. The treatment of wood lies at the heart of the affinities between Brancusi and his anonymous Black colleagues. The Brancusi-as-earthy-peasant myth may have little bearing on many aspects of his art, but it cannot be disregarded in relation to his primitivism. The Carpathian shepherd of farmers' stock was endowed with a greater comprehension than most of

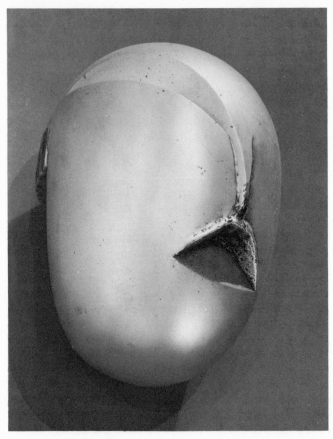

Constantin Brancusi: *The First Cry*. 1913. Bronze. 7″ x 10″ x 7″. Collection of Miss Jane Wade. Photograph courtesy of The Museum of Fine Arts, Houston.

his artist contemporaries of the artisanal, agricultural relationship between man and the land on which he lives. "Only Romanians and Negroes know how to treat wood," he once said.[16] The two cultures should obviously not be equated, but the tall vertical of Dogon sculpture, the erect carriage and innate nobility of almost all African ancestor figures, of the Bambara antelope headdresses or the magnificent Senufo hornbilled bird, express the position of man between earth and sky, life and death, a pillar (or the Oceanic and Indian totem, or Brancusi's *Endless Column*) raised to bridge the gap between two worlds, a pillar sharing the earth's fertility and the sky's infinity. The short, bent-legged stance and long torso of African figures appear in Brancusi's *Caryatid*, 1915; it makes them seem to emerge from the earth, predicting full growth and a leap into power as well as conveying a humble sense of earthbound compact form. Ivan Goll wrote that Archipenko sought the "striking humility of African art" and Vlaminck called it "the only still virgin art." [17] Dominique de Menil, by calling her exhibition "Humble Treasures," set a certain tone for the receptive viewer that results in a profoundly moving experience. We tend to read into African art today the aggressive character inherent in the modern avant-garde, but largely foreign to the tribal sculptor. Where the twentieth-century European employed African sculptural solutions for the purpose of liberation and artistic change or advance, the Africans themselves used art to maintain the status quo, to avoid catastrophe by conforming to the proper rituals. Their styles were rich within these restrictions (varying from tribe to tribe), but the expressive purpose was relatively constant. Theirs was a humble, restrained art in which even the decorative utensils and weapons share that authority and dignity which must, finally, have been the greatest attraction for artists of the "Heroic Years."

[16] Giedion-Welcker, *op. cit.*, p. 33.
[17] *Action*, No. 5 (October, 1920); *Action*, No. 3, *op. cit.*

Notes on Dada and Surrealism at the Museum of Modern Art*

Il n'y a plus de roues de bicyclettes
SAMUEL BECKETT, *Endgame*

Most published accounts of Dada and Surrealism have a monotonous sameness. The two movements have been generally overanalyzed and specifically underanalyzed, and the result has been a kind of aesthetic nonviolence, a going limp in the hands of historical clichés and "facts." Most of the so-called studies in depth seem simply to be listing events or searching among those slippery strands of unreason for a philosophical nit to pick.

The best thing about the current, and comprehensive, Museum of Modern Art exhibition is that it provided its director, the new Curator of Painting and Sculpture, William Rubin, with an excuse to publish a corrective to all of those half-baked generalizations. Dada and Surrealist art is finally fitted into the main currents of art history, related not merely to random iconoclasts and fantasists from the past (the only history Surrealist officialdom would accept) but to a broader continuity of modern art, from Cubism through post-painterly abstraction.

* Reprinted from *Art International*, Vol. XII, No. 5 (May, 1968).

Dada is usually shunted off as a childhood overture to Surrealism's magnificently prolonged pubescence. Here, for once, it is presented more extensively, and, as a whole, comes off better than Surrealism. The vitality of the Zurich group is especially evident here with the fine Arp reliefs, Sophie Taeuber's machine-marionette, Augusto Giacometti's proto-Abstract Impressionism (wildly ahead of its time though it is, his *Painting*, 1920, looks like a heavily painted Jon Schueler or Ernst Wilhelm Nay). Hans Richter's 1923 *Rhythm* scroll is too late to be called Dada, but it is a far better example than the ones at his recent Finch show. The New York group, thanks to Duchamp and Picabia, looks terrific; the Berliners, aside from Hausmann and Grosz, were not aesthetically brilliant, but then they had no intention of so being. It is too bad that the Cologne work has been so dispersed that it is apparently impossible to represent anyone but Ernst and the two Baargelds owned by the Museum; they were far and away the major, but not the sole, participants, and since I am interested in establishing a chronology for the discovery and development of Dada photomontage, I should like to have seen more.

I still regret the fact that there has never been a museum exhibition devoted to Dada alone in the United States. Dada and Surrealism are fundamentally different, Surrealist systematization being in many ways a direct reaction against Dada anarchy. Yet Dada itself harbored an integral dualism in its simultaneous leanings toward destruction, fantasy, and purism, exemplified most clearly by Schwitters, Arp, and even van Doesburg, but found in a more exaggeratedly schizophrenic form in the work of Max Ernst, Picabia, Man Ray, and Duchamp. Purism is the wrong word; it was rather an inclination to organize and clarify the most apparently destructive motives, to analyze the most irrational juxtapositions, and can be explained as the consequence of a longing for a *tabula rasa* similar to that of the Russians at the same time. All the Dada sloppiness sometimes seems a nostalgia for, or a deliberate move toward, the literally clean slate. The Dadas in Germany were reacting against Expressionism more than Cubism, and Schwitters, Ernst, Grosz, Picabia, Hausmann retained for the most part a Cubist structure, as had de Chirico.

The Surrealists had nightmares because they couldn't paint too well.

SIDNEY TILLIM

Overcrowding disappointingly diminished the impact of Ernst, Tanguy, and Magritte (and less so, Arp and Giacometti). With Dali it didn't matter; nine paintings from his major period (1928–34) are jammed into a dimly lit, dark-walled gallery within a gallery; the *Venus de Milo of the Drawers* (her knobs are fur pompoms) holds the center like a boudoir fountain. The result is an intimacy these small paintings need, though it may be unwanted by many spectators, considering the often-repulsive subject matter. For all their preciousness, these are potent translations of the Surrealist dream of painting dreams. The opportunity for iconography hunting is unsurpassed, and for an art historian, irresistible. The transitional *Senicitas* of 1928, the tiny *Illumined Pleasures, Accommodations of Desire, The Lugubrious Game, The Great Masturbator, The Invisible Man, The Persistence of Memory,* and the unfinished *Imperial Monument to the Child Woman* provide a fascinating web of process, a footnote to which is found in the object section where a Dali contribution is a presumably "found" glass paperweight bearing exactly the roaring lion's head image found in his paintings. From one of these works to another, a motif is born, evolves, and offers various interpretive nuances during its development into a full-blown symbol, then avidly frozen in the Dali repertory.

For instance, aside from the very specific references to de Chirico, Ernst, Magritte, Miró, and Tanguy, one can follow an image like the "sleeping" self-portrait at the far left in *Senicitas* from relatively realistic front-face to an increasingly fetal image, through *Illumined Pleasures, The Lugubrious Game,* and *The Great Masturbator,* to the almost unrecognizable, fishlike biomorphic form in *The Persistence of Memory.* This is the prototype for all of the "soft" forms used consistently from then on. This same self-portrait sometimes fuses with that of the "Child Woman," which has its seeds in a female head-pitcher image, the development of which is out-

lined in steps in *Accommodations of Desire*—woman as vessel, and Dali himself an androgynous figure. In a contemporary portrait of Paul Eluard—Gala Dali's husband when Dali met her—Gala too becomes identified with this image, and the "sleeping" or fetal self-portrait becomes an angry phallic fish. The metamorphosis of the mannequin's head with a human head inside of it (*Illumined Pleasures*) is made clear by the fact that in *Accommodations* this form is still a head bursting out of an egg shape. Images from the Dali-Buñuel films are also recalled, such as the mouth disappearing, becoming a wrinkle, the palm of a hand with hair and then ants coming from it. (In *Illumined Pleasures* Dali's "ants" are little men on bicycles carrying huge crumbs on their heads.)

The large Mirós are certainly *the* aesthetic experience of a show, the first half of which sometimes seems delivered into the hands of a historical survey for suvey's sake. *Birth of the World,* 1925, and *Painting,* 1930, are stunning paintings, large in scale as well as in size, achieving both simplicity and breadth. The former's brushy looseness and unrestrained drips, the latter's soft but authoritative reductionism are prophetic of painterly and then post-painterly abstraction in the fifties and sixties. *Birth of the World* is particularly impressive, though one is perhaps bowled over by its prophetic qualities; the linear and flat germlike elements superimposed on the irregular receding grays of the ground do not really work as well as the woven dispersiveness of *Harlequin's Carnival,* completed in the same year, but in an entirely different mood (though both anticipate the allover configurations of Miró's work in the early forties).

Miró's versatility, and his tremendous ease, displayed only by the greatest artists, is reflected throughout the twenty-four works exhibited. These range from the lyrical *Landscape with Rooster* to the witty *Gendarme* (where an eyebrow line doubles as the *flic's* hat; this is an 8 by 6 feet canvas and it justifies its size); from the playful fluidity of the poem paintings to the decorative boldness of *Snail Woman Flower Star;* from the weighty realism of *Still Life with Old Shoe* (a comment on Van Gogh? there is a potato at the left, I think) with its acrid

"psychedelic" lighting, to the almost absurd economy of *Spanish Dancer*, where three lines, a rectangle, and a high-heeled shoe are *it*. There are also objects (one from 1931 with a Pollock-like puddle of paint, another to add to the long list of spurious "prototypes" for the drip technique); and delightful drawings (*Automaton*, 1924, including the letter *A* and a Klee-like flywheel in fine Dada style). Although Ernst's innovations led him into as fertile, but never as fully resolved territory, Miró is unquestionably the major painter of this group.

Mr. Rubin's total persuasion of this supremacy led him to give Miró so much attention that it did seem slightly out of proportion to the historical aims of the show, but the guts of the exhibition lie appropriately enough in this middle section, in the Mirós and the transfusion of many of Miró's principles via Masson and even Matta, into Gorky and the New York School. The exposition of this Miró-Masson-Matta-Gorky sequence constitutes an interesting and potentially autonomous exhibition in itself. The present selection crystallized and illustrated certain ideas taken for granted but necessarily reduced to inadequate visibility in the literature.

Miró's influence on the New York School is indisputable. Masson's importance, on the other hand, remains, and probably *is* ambiguous because of the ambiguous quality of his work; he is a most uneven painter. Except for the 1927 sand paintings, the more I see of his work the more I am convinced that his innovatory tentatives were more significant than the œuvre per se, even at its best. *Meditation of the Painter* (1943), for all its biomorphism that seems about ready to break out of its solid contours into a Gorky or de Kooning, is so dry and heavy and overworked (physically and allusively) that what it gains by its color and rhythm, it loses by its turgidity. In fact, if this selection is any indication, it is ironic that Masson's greatest reputation here has been for the influence of his automatic drawings on the growing freedom of the younger American painters. These drawings are most successful when a tight analytic Cubist structure is most strongly in evidence; the fluidly "automatic" line, when not woven into this sort of interlocking shallow space, seems to be seeking desperately for a

figure to describe, prefiguring the Abstract Expressionist dilemma Clement Greenberg calls "homeless representation."

The relationship between Matta and Masson is not very clear. Masson lived in Connecticut when he was here "in exile," and he arrived two years after Matta, who had only been involved with the Surrealists a year before he left Paris. Both were concerned with a kind of humanism, though Matta's was more abstract and even scientistic while Masson's was rooted in an earthier allegory. Mr. Rubin observes that these two were "the artists who gave the erotic the crucial role of catalyst to the creative powers. . . . Both understood the sexual paroxysm as the moment of the fusion of contraries; the conscious and the unconscious, mind and body, the self and the 'other'; and, hence, the moment of the liberation of the imagination."

Matta's *Inscape* (*Psychological Morphology #104*), made in Paris in 1939, includes his already characteristic gelatinous biomorphic forms and their eerie glow, but it also opens up into much rougher, heavier areas of painterly handling that bears a probably coincidental resemblance to Masson's later work, as well as predicting Gorky more specifically than Matta did after coming to New York. The 1939–42 canvases parallel Miró in the sense that Matta used increasingly small forms, of a size, and distributed evenly over the surface, almost disregarding a shallow Cubist space in favor of the ambiguous depths to be explored by Pollock. Gorky, on the other hand, usually retained an "interior space," but his multiple forms did not stay separate as Matta's did, especially in the drawings; they fused into a new and moving whole in the last works, of which the grisaille *Soft Night*, 1947, is a lovely example.

Looking at this section, it is well to remember that New York artists had already been exposed to Surrealism at the Julien Levy Gallery and in Alfred Barr's big "Dada, Surrealism and Fantastic Art" show in 1936. The Museum purchased several works from that show that are included in this one, among them a star publicity-getter in the thirties, Meret Oppenheim's fur-covered teacup, and, more important, Giaco-

metti's *Palace at 4 a.m.* This seems to be specifically quoted in David Smith's 1939 *Interior for Exterior* (the bird-in-frame shape). David Hare's later *Magician's Game* and Herbert Ferber's *He Is Not a Man* follow the Surrealist tradition of the "personage," the single hybrid figure either isolated in vague painted space or in real space as an object; Ernst's *Round Head* of 1935 (now called *La Belle Allemande*) was an advanced example of the genre in the Fantastic Art show which relates closely to the Ferber, though probably coincidentally.

In paintings, the same motif appears in Clyfford Still's 1944 *Jamais* and Barnett Newman's *Genetic Moment,* 1947, both of which reflect Ernst's ubiquitous sun-moon device, which Newman has even placed over a plane that could have been made by an oil-frottage process; it is flanked by two vertical forms that can be seen both as Ernstian forest-planks and Newman stripes. (The second Newman, *Pagan Void,* seems more Massonesque, as do the early Stamos, Ossorio, and Cohen.) A major example of this cross-fertilization is Rothko's beautiful *Slow Swirl by the Edge of the Sea,* 1944, in which three of these personages are lined up in a frieze composition against a beach and low horizon line, in a manner very like that of such 1920 Ernst collages as *Démonstration Hydrométrique,* in this show, or *Gramineous Bicycle* and *1 copper plate, 1 zinc plate,* both in the 1936 show. However, more significant than this, and than the Miróesque line and Gorkyesque attenuated bulbous forms, is the Rothko's grace and mastery of its genre, its size (6 feet 3 inches by 7 feet $\frac{1}{2}$ inch) and freedom. One can even, perhaps overzealously, see the division of the painting into three atmospherically defined horizontal zones as a premonition of Rothko's mature style.

Wols's *Whales in Water Flowers,* 1937, is also distinctly reminiscent of Ernst's *Bride of the Wind* series in the mid-twenties. I find all these Ernst references interesting because for all his early and continued involvement in the primitive as a source for art, and in the subconscious roots of myth, Ernst had only at certain periods achieved an equivalent stylistic breadth, notably in the twenties, when he focused on oil frottage. Ernst's work while he was in New York was much tighter and more detailed and would not have been attractive to the New

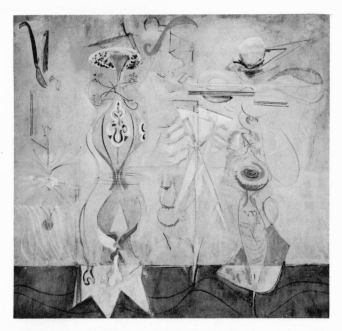

Mark Rothko: *Slow Swirl by the Edge of the Sea*. 1944. Oil on canvas 6′3″ x 7′1/2″. Collection of the artist's estate.

York School, but the earlier things were also being shown. If Miró was a prime influence and Masson and Matta opened up possibilities which they themselves could not resolve, Ernst must have offered an imagery, a strong, simple vocabulary that seemed valid to those who sought a return to the directness of myth and primeval sources; it served as a temporary vehicle for what Rothko and Gottlieb called in 1943 "the simple expression of the complex thought."

The Surrealists considered poetry the only appropriate and complementary analogue to painting, so criticism, as we define it, was bypassed. Breton and Éluard said in 1929 that "a poem must be a debacle of the intellect." Yet at the same time, Surrealism, outwardly the most unscientific of movements, was mightily attracted to science. Artists and writers, particularly in the thirties, continually referred to physics, geometry, and, of course, psychoanalysis. The Dadas had ridiculed science and carried it to ridiculous extremes, à la Jarry's Faustroll, *"savant pataphysicien,* imperturbable logician, carrying to their ultimate consequences the "speculations" of the geometricians, physicists, and philosophers, and quite at ease in a world grown utterly absurd" (Maurice Nadeau, *The History of Surrealism,* p. 73). The Surrealists, on the other hand, took the absurdity quite seriously, as they took themselves and their own intellectual–anti-intellectual endeavors. Breton saw science as an indicator of the unknown similar to Surrealist art. His "objective chance" was the expression of a hidden order rather than the Dadas' exposure of a lack of order.

Roger Shattuck has observed that the three favorite Surrealist metaphors (all Breton's) belong to physics: *"interference,* the reinforcement and canceling out that results from crossing different wavelengths; the *short circuit,* the dangerous and dramatic breaching of a current of energy; and *communicating vessels,* that register barely visible or magnified responses among tenuously connected containers." The incorporation of flux and contradiction, of relativity, into modern science was interpreted by Breton as a confirmation of Surrealism's "will to objectification," of its scorn for "mere art," and of its at-

tempts to systematize products of the unconscious: "Like science, like philosophy, poetry is a means of knowledge." The "inquiry" was a favorite literary mode of experimentation in the 1920's, and the movement's organ, *La Révolution Surréaliste,* was modeled after a scientific journal, *La Nature;* the scandals therein were presented, not entirely ironically, as research and experiment. The "Bureau des Recherches Surréalistes" continued the simile; the public was invited to come and record its dreams, desires, obsessions, and hallucinations. If automatism offered the raw materials of art rather than art itself, then every man could be an artist and no man was an artist.

Later, in the late thirties, Paalen, Dominguez, Matta, and Onslow-Ford, departing probably from Duchamp's ironic metaphysics, concocted involved theories about psychological morphology and new concepts of cosmic time, space, and humanism, couched in the most resounding pseudoscientific terms. Matta, the ex-architectural student, wrote about a "sensitive mathematics," and Dali too went in for a good deal of scientism, especially in his *The Object Revealed as Surrealist Experiment,* 1932. Nadeau summarizes the attraction of Einstein for the Surrealists:

> [Einstein's] scientific language is not always understandable, but strange illuminations gleam here and there like an aurora borealis. "We have made a mistake," he says in substance, "the real world isn't what we thought, the best-founded conceptions apply only to our daily round, out there they're false. False our old conceptions of space, false the time we've fabricated. Light is propagated in a straight line, and the mass of bodies is a kind of rubber band." The epistemologists fall into step, questioning the conditions and limits of knowledge. It seems that knowledge is something else besides action, for which science furnishes recipes that apply to it. The two can no longer be identified: here are the mathematicians with a geometry that dispenses with Euclid and his famous postulate. Reason, all-powerful reason, stands accused, and stands mute: she has nothing to say in her defense. Reality is something

besides what we see, hear, touch, smell, taste. There exist unknown forces that control us, but upon which we may hope to act. We have only to find out what they are.

Do you still remember that time when painting was considered an end in itself? We have passed the period of individual exercises.

CATALOGUE OF SURREALIST EXHIBITION,
GALERIE PIERRE COLLE, PARIS, 1933.

The seeds of Dada and Surrealism appear in such unlikely forms and in so many areas today that they can only be implied in a paragraph, or in two small exhibition spaces. Nevertheless, one of the main reasons for a Surrealist show at this time is the resurgence of interest in a highly conceptual and acceptive art, typical of the 1960's. Aside from the obvious case of the "intermedia revolution," there are other parallels between the Age of Surrealism and today that are so pervasive as to be less visible; one of them is the increasing use of scientific and mathematical ideas as tools for art. Another is the current preoccuption of abstract art (and some figuration) with the late twenties and thirties, with "Hollywood modern" and a kind of synthetic Orphism, which must also be related to the curiosity about Surrealism, an art diametrically opposed to 1930's formalism on a visual level, but not so distant on an intellectual level. In addition, like American artists of the last three decades, the Surrealists "fell back on art" after being disillusioned by the impotence of their political actions. Surrealism welcomed violence as a means toward a clean slate, a new world, and a new humanism. Despite the determined nonviolence of the younger generation today, violence is inherent in our society. The "Destruction in Art" group is not the only one to see it as an aesthetic medium. In a strange way, all the most puritanically idealist movements have welcomed violence in one guise or another as herald of the *tabula rasa*.

If the later "heritage" section of the Museum exhibition had reflected some of this instead of being limited to art that more or less *followed* Surrealism, it would have been more relevant. The 1940's New York School looks better than the original

Surrealists, but the fifties and sixties are made to look retrograde by comparison. Duchamp, in particular, has been a far more radical influence on recent art than would be supposed from this rather tame selection; it seems to have been made less on the basis of quality than on that of illustration. In the book, the recent work is smoothly fitted into the exposition as comparative material; but dumped unceremoniously at the end as it is in the show, its general weakness (there are of course major exceptions) is all the more apparent. Mr. Rubin's own taste, or distaste for a good deal of current art, has interfered with his objectivity, so successfully maintained in the other sections. I find it hard to believe that he himself really likes some of what he has included, such as the blatantly bad painting by Clarence Carter, the Biasi and Trova assemblages, or the Lemaître lettriste composition.

There is a great deal of interesting abstract art being made that owes a strong, if at times indirect, debt to Dada and Surrealism. I should like to have seen, at least represented, work like Robert Morris' new felt pieces, some of the New English Sculpture, Bruce Nauman's three-dimensional visual puns, the fusion of post-Surrealism and primary structures found in the work of Eva Hesse, Frank Lincoln Viner, Gary Kuehn, Keith Sonnier, or Jean Linder, Louise Bourgeois' latex molds, or the advanced funk of Mowry Baden, Harold Paris, Don Potts, William Wiley, Bruce Conner, or Kenneth Price. And what about Craig Kaufman's Picabiaesque vacuum forms, Carl Andre's "particles," Paolozzi's chrome versions of Tanguy's tableland period? Or within the narrower limits apparently set, why was there not a more original Westermann and a better Kienholz, a stronger and more erotic Oldenburg (a drainpipe, or bathtub)? As for Surrealist objects, the two Samaras' would have been better accompanied by Kusama's phallus-studded furniture, one of George Brecht's early "events," a Fahlström, a Whitman, Ed Ruscha's drawings, an Artschwager, a Wesley, a Richard Hamilton (or for that matter a specimen from Sam Goodman's Shit Show, or the compulsively repulsive work of Tosun Beyrak, a genuine contemporary Dali). Where are Duchamp's ideas better followed up than in Les Levine's disposables, Warhol's portraits, Morris'

early lead reliefs? A near-total ban on Pop Art omitted the distinctly post-Surrealist compartmentation of Rosenquist, Lichtenstein's art about art, Segal's frozen happenings, and Dine's conscious departures from Dada documents, not to mention the Europeans.

This may seem an unnecessarily harsh judgment on an exhibition so important in so many ways, but the New American painting section showed so intelligently how new ideas could be born of a dying Surrealism, it is a pity that it could not have been carried through into such 1950's manifestations as the March Gallery, Reuben Gallery, or Judson groups and the abstraction of the sixties. If this had been done, the exhibition would have ended with an open bang instead of a closed whimper; it would have been less of a museum piece and more in the spirit of the original movements, as the demonstrators outside the Museum on opening night were trying, abortively, to indicate.

Dada into Surrealism:
Max Ernst*

What is Dada? A Virgin Microbe.
Dada is a Tomato.
Dada is a Spook.
Dada is nothing, nothing, nothing.
Surrealism is a way of life.

The word Surrealism is now used to embrace and conceal the
original innovations of Dada, while Dada itself is falsely sum-
marized as an eccentric drop in the bucket of reason, a pri-
marily political and nihilist explosion with few lasting effects.
On the contrary, Dada's nihilism, as Robert Goldwater has
observed, was instrumental rather than fundamental.[1] All the
seeds of Surrealism were present in pre-Parisian Dada: bru-
talist and simultaneist poetry (via Futurism), automatic writ-
ing, the sexual, anticlerical, revolutionary content, the ex-
ploitation of the unconscious and of chance. And on the visual

* Reprinted from *Artforum*, Vol. V, No. 1 (September, 1966). Originally
titled "The Virgin Microbe Comes of Age."

1 Robert Goldwater, "Book Review: Dada Painters and Poets," *Art
Bulletin*, Vol. 34, No. 3 (September, 1952), p. 250.

side, biomorphism, collage and painting based on the fusion of unrelated realities, objects and found objects, interest in art by the insane, children, primitive cultures, and autodidacts. Surrealism is in fact housebroken Dada, postgraduate Dada, Northern fantasy subjected to French lucidity, chaos tamed into order.

Dada and Surrealism are not interchangeable; the relationship between them would be clearer if events in Paris from 1921 on were simply called Surrealism. Swiss and German Dada, with its hostility, exuberance, and basic optimism, represents the childhood stage of the phenomenon, Parisian Dada and Surrealism the throes of adolescence, with all the connotations of innocence and sophistication implied. In 1916 Hugo Ball recommended "everything childlike and symbolic in opposition to the senilities of the world of grown-ups." But his "childlike" touched on the "infantile, dementia, and paranoia," and he added, prophetically: "The credulous imagination of children is also exposed to corruption and deformation." [2] This exposure resulted in a loss of freshness and entrance into a second stage, characterized by obsessions notably consistent with the years of puberty, from which Surrealism in some ways never emerged.

Dada lost its political and aesthetic virginity to the postwar period. By fall, 1920, the war had been over for two years and it was obvious that the *tabula rasa* for which Swiss-German Dada was striving could not be achieved. The Dada attitude began to shift, imperceptibly at first, to the potential nihilism for which it is now known. This change coincided with the move from a German to a Parisian focal point. The major literary figures were in Paris, particularly Tzara, whose arrival in the Breton stronghold at the end of 1919 did more to ignite than to unite the movement. In the visual arts, Picabia was unchallenged (since Duchamp had largely decamped) until May, 1921, when Max Ernst's show of *"dessins mécanoplastiques plasto-plastiques peintopeintures anaplastiques anatomiques antizimiques aérographiques antiphonaires arrosables et républicains; au-delà de la peinture"* (or collages; only one-

2 Hugo Ball, *Die Flucht aus der Zeit* (Lucerne: Josef Stocker, 1946).

fifth were glued) announced the advent of a new approach. These small works, executed from 1919 to 1921, constituted the immediate source of visual Surrealism, and Ernst's development during this period is a microcosm of Dada into Surrealism.

Cologne Dada, like all the most artistically fecund Dada groups, was very small; like Schwitters' Hanover, and Duchamp's and Picabia's New York, it was isolated from other avant-garde circles. Max Ernst and Johannes Theodor Baargeld, a painter and pseudonymous banker's son, were the only full-time members.[3] Arp, who was not in Cologne as often or as long as is generally implied by historians, was still important in his role as catalyst and quizzical guide to greater Dadadom. The extent of Arp's actual participation is still not solved. He does not seem to have been present either for the November, 1919, or the April, 1920, exhibitions (though his work appeared in both), but probably stayed in Cologne for at least two months at the beginning of 1920, cooperating in the publication of *Die Schammade* (*Dadameter*) a one-shot review which significantly included a broad selection of major Zürich and Paris Dadas as contributors. Broadly traveled, and at that time still peripatetic, Arp was known and liked by all the major Dadas. His friendship with Ernst dated from 1914 and his gentle fantasy and inclination to pure abstraction complemented Ernst's more intellectually mordant strain. They agreed to "purify the imagination"; "Sentiment must go and so must the dialectical process which takes place on the canvas alone."[4]

Baargeld's role has been minimized in what passes for Dada art history, mainly because so little is known of him; he died in an avalanche in 1927. An inventive draftsman and collagist who shared Ernst's early debt to Picabia, his style was somewhat more expressionist, his handwriting more rounded and

3 Others involved in the W/3 West Stupidia group were Heinrich and Angelika Hoerle, Otto Freundlich, Franz Seiwert, Anton Räderscheidt, Wilhelm Fick, Hans Bolz. Their art, however, was formally conventional and not Dada.

4 Hugo Ball, on Arp, *op. cit.,* quoted in Hans Richter, *Dada Art and Anti-Art* (New York, 1965), p. 47.

heavy than Ernst's, so that despite their presumed collabora-
tions, Baargeld's physiognomous landscapes are individually
recognizable. *Anthropomorphic Tapeworm,* reproduced in *Die
Schammade,* equals Schwitters' contemporary junk construc-
tions in quality and imagination, surpasses them in eccen-
tricity. Baargeld also participated in one of the best-known
Dada collaborations—*Fatagaga (fabrication des tableaux ga-
rantis gazometriques)* though it is usually attributed to Ernst
and Arp alone. (Ernst's 1921 Paris catalogue lists Arp-Ernst
and Ernst-Baargeld fatagaga items separately.) Arp's whimsical
account of this undertaking refers to one of Ernst's photo-
collages—*Laocoön*—which has at least once been exhibited
under Arp's name: "Overcome by an irresistible longing for
snakes, I created a project for reformed rattlesnakes, beside
which the insufferable rattlesnake of the firm Laocoön and
Sons is a mere worm. At the very same moment Max Ernst
created *Fata.* My reformed rattlesnake firm and Max Ernst's
Fata firm were merged under the name of *Fatagaga* and can be
brought to life at any time on request." [5] Hugnet calls the
Fatagaga photocollages a "Dadaist pact" resulting from Arp's
expression of "regret at not having done certain collages by
Ernst," whereupon Ernst suggested they both sign them. Re-
cently these collages have been discussed as though they were
executed by more than one person, and Sanouillet says that the
Cologne Dadas inaugurated the *Cadavre Exquis* method in
Fatagaga.[6] However, none of those works surviving show evi-
dence of such a technique and the hand is unmistakably
Ernst's. No photocollages by Baargeld or Arp have survived,
to my knowledge, and given Arp's preoccupation with abstrac-
tion at the time, it seems unlikely that he devoted any time
to what, for him, was an incompatibly literary medium. Ac-
cording to Ernst, *Fatagaga* was a very casual collaboration. He
was already making photocollages when Arp arrived in Co-
logne, and the three spent several afternoons together, Ernst

[5] Hans Arp, "Looking," in *Arp* (New York: Museum of Modern Art,
1958), p. 13.

[6] Michel Sanouillet, *Dada à Paris* (Paris: Pauvert, 1965), p. 41.

executing the collages and Arp and Baargeld making poetic
punning suggestions for images or titles.

Unique in its visual orientation, Cologne Dada was to Sur-
realist painting what the Parisian branch was to poetry. While
Ernst and Baargeld both wrote biting Dada prose and poetry,
they consciously avoided the Berlin brand of polemic. Politics
were not allowed to interfere with the main business at hand—
establishment of a fine-art anarchy intended to pave the way
for a "new reality" that would bury Expressionism, by then
the official German style. No cows were so sacred that they
couldn't be milked for Dada punch. "Everyman loves every-
man's Cézanne and rolls his eyes: This painting. Ooooh this
paaaaaynting! I don't give a damn for Cézanne, for he is an
enormous hunk of painting," wrote Ernst in *Bulletin D.*
"Everyman also loves everyman's Expressionists, but he turns
away in disgust from the ingenious drawings in urinals. The
most perfect plastic art to date is the piano hammer, dada."

Nevertheless, Cologne art, for all its newness of approach,
was very aesthetically oriented. Arp and Ernst were both at-
tracted to a highly organized arrangement of images that
might have originated in chance or free association. A dis-
tinctive clarity and fundamentally Cubist scaffolding lies be-
hind Ernst's anthropomorphic parodies as well as behind Arp's
nonobjective *papiers dechirés* and reliefs. It should be noted
that Ernst, Arp, and Schwitters, among others, were rebelling
against Expressionism rather than against Cubism, which they
had seen very little of due to the war. ("The exhibition of
feelings is against *my* feelings," says Ernst.) The Cubist frame-
work of Zürich and Cologne Dada art is owed to the fact that
for them Cubism, Futurism, and abstraction were the most
radical styles available. The French, on the other hand, had
seen Cubism diluted and academized. Breton and the potential
Surrealists in general rejected abstraction, which was con-
demned as art for art's sake, and delved into the subconscious
for subject matter; having denied Dada's tentative abstraction
and lacking any other plastic innovation, they reverted to a
conventional realism applied to "super-real" images. As Ernst
evolved a more literary style, he too moved away from the
Cubist vignette and shallow boxlike space of Picabia to a

deeper interior space and finally into a romantic landscape distance inspired by de Chirico, though he temporarily re-established a flat surface in the frottage paintings of the later twenties.

The 1919–20 printer's plate "collages," actually altered relief prints or rubbings made from the plates of a technical textbook, reflect the influence of Picabia on Ernst's earliest Dada output, but they are also consistent with his own, infrequent paintings and drawings from the war period, such as the 1916 cover sketch for *Der Sturm,* where a Klee-like scratchy line, pipe and wheel shapes within a rectilinear grid, convey metaphysical rather than mechanical connotations. The printer's plate drawings, modified by ink lines and, later, rubber stamps and watercolor, are delicate, ordered, very abstract, in spirit quite different from Picabia's careless, awkward tracings of the entrails of an alarm clock, made in Zürich just a month or so before. (Cover of *Dada* 4–5.) There is no question that Picabia's drawings, such as *Tamis du Vent,* in the February, 1919 (Zürich) issue of *391,* which has cryptic phrases written along the "technical" forms and diagrams, are the most direct source of the printer's plate works, or that such paintings as *Amorous Parade* are the basis of Ernst's gouaches, like *Undulating Katherina.* Yet Picabia himself never followed through on the potential of his machine drawings, never explored them except from an iconoclastic, plastically superficial point of view, whereas Ernst, after assimilating a second major influence—de Chirico—fused the two antithetical styles with his own and continued to develop.[7]

12 Opére di Giorgio de Chirico, a booklet of reproductions published by *Valori Plastici* in August, 1919, had a decisive effect on Ernst. Previously he had been more impressed by Carrà's patently artificial doll figures, reproduced in *Valori Plastici,* but only one painting and two drawings by de Chirico had appeared there during the time he would have seen the review. He recalls painting *Aquis Submersus* immediately after seeing the de Chirico booklet, and the exaggerated per-

[7] The most obvious example of this as yet undigested mixture is *Fiat Modes, Pereat Ars,* a portfolio published by the city of Cologne early in 1920.

spective of the "swimming pool" was probably inspired by the
platform in *Sacred Fish,* to which he was especially attracted.
(Perhaps coincidentally, the buildings, pool, and clock in *Aquis
Submersus* closely resemble those in *Delights of the Poet,*
which was not in the booklet, but these elements might have
been suggested by a drawing, *Solitude,* which was.) The semi-
aquatic, semihuman figure recurs in the contemporary *Justicia*
and is apparently Ernst's adaptation of the Scuola Metafisica
doll-mannequin. *Resurrection of the Flesh,* also titled *Last
Judgement,* makes use of several obviously de Chiricoesque
devices, including upshot perspective, drawn line of windows,
and the modeled curls and flabby texture of de Chirico's
classical statues, which always look more like petrified nudes
than real stone. The broad humor—comic posturing, irreligious
subject, details like the analogous handling of "meaty" hu-
man and bovine buttocks, perhaps a reference to Rembrandt's
"immortal" sides of beef—reveals a Dada grain of salt with
which the serious and psychologically profound art of de
Chirico was taken.

Not only the vertiginous foreshortening of de Chirico, but
an additional spatial ambiguity found in *Resurrection of the
Flesh* was then developed by Ernst throughout his Dada col-
lages. This consists of a rather awkward superimposition of
shallow upon deep space, omitting the expected passage be-
tween the two, an interruption of a long vista to the vanish-
ing point by off-center placement of the *repoussoirs.* The rec-
tangular bars on each side, parallel to the picture plane, serve
to flatten out the effects of hurtling illusionism and throw
doubt on the "reality" of the entire scene. This mannerism
was directly inspired by the dissection method of Ernst's col-
lage, in which images torn from different environments are
allowed to retain their old space in a new setting. *Dada in
Usum Delphini,* of 1920, is a more skillful example. The
plunging lines of floor and ceiling imply great distance, but
this is immediately contradicted by the "nearness" of the
cow in her stall, set like an end wall to halt the angled lines
and in scale only a few yards away from the seated figure. At
the same time, deep space is allowed to filter on through the
stall window which is, in turn, flatly barred to present another

obstacle. Further complicating matters is a band of cloudy sky along the upper edge of the scene, implying distance by association but nearness by flat treatment and logic or perspective. A similar but less complex effect occurs in gouaches like *l'Enigme de l'Europe Centrale* where the modeling of the friezelike objects in the foreground is neutralized by the flat parallel frieze of landscape in the distance. Such anarchistic manipulation of illusion and perspective had appealed to Ernst before he saw de Chirico. Kaleidoscopic spatial mixtures can be found in the first, pre-Dada, paintings he did on his return from the war. The Guggenheim Museum's so-called *Landscape Fantasy,* rendered in a folkloric style like that of Campendonk and other Junge Rheinland artists, employs images that suggest a possible source in Hogarth's satirical frontispiece to Kirby's *Perspective.*[8] Disrespect for the traditional laws of painting is well in line with Dada's program; *Fiat Modes* and many other collages humorously distort perceptual diagrams like those for the camera obscura.

Thus de Chirico's exaggerated, dream perspective and Dada dislocation also challenging reality were merged in Ernst's proto-Surrealist collage. The dialectical reconciliation of opposites was especially appealing to him, for he had personally (autobiographically) thrived on such conflict. Raised as a Catholic in Germany, son of an academic Sunday painter but member of the avant-garde as early as 1912, brought up on the German romantics, Wilhelmian children's books, legends, and fairy tales, but rigorously trained in philosophy and science, possessor of a penetrating, literate mind as well as a strong desire to explore the darker side of the unconscious, Ernst was the ideal figure to make the transition between the Teutonic emotionalism of Dada and the refinements of French Symbolism. A thorough romantic, he was also able to keep a dry and skeptical distance from sentiment and, in the twenties at least, from excess. The indirect impact of illustrations by Max Klinger and Alfred Kubin, who employed, respectively, the pervasively disturbing nuance and violent change of scale to wrench objects from their familiar contexts, must

8 I am grateful to Dr. Ilse Falk for this suggestion.

be noted although space precludes their discussion. In addition, the picture encyclopedias popular with children and adults at the turn of the century included juxtapositions of wildly unrelated treatments, images, diagrams, demonstrations, and scenes. These and similar books provided the raw materials for innumerable collages in 1919 to 1922, the first of which to be published was the cover of *Bulletin D,* in November, 1919—badly drawn figures and objects isolated, not as yet to form a new reality, but departing from the old.

The exhibition for which *Bulletin D* was the catalogue was the first of the three main Cologne Dada events and is less known than the other two ("Die Schammade" and the Dada "Vorfrühling" show at the Brauhaus Winter). *Bulletin D* is important because it presents for the first time several aspects of Surrealism. Ernst is listed on the back cover as "responsible for the contents." Along with the Dada works are noted "expressionist photographs" by Kokoschka, Davringhausen, and Oppenheimer, and, most significantly, children's drawings, mathematical models, paintings by dilettantes, an African sculpture, found objects (umbrellas, pipe, pebbles, piano hammer), and drawings by the insane. The exhibition began as an uninformed invitation to the Dadas to take part in a show of Karl Nierendorf's *Gesellschaft der Künste;* it became a Dada event when Nierendorf disavowed their contributions and banished them to a separate room with separate poster and catalogue.

The presence of what is now called "art brut" in the "Bulletin D" show might indirectly be traced to Zürich, where interest in primitive sources was evident in the poetry, dances, and masks, but was mainly due to Ernst, whose exploration of the subconscious and the art of the insane predates that of all other Surrealists. Beginning around 1912, as a philosophy major specializing in abnormal psychology at the University of Bonn, he had spent a good deal of time studying the art made in a nearby asylum; it included kneaded bread sculpture. He even planned a book on the subject, canceled by the war. Because of his association with the Blaue Reiter, through August Macke, he would also have appreciated other types of primitivism, such as folk and African art and was, incidentally,

aware of some of the earliest examples of pictorial automatism
—Kandinsky's improvisational drawings. At the time, Ernst
was painting a skillfully eclectic mixture of analytical Cubist
form and Expressionist color with touches of Futurism. "The
intermingling of writing and drawing which is now recognized
as typical of schizophrenic art" [9] would surely have interested
an artist involved in such forms, and it is possible that Ernst's
highly advanced 1913 construction—*Fruit of a Long Experi-
ence*—was the result of these researches as much as of Picasso's
constructions, first published in November of that year, in
Soirées de Paris. As a psychology student Ernst would have
known the work of Freud (whose statements about the "hy-
pocrisy inherent in consciousness" are echoed in Dada and
Surrealism) as well as the pioneering studies of neurotic art
by Simon and Lombroso, then Prinzhorn. By 1917 Arp was
advocating "complete surrender to the subconscious," the
Zürich Dadas were experimenting with free association in
poetry and conversation, while in Nantes André Breton and
Jacques Vaché were contemplating a similar breakthrough for
the arts.

On Ernst's part the real breakthrough was the photocollage
medium—not the heightened realism of the Cubist *papier
collé* or the explosive vignettes of the Futurist *parole in libertà*
or the combination of these two modes employed by the Berlin
Dadas, but hallucinatory, fragmented images from reality de-
racinated and rearranged in a new context to form an entirely
new image rather than a grotesque version of the original (as
in Grosz's *Remember Uncle August*). Ernst has since described
collage as "the cultivation of the effect of a systematic displace-
ment." The word systematic is the clue to its proto-Surrealism,
for Dada in general was anything but systematized. By setting
his hybrid forms in a photographic interior or landscape that
is credible, if unheard-of, Ernst achieved a coherence alien to
Dada and a consistently fantastic image alien to earlier move-
ments. His 1919–20 photocollages are usually miscalled pho-
tomontage, a word wrongly used from the start. Photomontage
should be reserved for the purely photographic technique of

9 Margaret Naumberg, *Schizophrenic Art: Its Meaning in Psychotherapy*
(New York: Grune & Stratton, 1950), p. 3.

printing combined negatives to produce a multiple image. The accurate term for reproductions or snapshots pasted up on paper along with letters and words would be photocollage, or typo-photocollage. Even when Ernst photographed his finished collages to enlarge them, rework them, or to make small editions in which all sign of working process is forever deleted, this was not photomontage. The origins of the latter are clouded in self-perpetuating myth and so far no study has been made of the history of photomontage and photocollage. It is clear that the photomontage technique goes back at least to the "combination printing" of Oscar Rejlander and Henry Peach Robinson in the 1850's and both methods are found in magazines and greeting cards from at least 1900.[10] (Raoul Hausmann's claims to the discovery of photocollage are of doubtful significance, especially when he contradicts himself in his writings as to the dates involved. Grosz and Heartfield also "invented" the medium, but the work of all Berlin Dadas until 1920 consisted of the addition of photographic materials to watercolors, drawings, or oils, not the entirely "ready-made" visions of Ernst.)

The photocollage lent itself to numerous effects and variations that can only be outlined here. Aside from objects and assemblages, Ernst concentrated on three broad types in his Dada years; since then no innovation has been made in the medium by him (or anyone else), though it has been adjusted to every succeeding mainstream style by countless imitators. First were the *Fatagaga* photocollages and their successors (*Chinese Nightingale*) in which abstract or anthropomorphic images were created from unrelated fragments and placed in a "foreign" setting, usually generalized, like sky or grass; the entire surface is covered by the photographic materials. Secondly, the vignette, in which images concocted from photographs, photoengravings, or illustrations were set on solid grounds or in simple, geometric settings drawn or painted on the white paper (*The Hat Makes the Man*). Simultaneously there was the "unglued" abstract collage like *l'Enigme de l'Europe Centrale* in which a ready-made image—usually scien-

10 Gretchen Lambert has provided information about experimental photography and photomontage.

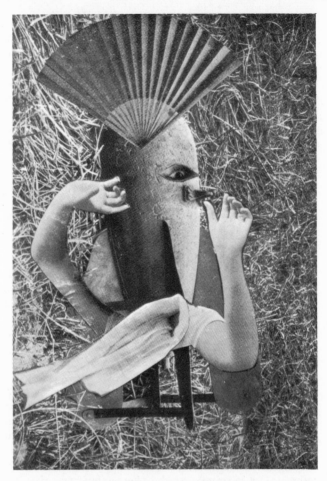

Max Ernst: *The Chinese Nightingale. Ca.* 1920. Pasted photographs and halftones. 4¾" x 3⅜". Formerly in the collection of Tristan Tzara. Photograph courtesy of The Museum of Modern Art, New York.

tific charts or pages from technical books, hat catalogues, and the like—were altered beyond recognition with mixed media, mainly gouache. Then, in 1921, came the collage made entirely of old-fashioned photoengravings, technically allied to the *Fatagaga* type of photocollage but less abstract and far more homogeneous.

The first of these was *Preparation of Bone Glue* (in homage to the collage medium?), a little-changed image of the diathermy process, after which a painting was later made. The photoengraving collage in fact provided both the images and the stylistic foundation for Ernst's painting from 1920 through 1924, when frottage, an offshoot of the collage discovery, opened up new possibilities. Once rendered in paint, the photographic materials took on a different aspect and can be considered the origin (with de Chirico) of what William Rubin calls the *peinture-poèsie* vein of Surrealist painting; Magritte, Tanguy, and Dali were all much influenced by Ernst's works of this period. The earliest oils in this mode retained, at some expense to their coherence, the juxtaposed space of the collages, but this was an awkward device on canvas (as demonstrated by *Resurrection of the Flesh*), and the homogeneous illusionism of the later collages was far more viable for such a dry, pseudoacademic treatment. In such oils as *Woman, Old Man, and Flower,* the central image of which was adapted from *Chinese Nightingale,* Ernst mastered the manipulation of unexpected images within a convincingly "real" space.

The 1919–20 collages had been essentially Dada in their dissective and destructive approach to accepted meanings and pictorial references; they were compositionally simple and founded on the harsh conjunction of opposing realities. In 1921, dissimilar objects began to be connected by association so that the result was no longer a single new image but a new situation or drama comprised of recognizable images integrated into a novel context, closer to the now-standard idea of dream pictures. The unity of this carefully constructed oneiric realism, unmistakably narrative in intent, was assured by such smooth passage between images; these collages seem like one frame from a film or comic strip, a dislocated part of some strange tale. The photoengraving was ideal for this represen-

Max Ernst: *Woman, Old Man, and Flower*. 1923–24. Oil on canvas. 38" x 51¼". Collection of The Museum of Modern Art, New York.

tational aim, better than the halftone or photograph, since it was already once removed from reality and featured unfamiliar period costumes and details. (The same principle was later applied by Pop artists who chose to depict "real life" as filtered through other media.) This method was brought to a climax in the collage novels: *Femme 100 têtes* (1929), *Rêve d'une petite fille qui voulut entrer au Carmel* (1930), *and Une Semaine de Bonté* (1934). They convey action and sequence complemented by ambiguous poetic captions, like silent movies with Chinese subtitles.

The change from the Dada (1919–20) to "Surrealist" (1921–24) collages was not an abrupt one, but it can be located around the summer of 1921, when Ernst first met members of the Paris Dada group. A vacation in the Tyrol united Arp, Ernst, Tzara, and briefly, Breton, who had been in correspondence with Ernst for two years and had recognized, as Sanouillet has pointed out, that Ernst's metaphysical point of view was more compatible with his own literary orientation than Picabia's ideas had been.[11] Ernst was already fully committed to what Aragon termed "the vice called Surrealism . . . the immoderate and passionate use of the drug which is the 'image.' "[12] In the fall of 1921 Paul and Gala Eluard came to Cologne to meet Ernst and choose collages to illustrate Eluard's *Répétitions*. These and their second collaboration, *Les Malheurs des Immortels,* also 1922, retain a Dada sharpness and iconoclasm—a black but still robust humor with no traces of mannerism. In August, 1922, Ernst finally arrived in Paris for good and by then the transformation was complete. Whether contact with the Parisian Dadas in 1921 simply coincided with his natural evolution or whether their attitudes did make some impression on the hitherto isolated artist, from then on Ernst was not a proto-Surrealist but a Surrealist pure and simple.

[11] Sanouillet, *op. cit.,* p. 248.
[12] Quoted in Marcel Raymond, *From Baudelaire to Surrealism* (New York: Wittenborn, Schultz, 1950), p. 286.

An Impure Situation*

"The breaking of aesthetic habits has become such a habit that it is no longer truly viable for many younger painters. Why bother with 'modernist' originality if it is so easily defined?" This statement, true *and* false, is taken from G. R. Swenson's forty-page essay "The *Other* Tradition," written over a period of years and published to accompany, though not to parallel, an exhibition organized by him at the Institute of Contemporary Art in Philadelphia. Very much products of their time, as well as a highly personal operation, essay and exhibition are often successful attempts to expand the rapidly shrinking scope of criticism and ways of seeing art. In such a case complete success is beside the point. More important is the fact that Swenson has provided a barrage of ideas and visual cross-references that send up vital sparks of perception. Rambling, obscure, studded with provocative extra-art quotations, everything he says is open to discussion and dispute, but it is also a flying wedge into the heart of the matter. †

* Excerpted from "An Impure Situation (New York and Philadelphia Letter)" and reprinted from *Art International*, Vol. X, No. 5 (May, 1966).
† Gene Swenson was killed in an automobile accident in the summer of 1969. He was in his early thirties, and had been for some time a lone voice of eccentric, erratic, but always honest, and often significant opposition to the corrupting herd instinct prevalent in the art world.

Unlike most "theme shows," the "Other Tradition" did not demonstrate a single theory cut, dried, and laid out for the spectators' secondhand delectation. It encouraged participation in the thought process that produced it. The University of Pennsylvania Art Library, an ancient eclectic eyesore, is far from being well designed for "modern" installation, which was just as well. Partially due to the work shown, partially due to the environment, the show had an informal atmosphere associated with photographs of "historic" exhibitions in the century's first three decades. The hanging was not so handsome that the paintings were visible first as attractive groups and secondly as individual works, which is so often the case. In one room, Magritte's *L'Appel des choses par leur nom* and Johns's *Periscope (Hart Crane)* immediately set up a dialogue, joined by Rosenquist's *Marilyn II* and echoed by the Dine, Lichtenstein, Oldenburg, two Wesselmanns, and glass cases of Dada, Surrealist, and contemporary periodicals, literature, and graphics. The Johns demonstrated how far artists of the last decade have gone beyond Magritte's paradox. I doubt, for instance, if it would have occurred to the Surrealist to use color and brushstroke as ironic tools. Yet the Magritte and the Johns in question did communicate a similar *feeling,* partly because the Magritte—brushy "clouds" on a dark ground, labeled "canon" and "miroir"—is atypically free, recalling Tanguy's early *Storm* more than the usual precise de Chiricoesque alignment. The Johns is a "gray" one of 1963, divided into three horizontal panels with a ground of greatly varied tone, color, and *matière,* ranging from transparency to impasto with delicate and sensuous touches of muted or brilliant color that can in no way be called parodic paint treatment. The panels are labeled red, yellow, and blue, each in a different manner and with different suggestions as to placement, reversal, and significance; at the upper right is a semicircular "device" made by scraping the paint surface from a central point: the module by which it was drawn ends in a handprint. This could refer to Leonardo's outstretched arms as a human measure of art, to Reinhardt's standard of 5 feet by 5 feet as a similar unit of human scale, or, as Rosalind Krauss has noted in reference to other instances of this motif,

to the handprint in Pollock's *Autumn Rhythm* [1]—or, for that matter, to the whole "hand of the artist" syndrome. Directional focus is also mocked throughout, and a small arrow points obliquely down at the right.

The Rosenquist, a tondo (or the face, traditionally and naïvely drawn as a circle), is more directly "artificial." Marilyn Monroe's features appear through a multicolored veil sectioned off by a piece of string as a compass, still attached to the canvas and holding a red and a green balloon (breasts?). This device might refer to Johns, but mainly recalls the billboard technique of "snapping a line" with chalk and taut twine. The circular form of the painting is thus determined by nature, history, experience, and implied action as well as by the subject. Lichtenstein's *Brushstroke* emphasizes the fact that in this company one's eyes alone are not to be believed. It not only depicts an act as an object; it is not even a painting of a paint stroke, but a mass-produced enamel plaque. The two Wesselmanns are a late, geometric two-dimensional *Still Life* and a three-dimensional black-and-white drawing of a still life. In the painting a radio is the only "recognizable" object; it confers its recognizability to the Mondrian background and the flat orange circle, which becomes an orange. In the drawing, the orange is gray, but it is modeled naturalistically and, taken separately, looks more like an orange than the colored circle. Similar conclusions can be drawn or not drawn about abstraction and reality in the Oldenburg and Dine contributions. Dine has said of his *Black Bathroom II:* "The canvas is the last vestige of unrealism. . . . It's so unrealistic to put that washstand on the canvas I have to do it, otherwise there is no more art; you could destroy it."

To say that the "Other Tradition" codified here is just the Dada-Surrealist-Pop stream would be gross oversimplification. Morris and Albers are included, though Swenson notes that "its major importance lies outside or beyond 'significant form,' and its application is useful chiefly to nonabstract art." It might be isolated better as one branch of the intellectual

[1] Rosalind Krauss, "Jasper Johns," *The Lugano Review*, No. 2 (1965), p. 92.

tradition, since its nonformal nature necessarily focuses on the metaphysical. It is for the most part a self-conscious tradition. The spirit of Duchamp permeates the essay, if in a more subtle and pertinent manner than we are accustomed to at the moment. The "Other Tradition" paintings are described as "mirrors of what happens to us without our knowing or realizing it," a manner in which to "objectify experience, to turn feelings into things so that we can deal with them." [2] The painting itself as an object, or a fact without regard for outside or inner experience, is a premise taken for granted by many nonobjective artists for some time now; it started as an effort to free form of anecdotalism and often of emotion, and has progressed to the point where the *idea* is often an object. The "Other Tradition" is more intent upon emancipating the metaphor from its subjective bonds. The chapter on "Feelings and Things" quotes Breton: "poetic objects are objects . . . whether or not they possess plastic qualities"; Dr. Robert Coles: "Analysts have realized that what distinguishes people is less what is in their unconscious than what they do with what is in it"; and later, John Barth: "A man's conscious reasons, the causes he *thinks* lie behind his acts, are not without importance, and I don't mean symptomatic importance." [3] Warhol is, of course, the prime example of such an attitude carried to extremes, and it is not restricted to the fine arts either. The following item appeared last November [1965] in the *New York Post:*

> Victor Mature, who won't mount a horse, jump into water or take a fall, has a double doing all these things

[2] Ellen Johnson made a similar conclusion when she said that since the artist "lives in a total reality which every day becomes more difficult to grasp, is it surprising that he often focuses on that particular segment of reality which he *can* hope to understand: the paraphernalia, properties and problems of painting?" (*Art and Literature,* No. 6 [1965], p. 140.) From here on, unsourced quotations will be from Swenson's catalogue.

[3] Swenson has previously insisted upon the will to objectivity inherent in the new art which is to be based on public rather than private attitudes, and even clichés, in an article on Warhol, in *Collage,* Nos. 3–4 (1965). (Of course Marshall McLuhan's writings must be taken into consideration here too.)

for him. The double resembles Mature so much that he
doubles even in medium close-up shots. . . . Mature says:
"My dream someday is to star in a movie without my ac-
tually being in it at all."

Investigation is a popular critical and philosophical term
today, and one of the broadest virtues of the "Other Tradi-
tion" is its insistence upon constant investigation, its refusal
to maintain a single point of view in a single picture. As Swen-
son says of Dada machine art, "they were not simply ridicul-
ing men who made war machines nor were they simply seeing
how man is like a machine in a positive (preferable) sense, but
they were intuitively investigating both sides of that coin."
The fascination of Duchamp, Johns, Morris, and numerous
others with measures, standards, rulers as ironic modules for
the unmeasurable, is typical. By developing a mirror view-
point, they deny that either position is correct, or more correct
than the other. They may make the subjective objective, but
it obviously works the other way too. These artists cannot be
characterized as wholly visual (formal) or wholly intellectual
in orientation. Johns has written: "Sometimes I see it and
then paint it; other times I paint it and then see it. Both are
impure situations, and I prefer neither."

Because it partakes almost equally of "formal" and "non-
formal" natures, this mode is particularly open to misinter-
pretation, or for that matter to interpretation of any kind.
Swenson thinks that "given a freer atmosphere for 'literary'
painting, Johns would be an even more important painter
than he is at present; formal criticism has in a sense stunted
his natural and considerable philosophic bent." On the other
hand, the kind of art that allows and encourages endless specu-
lation on its content is more welcome than ever right now,
when so much of the best work being done is so hard to
verbalize about. Things that can be explained or so exhaus-
tively investigated as Johns's or Duchamp's are not necessarily
the most fully satisfying, but since they provide such fertile
ground for exposition, they often receive an exaggerated
amount of critical attention. Duchamp's œuvre is so well
known that incestuous iconographical references to it in the

work of younger artists are immediately recognized. And it has been explained so extensively that much of its intellectual content has been drained, leaving one with the fundamental formal armature. In any visual art of any tradition only so much can be told, and the rest must be convincingly *shown*. Swenson is not insensitive to the formal side of things, but he has taken on a devil's advocate role here in his intense dislike for formalist criticism. In early 1964, Don Judd denied that his then-unfamiliar structures were without feeling, pointing out that painterly feeling "is just one area of feeling and I for one am not interested in it for my own work. It's been fully exploited and I don't see why it should exclusively stand for art." [4] Positions have been reversed since then and now Swenson's exhibition stands in the corrective corner.

At this point it becomes clear that the "Other Tradition" is the *other* and not *the* tradition. This is an exhibition of painting about painting and the painting it is about is the mainstream. This, of course, has no bearing on the respective quality of works shown, and the essay provides the basis of an antidote to the simplistically black-and-white situation of formal and nonformal that is prevalent. Swenson has admirably lowered the barriers, or confused the issue, by his inclusion of Picasso, Albers, Gorky, Pollock, and Robert Morris; the last named, with one foot in each camp until recently, is a prime example of the schizophrenia inherent in "Other Tradition" art. It is certainly time that the word intuitive regained its dignity and rejoined the word conceptual as a necessary aesthetic ingredient, especially in those cases where criticism has frozen artists into one hard mold of logic. The nonformal juxtapositions of the Philadelphia exhibition allowed both formal and nonformal connections to be made. The same should be true, but now all too often is not, of criticism. There is no reputable (or disreputable) critic who has not in the last year or two spoken out against false and rigid classifications of art and artists nor is there one, myself included, who has managed to stop classifying. To some extent, classification is

4 Bruce Glaser, moderator, a taped discussion among Frank Stella, Don Judd, and Dan Flavin, February, 1964, WBAI-FM, New York.

the role of criticism, since it is part of clarification, and there is nothing wrong with it if not allowed to become an end in itself. The trouble starts when critics get so concerned with the role of *criticism* that they feel they must classify *themselves*. The critic should, ideally, be equally involved with arts that seem opposed. His own criteria should be broader rather than narrower with each new work seen; he should be capable of using different tools when confronted with different intent and extent of art. There is nothing wrong with a critic's being temperamentally more sympathetic to a certain kind of art; I think the so-called objective criticism is impossible and confining. Similarly, if a critic restricts himself to writing about one kind of art, he sometimes becomes confused with the artists. Their statements merge in the mind of the observer and a single public personality emerges.

Formalist criticism, that is, criticism which is chiefly concerned with detailed and logical analysis of single works and the contribution of an artist in relation to others, to the general formal "advance," parallels and is the most valid way to approach some of our best current art; the danger is that it becomes the usual manner of approaching all art. The most intelligent formalist critics tend to demand a great deal of themselves as well as of the art, and reject the idea of simply producing a honeyed counterstream. This is a healthy situation and now needs to be applied more frequently to nonformal commentary. Swenson finds formalist criticism narrow and limited, and at times it becomes so. When it is acceptable and even complementary to say that the art one likes is *boring,* the time has come for a re-evaluation. As an idea to develop, the boring bit is fine. As a truth it is lacking. Just because an artist *utilizes* tedium, as does Samuel Beckett or, at one point perhaps, Frank Stella, does not mean that the end product, if any good, is tedious. Significant art is never boring. It is against this sort of thing that Swenson is directing his campaign, and I trust that is approximately what he had in mind when he wrote: "Perhaps criticism to be good must be called 'obscure' and 'confused' when it is written. . . . Art certainly ought not to be reduced to cultural sophistication."

My main quarrel with the "Other Tradition" is that, as

presented here, and aside from the Pop artists, it lacks a strong younger generation to make it important in terms of actual work accomplished. I would propose quite another group than Arman, Ray Johnson, Joe Raffaele, Richard Smith, Paul Thek, Michael Todd, and Anne Wilson as the white hopes of anti-decorative painting. Whether or not my own limitations are showing, Arman, Raffaele, and Thek leave me cold. Neither the nonformal nor any other critical approach provides me with the apparatus to appreciate preciosity. Swenson scoffs at the irrelevancy of applying formal criteria to Raffaele and Arman, but offers no alternative. While these artists lack the intellectual stringency of a Morris, the absolute dissociation of a Warhol, the metaphysical wryness of a Duchamp, nevertheless, they do supply schematic counterpoints in an exhibition which releases one innuendo after another. It moves from a Masson drawing and a 1951 Pollock sketch to a 1931 Miró, to a biomorphic white relief and a gray stone sculpture by Arp, a Duchamp vitrine including the miniature plastic reproduction of *Nine Malic Moulds,* to two late Tanguy drawings where biomorphism freezes into the mechanical, to a disturbing white cluster of balls, shoe lasts, and bolts by Michael Todd, and a 1951 Albers relief incised in vinylite, made, not by the artist, in a multiple edition. Albers is quoted in the catalogue as being opposed to the belief that the handmade is better than the machine made; this leads to a Robert Morris drawing on acetate of 1963, a plan for the four mirror cubes shown last year [1965], with exacting notes as to measurements, and it sends off waves to the Duchamps as well as to Warhol's clear plexiglass panel with a double silk-screened film still that is "projected" onto the wall behind. The intellectual "hardness" of the Albers-Morris product is in turn fed into the very different mechanism of Peter Phillips' "custom prints" (which seem a parody of Albers' various influences on the scene) and *their* glossy, luxury-oriented surfaces find a shadowy reflection in Richard Smith's *Marlboro Country.* The third and last room dealt largely with art about art, specifically art about Cubism, with which the catalogue deals at length. It included, among others, Arman's burnt violin encased in polyester, a Warhol "unfinished" follow-the-dots still life, Lichtenstein's

Picasso, *Femmes d'Alger,* one of Indiana's departures from Demuth's *Figure Five,* and Miro's *Personnage,* painted over a pompous portrait in a memorial frame, like a transparent veil of fantasy over a heavier, more academic unreality. All of which recalls Miró's statement about smashing the Cubist guitar.

Eroticism in one form or another is a common basis for most of the "Other Tradition," and Swenson's comments on the new objectivity of a post-Freudian sexuality are thought provoking. Since sexuality, Freudian sexuality, is the prime mover of all Surrealist art, this provides both a connection to and a breakaway from the earlier movement. The assemblagists borrowed the shock element from Dada and Surrealism but confined it within the old interpretations; for this reason most recent assemblage is invalid in the sixties. People today are "more likely to know why they are doing something than what they are doing." The increasing interest in the *what* has carried the involvement in gesture and motive over to product or object alone. Surrealism may have been a formal influence in the forties, but now it is "more important in opening intellectual possibilities for younger artists." The Surrealists were unalterably opposed to abstraction and to aesthetics for aesthetics' sake; their ideas continue to surface in odd guises. Perhaps the layman's use of the term "Surrealistic"—ubiquitous in the mass media and newspaper criticism—is, after all, correct. To most people it means anything odd, suspicious, impolite, unfamiliar, threatening, obscene, or just plain unconventional. Claes Oldenburg's recent exhibition at Sidney Janis' gallery is "Surrealistic" in that sense.

This time, Oldenburg has undertaken to transform the "American Trinity"—bathtub, washbowl, and toilet—as well as a miscellany from the household and garage, the latter centered about a large "Chrysler Airflow" of which only models and parts were shown. Some of the pieces appear in various stages of gestation-drawing, rectilinear brown cardboard maquette, "ghost" canvas model, and Final Vinyl. Most parody the image of the bathroom as the last bastion of privacy, the home of scatalogy and sexual fantasy even more than the bedroom. Oldenburg's soft-sculpture idea will stand a lot of mile-

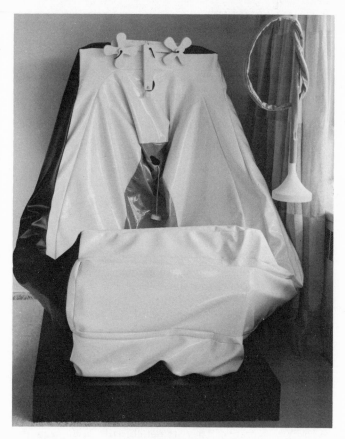

Claes Oldenburg: *Soft Tub*. 1966. Vinyl, flexiglas, and kapok.
30″ x 80″ x 30″. Collection of Mr. and Mrs. Roger Davidson.
Photograph courtesy of Sidney Janis Gallery, New York.

age, since it produces a different group of sensations and asso-
ciations with each object or type of object to which it is
applied. Soft food and soft porcelain are not at all the same
thing, neither are hard clothes and perspective furniture. So
even if his methods remain static for some time, they run less
risk of monotony than those of, say, George Segal. The vinyl
is elegant and sensuous, tremendously tactile and, more impor-
tant, its viscous surface permits a manipulation of space, by
artist or viewer, that is far more interesting than the run-of-
the-mill scientizing kinetic art. All of Oldenburg's objects have
what Harris Rosenstein calls the viscerotonic impulse of an
endomorphic type,[5] but they are more important in their stasis
and potential motion. The initial paradox of a hard object
rendered in soft material is only superficial; the endless altera-
tion of form, to say nothing of the quasi-erotic and humorous
experience of poking and prodding a malleable toilet or car
motor, reach both the subjective and objective, sensuous and
intellectual equipment of the viewer. The two best pieces,
bathtub and toilet, in slick white with blue water, make their
point in the ultimate squashiness of the plastic "push and
pull" invitation. Especially the bathtub, standing on end so
that it yawns like the cross section of an immense and awk-
ward womb, testifies to Oldenburg's "desire for every kind of
contact sensation for his sculpture (eating, touching, sitting
on, caressing)." [6] There is no need to belabor the sexual or
kinesthetic connotations. These sculptures are the source mate-
rial for a witty and objective eroticism that could be abstract
as easily as figurative. They are not objective in the sense that
they are opposed to the subjective, but in that they make
little of the fact of their subjectivity. The imagery is open to
Freudian interpretations, but offhandedly so.

[5] Harris Rosenstein, "Climbing Mount Oldenburg," *Art News* (March, 1966).

[6] *Ibid.*

James Rosenquist:
Aspects of a Multiple Art*

When some of the lights on the Forty-Second Street movie marquees were turned out in order to attract attention in that neon jungle, we reached a significant saturation point. Rosenquist departs from the resulting half-lit world of contrasts rather than from the all-out Fun Fair that preceded it. His references are oblique, his images obscured, his aims complex; his is a multiple, rather than a single-minded art, made up of a unique combination of sassy Pop realism, mysterious irrationality, and an essentially nonobjective sensibility. The key to Rosenquist's work is not its commercial vocabulary, or its detachment, but its scale. "For me things have to be life size or larger. I believe it is possible to bring something so close that you can see through it, so it comes to you right off the wall. I like to bring things into unexpected immediacy—as if someone thrust something right next to your face—a beer bottle or his shirt cuff—and said 'how do you like it?' " [1]

* Reprinted from *Artforum*, Vol. IV, No. 4 (December, 1965).
[1] All unascribed quotations are from the artist, primarily in conversations with the author, and also from G. R. Swenson's interview "What Is Pop Art?" *Art News* (February, 1964); and Dorothy Seckler's "Folklore of the Banal," *Art in America* (Winter, 1962).

If a beer bottle is painted six feet tall, it radiates suggestively beyond the painting. (If the bottle is that big, what about the people?) Many paintings executed in conventional scale will diminish and lose their impact in the ordinary room or exhibition space. A Rosenquist retains its vigor in much the same way that a Rothko or a Newman holds its own in any space and in fact remakes the space in its own image. Their single images and Pollock's allover compositions also reject the static relationship between objects imposed by conventional, consistent scale. The Cubists brought the objects portrayed forward to the picture plane; the Futurists attempted, with little success, to go beyond it. The Surrealists, who made full use of juxtaposition and arbitrary scale, did so only within the limits of conventional space, depending on the recognizable framework—a room or a landscape—to define the size of an object. They still saw the rearrangement of scale in literary, nineteenth-century terms, and were involved in a limited alteration of scale, changing the way certain objects or places were seen, rather than in rescaling a new immediate environment.

Rosenquist's work is often compared to that of René Magritte. Although he admires the Belgian Surrealist, the similarity is superficial. They share a knowledge of the mystery inherent in common images. Yet Magritte's remote and deadpan approach is closer to that of the other Pop artists than to Rosenquist's. His questions about illusion and resemblance are posed in an earlier, and static, spatial language; his picture-within-a-picture motifs are concerned with dislocation rather than reintegration. Magritte plays devil's advocate rather than God with reality. He challenges known nomenclature but rarely renames anything. To Rosenquist it makes no difference what things are called. What they look like counts. He employs artifice as a formal tool and surface reality to rob objects and people of their identities. More important, and this is the crux of the visual difference between Pop and Surrealism, Rosenquist's disparities of scale are not intended to reflect upon neighboring images, but to act directly upon the spectator.

Traditional implications of illusionism are reversed. The disproportionate scale of Rosenquist's images forces them out

rather than back into the painted distance, envelops the spectator in an elephantine *trompe l'œil*. Where other Pop artists have used scale to overpower but not to attack, holding the image on the picture plane in an arrogant withdrawal, Rosenquist uses his gigantism as an assault on normality: this is the first aspect of his work. In the process of the attack, the object loses its identity and becomes form. This is the second experience—a more subtle and less recognized one. Lichtenstein and Rosenquist are the two nonobjective painters involved in Pop. That is, they share basic intentions with their wholly abstract contemporaries. "One thing, the subject isn't popular images," Rosenquist has insisted. "It isn't that at all."

At one time there was a popular misconception that this "former sign painter named James Rosenquist" (*Newsweek*) was a kind of updated *peintre naïf,* hauled off his scaffolding by some inspired entrepreneur. In fact, he has been painting seriously for fourteen years. From 1952 to 1955 he studied art with Cameron Booth at the University of Minnesota, then came to New York for a year's scholarship at the Art Students League. After various odd jobs he was hired by the General Outdoor Advertising Company, having learned sign-painting as a trade at the age of twenty. By 1960 he had developed a distinctive allover style, predominantly gray, a heavily painted "grid of many colors, like an old rug." The one transitional painting, still nonobjective, superimposed a huge red arabesque derived from billboards. The fresh, lurid color of his present work was the final break with early influences.

In winter 1959–60, Rosenquist made a series of window-display murals for Bonwit Teller and Bloomingdale's based on billboard techniques, and he has often spoken of his experiences painting signs and of the possibilities of working seriously in that manner. It was not, however, until the fall of 1960 that he first applied commercial techniques and subject matter to his own painting. *Zone,* the first canvas in his present style, still exists, though greatly changed. Aside from a huge face, it originally included some cows, a hand shaking salt on a lapel, a naked man committing suicide. A flood in the studio washed off some of the paint and it was reworked. The colors were too bright and too many. The man was too

small. "He fell into the old pictorial space," and Rosenquist was primarily concerned with getting away from conventional pictorial traditions, especially those of scale and space. He began (as Andy Warhol did at roughly the same time) by rendering his new images in Abstract Expressionistic techniques and "drips." Even after abandoning this to make a clean break, he retained for a few years a freedom of execution that went generally unnoticed. At a normally chosen vantage point an image would look almost stenciled; on closer inspection, loose, relaxed strokes could be discerned, though this derived more from the distance factor of billboards than from any Expressionist tendency.

Rosenquist still prefers to paint the individual images "so well that they might sell something, as though it had to be done by noon on contract. By painting fast and directly, even if it's just to sell snake oil or stockings, more goes into it than you realize." Most of his paintings go through myriad transformations, sometimes as many as five major changes a day, each decided and executed at almost breakneck speed. No matter how large or how finished or how close to the deadline a canvas may be (the New York World's Fair mural, for example) he will begin from scratch on an entire section, or rearrange the whole composition the day before it is to be installed. While the basic principles of Rosenquist's fragmentation are those of collage, he completely eschews ready-made pictorial materials, and is equally opposed (for his own art) to mechanical aids and reproductive processes, finding them too limiting. "Change is what makes art. Collage is too divorced from materials. Painting goes into more depth. The work changes all the time no matter how careful you are to stay close to what you are copying." On the other hand, some of his preliminary studies are impermanent collages, bearing no strict resemblance to the completed canvas. He begins by making numerous composition sketches in the form of scribbled "ideagrams," pastel or pencil drawings with color and conception notes, and apparently nonobjective oil-on-paper studies. Color areas stand for the images, which, when chosen from magazines, newspapers, or other commercial sources, are stapled onto a piece of paper, in approximately their final shape or

order. But between these work sheets and the finished product, the scale and color of everything may be completely revised. Change of scale gives the artist complete flexibility and provokes new ideas even after the original decisions have been made. In the work sheet a man's trouser leg and a candy bar may be about the same size, while on the final canvas one is ten times larger than the other.

Even if Rosenquist wants to "avoid the romantic quality of paint and keep the stamp of the man-made thing," his approach is fundamentally romantic, which again sets him apart from the rest of the major Pop artists, except for Oldenburg. He is also a "wholesome" painter (though this word has been relegated to the level of bread and bad movies), a moral artist in the sense of Robert Motherwell's statement:

"I think a great deal of what's happening between America and Europe now—I'm speaking of younger artists—is our implacable insistence here on moral values, which I think is slowly disappearing among younger artists in Europe, who paint mainly with taste. And I don't mean this in a superior way, but almost primitively, as a kind of animal thirst for something solidly real. It's directed to what one really feels, and not to what one prefers to feel, or thinks one feels." [2]

The idealism of today is irony. Satire and social protest are not major elements in Rosenquist's art. In fact, the only painting that is conspicuously "political" is a large triptych entitled *Homage to the American Negro*. Here a headless "white" man (posed, but unintentionally, like the Lincoln Monument), sits on a Negro's head. Through and around a pair of dark glasses the sky and rectangular background are subtly varied by color and value switches. A white mother whispering advice to her children is placed before a camera aperture reading "darken, normal, lighten," and her nose is decorated with IBM perforations. The only brown thing in the painting is the delicious-looking chocolate frosting on a huge piece of vanilla cake that takes up the entire right side. Elsewhere the "colored people" are literally colored—green, blue, orange, etc. The painting is about color, but not the color of

skin. "It is about the colors in a colorful person, the colors you do not see through glasses."

Rosenquist's last one-man show (April, 1965), which consisted solely of the twenty-three-foot mural, *F-111,* was entirely devoted to a social theme, that of the artist's position in today's society, the insignificance of the easel painting in an era of immensity, of jet war machines and "noveaux collectionneurs" buying wholesale. He has used scale here to force acknowledgment of the importance of art, as a "visual antidote to the power and pressure of the other side of our society." Nevertheless, this message is far from apparent to the casual or even to the concentrating viewer, and serves as further indication of the determinedly iceberg quality of Rosenquist's art and aims. The same is true of the specific images in the majority of his works. They have no "story to tell," but they often do have a personal significance to the artist, a significance that he refuses to make obvious because it is personal, and because the painting is to be seen first and foremost as a painting, as a "visual boomerang." He constantly avoids clever, witty, poetic, easily absorbed, or humorous imagery in his use of juxtaposition. While the idea for a painting and its title usually occur to him simultaneously, neither is literal. *A Lot to Like,* 1962, seems to demand a generalized interpretation pertaining to the mad rush of the consumer to consume, but it was intended as a comment on the flaunting of masculinity. (The football player throws his "pass" through the hole in the razor blade and into the bottomless woman.) Blandly round and smooth forms are contrasted with sharp edges and associations, such as the blade (deceptively painted a soft gray), the point of the umbrella, and the hard green rain ("like Hiroshige, but radioactive, Hiroshima too"). Here, as elsewhere, there is a distinct abstract eroticism emphasized by the unidentified and consequently suggestive anatomical areas, and by the sinuous arabesques that join and transform the ragged, quick-flash image compartments. The irony of Rosenquist's work is pervasive, not specific. He refers to the fifties by hair styles, cars, or clothes from the recent past, images that "people haven't started to look at yet, that have the least value of anything I could use and still be an image, because recent history seems unremem-

James Rosenquist: *Early in the Morning.* 1963. Oil on canvas with plastic. 95″ x 56″. Collection of Mr. and Mrs. Robert C. Scull. Photograph courtesy of Leo Castelli Gallery, New York.

bered and anonymous while current events are bloody and passionate and older history is categorized and nostalgic."

Rosenquist's experience as a billboard painter sharpened his reactions to the nonrepresentational aspects of outwardly representational forms. This might not have been the case had he not had the eye of a nonobjective painter. Being hoisted up Kirk Douglas' cheek to paint a four-foot eyelash, he became aware that Kirk Douglas had disappeared, the cheek was no longer a cheek, or the eyelash an eyelash; that he was enveloped in a sea of purely plastic form and color defined by immense arabesques. In turn, it is this familiarity with the monstrous that allows Rosenquist to understate his enlargement. Most of us will get no closer to such an experience than seeing Jayne Mansfield's ten-foot-high monotone breast emerging from the movie screen. There is something of the old 3-D films or even of stereoscopic images in Rosenquist's protruding forms, and parallels are suggested with advanced film technique such as the lovemaking scenes from *Hiroshima, Mon Amour,* where specific parts of the body are seen in such close-up detail that they become the anonymous essence of union. In this sense he is again in opposition to Lichtenstein and Wesselmann, who have gone to great lengths to flatten and remove their images from spectator space in order to achieve that other ambiguity between two and three dimensions. Less rigorous and more experimental than the other Pop artists, Rosenquist is also more uneven. His methods demand an intuitive control and at times the images float uneasily on the surface in a spatial no-man's-land, or are landlocked in crowded incoherence when the formal idea is not fully resolved. His mastery of these complexities is grounded in a highly developed and still expanding vocabulary of spatial devices.

These devices are, for the most part, based on minutely varied color changes. The eye unaccustomed to such refinements misses a good deal in his work. Rosenquist acquired a heightened awareness of monotone nuance from the *grisaille* billboards. (In *Silver Skies,* for instance, each gray is tinted a different color.) The white-lead base of practically all of his colors (except for the day-glo tones, which he was perhaps the

first to use extensively) gives them a fresh and ingenuous air (also saccharine and pungently repellent when so desired). White is particularly important in the pale "unfinished" colors, like those of printers' color-separation proofs. In other contexts, white is used to segment and imperceptibly alter forms that are in other respects "whole." An all but invisible line, a psychological rather than visual division, is obtained by the addition of an infinitesimal amount of white; the result is like a shadow across the surface, almost unnoticeable, providing a quieter dimension to the excitement of an art which first seems implacably resistant to a subtle reading. Similar effects hold one image in front of another or signal sharp divisions within a single image, or set up dissimilar spaces. A pictured object, moving from one subtly defined compartment to another, may change abruptly in value but not in color, or vice versa. A brilliant cadmium may be juxtaposed against a still more brilliant day-glo red on one side, a cool gray on the other, forcing a change of identity in midform and, radically, but again nearly imperceptibly, distorting its role in the overall design.

Such subtleties are employed in a clearer and more formal manner in the use of a painted or separate and slightly projecting rectangle that repeats or modifies its ground. This stresses the nonobjective character of the work as well as reinforcing certain effects of scale. In *Noon,* a sky panel set in another sky enlarges an infinite and virtually unenlargeable area by making it relative (an eminently Magrittean idea, but used for different ends). A more extensive exploration of the relief panels occurred in *Capillary Action I,* 1962, a large painting of a tree in a park landscape where green and greenish, photographic grays, and "natural" tones are played against each other to expose the artificiality and banality of nature. A *grisaille* foreground implies "Please Don't Step on the Grass," a kelly-green panel stuck over a swatch of paint-smeared newspaper and tape implies "Wet Paint." Rosenquist says it is about "seeing abstraction everywhere, looking at a landscape and seeing abstraction," in contrast to the usual spectator sport of finding the figure or landscape in abstractions. The implications of this theme were followed up in a construction—*Capillary Action II,* 1963, where the tree is real,

about eight feet high, and neither painted nor refurbished. Here too a piece of torn newspaper hints at the artifice of reality itself. The space is animated by three stretched plastic panels and a square drawn in wiggly red neon, all set at different distances from the surface of a larger, inset panel. "A painter searches for a brutality that hasn't been assimilated by nature. I believe there is a heavy hand of nature on the artist," Rosenquist has said. This second piece proved him right in an extra-art manner. It was the result of a wild day and night search through Westchester for the "right tree," which never turned up. "Nature couldn't provide it."

When he began to add extraneous materials to his canvases consistently in 1962–63, Rosenquist chose carefully, concentrating on "abstract" substances, such as mirror, tin, clear plastic, glass, aluminum, and rainbow-streaked bars of wood. One of the most effective was sections of limp plastic drop sheet, either transparent or vertically dripped with paint, which acted upon the canvas below and combined visually to make new colors, providing a shifting chromatic screen through which that area of the painting changed continually, and adding a capricious dimension subject to the breeze or light in the room. In 1964 he made several freestanding constructions, most of which employed light. These were environmental in that they were more concerned with extending sensuous experience than with pure form. Light and clear plastics share with Rosenquist's iconography a quiescent immateriality, the ability to destroy conventional space and define further levels or "vantage points" from or through which an object might be seen. A chrome-plated barbed wire extravaganza with a flourish of blue neon streaking through it used light as abstract fantasy; a luridly multicolored ramp set over a sheet of brightly painted plexiglass with colored light flashing beneath it was illusionistic; a ceiling panel of a floor plan with bare bulbs suspended from it was paradoxically "realistic." All of this was part of a burgeoning interest in irregularity, manifested in various nonrectangular or centrally pierced works and two small paintings hung "off kilter" to stress the expendability of background and show that "a

painting shouldn't be perfect. Perfection makes a pun. I'm tired of the Mondrian kind of relationship."

For most of 1965, however, Rosenquist abandoned these experimental pieces and returned to a stricter and more highly polished evolution of his straight painting style, which culminated in *F-111*. Partially responsible for this switchback was a summer (1964) in Europe, where everything was so graciously "artistic and beautiful" that on his return he felt forced to revert to a raw, brash, and "nonartistic" idiom to get started again. During the past summer (1965) spent in Aspen, Colorado, Rosenquist became vitally interested in Oriental thought and also embarked on an extremely personal project to experiment with the effects of peripheral vision. Not painting, or construction, and only ambiguously environmental, this series of tentlike arches of painted canvas may constitute the breakthrough into the nonobjective which has been imminent for at least two years. The climactic summing-up of *F-111* would seem to necessitate it, were it not that the unexpected and wide-open character of the man and the work defies prediction.

Eccentric Abstraction*

Only the ugly is attractive
CHAMPFLEURY

The rigors of structural art would seem to preclude entirely any aberrations toward the exotic. Yet in the last three years, an extensive group of artists on both East and West Coasts,

* Reprinted, slightly cut, and rearranged, from *Art International,* Vol. X, No. 9 (November, 1966). This article provided the basis for lectures at the University of California in Berkeley and the Los Angeles County Museum in the summer of 1966, and for the catalogue of an exhibition of the same title at the Fischbach Gallery, New York, October, 1966 (artists represented were Adams, Bourgeois, Hesse, Kuehn, Nauman, Potts, Sonnier, and Viner). This show has received an unjustified amount of attention because several of the artists in it are now so well known. Their work seemed much more "eccentric" in 1966, in the heyday of the primary structure and Minimal Art, than it does today. Most of its more exotic elements were soon eliminated. I was at the time far from fully aware of the implications of this work and overemphasized the Surrealist connection, although it is Surrealist automatism that provides the association with Pollock. Robert Morris' article on "Anti-Form" (*Artforum,* April, 1968) is a much clearer discussion of the way in which the nature of the materials and physical phenomena determine the shape of much new sculpture. His own felt works of that year worked from the premises of Nauman's rubber streamers and random pieces, and perhaps from those of Barry le Va and Josef Beuys, although all three were omitted from Morris' essay. The entire "Anti-form" tendency has since been credited to Morris, although a number of young artists were developing the idiom simultaneously, in Europe as well as America.

largely unknown to each other, have evolved a nonsculptural †
style that has a good deal in common with the primary struc-
ture as well as, surprisingly, with aspects of Surrealism. The
makers of what I am calling, for semantic convenience, eccen-
tric abstraction, refuse to eschew imagination and the exten-
sion of sensuous experience while they also refuse to sacrifice
the solid formal basis demanded of the best in current non-
objective art. Eccentric abstraction has little in common with
the sculpture of the fifties, since it rarely activates space, or
with assemblage, which incorporated recognizable objects and
was generally small in scale, additive, and conglomerate in
technique. In fact, the eccentric idiom is more closely related
to abstract painting than to any sculptural forms. Many of
the artists are around thirty years old and, like the structurists,
began as painters rather than sculptors; when they moved into
three dimensions, they did so without acquiring either sculp-
tural habits or training. The increased influence of painting
has undermined sculptural tradition, and provided alternatives
to the apparent dead end of conventional sculpture. But
where formalist painting tends to focus on specific formal
problems, eccentric abstraction is more allied to the nonformal
tradition devoted to opening up new areas of materials, shape,
color, and sensuous experience. It shares Pop Art's perversity
and irreverence. The generalizations made here and below do
not, of course, apply to all of the work discussed. Its range and
variety is one of the most interesting characteristics of eccentric
abstraction.[1] ‡

† I no longer think that either "nonsculptural" or "antisculptural"
make sense as adjectives. At the time this was written, these terms seemed
the only ones to imply the radicality of the moves being made away from
traditional sculpture. Now, only four years later, this radical nature can
be taken for granted. Distinctions between painting and sculpture, or
two- and three-dimensional art, have been overcome almost entirely.
Similarly, the distinction between art and nonart ("But is it Art?")
seem a waste of time. Better to call everything art than to waste time
inventing semantic labels and rationalizations that will be obsolete so
soon.

[1] I have seen reproductions that indicate artists in other countries
(e.g., Barry Flanagan in England and Emilio Rewart in Argentina) are
working in similar directions, to say nothing of the Americans omitted
here due to lack of space.

‡ I did not know at that time about the seminal work of the German

If government-sponsored academic sculpture is rooted in a heroic and funereal representation left over from the nineteenth century, the primary structurists have introduced a new kind of funeral monument—funereal not in the derogatory sense, but because their self-sufficient unitary or repeated forms are intentionally inactive. Eccentric abstraction offers an improbable combination of this death premise with a wholly sensuous, life-giving element. And it introduces humor into the structural idiom, where angels fear to tread. Incongruity, on which all humor is founded, and on which Surrealism depends so heavily, is a prime factor in eccentric abstraction, but the contrasts that it thrives upon are handled impassively, emphasizing neither one element nor the other, nor the encounter between the two. Opposites are used as complementaries rather than contradictions; the result is a formal neutralization, or paralysis, that achieves a unique sort of wholeness. Surrealism was based on the "reconciliation of distant realities"; eccentric abstraction is based on the reconciliation of different forms, or formal effects, a cancellation of the form-content dichotomy.

For instance, in her latest work, a labyrinth of white threads connecting three equally spaced gray panels, Eva Hesse has adopted a modular principle native to the structural idiom. She limits her palette to black, white, and gray, but the finality of this choice is belied by an intensely personal mood. Omitting excessive detail and emotive color, but retaining a tentative, vulnerable quality in the simplest forms, she accomplishes an idiosyncratic, unfixed space that is carried over from earlier paintings and drawings. A certain tension is transmitted by the tightly bound, paradoxically bulbous shapes of the smaller works, and by the linear accents of the larger ones (see reproduction in *Art International,* Vol. X, No. 5, May, 1966, p. 64). Energy is repressed, or rather imprisoned, in a timeless vacuum tinged with anticipation.

There are a good many precedents for the sensuous objects, one of the first being Meret Oppenheim's notorious fur-lined

Josef Beuys in this field, nor of Richard Long's and Jan Dibbets' similarly developing ideas.

teacup, saucer, and spoon. Salvador Dali's extension of the
idea, a fur-lined bathtub made for a Bonwit Teller display
window in 1941, was a more potent vehicle for sensuous iden-
tification. The viewer was invited figuratively to immerse
himself in a great fur womb; twenty-five years later an anal-
ogous invitation was extended by Claes Oldenburg's gleaming,
flexible blue-and-white vinyl bathtub. Yves Tanguy's 1936
object, *From the Other Side of the Bridge,* was another early
example—a stuffed handlike form suggestively choked off in
two places by a tight rubber band extending from a panel
marked "caresses, fear, anger, oblivion, impatience, fluff."
Around 1960, Yayoi Kusama developed similar ideas in her
phallus-studded furniture which, though unquestionably fe-
cund, remained Surrealist in spirit. Lee Bontecou's gaping
reliefs were a departure in the way they firmly subjugated the
evocative element to unexpected formal ends, and H. C.
Westermann's *The Plush,* 1964, humorously fused the sensu-
ous element with deadpan abstract form.[2]

Since the late forties, Louise Bourgeois has been working in
manners relatable to eccentric abstraction—not nonsculptural
but far out of the sculptural mainstreams. Her exhibition at
the Stable Gallery in 1964 included several small, earth or
flesh-colored latex molds which, in their single flexible form,
indirectly erotic or scatological allusions, and emphasis on the
unbeautiful side of art, prefigured the work of other artists
today. Often labially slit, or turned so that the smooth, yel-
low-pink-brown lining of the mold as well as the highly tactile
outer shell is visible, her mounds, eruptions, concave-convex
reliefs, and knotlike accretions are internally directed, with a
suggestion of voyeurism. They imply the location rather than
the act of metamorphosis, and are detached, but less aggressive

[2] Ay-O, Lucas Samaras, Lindsey Decker, Vreda Paris and others have
achieved similar fusions, though without abandoning the conventional
box, vitrine, or platform format. The latter isolates forms and controls
the space they are seen in as well as being a counterpart of the famous
Surrealist dissecting table where umbrella and sewing machine met. Use of
a platform or box as a vehicle of such strange isolation can be traced back
to de Chirico's empty piazzas, Ernst's (then Dali's and Tanguy's) broad
plains, and Giacometti's Surrealist and later sculpture, as well as to the
Surrealist object in general.

than the immensely scaled work of her younger colleagues. In usual sculptural terms, these small, flattish, fluid molds are decidedly unprepossessing, ignoring decorative silhouette, mass, almost everything conventionally expected of sculpture. On the other hand, they have an uneasy aura of reality and provide a curiously *surrounded* intimacy despite their small size. They provoke that part of the brain which, activated by the eye, experiences the strongest physical sensations.

Such mindless, near-visceral identification with form, for which the psychological term "body ego" or Bachelard's "muscular consciousness" seems perfectly adaptable, is characteristic of eccentric abstraction. It is difficult to explain why certain forms and treatments of form should elicit more sensuous response than others. Sometimes it is determined by the artist's own approach to his materials and forms; at others by the viewer's indirect sensations of identification, reflecting both his personal and vicarious knowledge of sensorial experience in general. Body ego can be experienced two ways: first through appeal, the desire to caress, to be caught up in the feel and rhythms of a work; second, through repulsion, the immediate reaction against certain forms and surfaces which take longer to comprehend.

In 1853, P. J. Proudhon wrote: "The image of vice, like that of virtue, is as much the domain of painting as of poetry: According to the lesson that the artist can give, all figures, beautiful or ugly, can fulfill the goal of art." [3] In a broad sense all modern art is subject to the Camp cliché, "it's so bad it's good," which neutralizes opposites. The words ugliness and emptiness are resurrected periodically even now in regard to new art styles. They, and the modifying concept of anti-art, which rationalizes unfavorable reactions to the new, are obsolete. Nothing stays ugly for long in today's art scene. Following the line that dualism is also obsolete, some of these artists have tackled the almost impossible task of reconciling the two major attitudes toward art today, which are as mutually opposed as oil and water: the art-as-art position and the art-as-life position.

[3] I am grateful to Elizabeth Gilmore Holt for suggestions on the nineteenth century in this context.

"Eccentric Abstraction" installation: (l. to r.) Frank Lincoln Viner (hanging at rear), Don Potts (on floor), Eva Hesse (on wall). September, 1966. Photograph courtesy of Fischbach Gallery, New York.

One element in their work that characterizes this attempt is the adaptation of aspects of Pop Art to a nonobjective idiom. While Pop Art has had no direct influence on these artists, it was Pop that made palatable parts of the contemporary environment previously considered vulgar, ugly, and inferior to the "beauty" required by tastemakers in art, fashion, and commerce. It opened up new possibilities for materials and attitudes, all of which must be firmly controlled from the aesthetic angle.

Frank Lincoln Viner, who has been working in this idiom since around 1961, has explored multiple areas of sensuality purged of sentiment, and is now concerned with a more stringent but equally nonsculptural direction, based on the juxtaposition of taut, boxy, hard forms against limp, random, soft forms, or fusion of the two in a single work, such as his huge expandable hanging piece made of orange vinyl, silk-screened with large spiral shapes in blue and yellow and edged with a still more multicolored fringe. The series of identical rectangular shapes are pierced by a central hole, or corridor. His combination of garish pattern and disciplined form does not so much soften structural effect as it shifts the focus. In other works he has manipulated surface until it contradicts the form it covers, armoring a soft surface with shiny metal studs while the hard forms are softened with irregular, wavy bands. Because he has consistently worked in this manner over a period of years, Viner has already excluded some of the more obvious aspects of eccentric abstraction with which others are still occupied. His work transcends ugliness by destroying the notion of ugly versus beautiful in favor of an alogical visual compound, or obstreperous Sight.

The size of Viner's latest works approaches an environmental concept. Most of these artists have, so far, avoided such ideas, largely because of their concern with formal wholeness. Harold Paris, who persists in a more sculptural concept, has made a series of rooms that extends the reconciliation of sensuous opposites to a more complicated level. The latest and most successful room even includes temperature change and electronic sound controlled by the viewer's movements and pressures on the surfaces. Made primarily of various kinds of

black synthetic rubber, each surface has its own chiaroscuro, glowing with absorbed or repelled light. Some are smoothly soft, others matte, others finely textured or ribbed. They and the folded, molded organic forms fool the hand as well as the eye. A deceptively squashy-looking shape will be hard as metal, while a flat, wall-like surface gives resiliently when touched. The sculpture itself is set up in a multipartite, aislelike arrangement, small forms before larger, parent forms, augmenting the ritual quality of the entire environment.

These artists usually prefer synthetics and avoid materials with long-standing literary associations, but Don Potts (like Paris, from San Francisco) uses fur and leather with a wood veneer. More a sculptor than most of those mentioned here, he converts his materials into surfaces of such commercial precision that they can be explored in a directly sensuous manner instead of as anecdotal devices. Potts's great flowing structures, or the planar piece that suggestively rubs its furred edges together, are luxury items that invite touch but repel emotion by their almost maliciously perfect appearance. *Up Tight, Slowly,* an immense undulating floor piece with a two-color leather surface, is both sensuous and sensual; it forces a kind of attraction that might be said to border on titillation, were the form not so clearly understated.

The materials used in eccentric abstraction are obviously of distinct importance. Unexpected surfaces separate the work still more radically from any sculptural context, and even if they are not supposed to be touched, they are supposed to evoke a sensuous response. If the surfaces are familiar to one's sense of touch, if one can tell by looking how touching them would feel, they are all the more effective. As far as American art is concerned, Claes Oldenburg has been the major prototype for soft sculpture. Though his work is always figurative, he divests his familiar objects of their solidity, permanence, and familiarity. His fondness for flowing, blowing, pokable, pushable, lumpy surfaces and forms has none of the self-consciousness of, say, Dali's illusionistically melted objects. By taking single manufactured items and ready-made goods for his subjects, and using them with a high degree of abstraction, he bypasses the anecdotal barrier set up by the assemblagists

with their combinations of objects. Several, though by no means all, of the younger abstract artists working in soft materials noted their possibilities through Oldenburg's work; it differs from earlier uses of cloth in that he uses the medium in full range—stuffed and slightly resistant, left loose and absolutely manipulable.

Taken together, the effect of an Oldenburg soft canvas ghost model for a giant light switch and the streamlined, hard final version make up a kind of before-and-after or double-edged experience. Similarly, the "subject matter" of many of the works illustrated here could be said to be an understated metamorphosis. Though energy in any active, emotive sense is anathema to most of these artists, they have not rejected the idea of change, but systematized it, suggesting the force of change rather than showing its process. Their work tends to be anticlimactic, with no crescendo or buildup of forms. Gary Kuehn, for example, makes structures that use asymmetry as a neutralizing agent. Precise rectangular sections melt into a broad, fiberglass flow. Kuehn's earlier works were more tumbling and active, more obvious in confrontation of box and flow, but in the recent pieces, the flow is heavy, extremely controlled, and self-contained, often separate from its parent form, epitomizing inactive contrast. Momentary excitement is omitted; the facts before and the facts after action are presented, but not the act or gesture itself. Kuehn has been working with a structural versus idiosyncratic combination for some three years now, building primary single forms and juxtaposing them first against pillows and soft objects, then bundles of bare branches or twigs, bright-colored plaster flows, or swatches of hairlike nylon fiber. The high finish and assurance of the recent work deemphasizes novelty and oddity in order to stress and crystallize a concrete aspect of sensuous experience.

The use of a flexible instead of a fixed medium opens up an area somewhere between kinesthetic and kinetic art in which moving or movable elements are extremely understated, as opposed to the hectic "technological" bases of most kinetic sculpture. Keith Sonnier's inflatable forms are sometimes static, sometimes "breathing." The ones that inflate and deflate boxy vinyl forms include a similarly boxy counterpart in

hard, painted material—thus presenting two apparently contradictory states as parts of a single phenomenon—a very slightly speeded-up version of the kind of soft sculpture that can only be altered by touch. The rhythm gives life to inert forms while their static precondition is simultaneously noted. Even when the inflated shapes do not move, they span space (from wall to floor) in a manner that suggests the lines of movement within a single physical sensation. The clear vinyl forms give the effect of formal mass but physical impermanence, a strength derived from frailty.

Rutgers University, where Sonnier and Kuehn have taught, is a hotbed of eccentric abstraction, a phenomenon due mainly to the individual developments of the artists, but indirectly attributable to Allan Kaprow's unrestricted ideas and his history of involvement with bizarre and impermanent materials, which was influential there even after his own departure. Last year Robert Morris also taught at Rutgers and his older work mingled contradictory premises in a cerebral manner opposing Oldenburg's intuitive approach. Jean Linder, who was making large phallic sculptures of epoxied and painted cloth in San Francisco, also taught at Douglas in 1965–66, when she moved away from the rough materials and techniques that characterize the so-called funk art of San Francisco (mainly Berkeley). Now in New York, she makes furniture-like structures, overtly sexual in their imagery and utterly unexpected in their awkward and uninhibited forms. With soft clear plastics and vinyl fabrics she has developed a hallucinatory use of transparency; her best work is relatively simple and less imagist.

This applies to most of the San Francisco artists who deal with "funk," described by a West Coast writer as a kind of rugged individualist's Camp, unofficial and inelegant: "While Camp cultivates 'good' bad taste in a way that is often precious and even recherché, Funk is concerned more with the essence than the pose, and can even be 'bad' bad taste if the Funk is mean enough." [4] Whereas funky art, or West Coast

4 Kurt von Meier and Carl Belz, "Funksville: The West Coast Scene," *Art and Australia*, Vol. 3, No. 3 (December, 1965), p. 201.

eccentric abstraction, deals with a raunchy, cynical eroticism that parallels that of the New York artists, the West Coast is more involved with assemblage than with structural frameworks. Among those artists with a more developed formal sense (as far as I can tell from the little work I have seen) are Wayne Campbell, Dennis Oppenheim, Rodger Jacobsen, Jeremy Anderson, and particularly Mowry Baden's big fibrous, membrane-like *Traps*, as well as his more abstract ceramics.

Typical of a much cooler kind of Funk is Bruce Nauman, who lives in San Francisco and has shown once in Los Angeles. Nauman's paradoxical ideas and intellectual inventiveness recall those of Robert Morris, though the work bears no resemblance. He has manipulated blotchy synthetic rubbers, tinted fiberglass, painted woods and metals into a curious limbo between mere existence and establishment of barely marked areas of space. His recent pieces are concerned mainly with molds—the negative-positive and inside-out properties of hollow, open, and solid forms and their enclosed or filled spaces. The older work is more random—a group of rubbery streamers, a thin T-bar with a slightly curved-out stem, an irregular "melted" barrier arched against the wall, a roughly circular group of centrally attached rubber strips to be thrown arbitrarily on the floor. The majority of Nauman's pieces are carelessly surfaced, somewhat aged, blurred, and repellent, wholly nonsculptural and deceptively inconsequential at first sight. Their fragility suggests fragmentation, but they are disturbingly self-sufficient, with the toughness of lost, left-over function and a total lack of elegance. When Nauman uses color it is spiritlessly urban, but not commercial—like a shrimp-pink house badly in need of a paint job.

Kenneth Price, in Los Angeles, conveys an ambivalent sense of vulnerable hostility in his small, painted ceramic ovoids. The self-containment of the bright, dry armored shell is at odds with the dark, damp tendrils emerging from the core. In later pieces the outer form is free and fluid, still biomorphically sensuous but avoiding any specific erotic reference, and in others, a single form—lumpy, independent, like a small island—is taken entirely out of the organic category. Though the metallic, glowing color has the same sort of sin-

Bruce Nauman: Untitled. 1966. Latex. Collection of Panza
di Biumo, Varese.

ister refinement as the earlier pieces, the later ones are more arresting in their divorce from extant sculptural tendencies. The fact that Price, a highly self-reliant artist, and by choice isolated from the stylistic mainstreams, has arrived at an un-fixed asymmetrical flowing form that can be related distantly to Kuehn's and Nauman's is indicative of the extent to which such an idiom is in the air.

Alice Adams was an accomplished weaver for many years; when she turned to sculpture, she acquired no sacred sense of medium, and was free to invent. Her familiarity with flex-ible, manipulable materials led her to work with forms that are patently man-made, but have a strangeness operating close to a natural level. The gawky, semi-architectural armatures of chicken wire, industrial cable, and link fencing retain traces of biomorphism, though not so much as her older work, which evoked unnamed creatures—ropy, rough tangles of fiber and painted cable. Adams' animate references are erotic and often humorous, whereas Robert Breer's white styrofoam "floats" are more ominous. Unseen motors enable them to creep at an almost imperceptibly slow pace and they constantly alter the space in which they move. Their simple, angular, quasi-geo-metric shapes dispel by understatement most of the biological suggestions that arise from their motion, and unlike the re-lated kinetic sculptures of Pol Bury, they avoid cuteness.

In 1924, André Breton wrote that for him the most effective image was the one with the highest degree of arbitrariness. The artists discussed here reject the arbitrary in favor of a single form that unites image, shape, metaphor, and associa-tion, confronting the viewer as a whole, an undiluted aes-thetic sensation, instead of as a bundle of conflicting or bal-anced parts. Evocative qualities are suppressed to subliminal level without benefit of Freudian clergy. Sensual aspects are, perversely, made unpleasant, or minimized.[5] Metaphor is freed from subjective bonds. Ideally, a bag remains a bag and does not become a uterus, a tube is a tube and not a phallic sym-bol, a semisphere is just that and not a breast. Too much free

[5] See Barbara Rose, "Filthy Pictures: Some Chapters in the History of Taste," *Artforum*, Vol. 3, No. 8 (May, 1965), p. 24.

association on the viewer's part is combated by formal under-
statement, which stresses nonverbal response and often height-
ens sensuous and/or sensual reactions by crystallizing them.

Abstraction cannot be pornographic in any legal or specific
sense no matter how erotically suggestive it becomes. (There
is no pornographic music.) Instead of employing biomorphic
form, usually interpreted with sexual references in Surrealism
and Abstract Expressionism, several of these artists employ a
long, slow, voluptuous but also mechanical curve, deliberate
rather than emotive, stimulating a rhythm only vestigially
associative—the rhythm of postorgasmic calm instead of ec-
stasy, action perfected, completed, and not yet reinstated. The
sensibility that gives rise to an eroticism of near inertia tends
to be casual about erotic acts and stimulants, approaching
them nonromantically. The distinction made by the Sur-
realists between conscious and unconscious is irrelevant, for
the current younger generation favors the presentation of
specific facts—*what* we feel, *what* we see rather than *why* we
do so.[6] The Surrealist poet Pierre Reverdy said thirty years
ago that "the characteristic of the strong image is that it de-
rives from the spontaneous association of two very distant
realities whose relationship is grasped solely by the mind,"
but that "if the senses completely approve an image, they kill
it in the mind." [7] This last qualification clearly separates Sur-
realism from its eccentric progeny. For a more complete ac-
ceptance by the senses—visual, tactile, and "visceral"—the
absence of emotional interference and literary pictorial associ-
ations is what the new artists seem to be after.

[6] See G. R. Swenson, *The* Other *Tradition* (Philadelphia: Institute of
Contemporary Art, 1965).

[7] From "Le Gant de Crin," quoted in Marcel Raymond, *From Baudelaire
to Surrealism* (New York: Wittenborn, Schultz Inc., 1950), p. 288.

Cult of the Direct
and the Difficult*

"Direct" and "concrete" were suggested as alternatives to the term "Abstract Expressionist" by the artists themselves in a 1950 symposium. Both words imply a tough, no-nonsense ideal that has been a constant factor in American art for the past two decades. "Perhaps pure painting is a direct experience and an honest communication," wrote Ad Reinhardt in 1948; Barnett Newman, the other, very different, pivotal figure between the painterly and the post-painterly generations, wrote in the same year: "The image we produce is the self-evident one of revelation, real and concrete, that can be understood by anyone who will look at it without the nostalgic glasses of history."

A disaffection with "easy art" is an integral element of recent American painting that unites most of the stylistically various artists who have come into prominence between 1946 and 1966. The most obvious manifestation of this disaffection is the Oedipal ritual of action and reaction inherited from art history: the ruling genre, the most seen and thus most imitable style, becomes "easy" and must be renounced for

* Reprinted from *Two Decades of American Painting*, Museum of Modern Art, New York, catalogue for an exhibition sent to India, Japan, and Australia, 1966–67.

a more "advanced" art. So-called Abstract Expressionism—against which many young artists apparently reacted around 1960—was many things, often neither abstract nor expressionist; it is impossible for an artist, or a critic, who matured intellectually in the later 1950's, to have anything but an ambivalent attitude toward the original New York School as a whole. Yet it should be said that the progressive and rapid replacement of American art styles is due to something more specific than cyclic determination. The often and pejoratively remarked cult of the new is actually a cult of the difficult.

"Beauty," "prettiness," "decoration," and "subtlety" have become suspect words in their suggestion of easy communication, of professional weakness on the part of the artist who had painted likable pictures and had not forced himself into less familiar areas. They implied too little rejection of the past in the fifties, too little formal rigor in the sixties. (Pop Art, so often accused of pandering to the public, is in fact particularly perverse in this context, for its choice of subject matter was so initially unpopular, so distasteful and outwardly nonaesthetic, that the "difficulty" was compounded; the great success of Pop Art was hardly predicted by the artists who independently invented it.) The large canvas characteristic of American painting since the late 1940's counts among its attributes an augmented presence—the confrontational directness of an object placed unavoidably and implacably before the spectator. The Abstract Expressionists adopted it for a sense of expansive, infinite space; the color painters for an added chromatic breadth and intensity; the Pop Artists to dwarf and amaze the viewer; the structurists to emphasize spareness and self-containment. No recent American painting of any quality in large scale is intended to provide the spectator with a wealth of sensuous detail; it is meant to overwhelm first and to please or distract second, if at all. † One of the results of this particular product of the will toward difficulty is an unplanned obsolescence that contributes involuntarily to the workings of the American art world. By virtue of

† I should not care to defend this statement four years later. There were works of high quality with a wealth of intricately structured detail being made at that point, but I was unaware of, and unreceptive, to them.

size of the works alone, collectors of American painting tend to change collections every few years; if they continue to be involved in recent painting they are forced either to store away or to sell less recent acquisitions to make room for the new. Contrary to popular opinion and to continual complaints about the triumph of novelty over originality, such a turnover is produced not only by an increasingly commercial atmosphere but by the artists themselves, through their commitment to a grueling, self-demanding ethic based on distrust of the accepted and the acceptable.

Progress is supported by morality, in this case a morality outside of religious and theoretical confines, but distinctly rooted in puritanism, native or philosophical. It involves a dislike, or fear, of abdicating to the pleasure principle, and was first based on a standard of self-denial. In 1951 Robert Motherwell wrote: "The specific appearance of these canvases depends not only on what the painters do, but on what they refuse to do. The major decisions in the process of painting are on the grounds of truth, not taste." (Or, in one of the most extremely idealistic expressions, Richard Pousette-Dart writes: "The artist is the only moral man, because he alone overcomes fear and has the courage to create his own soul and live by means of the light of it.") Thus Baudelaire's "I have a horror of being easily understood" has been echoed by artists widely ranging in style, from Clyfford Still ("I fight in myself any tendency to accept a fixed, sensuously appealing recognizable style. I am always trying to paint my way out of and beyond a facile doctrinaire idiom.") to Marcel Duchamp ("I force myself into self-contradiction to avoid following my taste.") to a painter still in his twenties who sees his work as a "reaction to the 'easy art' of recent years . . . the everybody-can-like-it-and-collect-it kind of picture. Like religious or historical painting of the past," he asserts, "these groups have given the public outside reasons for liking and accepting their work—the subject matter of Pop, the color-shape gymnastics of Op, and the combination of brilliant color, exciting shape, and new materials of hard-edge painting and sculpture. I think my work and others'—notably Frank Stella's—marks a return to an antidecorative, difficult art." Stella, denying a

nihilistic intent, says simply, "It's just that you can't go back. It's not a question of destroying anything. If something's used up, something's done, something's over with, what's the point of getting involved with it?" † By now Motherwell's romantic note has been firmly eschewed by younger artists who prefer a factual view of the artistic process. Existentialist art has been replaced by an anticlimactic art founded on the same principles of opposition to the easy, but expressed in noncommittal, nonevangelical terms.

The formal and the moral dilemmas posed by such rigorous striving for the advance that gives the avant-garde its name are manifold. The impact that the new American painting has had on the postwar international scene is no different from that of Paris-based movements in the first half of the century, except that the example of the earlier breakthroughs has speeded things up. Mistrust of demonstrations, labels, manifestos, and group solidarity marks American art of the sixties. The currently intellectual approach precludes emotionalism just as it does a vague, indirect expression. With ramifications of new ideas immediately seized upon and extended by other artists, the assurance of belonging instantly and involuntarily to a "new academy" before personal researches have been completed has plagued American artists for a decade. A painter can, of course, read himself out of the mainstream, where he may have lingered happily for a short period, and stubbornly insist upon exploring a concept that may be "outdated" in a year, despite the fact that this concept may not yet have been fulfilled in personal terms. The majority of older artists in this exhibition find themselves in such an unenviable position, partly because they must continue to be tough, unsentimental, disdainful of the easy as they were in the "heroic years," even though expressionist idioms are notoriously quick to burn out; partly because to develop these idioms in a more precise and ordered framework may well involve a betrayal of principles pledged in those same heroic years, as well as the risk of seeming to follow recent fashions. All but a few members of the Abstract-Expressionist generation have exhausted the possibil-

† See pp. 206–212.

ities of their known styles, but they are not allowed, and they do not allow themselves, to rest comfortably on their laurels. The very nature of the new American painting is opposed to the European *"cher maître"* tradition, characterized by an artist's spending his old age repeating and diluting youthful formulas amid security and adulation. De Kooning, the major figure of the expressionist branch of the New York School, is in a particularly poignant predicament. His recent work seems tinged with desperation, but it is as fully committed as the earlier. He absolutely refuses to compromise, as some of his colleagues have, with directions alien to him and to the foundations of his art.

One alternative to continual *formal* advance, following the direction of the nonformal, "other" traditions (Dada, Surrealism, assemblage, Pop, and the more recent sensuous and eccentric art), is the replacement of an aesthetic or formalist foundation with one of post-Freudian metaphor. A second, less interesting prospect is virtually to ignore advance of any kind and retreat to private realism, or abstraction, that makes no attempt to be "difficult" except in that all art of quality is hard to make. A third, and the most currently viable, possibility renounces the dichotomies of action-reaction, form-content, conceptual-intuitive, objective-subjective in favor of an art of inaction, one that "simply exists between mind and matter, detached from both, representing neither." Frank Stella's contribution, if not full commitment, to the formulation of such an approach cannot be minimized, while Ad Reinhardt's square, symmetrical, black paintings are the only works by a member of the original New York School that still seem difficult in view of this recent development. The more Reinhardt omits of detail, color, and composition, heretofore taken for granted as necessities to painting per se, the more the bared fact of the painting is imposed upon the viewer.

Reinhardt's "negative" and truly rejective approach is paradoxical but never contradictory. He avoids effusion by stating only what his art is not; it is not colored, not composed, not inflected, not meaningful in any directly interpretable sense. While his ideas cannot be equated with the Abstract Expressionists' romanticism or with the single-minded conceptualism

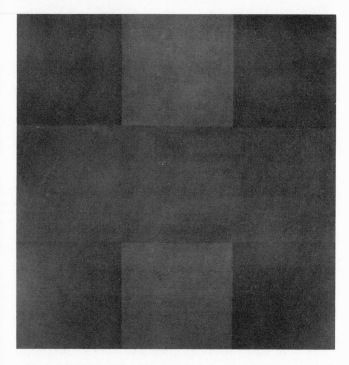

Ad Reinhardt: Untitled (Black). 1960–66. Oil on canvas. Photograph courtesy of The Jewish Museum, New York.

of the younger structurists, his writings relate, always critically, to both. He has been called "the Conscience of the Art World" and the "Great Demurrer in a time of Great Enthusiasms." Wholly committed to nonobjective art, he calls his works "Abstract Painting" or "Timeless Painting" or "Ultimate Painting." "Perhaps semiabstract is half-wit," he has said. "A representational fine art perhaps is as ridiculous and useless as an abstract commercial art. . . . Perhaps [pure painting] is a creative completeness and total sensitivity related to personal wholeness and social order because it is clear and without extra-aesthetic elements." Barnett Newman minimizes the painting process and detail in order to emphasize broad metaphysical implications. His canvases (like Pollock's, Rothko's, and Still's, in their diverse ways) expand into Elysian openness, space, and light; Reinhardt, with equally spare means, reverses the procedure, making closed, dark, impassive, and specific paintings whose complete detachment can incite a complete involvement by the viewer willing to sacrifice all ordinarily expected titillations.

The fact that Reinhardt is a reputable scholar of Oriental art has contributed to the fact that he is the mature New York artist most equipped to deal with the radical reevaluation of theoretical expression taking place in the science, philosophy, and art of the Western world. So many principles of Oriental thought have been assimilated by the West in the last decade or so that one need no longer be a scholar or even aware of these principles to be affected. The Western Renaissance tradition demands acceptance of Judeo-Christian dualism. Oriental painting, contemplative or decorative, has always, if deceptively, seemed visually simpler than Western painting; the Zen aim of a no-ego *tabula rasa,* an equilibrium of intellect and expression, is not irrelevant to the arts of the sixties. It was the technical spontaneity, if anything, of *sumi* paintings that attracted the Action Painters, but, aside from Mark Tobey, the Abstract Expressionists, de Kooning in particular, were unsympathetic to Eastern art, finding it lacking the tangible substance and paint quality of a Rembrandt or a Titian. Rejection of Abstract-Expressionist techniques has not brought on any great influence of Eastern art,

but the prevalent nonromantic concept of simultaneous detachment and involvement has been attributed, rightly, I think, by Marshall McLuhan, to a general orientalization of our electric age. For instance, the phenomenon of "cool," a word first popularly applied to jazz, is now applied to the customs, attitudes, and paraphernalia of a "teen-age culture" as well as to current art. It is characterized by the wearing of dark glasses (or "shades"), which can be interpreted as protection against the hot, light, "uncool" ideals of a mechanized world. Basic equipment of the cool stance, dark glasses "create the inscrutable and inaccessible image that invites a great deal of participation and completion." They present a "blank" surface, self-contained but curiously compelling, like much of the most recent art, which embraces the varied painting styles of Warhol and Stella, the sculpture of Donald Judd, Robert Morris, Sol LeWitt, and Carl Andre. This brings to mind the Western cliché about the "inscrutable East," which suggests a dimension of difficulty hitherto inaccessible to American art.

As Painting Is to Sculpture: A Changing Ratio*

A definition of sculpture: something you bump into when you back up to look at a painting.

AD REINHARDT

The relationship between two- and three-dimensional art has changed radically over the last few years, and not only because color has been broadly reintroduced into sculpture during that time. At the moment, there is considerably more interest in sculpture than in painting simply because there seems to be more interesting sculpture than painting being made. Formally and nonformally oriented sculptors are now exploring aesthetic areas either exhausted or rejected by painters over the last half century. Sculpture has long been considered a more or less subsidiary art, following painting's innovations and docilely translating them into three-dimensional versions. When one categorized sculpture, one did so, awkwardly and often ridiculously, in the context of painting; there has been Cubist sculpture, Abstract Expressionist sculpture, even "hard-edge sculpture" and "painterly sculpture." Now the relationship is more complex. In several important

* Reprinted from the exhibition catalogue *American Sculpture of the Sixties,* Los Angeles County Museum of Art, 1967.

ways, sculpture is gaining its independence from painting and painting, in turn, frequently finds itself the follower. "Structural painting" † borrows from primary structures. In the present exchange and occasional confusion between painting and sculpture and the structural "third stream" (which includes some shaped canvases), three interacting points seem particlarly pertinent: the relationship of painting and sculpture as physical objects, as vehicles for formal or sensuous advance, and as vehicles for color.

Although nonrepresentational painting has progressively eliminated all attributes not consistent with its imposed flat, rectangular surface, the result of this total emphasis on two-dimensionality has been, paradoxically, a concomitant emphasis on painting as three-dimensional object, a fact leading directly to sculpture. With Neoplasticism in the twenties and thirties, this progression had already reached the point where sculpture could not effectively follow painting, for while Cubist sculpture could treat directly the volumes that Cubist painting's shifting planes attempted to subdue, there was little that Neoplastic sculpture could achieve within the de Stijl and Bauhaus programs that could not be better achieved in painting, architecture, or design. It could only echo painting's colored, asymmetrical surfaces. While a handful of Suprematist and Constructivist sculptors managed to escape briefly these painting-regulated strictures, their accomplishments, though important, were few and isolated. Geometric sculpture from then on was a pallid reflection of geometric painting. In the early sixties, this situation surfaced again, so to speak, but under entirely different conditions, and in America, where younger artists had reason to be overwhelmed and dissatisfied by the successes, dominance, and inexorable progression of painting over a twenty-year period. There was, and is, no Movement, or even much agreement between the artists on what they are doing; it is a general phenomenon that a good many painters began to "escape" to sculpture, though their lack of sculptural habits and training made the results peculiarly nonsculptural in effect. In all probability, the possibil-

† My term at the time for "reductive," "rejective," or "minimal" painting.

ities of painting per se only *seem* limited at this time, but this notion is prevalent enough to impel many artists into three dimensions.

Mark Rothko's insistence upon the painting as an independent object in the early fifties, bolstered by his habit of making stretchers deeper than usual, painting around the side edges, and dispensing with frame and stripping, was part of this development. It was Mondrian's much earlier decision to mount the painting instead of framing it. The canvas stood away from the wall as a separate entity, free of the transitional and taming agent of frame to isolate pictured reality from everyday reality. With others of his generation, notably Pollock, Newman, and Still, Rothko also used large size and scale to force a picture's "presence" to dominate the space in which it was hung. Ad Reinhardt's black rectangles and stringently rejective program further contributed to the process in which painting became more than a decoration, illustration, or conversation piece. The breakaway from easel painting provoked a new sculpture as well, for the great self-consciousness and growing self-assurance of the New York School's heroic period permitted freedom of scale and the consequent conceptual freedom to revise conventional definitions of sculpture as well as of painting. From around 1960, this attitude was implemented by a growing body of new sculptural directions.

The notion of the painting as object has two interpretations. First as a specific surface, but without connotations of volume and physicality, second as an actual three-dimensional thing. Both contributed to the idea of a nonsculptural sculpture, that is, a sculpture that rejects the history of sculpture as precedent in favor of the history of painting, and at times, of architecture and engineering. The notion of the sculpture as object is equally equivocal. Until recently, the "object" implied an additive, Dada or Surrealist or assemblage work made of nontraditional materials or found items. Structures, or as Don Judd has called a broader grouping—"specific objects"—are, on the other hand, simple, single, or strictly repetitive, serial or modular, with a quality of inertia and apparent (superficial) abdication of the transforming

powers of art. In this context, the object or objectness is directly opposed to the additive premise on which most post-Cubist works are founded. But its connotations, like those of the Dada object, are nonsculptural and even antisculptural. In that many of the artists are former painters who have rejected painting, this is also an antipainting idiom, though most of these artists are far more interested in recent painting than in recent sculpture. For all the magnitude of David Smith's achievement, and his historical importance as the major American sculptor, the extent of his influence on the current young generation has been much overstated. His polychromed *Zigs* as well as his *Cubis* are less relevant to recent developments than to the tradition preceding him; he can be seen as the culmination of an area of post-Cubist sculpture, though this area still presents suggestions for further, if minor, developments.

Many of Smith's apparent successors were not influenced by him so much as they were subjected to the same influences he was—namely New York School painting and that of the younger "color painters." Anthony Caro knew Noland and Olitski as well as Smith at Bennington; Chamberlain, Doyle, di Suvero, and a somewhat older group reached artistic maturity in the late fifties, when Abstract Expressionism and related idioms were at their exposure peak. Di Suvero's debt seems to be to Kline, and de Kooning's broad color swatches have appeared in many sculptural guises. Similarly, the concurrent rejuvenation of the collage medium, which also dealt with overlapping planes and flat irregular patches of color, was important to American sculptors in the fifties just as it had been years before to Picasso, Gonzales, and the ensuing line of "junk sculptors." [1] A parallel pictorial mainstream—the ideographic image—was translated into the open but increasingly rigorous sculpture of the fifties and at the same time found its way into Sugarman's, Weinrib's, and Doyle's more experimental "space sculpture" of the early sixties, which has, in turn, had successors. Still another contribution

[1] See Clement Greenberg, "The New Sculpture" and "Modernist Sculpture, Its Pictorial Past," *Art and Culture* (Boston: Beacon, 1961), pp. 139–45, 158–63.

of the New York School—the quasi-geometric single image—was later to become important to Don Judd and Robert Morris.

Around 1962, the structurists and structural painters were actually paralleling each other's efforts to advance formally within their chosen means. Frank Stella's continuing use of a very deep stretcher and "deductively" shaped supports, Dan Flavin's lighted "icon" boxes, Ronald Bladen's flat forms projecting from panels, Donald Judd's ribbed and striated reliefs, and Richard Smith's canvas constructions all demonstrated a preoccupation with expanding the dimensions and formal possibilities of painting, or wall-hung pieces. The fact that all but Stella further approached or moved into freestanding structures and all but Stella and Smith are now considered sculptors is significant. Perhaps the most important aspect of the increasing attraction of sculpture today is its apparent potential as a vehicle of advance †—both formal and evocative, or sensuous. This comprises its most crucial relationship to painting, for it is only with the avant-garde's decreasing interest in painting that sculpture has come to the fore. This is a very literal period. Sculpture, existing in real space and physically autonomous, is *realer* than painting. Yet sculpture also has its own peculiar kinds of illusionism, which it has not, like painting, had to give up in the interest of fidelity to medium. For instance, a lacquered wooden surface disguises the color and texture of wood, but retains a mellowness characteristic of wood, whereas a hard, shiny, enameled wooden surface disguises wood to the point of making it an illusion of metal. A shiny, reflecting metal surface gives the illusion of insubstantiality or transparency by reflecting its surroundings, and a burnished metal surface like that of David Smith's *Cubis* can give the illusion of several atmospheric depths as well as asserting the surface. By painting their materials, whether masonite, wood, steel, plaster, most abstract and some figurative sculptors are trying to avoid the connotations of the materials—naturalistic or industrial or academic—and give the

† This is all pretty muddled. "Advance" was a catchword at this point, and I am not at all sure it is preferable to "avant-garde," which was, and still is, out of favor. Both infer to an exaggerated degree that "advance" equals "best."

illusion of something autonomous and new in itself without reference to its antecedents—physical or historical.

Smith himself was not averse to painting his sculptures in much the same manner that one might paint a canvas. His *Zigs* often combine strong sculptural form with a frontal, centralized image, polychromy, and even brushwork that was frankly allied to painting. Only Smith's knowledge of sculpture kept most of them from looking like one-image painting peeled off the wall. One-image painting, in turn, could be said to imitate (unconsciously) the singleness and self-sufficiency of sculpture; when Barnett Newman made an exaggeratedly tall, thin monochrome painting as well as bronze sculptures out of the stripe that divides all his canvases, he was admitting in effect that the stripe was the unit by which his painting existed, denying, at least temporarily, the importance of that stripe's placement on the supporting surface. There has been other single-image planar sculpture (structures are generally imageless), such as Ellsworth Kelly's flat monochrome shapes which, like Newman's stripes, seem to have been freed from their canvas grounds to exist rather precariously in three dimensions. The "thin" idiom itself, in more hierarchical form, can be traced to Calder's stabiles and to Matisse's late cutouts. Such works could be said to mimic and even parody the necessary flatness of a painted image by their own unnecessary flatness. The kind of color Kelly uses, for instance, so sharp and positive in a painting when juxtaposed against another color or the white of a wall, becomes far more ambiguous when isolated in actual space.

For that matter, very little of the new sculpture—from assemblage to "space sculpture" to structures—is anything but ambiguous as a vehicle for color, though the effectiveness of color should not be underrated. Color in sculpture is more difficult to work with than color in painting because so many factors must be taken into consideration. It is also more difficult to assess from a critical point of view. Whereas color in painting can be judged within a relatively understood system of theory or experience, such a system, fortunately, is not yet established for sculpture. No matter how large a painting is, the surface can be taken in at a glance, and while the form

and color action may be extremely subtle and engender different effects after different viewing times, it can be perceived initially as a unity. A sculpture must hold its own in space and from different angles; color must be so thoroughly controlled that it is both absorbed by and heightens the purpose (formal or psychological) of the sculpture itself. Because of this, and because color had largely disappeared from sculpture for so long, its development is in a much earlier stage.

The quite sudden prevalence of color in sculpture occurred when color in painting was at a high point of brilliance and dominance. The Whitney Museum Annual of December, 1964, devoted to sculpture, reflected this trend and may even have been influential, for the noncolored (naturally colored) sculptures, with some exceptions, looked dull and obsolete in the company of brightly painted pieces which were of equal aesthetic quality. In the heyday of hard-edge and Pop and Op Art, assertiveness and aggression were valued effects; colored sculpture could hold its own with painting. Since that time, sculptors' use of color has rapidly become more sophisticated and recently has paralleled the preoccupation of certain structural paintings with an "off-color"—grayed, neutral, metallic, sweet tones in preference to the extreme brilliance and decorative obviousness of the primary hues. An initial enchantment with hit-or-miss application of any old bright color gave way to a more serious consideration of the formal role color could play. It is used illusionistically to disperse and minimize volume, to separate shapes in space, making heavy forms seem weightless, light ones heavy, near forms farther away, and far ones closer. And it is used to unify, to make a form more "real," isolating it from the environment and asserting the piece as a self-contained whole. Yet unless the material is colored to begin with, like certain plastics, color is applied after form and too often comprises an arbitrary "envelope" apparently chosen for neither a metaphorical nor a formal reason, but merely as an attracting, eye-catching device. Clement Greenberg's complaint about Anthony Caro's color could be applied to any number of other sculptors: "I know of no piece of his, not even an unsuccessful one, that does not transcend its color, or whose specific color or combination of colors

does not detract from the quality of the whole (especially when there is more than one color). In every case I have the impression that the color is aesthetically (as well as literally) provisional—that it can be changed at will without affecting quality." [2]

Monochromatic color especially tends to represent an abdication of its formal positive virtues, as well as a rejection of aspects of painting carried over to sculpture. The planar surfaces of the structurists are not in any sense surfaces for decoration, though other sculptors, including David Smith, Kenneth Price, and Robert Hudson, have painted images on their surfaces either to stress or to contradict the underlying forms. John McCracken is perhaps the only structurist for whom surfaces are literally vehicles for color, though Judd has made isolated pieces of which this is true.† The problems inherent in a polychromed object are quite different from those of monochrome. At best a polychrome sculpture is colored in such a specific way that it approaches the pictorial; justice of form and color are inseparable from each other. Price, for instance, is able to color relatively small and similar forms so that each is invested with a highly particular aura—too detached to call a mood, but certainly of some psychological importance. An ovoid of one red seems to *mean* something different from a slightly dissimilar ovoid of a slightly dissimilar red. Of course assemblagist, figurative, or abstract post-Surrealist sculptors use color in a necessarily more specific manner than the formalists. The fact that a recognizable object or referential image is its "natural" color, or not, has to be important, whereas in wholly abstract sculpture, color has more of a chance of standing for its own properties. The question of meaning in nonobjective art is intricately involved with the question of color, and while this aspect remains to be clarified both from the angles of achievement and criticism, the psychological effects are important even when unintended.

Color in painting is always added color; in sculpture it

[2] Clement Greenberg, "Anthony Caro," *Arts Yearbook*, No. 8 (1965), pp. 106–09.

† By now it has become obvious that Judd is integrally concerned with color.

can be inherent in the material. Sidney Geist has asked some basic questions about this aspect: "Does all sculpture, by virtue of being material, have color? Does a touch of color or the use of subtle or quiet color qualify for the title of colored sculpture? Is a sculpture painted all blue more 'colored' than a white marble?" [3] Obviously touches of color or quiet color do qualify and are often more important to the work than a large area or bright hue. Yet naturally colored traditional materials such as wood, bronze, marble, stone, no matter how much color they may provide, would not make colored sculpture in the strict sense, partially because of their long acceptance and consequent low level of visibility, but mainly because other characteristics of these materials, such as grain, reflectiveness, surface, texture, are likely to be more important than their color. Thus a sculpture *painted* gray is more "colored" than a gray stone sculpture because the color is a positive, added factor, an agent of change that disguises or regulates all other properties of the material. A good many new materials, such as opaque and translucent plastics, vinyl, neon and fluorescent light, cloth, synthetic rubbers, have color qualities that are entirely new and therefore dominate their other properties, though here, too, one is eventually aware of the material *qua* material as much or more than one is aware of its color. For this reason, they are difficult to manipulate and control on a formal basis, lending themselves more aptly to evocative or sensuous goals. The color of Oldenburg's vinyl objects is far less important to the result than the color of his painted plasters were.

As new materials are tested and found viable, the kind of color open to sculpture expands and is in turn often picked up by painting. Metal-flecked, day-glo and other commercial paints, sprayed color, professional "fabrication" and color application, garish Pop derived hues are examples of this feedback. The constant introduction of new media is one reason that sculpture seems to bear more possibilities for originality than painting at the moment, even in the nonformalist idioms

[3] Sidney Geist, "Color It Sculpture," *Arts Yearbook*, No. 8 (1965), pp. 91–98.

to which "advance" is beside the point. These materials liberate forms previously "used up" in painting and traditional sculpture. A vinyl biomorph is an entirely different sight and experience from approximately the same biomorph in marble by Arp, or in paint by Gorky. Every object employing labyrinthine wires, threads, ropes, allover linear patterns can be tenuously traced to Pollock and therefore accused of being unoriginal.[4] However, this attitude seems unnecessarily exclusive, and finally invalid. Exact use of color alone, as evidenced in Kenneth Price's work, transforms shapes previously used by Brancusi and Arp into something new, just as Sol LeWitt's structural frameworks of a square within a square bear no visual resemblance to Albers' *Homage to the Square* paintings, or Bruce Nauman's random, rubbery shapes to Masson's automatism. Three-dimensional objects can, I believe, return to the vocabulary of previous painting and sculpture and, by changing the syntax and accents, more fully explore avenues exhausted in two dimensions or conventional materials and scale, without risk of being unoriginal or reactionary.†

4 See Hilton Kramer on Eva Hesse in the *New York Times,* Sunday, September 25, 1966.

† This pictorialization of recent sculpture has now come about in much earthwork, idea, and "antiform" art. Robert Morris has attributed the historical source of his "antiform" to Pollock.

Silent Art: Robert Mangold*

The art for art's sake, or formalist strain, of nonobjective painting has an apparently suicidal tendency to narrow itself down, to zero in on specific problems to the exclusion of all others. Each time this happens, and it has happened periodically since 1912, it looks as though the much-heralded End of Art has finally arrived. The doom-sayers delight in predicting an imminent decease for any rejective trend. While Dada, assemblage, and Pop Art have come in for their share of ridicule and rage, the most venomous volleys have been reserved for those works or styles that seem "empty" rather than "ordinary" or "sloppy." The message of the Emperor's New Clothes has made a deep impression on the American art public. "Empty" art is more wounding to the mass ego than "sloppy" art because the latter, no matter how drastic, is part of the aesthetic that attempts to reconcile art and life, and thus can always be understood in terms of life. There is nothing lifelike about monotonal paintings. They cannot be dismissed

* The article on "Robert Mangold and the Implications of Monochrome" (*Art and Literature,* No. 9, 1966) and the one on "The Silent Art" (*Art in America,* January, 1965) overlapped a good deal. The following piece has been put together, but not revised, from both; asterisks mark the breaks.

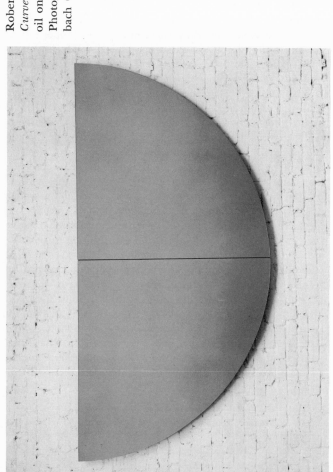

Robert Mangold: ½ Green-Gray Curved Area. 1966. Sprayed oil on masonite. 48″ x 96″. Photograph courtesy of Fischbach Gallery, New York.

as anecdote or joke; their detachment and presence raise questions about what there is to be seen in an "empty" surface.

* * *

Robert Mangold's near-monochrome *Areas* are in themselves a comment on abstract painting's current dilemma. We have reached the point where only the symmetrical (square), imageless, textureless, patternless, even colorless canvas can be considered radically advanced. Composition, drawing, even inflection are gradually being ruled out by the proponents of an outwardly simple, essentially complex, self-critical art—"ABC Art," as Barbara Rose has called it in an article that is *sine qua non* for an understanding of the new sensibility.[1] Unlike a number of younger artists who have concluded that "painting is finished," [2] and who have become structurists or nonsculptors, Mangold has decided to meet the challenge of the increasing limitations set by the two-dimensional plane. His approach involves the fusion of extremes—the assertion of an impassive surface, and an almost invisible atmospheric haze—into a statement that neutralizes its ambiguities and can be seen as a physical fact, rather than as an entertainment or an aid to autoanalysis. "Although I don't consider my pieces radical in the sense of denouncing traditional painting," says Mangold, "I do feel they are a reaction to the 'easy art' of recent years—Pop, Op, and even the hard-edge, jazzy school—the everybody-can-like-it-and-collect-it kind of picture. I think that like religious or historical painting of the past, these groups have given the public outside reasons for liking and thus accepting their work—the subject matter of Pop, the color-shape gymnastics of Op, and the combination of brilliant color, exciting shape, and new materials of hard-edge painting and sculpture. I think my work and others—notably Frank Stella's—mark a return to an antidecorative difficult art."

[1] *Art in America*, Vol. 53, No. 5 (October–November, 1965), pp. 57–69.
[2] Don Judd, quoted by Dan Flavin, *Artforum*, Vol. 4, No. 4 (December, 1965) p. 21.

Robert Ryman: *Standard*. 1967. Oil on metal. 48″ x 48″.
Photograph courtesy of Fischbach Gallery, New York.

* * *

It should be clear by now that monotonal painting has no nihilistic intent. Only in individual cases, none of which is mentioned here, is it intentionally boring or hostile to the viewer. Nevertheless, it demands that the viewer be entirely involved in the work of art, and in a period where easy culture, instant culture, has become so accessible, such a difficult proposition is likely to be construed as nihilist. The experience of looking at and perceiving an "empty" or "colorless" surface usually progresses through boredom. The spectator may find the work dull, then impossibly dull; then surprisingly, he breaks out on the other side of boredom into an area that can be called contemplation or simply aesthetic enjoyment, and the work becomes increasingly interesting.

The ultimate in monotone, monochrome painting is the black or white canvas. As the two extremes, the so-called no-colors, white and black are associated with pure and impure, open and closed. The white painting is a "blank" canvas, where all is potential; the black painting has obviously been painted, but painted out, hidden, destroyed. An exhibition of all-black paintings ranging from Rodchenko to Humphrey to Corbett to Reinhardt, or an exhibition of all-white paintings, from Malevich to Klein, Kusama, Newman, Francis, Corbett, Martin, Irwin, Ryman, and Rauschenberg, would be a lesson to those who consider such art "empty." As the eye of the beholder catches up with the eye of the creator, "empty," like "ugly," will become an obsolete aesthetic criterion.

* * *

Instances of single-color, single-surface paintings during the past fifty years are few. The first and best-known monochrome painter was, of course, Kasimir Malevich. His *White on White* series, executed as Suprematist studies around 1918, was paralleled by Alexander Rodchenko's black-on-black canvas, also sent to Moscow's Tenth State Exhibition in that year, apparently as a reply to Malevich's white works. Rodchenko's manifesto at that time consisted, coincidentally, of a list of quotations (a device used thirty years later by Ad Reinhardt): "As

a basis for my work I put nothing"; "colors drop out, every-
thing is mixed in black." Malevich, who was something of a
mystic, equated white with extra-art associations: "I have
broken the blue boundary of color limits and come out into
white. . . . I have beaten the lining of the colored sky. . . .
The free white sea, infinity lies before you." Actually, the
square in the Museum of Modern Art's *White on White* is
diagonally placed to activate the surface by compositional
means. This concern with dynamism separates Malevich from
later monotone developments, although a series of absolutely
symmetrical drawings from 1913 predicted the nonrelational
premise of Ad Reinhardt and the younger artists of the sixties.
He also emphasized, like today's painters, the art of painting
as painting alone, a medium sharing none of its particular
properties (two-dimensionality, rectangularity, painted sur-
face) with other media: "The nearer one gets to the phe-
nomenon of painting, the more the sources lose their system
and are broken, setting up another order according to the laws
of painting."

In retrospect, it is clear that Malevich and Rodchenko were
not making monotonal paintings, but they undoubtedly looked
more extreme then than they do today. The education of the
spectator's eye must be taken into consideration. The history
of abstract art has been punctuated not only by an increasing
intellectual acceptance of extreme solutions but also by an
increasing optical acceptance. In 1918, and in fact until the
late fifties, a monochrome canvas in which the values were
fairly close looked monotonal or blank to many people. Now
our eyes are accustomed to the gloom of Rothko's and Rein-
hardt's black and blacker canvases, and our perceptual faculties
have been heightened in the process. Work that once looked
radically uncolorful or invisible now seems nuanced and
visible. Similarly, Mangold's monotonal canvases have more
than one color in them and are not, therefore, monochromatic;
but they appear monochromatic until all the senses have been
adjusted to the area within which these subtle colorations
operate.

The ultimate in a no-color object that is still a painting
might be a square (the only undistorted, unevocative shape)
with a sprayed white surface (not white formica or any other

absolutely smooth ready-made material, for if a surface is not painted, it becomes "sculptural" no matter how the edges are treated). Would this be an empty canvas? Probably not, if it were done right, for as the rejection becomes more extreme, every mark, every absence of mark takes on added significance. As Clement Greenberg has pointed out, an untouched "stretched or tacked up canvas already exists as a picture—though not necessarily a successful one."

Reinhardt, Barnett Newman, and Mark Rothko are the major American precedents for the current monotonal art. In virtually opposing manners and degrees, they all stress the experience of the painting above all surface incidents, and since around 1951, they have dealt more or less consistently with nearly monochromatic or nearly monotonal art. In its denial of compositional balancing of forms, monotonal art is, in fact, an offshoot of the allover principle of much New York School painting in the late forties. But monotone is all-over painting par excellence, offering no accents, no calligraphy, no inflection. Around 1950, Newman, a strong influence on the younger generation now concerned with monotone painting, made several only slightly modulated, single-color, single-surface canvases, such as the tall vertical *Day One* and an all-white painting shown in 1951. His *Stations of the Cross* series (1958–66) concludes with a precise, pure, white-on-white work that is unavoidably interpreted as representing transfiguration. Newman's titles indicate that he welcomes such symbolic or associative interpretation; most of the younger artists, on the contrary, are vehemently opposed to any interpretation and deny the religious or mystical content often read into their work as a result of the breadth and calm inherent in the monotonal theme itself.

Mark Rothko has for some reason been much neglected in this sense and is of particular interest in regard to the direction Mangold has taken. He was the first to give up drawing, a sacrifice that had broad consequences.[3] As such he too is a pioneer of the impulse toward the monochrome. His

[3] I cannot agree with Michael Fried that Pollock was the first to give up drawing, that his line was "freed from the job of describing contours." (*Three American Painters* [Cambridge: Fogg Museum, 1965], p. 14.)

hovering rectangles manage somehow to exist in a half-world of space that compromises very little with a disappearing depth, and this is accomplished by a unique control of his media. Rothko's canvases are the ultimate in nonobjectivity despite their sensuous luminosity. They do not suffer from "homeless representation" though they deal with those most difficult evocative elements: color, light, and atmosphere. His art has been something of a dead end for imitators. No one has had the nerve to be influenced by Rothko in any obvious manner. His style and his approach are still too much his own; his influence, although great, has been largely indirect. Max Kozloff has noted that Rothko's "relationship between the abstract and hence finite formal structure, and the insubstantial or ephemeral paint has to be reciprocal and self-adjusting. . . . Not only because of the difficulty of control and the inevitability of compromise, but because color-light rejects the continuous twentieth-century affirmation of the surface, have artists been reluctant to enter into its dialectic." [4]

Any discussion of modernist monotone painting must center on Ad Reinhardt, whose square, black, symmetrically and almost invisibly trisected paintings are, according to him, "the last paintings that anyone can paint." Reinhardt is virtually the first artist since Malevich to develop extensively the classical possibilities of the single surface. He began his glowing all-red or all-blue works around 1952, and for the next eight years took them increasingly nearer to a total absence of color. "There is something wrong, irresponsible, and mindless about color," he has said, "something impossible to control. Control and rationality are part of any morality." By denying color in his black paintings after 1960 (though some of them still retain traces of the extremely close-valued red, blue, and green with which they began), Reinhardt has simply taken his steadfastly art for art's sake aesthetic to its logical end. "The one work for a fine artist now," he says, "the one thing in painting to do, is to repeat the one-size canvas—the single-scheme, one-color monochrome, one linear-division in each direction, one symmetry, one texture, one

[4] *Artforum,* Vol. 4, No. 1 (September, 1965), p. 40.

formal device, one freehand-brushing, one rhythm . . . paint-
ing everything into one overall uniformity and nonregu-
larity."

The two (not necessarily divergent) possibilities emerging
from the Rothko-Newman-Reinhardt positions are colorist and
structural. The structurists must work either from an additive
or a subtractive proposition. The additive process, building
out from a rectangle, results in an image, analogous to a
drawn image on a blank page. Because of our preconception
of the rectangle as the natural shape for a picture, an addi-
tively shaped canvas (augmenting the rectangle rather than
paring it down) becomes a figure on a (usually white) field
that is actually the wall; the wall provides the rectangular
format we subconsciously demand. Mangold's are structural
paintings, not constructions (the latter implying an additive,
assemblage aesthetic); as a painter he has no interest in be-
coming a sculptor or an object maker. In spring, 1965, in
fact, a model had been made for a stepped piece that was to
jut out some five feet into the room. By rejecting the inevi-
table move into freestanding structures, Mangold made a sig-
nificant formal decision. The questions posed by the spraying
technique in terms of flatness seemed more provocative than
the sculptural prospects. As a result, the *Areas* appeared in
the early summer of 1965, and it is in them that the prob-
lems intrinsic to Mangold's impurism, his fusion of naturalism
and nonobjectivism, illusionism and structuralism, come to a
head. Based on a contradictory concept of ambiguity, they run
the danger of reducing his earlier achievements to mannerism.
Yet they are also his best work, succeeding visually by dint
of sheer conviction and physical presence, where they are
questionable theoretically. The asymmetrically niched and
sliced edges can look like detail on an eminently undetailed,
restful field. *Yellow Area,* the only piece in the (1966) exhibi-
tion to retain a rectangular format, was in some ways the most
interesting, despite the inadequate construction that later led
the artist to destroy it. The irregular format is, however, part
of Mangold's development toward the less specific. The func-
tion of a wall, for instance, is to close off space, to define a
potential enclosure, even when the wall is a fragment of a

larger design. The *Areas* were based on a broader, more dangerous notion of "cropped atmosphere." They too have a naturalistic (even autobiographical) origin. When the spray gun was acquired, the Mangolds had recently moved to a "penthouse" on top of a Grand Street loft building higher than most of those surrounding it, affording a glorious view of the sky. For a New Yorker to live that close to the firmament is a rare and exhilarating experience. Mangold found himself studying the expanse, its changing colors, its atmospheric gradations, in terms of the luminous character of the sprayed surface, which has a buoyancy and airy lightness peculiar to the essentially pointillist technique. The fully, flatly sprayed surface is as two-dimensional as any other, but it is not quite as hard; it implies density without actually containing any value variation or actually dissolving the plane. Since Mangold always thinks of his paintings in terms of walls, he first had the idea of a "sky-wall," but this was too specific and too allusive. The *Areas* are essentially nonobjective. Were the tinting any less subtle, he might have to worry about too much landscape association. The evocation is ideally on a subliminal level; the scope of the sky is implied but not its literary connotations.

Blue Area moves from the palest pink into an equally ethereal and similarly valued blue, while the grays of *Pink Area* become lavender by encountering the warm band infiltrating the lower half. Prettiness, a hazard with such a palette, is absent. The delicacy of hue augments the effect of majestic calm, but the painting is given a rigid austerity by the knife-line of the central seam and the outer edges. The minutely graded surfaces are first read as monochrome, but a monochrome surface retains its scale with difficulty, despite its impressiveness, scale being a relative quality. This has been solved by the expanding properties of the misty sprayed color-light and the almost imperceptible changes in tone which, when used with the utmost control, tend to lift the surface toward the upper edge rather than make it recede in depth. While at times the elusive surfaces and colors can be arbitrarily imposed on the various silhouettes, they do bear general relationships to their framing edges. All the first *Areas*

dealt with a color change, or blush, rising from the bottom edge, and a niche out of the lower corner could be redundant. But when the scheme is reversed, and the darkest section rests on the lower edge, a niched lower corner or a slanting slice off the bottom alleviates the downward pressure.

The silhouette asserts the surface and, like the "cropped atmosphere" aspect, establishes both a visible and an invisible measure for its scale. That is, the irregular format defines the space, but defines it as fragmentary. While the unexpected shape presents a contained surface, the atmospheric quality dematerializes what is seen and indicates infinite expansion. Space is not contained the way it would be within a rectangular format; here it is less static. The rectangular format, especially in monochrome, implies that the visible plane *is* the space, if only because of our traditional adjustment to that particular pictorial containment. In the *Areas*, Mangold is trying to effect an equilibrium in which the notion of a partially contained space that continues unseen can operate within a structural and eminently *seen* framework. It is an art of equilibrium and paradox. By working with colors that cannot be pinned down, that fade and intensify into and away from monochrome as they are regarded, and with surfaces that yield like skies and refuse to yield like walls, Mangold is forcing the issues raised by Rothko and the current "minimal" trends. He is extending the possibilities of a positively reductive art.

New York Letter:
Rejective Art[*]

For some time the only valid approach to structural styles seemed to be to treat them as anti-art, to list everyhing they were not, in the manner of Ad Reinhardt, but without his leaven of wit and glancing profundity. The words "reductive" or "minimal," rather insulting in their implication of a final result that is less in quality than some earlier original, are still current, yet as Robert Morris points out: "Simplicity of shape does not necessarily equate with simplicity of experience." [1] (The job of deciding when it does, and why, is the main problem confronting today's criticism.) I prefer the word rejective, which implies a process of elimination but not attrition or "economy"—settling for less because it's cheaper aesthetically or practically. Although not an anti-art, the primary structure and structural painting are founded on a more negative premise than is usual. They rather arrogantly reject almost all the tenets of both painterly and "post-painterly" abstraction, rather than paying them the compliment of reaction; fact is preferred to ideology. The rejection was not painful. For some it was even ecstatic, for others logical, for

[*] Reprinted from *Art International*, Vol. IX, No. 6 (September, 1965).
[1] "Notes on Sculpture," *Artforum* (February, 1966), p. 44.

others simply a relief. I still think it is important that most of the structurists were originally painters, and I still think of the real space of the structure as a means of escape, not from previous sculpture, which was hardly considered, but from the dilemma in which nonobjective painting finds itself.

Since most of the artists themselves are vehemently against interpretive readings of their work (and such readings would seem virtually impossible anyway), and since these artists include such articulate figures as ex-critic Don Judd, occasional writers Robert Morris, Dan Flavin, and Robert Smithson, casual poets Carl Andre and Will Insley, and others who are not afraid to state their views as unequivocally as their objects reject the views of would-be interpreters; and since even the most anti-intentionalist critic has to admit that if anyone knows what he is trying to do, it is the artist himself, the artists have had, for once, a considerable amount to say about the way their work is annotated.

The primary structure (a term intended far more strictly and cohesively than it has been used) does seem to have sprung more full-blown from the brows of its creators than is usually the case with contemporary art. This is not to say that the whole of twentieth-century art did not provide the delivery table, but that a cleaner break with the sculptural past has never been made. There have been precedents but not prototypes. At first this contention seemed like pure egotism on the part of the artists—mainly Judd and Morris, since they were the first to exhibit such work—and was dismissed more lightly than it should have been. I began, like others, by grasping for straws in the direction of David Smith, though actually the only artist who seems to have been working in an absolutely structural idiom was Tony Smith, and his work was virtually unknown except for those who saw the "Black, White and Gray" exhibition in Hartford; [2] he is yet to have

2 This show, in 1964, along with a group at the Kaymar Gallery organized by Dan Flavin in March of that year (it included Flavin, Judd, LeWitt, Baer, Stella, Fleminger, Valledor, Jackson, Ryman, Bannard, Poons) and the following winter, E. C. Goossen's "8 Young Artists" at the Hudson River Museum (Andre, Bannard, Barry, Huot, Johansen, Milkowski, Ohlson, Syverson), and the "Shape and Structure" exhibition at Tibor de Nagy (Insley, Hinman, Judd, Morris, Murray, Bannard, Zox, Bell, Williams, Andre) were the first indications of a structural trend.

a one-man show. (Stella's paintings and ideas were another major ingredient; it is difficult to tell how much Reinhardt's extremely relevant attitude meant to the artists at the beginning of the structural trend.) Now I have changed my mind in favor of the immaculate conception theory, although it was immaculate only in terms of the visual arts; there were plenty of precedents to be found in other areas of aesthetics to which the artists were exposed.† McLuhan, Robbe-Grillet, Wittgenstein, Beckett, Fuller, Borges, and others provided fine points of departure for philosophizing on the subject. The distance of all these figures from the field of art criticism was important, and necessary, if the new art is to be taken as literally as intended. Nevertheless, the younger apologists seeking a "new criticism," as straightforward and immaculately conceived as the new art, tend to be in the position of Ionesco as Kenneth Tynan sees him: "A man who triumphantly succeeds in communicating his belief that it is impossible to communicate anything is in the grip, I cannot help thinking, of a considerable logical error." [3]

* * *

It was suggested at a recent symposium that Judd's and Morris' structures were not monolithic because they are shells, thus dealing with interior and self-contained space rather than solid volumes. They are monolithic, in that they are single shapes, though that is neither here nor there; they make no attempt to change or activate the space they fill, neither do they refer to anything outside of themselves. Yet by filling space they do change it, even if the change is minimal and inactive. The shell idea seems invalid. There is no way of telling which structures are hollow and which are just made out of light materials; while the bulk of some indicates the first by practical necessity, it is hardly a factor in their significance. The only artist working with interior space is

† Now, in 1970, I cannot say I believe in any kind of immaculate conception, but no other new "influence" or source has been revealed. "Minimal" art has many indirect precedents but remains free of direct ones.

[3] *New York Times Magazine,* January 9, 1966.

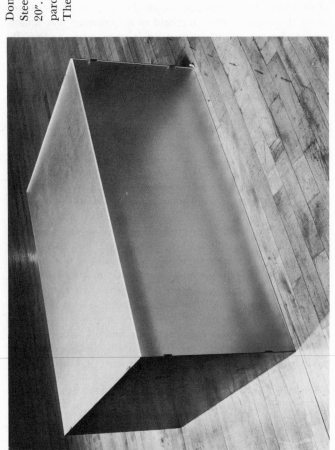

Donald Judd: Untitled. 1964. Steel and plexiglass. 31″ x 45″ x 20″. Collection of Lucy R. Lippard. Photograph courtesy of The Green Gallery, New York.

Sol LeWitt, whose recent show at the Dwan Gallery consisted of five large white structures conceived in a cubic frame module of about two feet. The two most important pieces he has made this year were those that took this idea to its most logical conclusion—a cube based on three modules, in the "Primary Structures" show at the Jewish Museum, and a single-level floor piece at Dwan, 6 by 6 modules. Because their entire structure, internal and external, is laid open to view, these are among the most cohesive works yet made in the genre. Nothing about them is secret. No angle is any better than any other angle from which to view them. There is no core, no "relationships" within or without the pieces other than the perfectly regular basis for construction; they are both transparent and solid, dark and light (depending on what the background is, or the lighting), and they come as close to not changing the space they fill as anything can (though maybe a clear plexiglass cube in this scale would go still further).

The ironic thing about LeWitt's structures is that despite their rigorous rejection of all chance and inflection, their apparently ultimate order, they are subject to the most drastic change and modulation because of the shadows cast by the bars, with or without dramatic lighting. The floor piece minimizes this effect, but the tall ones are never seen without a flickering pattern of grays across the skeletons of their exactitude. Because of this the outer contours take on an added importance; they provide the firm boundaries within which the network of intersections (and dissections) exists in perfect freedom despite the artist's ruling hand. In this sense LeWitt's structure at the Finch show—a tall (96 inches by 25¾ inches) rectangular frame in black, is more logical than the modular pieces, even though its proportions were arbitrarily decided. Its drastic elongation already takes into consideration, and deals with, the perceptual distortion that makes a cube not a cube when it is looked at from any viewpoint. Since the Finch piece is extremely simple and already distorted, change of viewpoint makes only a minimal change in its appearance. Yet the white, more recent works are far more substantial and impressive. The floor square at Dwan, although subject to change in outer form, retains its

identity more than the taller modular work. The single layer provides less interlacing of shadows and the high viewpoint orders its structure more clearly than the multiple side views of a cube. Because of its ground level the flatter piece seems more infinite than the cubes, perhaps because the horizontal is open by nature and association.

LeWitt's least successful works are those in which the modular rule is broken or incomplete, as in an L-shaped corner piece, three modules high and wide but only one deep, so that six modules worth of space in the corner is less defined. They can be filled in by the mind, as one did with Stella's shaped, striped canvases, but in real space that idea doesn't work as well. These structures are so factual, it seems that they should be there as facts, not fiction. The same goes for a lattice-like wall piece, a single-level (6 by 6 modules) vertical screen with 2-module perpendicular elements holding it away from the wall at each end. As LeWitt himself says in the Finch catalogue, a multipartite structure becomes "too architectural. . . . A single structure seems better, probably more inert, less inviting, somewhat ugly and impenetrable." He avoids the architectural implications by the cage or framework basis, refusing to make secondary walls even when he uses the specific gallery space, as in a different type of structure, closer to painting, consisting of three square frames—one on each wall of a corner (near the corner but not in it), and one lying on the floor with a corner pointing directly into the corner line of the wall. This makes a kind of dismembered perspective drawing and diverts attention from the floor-wall relationship to a more specifically concrete space. Logically there should have been a frame on the ceiling too, but the gallery moldings precluded that. As a group LeWitt's work was, incidentally, equally effective as in the best single pieces. Designed for the gallery space, it was as moving in its entirety as any show I've seen this year.

The shadows that transform LeWitt's structures and the perceptual distortions involved in looking at his work bring to it an element of disorder that neutralizes the fundamental order apparently governing its conception, a disorder that occurs when the object is not just conceived and diagramed,

but made, seen, and experienced in reality. This is an idea that has often been remarked upon by Don Judd, originally in his review of Robert Morris' first show of structures in 1965. Such an acknowledgment and controlled cultivation of the irrational is shared by these two fundamentally different artists, though their disorder is very much built-in and contended with, not accidental. Morris has written the clearest and most intelligent iconological analysis of the structural premise so far, though obviously from his own point of view.[4] He advocates autonomy above all, seeing sculpture as distinct from and even hostile to the values of painting. Although he counts among his previous œuvre a large series of reliefs, he has decided that the relief can no longer be accepted as legitimate: "An object hung on the wall does not confront gravity; it timidly resists it." His contribution to the Finch show dates from 1964, and while it does not hang on the wall, it does not rest on the floor either. A pyramidal structure set in (but not up against) a corner, it is in fact a single plane, since two sides are invisible. It does not fill or alter the corner so much as remove it. The architectural fact known as corner ceases to exist when it is interrupted by a triangular plane and the pyramid ceases to exist when only that plane is visible. In principle, therefore, the least autonomous of objects (since it depends on the presence of a corner), in actuality it is independent, defining a new planar shape.

Judd's piece at Finch does hang on the wall, and it is red—galvanized iron and lacquer. Whereas Morris' work has always been gray, and the most neutral gray possible—as near white as it can be without being white or "off-white," Judd's first show, in 1964, was primarily a brilliant, matte, cadmium red light, and he has consistently used strong hues as well as the natural colors of his materials. (The concepts of color and no-color in structures is basis for an essay in itself.) The Finch piece is 76⅝ inches long, 14⅝ inches deep, and 25⅝ inches high; because the theme of the show is creative process, it is accompanied by a smaller wooden model and a working drawing. The structure began as a flat box with rounded edges

[4] *Op. cit.*

cantilevered off the wall (he has made several versions of this). Then the proportions were changed, becoming more of a relief, and the rounded front edge was sectioned off or sliced out so that the front edge consists of four rounded projections and three cut-in planes. The dimensions (length) of these elements listed in the drawing, proportionately the same as in the sculpture, I think, are, left to right: 3, 4, 3½, 3½, 4, 3, 4½ inches. The visual effect is one of absolute order and irregularity. This irregularity, if analyzed, becomes a considered regularity within the given system and then disorder is acknowledged, perceived, and conceived. Judd insists that his approach is not rational; it is post-Cartesian. It accepts the asymmetrical as easily as the symmetrical but sees them as noncontradictory states. Scientists recently discovered that nature is not symmetrical, that antimatter does not mirror matter. Judd seems to have predicted this to some extent in his art. Negative and positive are neither directly opposed, nor are they balanced; they neutralize each other.

John McCracken's structures at Robert Elkon reverse the effect of LeWitt's as their highly polished and reflective surface (fiber glass and lacquer over plywood) do not expose but veil their construction, divesting the forms of weight and interior volume and opening them up to a disorder similar to that offered by LeWitt's shadows, but much more random. McCracken sees his work as "in a sense, kinetic, changing more radically than one might expect. At times certain sculptures seem to almost disappear and become illusions, so rather than describing these things as objects, it might be better to describe them as complexes of energies." [5] Energy, however, is anathema to LeWitt; when he used lacquer it was its dull glow he liked, not its ferocious polish. McCracken's color is more notable than his two- or three-layer (vertical or horizontal) forms—usually rectangles because the equalization of a cube seems too "placid" to him. The color is full strength, full density, decidedly hedonist and luxuriously sensuous despite its industrial connotations. One piece is a dark strong green, another—my favorite—a rich magenta, others azure,

[5] John McCracken, statement, July, 1966.

egg yolk-sun yellow, chocolate brown, medium cadmium, royal crimson. The tremendous refinement of finish seems to limit the scale. The structures shouldn't be any bigger because the intensity of the color would be diminished to just a mirror surface. What bothers me is the apparent lack of connection between the color and the forms; the combinations seem arbitrary, as does the division of the form, and the shiny colored surface becomes more important than the structural vehicle. McCracken's work is a little too given over to the pleasure principle for my present taste but there is no denying that looking at them is most enjoyable.

Into all this Carl Andre fits not at all neatly. He occupies a peculiar position in the ranks of the structurists, partly because he is among the most radically inventive and partly because his attitudes show a metaphysical tendency, a refusal to reject imagination and a concern with directing it into new channels. He writes deadpan poetry that takes the inventory motif to ultimate conclusions, consisting as it does of progressively and regressively listed nouns, arranged as ideograms that depart from but have no further relation to the pictorial calligrams of Mallarmé or Apollinaire, and are closer to Robert Lax. Andre's partite sculptures evolve from choice of a module that can be infinitely rearranged, a concept of "anaxial symmetry: any part can replace any other part." [6] Last year it was his big, bulky styrofoam slabs; † this year, in his second show at Tibor de Nagy, it is an ordinary whitish

[6] *Art in America*, No. 5 (1965), p. 67.

† Andre's importance has become increasingly evident since the time this was written, so in lieu of a still-incomplete article on his work, I am adding here my review of his first show in the spring of 1965, as published in *Art International,* Vol. IX, No. 6 (September, 1965):

Carl Andre has added an altogether different dimension to the post-geometric structure concept. His exhibition at Tibor de Nagy, in this day of conceptual extremism, was one of the most extreme events. The floor space, and much of the cubic space of the room, was literally filled by three immense grayish-white structures made of styrofoam bars, or logs: a broad-angled "fence," a low solid pen, and a high openwork crib, which could be looked into but not entered. No attempt had been made to make them look like "art," or, in fact, to make them visible at all, since there was only room for the determined viewer to edge around the forms, and vantage points

firebrick used in a distinctly perverse manner. The viewer is asked to turn his vision inside out. The bricks have been conceived as "holes," the exhibition space as solid volume. The bricks in the largest room made up an eight-part structure, the steel magnets in the smaller room a six-part structure. Both pieces were organized in terms of their special rooms and the parquet floors; the latter was based on a module of 120, what Andre calls a "convenient number" since it is a multiple of 1, 2, 3, 4, 5, 6, whereas *Lever*, in the Jewish Museum—a long thin line of bricks laid flat out from the wall, has 151 modules, an "inconvenient number," a multiple of nothing but one. (This piece, originally planned to extend from one room to another, had its style cramped by the other people's work

were denied. Consequently, the three pieces were seen as one effect, but they were not connected in any way except visually. It was important that they were separate conceptions. The unifying factor was the actual filling of space by their mammoth components. Even more architectural than the work of the other structurists, Andre's exhibits its negative-positive use of interior space but bars the way to experiencing it sensuously. The styrofoam logs are not attached, only laid on top of each other, so that the structures are dismantled after the show, ceasing to exist as anything but ideas— which is their prime role in any case. The form is impermanent but the materials remain—somewhere—as keys back to the intellectual domain in which these pieces exist. Such an extraordinarily cerebral approach to visual art has counterparts in those of Frank Stella or Robert Morris; it differs from those of Duchamp or Warhol in that the ironic or indifferent gesture is not the point. The idea is a plastic one—the displacement of space—and not necessarily negative, although the confined space that is filled does seem more important than what is filling it.

Andre had previously used huge raw wooden beams, but they proved too heavy for the second-floor gallery. The styrofoam logs are an improvement; dirty, dented, and manhandled, they do not evoke nature by rough wooden surfaces or industry by pristine mechanical surfaces. They are neutral, and therefore suited to an art in which the idea is central. In addition, they are essential to Andre's second theme: weight. Their very size and bulk is contradicted by their buoyancy, which in turn adds to their space-filling capacities, for they seem to expand. In several much smaller pieces, he further explores the propensities of materials for mass or antimass such as two heavy iron bars set across each other for a single statement of physical character, or a tower of magnets that can be manipulated, or a wooden crib with a heavy chain down the central well.

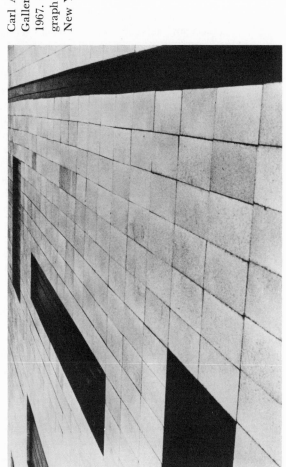

Carl Andre: Installation, Dwan Gallery, Los Angeles. March, 1967. Concrete bricks. Photograph courtesy of Dwan Gallery, New York.

which intruded, not quite on its space, but on its periphery. Andre's poem statement in the catalogue was on the words beam, reef, root, and room.)

Last year's [1964] ponderous pens and cribs displaced space by filling it abnormally full; this year's show leaves it abnormally alone, never rising more than a few inches off the floor; when seen positively instead of, as intended, negatively, it presents an aerial pattern, a floor plan. Space is now left unencumbered except for a series of accents, clues to the way it is to be experienced. Someone called it the Emperor's New Sculpture. It does demand imagination and ironic participation from the spectator in a way that is alien to most of Andre's structurist colleagues. No matter how logical such a confrontation may be in regard to the principles on which it is constructed, it withholds rationalism from (or perhaps confers a singular rationale upon) the experience of the unsuspecting viewer. Andre has also provided a witty solution to the problem of unwieldy bulk that suggests hostility to some observers of the structural trend. Yet his pieces are as unlikable as all the others because of their audacity. They are audacious in their possibilities rather than in reality. Few people have the confidence to live with a work of art that demands such extreme participation or study. The idea of a changeable object is not new and is part of the game aesthetic that has come to be common ground. Yet, like all the structurists, Andre has a precise sense of purpose. His game is frighteningly intense and consuming. His modules ask to be perfect, potentially perfect forever. But they become miniatures when executed on too small a scale, which goes to show that the idea is still not everything.

Robert Smithson bases his work on principles drawn from physics and crystallography that I don't pretend to understand, but he is on the way to stripping the mirror of its associational history by using it in a strictly investigational and even nonreflecting manner. His sculpture, however, is still immature, resolved in theory far past its visual effectiveness and remaining essentially illustrations of theoretical propositions. The colors, and even the forms, often seem arbitrary. They must be grasped primarily by the intellect since they lack the equilibrium between mind and eye achieved by the more

mature artists in this field; the point of visual art is, after all, to be seen. A polygonal well at Sachs and recent modular works at Park Place and the Jewish Museum resembling too closely flowers or stars, or scientific models, lack the rigors of rejective thinking Smithson admires in others. He has, for instance, praised the factual "hyper-prosaic" qualities of Judd, but has yet to attain them himself. His prosaicism is still of another, less interesting nature. The work at Finch—*Enantio-morphic Chambers*—is the best of Smithson's work I have seen, though it is not the most recent. The accompanying documents on the enantiomorphic phenomenon are fascinating, more so than the sculpture. One of the odd things about Smithson's work is that it is unmemorable. I don't mean it is ordinary, or unsubstantial, so much as that the experience it provokes is ephemeral, or perhaps it is so complex that it is not easily retained. The double, many-faceted *Chambers* may be an extremely advanced and not yet resolved example of an idea increasingly in the air, that involving techniques wherein perceptual illusion is exploited to what I call perverse perspectives, the structural answer to Op Art. Smithson's chambers are bewildering to the uninitiated viewer, though they proceed according to a strict "code of reflections" supplied by the artist along with a list of comments on the experience: "The chambers cancel out one's reflected image, when one is directly between the two mirrors." Definitions of the enantiomorphic "within the context of binocular vision" include "infinite myopia" and "equidistant dislocation." The concept of "seeing sight" is a fascinating one and the ramifications of perusal of scientific texts, once integrated with the visual side of the art, could be important. Smithson's writings,[7] incidentally, share the freewheeling open-mindedness and imagination combined with fuzzy and even ridiculous assertions that made G. R. Swenson's "The *Other* Tradition" such an exciting and maddening performance.

[7] The best is "Entropy and the New Monuments," *Artforum* (June, 1966), pp. 26–31.

Sol LeWitt:
Nonvisual Structures*

The two ideas that have increasingly occupied Sol LeWitt over the last four years are enclosure, or containment, and the paradoxical relationship between the visual (or perceptual) and the conceptual emphases in making art. His white structural skeletons are the most unsecretive of objects, their interior and exterior components laid bare to the eye; yet the eye does not know how to handle such total revelation, and retreats rapidly to its single viewpoint. The concept of a strictly visual order imposed by previous art can be rejected by LeWitt and certain other structurists in favor of the ambiguous relationship between order and disorder. But the significance of such a corrective in the direction of a strictly conceptual order will not be wholly comprehensible until the spectator becomes accustomed to the simultaneous operation of the conceptual and perceptual faculties. LeWitt's most recent project attempts to distinguish between visually and conceptually oriented art and consequently, despite its faultless logic, it seems "irregular" to the trained eye.

This project consists of four sets of models, each a developed sequence based on one nine-piece group of structures laid out

* Reprinted from *Artforum,* Vol. V, No. 8 (April, 1967).

on a 13 by 13 module grid. Each set represents a full-scale room, but the grid is on a low platform in order to avoid environmental implications. Each of the nine pieces has two elements, one centrally enclosed within the other. The four groups present a complete set of absolute relationships that is self-exhausting and finite. The premise is both two- and three-dimensional, beginning as it does with a flat-on-flat form (1½ inches high—the measure of the white painted aluminum bars used for construction), and moving as it does into both open and closed three-dimensional volumes. Set A consists of open frameworks of all the elements; Set B consists of open frameworks of the outer elements and closed (planar) versions of the inner elements; Set C consists of open frameworks for the inner elements and closed for the outer elements; in Set D all the elements are closed. (See illustrations.) The square forms themselves are regulated according to height and sequence from flat (a square) to medium (a cube, a box) to high (a column and large cube), and variations on this sequence operate straight or diagonally. The ground area covered by each element is constant: 3 by 3 squares of the grid for the outer form, one square for the inner.

The initial impression received from any single model is that the basis for the project is a one, two, three unit. But this scheme doesn't work out visually; the viewer notes that the columns in particular seem "off"—not twice or three times as high as the cubes. There are only two measurements used: 28 inches and 81 inches; all forms contain one or both measures.[1] By not conforming to the visual logic or symmetry we demand or have come to expect from geometric art, LeWitt's project enters a perceptual no-man's-land. He chose a system that could be clearly and briefly exposed and in which arbitrary decisions were kept to a minimum. The notion of a thing within a thing is laid out with sequence alone in mind—not space not proportion not volume or harmony, just the comple-

[1] The basis for measurement is actually the given dimensions of 28 and 81 inches. A thing within a thing has to be measured by thirds and three times 28 is 84, but 3 inches are omitted by overlapping of the 1½-inch bars on the grids. The figure 28 was controlled by the practical fact that the elements be enabled to pass through a doorway and the standard doorway is 30 to 35 inches wide.

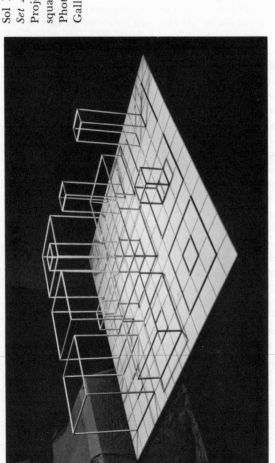

Sol LeWitt: *Serial Project #1, Set A.* 1966. Painted metal. Projected size: small forms 28" square; large forms 81" square. Photograph courtesy of Dwan Gallery, New York.

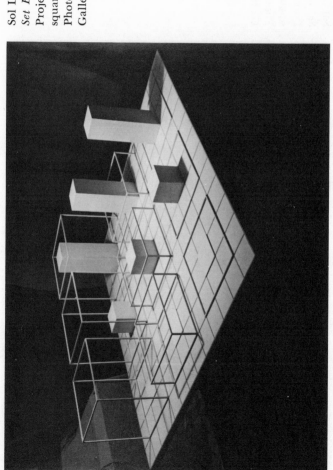

Sol LeWitt: *Serial Project #1, Set B.* 1966. Painted metal. Projected size: small forms 28" square; large forms 81" square. Photograph courtesy of Dwan Gallery, New York.

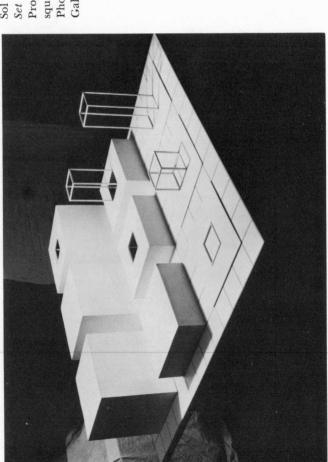

Sol LeWitt: *Serial Project #1,
Set C.* 1966. Painted metal.
Projected size: small forms 28"
square; large forms 81" square.
Photograph courtesy of Dwan
Gallery, New York.

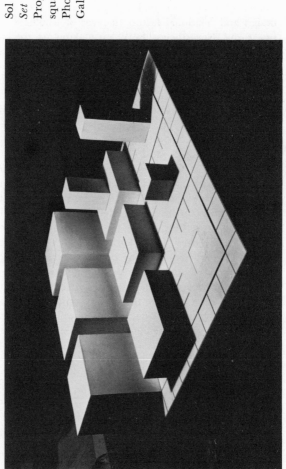

Sol LeWitt: *Serial Project #1, Set D.* 1966. Painted metal. Projected size: small forms 28" square; large forms 81" square. Photograph courtesy of Dwan Gallery, New York.

tion of a set of possibilities. This project is read sequentially like musical notations rather than statically like architectural models. When approached in accepted terms of perceptual order it does not reveal its clarity. A corrective is demanded that will return viewing methods from the extravagant reaches of pure sensuousness or visuality toward the perhaps equally extravagant conceptuality found in some (but by no means a great deal) of current art.

A blind man, says LeWitt, can make art. One must not be influenced by how art looks; this is the sole way to eliminate design and relational factors in favor of wholeness, integrity, new forms. Nevertheless, LeWitt is making art, the kind of art that is categorized for better or worse as *visual* art, and he welcomes the paradox involved. By trying to make an art entirely free of ambiguity he is in fact restoring ambiguity to an idiom castigated for its lack of subtlety. LeWitt's approach is not "formalist"; it is the reverse. The paradox originates in the two opposing stages of making art: conceiving it and executing it. In the first stage, the concept, or order, is pure; in the second, it is altered by the impurity of perception or disorder of "reality" that is affected and formed by accidental terms of conditions and experience. By sending out his work to be fabricated by a professional, LeWitt, like so many of the structurists, a negligible craftsman, abdicates the role of maker and the chance (or temptation) to alter the conception as he executes it. Earlier, rough construction was a matter of temperament, and peripherally of principle, since he contended that finish and technique were not an issue. Professional fabrication has made a difference; it is no accident that the recent pieces are the most convincing. (Another practical side effect is the use of metal, which permits thinner members and more air; the project outlined above retains the quality of a drawing, though physically realized.) The better the visual elements are realized, the more latitude is given conceptual development. While technology as such does not enter into LeWitt's intentions, the fact that it can be taken for granted is valuable to all of this work; his previous training in three-dimensional design with I. M. Pei provided a strong background.

The black-and-white reliefs and freestanding pieces begun

in 1962 reflect the main themes of LeWitt's evolution. He had been in the process of abandoning painting for some time and, like Stella and Morris, acknowledges a certain debt to Jasper Johns's questioning of the illusion in painting. The perverse logic of Johns's number and flag paintings—flat subjects on flat canvas—combined with an interest in Albers seemed to LeWitt to spell the death of painting. In an untitled relief construction of 1963 he first explored the concept of containment and nonvisual logic. A series of nested enclosures projecting into space, it is painted systematically, if roughly, black and white. Each section doubles the height of its enclosure and halves the peripheral distance. As an object, it shares the awkward quality of the recent project, for it would have "looked better" if the central core had not protruded so exaggeratedly; in other words, if its protrusions had been dictated by a visual rather than a conceptual logic.

The black-and-white series gave way to box-and-table-like constructions in brilliant primary colors, based on a grid and game, or chance, aesthetic (they could be moved or rearranged). These were replaced in turn by simple boxlike structures with mellow lacquered surfaces, which are more revealing in terms of later developments. They are made so that the viewer is psychologically encouraged to look into central wells or tunnels, but physically discouraged by difficulties of height, width, the necessity of stretching, craning across surfaces to see, eventually, nothing but the fact of enclosure. In 1964 a group of large structural peep boxes also reflected this theme. Inside of them Muybridge- (and perhaps Morris-) inspired photographs of a face or an impassive nude, seen from several angles or walking toward and away from the camera, would be glimpsed through inadequately small holes, often accompanied by flashing lights that compounded the difficulties already set by the perceptual process. One of these was a conscious paraphrase of Magritte's sectioned and gradually enlarged woman (*Delusions of Grandeur*). While LeWitt considered these boxes, even at the time, as "hobbies," they provided the means to explore still another aspect of sequence in time, one which had been previously manifested in a group of 1962 paintings depicting a Muybridgean man running.

The next group of works (LeWitt has always worked in

exhaustible series) developed the implacably physical aspects of the boxes. Shown at Dan Graham's Daniels Gallery in May, 1965, they constituted a relatively early instance of primary structure, and three of them were distinctly impressive. Their planar emphasis goes back to the paintings, reliefs, and tables, but for the first time the pieces themselves were self-sufficient as objects and acquired a scale commensurate with their size. A tall maroon booth with one folded-in wall represented the enclosure theme, and a blue piece was one of the first to be constructed on a more or less modular or conceptual rather than an intuitive basis. The waxy, lacquered surfaces were also to disappear soon, their slightly rounded edges and rather blurred effect made obsolete by the rigorously nonallusive black and then white frameworks that followed.

In the 1966–67 framework structures, for which LeWitt is now known, and particularly in the most recent ones, two aspects of his early researches were realized and fused: the structural simplicity and rectilinear fundamentals, and the confrontation of perceptual disorder and conceptual order. In the peep boxes he had called attention to the flashes by which we perceive even the clearest forms—flashes hard to see and hard to remember, from which an impression of the whole action or volume is reconstructed. In the intricate 6 by 6 module cube, 60 inches square, the shadows of the crossing rungs make a shifting allover pattern that both destroys and re-creates the negative volumes described. A photograph of this piece is orderly in that it is static and not subject to constant perceptual change, but it is absolutely disorderly in that it provides none of the flashes of information about the structure that are offered by direct confrontation of the object. Thousands of photographs might not suffice to provide the full picture of the piece that can be achieved in a few minutes of actual viewing time. Thus the more logical and complexly conceptual or closed Le Witt's premise becomes, the more open his work becomes in visual terms. The idea that because of its own self-containment structural art can only be appreciated from a fixed point of view (literally or philosophically) is a false one. In fact, it is the particular comprehension of visuality and its uncontrollable nature that makes LeWitt's nonvisual logic so interesting.

The structural artist actually exists in a far more spontaneous and therefore freer situation than an expressionist artist, whose momentary spontaneity is fixed once and for all upon a surface in the act of process and changed little by perception. The changes enacted upon LeWitt's multipartite skeletons by lighting, placement, point of view, make the contour all the more important, as it sets firm and ordered boundaries to the interior disorder. The open construction even diminishes the visual field to a nonentity, a frame implying rather than depicting the surface it contains. For instance, the three-piece work consisting of equal square frames (48 inches square), one on each wall of a corner, one on the floor between them, its angle pointing into the corner, is a kind of dismembered perspective drawing diverting attention from the floor-wall relationship and, by establishing new boundaries, depicting a new and concrete space.

The modular or unitary idea is not in itself terribly interesting, as is demonstrated by a good many inconclusive and mediocre structures on the exhibition circuit. It is interesting only when employed as vehicle for ideas that are not in themselves visually self-evident, that cannot be pictured mentally in their entirety and cannot be diagramed and experienced, but must be made. The treatment of interval and sequence is one of the more challenging problems at hand in such an idiom, for if a work of art sacrifices or subjugates the variety (of color, texture, relations) generally associated with intuitive idioms, it must offer a heightened complexity on another level. While the limitations often attributed to the primary structure are largely irrelevant, since the most constricted concept has infinite possibilities for expansion, any conceptual object suffers to some extent by separation from the body of work in which it has its just place. LeWitt's ambitious and admittedly unrealizable scheme for four full-scale groups of nine elements each provides its own finite macrocosm within which the microcosm operates. In addition, the existence of many parts challenges the inertia set up as ideal for the structural style. If that inertia can be made to coexist with a certain differentiation in form, the structural concept is further strengthened.

LeWitt's work, like that of some of his colleagues (notably

Judd, Morris, Andre, though they have little but fundamentals in common), depends on the eye being restored to a state of innocence, or a state of perfect union with the brain. This is a process that does not happen to an art audience overnight, and it is a process that can be implemented only by the visual arts themselves. The spectator who wills himself to see in this new manner sets himself a difficult task; for every artist determined to subvert accepted visual patterns and methods, there are dozens who retain them. Confronted by a wholly conceptual art, one tends to turn the eye off and the mind on; ideally the two would be inseparable, but not as they are in the usual viewing experience. It is not a matter of the brain subtly dictating to the eye how to order and associate what it perceives, but of the eye communicating the disorder it perceives to the brain without sacrificing that disorder to an intellectually imposed order.

One of the most particular of LeWitt's preoccupations is his long-standing desire to infer the existence of unseen or interior facts or objects. The concept of encasing in a block of cement the Cellini cup or the Empire State Building runs counter to the unsecretive quality of his open frameworks, though it certainly relates to the earlier enclosed spaces. He is concerned to control space to the extent of negating it, by means of a grid or clear enclosure.[2] In a similar manner he could control, or negate, any form or object known to man, no matter how allusive or potent a symbol, by imprisoning it in a block of stone and returning it to a state of matter alone, from which spirit is excluded. This is the contemporary reverse of Michelangelo's concern to free the figure, or humanity, trapped within the inert stone, and provides rather obvious contrasts between the individualism of the Renaissance and the anti-individualism of the electric age. Yet in another sense, it attests to the need for a core, unseen and

2 "When space is divided up into such equal parts, a kind of negation of space takes place. All parts are given equal value and space is so systematized that it becomes least important; in the resulting inertia sequence becomes most important." (LeWitt, in conversation with the author.)

imprisoned or not. Rigorous conceptualism is substituted for emotion by the artists of this generation.

Much idea art is dull. LeWitt's is not, and the attraction of his structures is their beauty. The frustration inherent in their strangeness, when nonvisual logic overcomes the visual, rests upon this dual provocation. The objects are, in the end, visually impressive. If they were not, they would be mere theoretical illustrations. Sets A and B of the new project are, accidentally, quite harmonious in visual terms. But Sets C and D, where the solids and frameworks seem disposed in a completely irrational manner, have an irritating, even humorous quality that forces the conceptual logic upon the spectator's vision. These last two plans are also those in which the conflict between perceptual and conceptual is most blatant. The program, clear in the four models, breaks down when the artist's directives cannot be imposed on the audience. In the pieces that call for an open within a closed, or a closed within a closed form, the concept is overcome by sheer physical (visual) reality. Out of sequence the object is restored to object status; standing alone, the solid outer box with an open column rising from it, or the solid column in solid box are odd and visually unsatisfying objects.

The major inconsistency forced upon LeWitt by the visualness of his art is an aspect of the enclosure concept that has haunted him all along. When a smaller (interior) open form is enclosed by a closed form that completely envelops it, is the invisible contained form *there* or not? Given all four models, its existence is certainly implied. Yet in order to convey this in unambiguous terms, LeWitt would have to label his work or make known the underlying concept by diagrams or manual. An exhibition of concrete blocks might or might not contain Cellini's cup or the Empire State Building. This interests LeWitt as an idea rather than a realizable project. But the four models demand that everything be where it is supposed to be. The only way to show, in Set D, that the containers contain the expected contents of the same height was finally to open the center of the top plane of the outer element and allow the top plane of the interior element to be seen. Since two things cannot occupy the same space, an in-

finitesimal line has to be added ($\frac{1}{16}$ of an inch) to show this separation, or containment, and thus the meticulously ordered measure is destroyed. The same applies to the closed outer box over open cube and closed outer cube over open column in Set C, and were this model executed in full scale, the point would be still more vague, since the open top of the tallest element would be invisible.

In any case, the large closed forms containing much smaller forms remain unresolved; there is no way to show the existence of the contained element and it must be taken on faith, or by conceptual inference, that in a series of three, when two are shown completely, the third will logically follow. The concept thus remains mysterious, just as the interior structure of the skeletal cubes is both clear and unclear. Confronted by the four sets of models, all but the most skeptical viewer must be convinced that contained and container are complete throughout. Having wholly disavowed the arbitrary in all possible areas except the choice of theme (thing within a thing) and color ("it had to be black or white and I chose white"), LeWitt has been forced to choose between visual and conceptual. The establishment of the physical autonomy of each form is more important in the end than perfect conceptual consistency. By admitting the visual priority, LeWitt, in spite of himself, proves his own paradox and proves himself more of an artist than a theoretician.

Perverse Perspectives*

Op Art—the idea in any case—had a certain attraction when it appeared in the galleries in 1964. It seemed to indicate a valid, if fundamentally conservative, direction for painting to follow. Though dependent upon Cubism and the geometric art of the 1930's, it marked the first broad and systematized aesthetic investigation of perceptual phenomena since Impressionism. Yet it soon became obvious that no matter how "new" or fashionable they might become, the limitations of pseudo-scientism held no lasting interest for most serious artists, who were more likely to be concerned with form, color, the poetic or formal expansion of painting than with perceptual effects alone. As William Seitz observed in his *Responsive Eye* text, "too much diversity of form impedes perceptual effect," and if the structural art that replaced Op as the prevalent mode despised diversity too, its conceptual ramifications have proved more enduring than those of the Optical phenomena. What made Op Art so dull was its predictability, its meticulous illustration of such standard propositions as the vibrations and afterimages produced by close-valued colors (all those endlessly spinning targets), moiré movement, the illusion of substance

* Reprinted from *Art International,* Vol. XI, No. 3 (March, 1967).

by bulging parallel lines. What interest it held was drawn from a queasy reconciliation of a pictorial unity dating from the Renaissance and post-Euclidian, Einsteinian theories made popular since the turn of the century. Op Art's spurious contemporaneity arose from its lusting after some vague technological ideal which, while not incompatible with art, is insufficient in itself. For all the talk about "modern" techniques relating to the most up-to-date theories of geometry, logic, and physics, most Op and kinetic art is absolutely elementary in scientific terms.

The attraction for the artist of mathematics as a metaphorical language is understandable, but very few (notably Poons, Pearson, and Bridget Riley) had the imagination to produce a valid fusion between aesthetics and suggestions tossed out by science. The results were usually mechanical rather than intellectual, and the integration of analytical and speculative approaches was consummated in the broader structural trend, in the work of Reinhardt, Judd, Morris, LeWitt, and others, rather than within the Optical framework. Optical Art corresponds to the old Greek logic based on syllogism, in which the conclusion is contained in the premises, and cannot be deduced without these premises. The newer, more empirical approach is inductive. "There is no vision without thought. But it is not enough to think in order to see. Vision is a conditioned thought; . . . The thinking that belongs to vision functions according to a program and a law that it has not given itself. It does not possess its own premises; it is not a thought altogether present and actual; there is in its center a mystery of passivity." [1]

Within the last year or so, a new and incongruous illusionism has appeared, incorporating the statement of the flat surface of a painting and the counterstatement of an inverse perspective that juts out into the spectator's space. Such "perverse perspectives" are founded on disunity, on a complex, tightly structured denial of pictorial logic that has its cake and eats it too, in the sense that it never wholly abandons the assertion of the picture plane arrived at by modernist or rejective painting, but

[1] Maurice Merleau-Ponty, "Eye and Mind," *The Primacy of Perception* (Northwestern, 1964), p. 175.

distorts and reconstructs that plane outside of the conventions of depth simulation. This goes back, as has often been observed, at least to Cubism, as well as to Cézanne and Neo-Impressionism, to say nothing of Roman mosaics juxtaposing static volumetric forms with vacillating illusionist patterns. Even de Chirico could be said to have anticipated this direction with his unnaturally upshot perspectives—patently unreal—relying on distorted geometry as in the trapezoidal pool in *Delights of the Poet*. By 1907 Konrad von Lange had written that "a painting must not be natural but must aim at decorative effects. . . . If previously painting strove passionately after the illusion of depth, artists now strive with equal passion to emphasize the plane. . . . If previously geometric schematization was rejected as inartistic, artists now wallow in canonic proportions, the golden section, the equilateral triangle." [2] Cubism, as a representational art, insisted on the plane by formally contradicting illusionist readings, by denying the known volumetric properties of objects depicted. When this device was carried into the mainstream of nonobjective modernism, the contradictions were compounded, since not even the framework was "known," and decorative pattern lends itself to ambiguity whether or not the artist intends it.

Since Synthetic Cubism, in which volume, shadow, and depth were strictly reduced to pattern and plane, there have been innumerable instances of perspective perversity, though few of formal interest. The three older men who should be mentioned as prototypes have all had some connection with the Bauhaus aesthetic: Max Bill, whose influence on the Park Place group has been acknowledged; Victor Vasarely, whose twisted planes still depend upon composition of details; and Josef Albers, who has experimented with ambiguous isometric devices of intersecting planes since the thirties. His recent *Structural Constellations* (engraved plastic plaques in black and white) continue these preoccupations, though they are open to the complaint leveled at so much Op Art—too close a resemblance to basic design exercises or to the diagrams that illustrate perceptual psychology books (the much-reproduced

2 Konrad von Lange, *Das Wesen der Kunst* (Berlin, 1907), pp. 383, 385.

"Thiéry figure," for example). Albers' work with color far surpasses such illustrative researches and it is in that area that he has contributed most to current trends.

A geometric art today can hardly be restricted to the familiar forms of plane geometry. Structurally, geometric form is as broadly inclusive as organic morphology; perusal of geometry books yields a greater formal variety than perusal of medical or biological texts. The attraction of diagramatic concepts illustrated in such books is obvious in the work of a good many younger artists today, though the extent to which they have derived their ideas from science and mathematics is often a sore point. Most of them know enough to realize, however, that "the line is no longer the apparition of an entity upon a vacant background, as it was in classical geometry. It is, as in modern geometrics, the restriction, segregation, or modulation of a pregiven spatiality." [3] Space, like form, has been broken up into orderly and disorderly schemes since the end of the nineteenth century, and the order of a geometric system is attractive to artists in the sixties not only as an antidote to the chaos supposedly typical of abstract expressionism and the modern world at large, but as a recognition of the peculiar nondynamic disunity of the electronic age.

Discontinuities and dissonances are constantly being proved in every field of art and science to be no less rational or orderly than continuities and harmony. Investigation of apparent ambiguities in this realm is the basis of widely divergent arts and attitudes—the work of Don Judd and Mark Di Suvero, for example. It is only possible to validate the use of geometry in art today by reconsidering the long-standing conceptions of geometric form in an entirely new context that finally ignores geometry as science (as does the "post-geometric" or "minimal" painting and structure) or else bends geometry to new and formally important feats. One of the most effective tools of a new illusionism has been the isometric projection of volumes (and topological theory in sculpture). Though the actual measurements of a three-dimensional figure are presented rather than the traditional distortions of focal perspective, and the drawn result is thus closer to "reality," it is less familiar

[3] Merleau-Ponty, *op. cit.*, p. 184.

and therefore more exotic. The fact of this exoticism in turn lends itself to ambiguities in which the Gestalt theory that we always pick out the simplest interpretation is not necessarily proved. E. H. Gombrich observed that "since art has begun to cut itself loose from anchorage in the visible world, the question of how to suggest one reading rather than another of any arrangement of forms has become of crucial importance. . . . Our inability to see ambiguity often protects us from the knowledge that 'pure' shapes allow of an infinity of spatial readings." [4] I suspect that a good many of the artists reproduced here share Leo Valledor's desire to provoke in the viewer a simultaneous experience of depth and plane. Gombrich says you can't have it both ways, and after the initial moment of confrontation, when such simultaneity can operate in a dazzling manner, he is right. Once the brain begins to work to figure out, reconcile, or at least identify the ambiguities, such spontaneity is out of the question, though eye and brain may continue to bounce back and forth between the competing interpretations.

There are two basic ways to deny the illusion of depth on a two-dimensional plane. The first is integral to the development of modernist, anti-illusionist painting: the picture is made absolutely frontal by flat forms or geometric shapes and a regular or symmetrical support. The second is to utilize illusion as a foil to such modernist flatness so that its falseness or trickery is apparent but necessary; persistent reversals of visual fact force the eye back to the plane. *Trompe l'œil* in the traditional sense merely presents the illusion as reality and depends upon the interest aroused by deception alone. The new perverse styles are both more direct and more devious. They make no claim to simulation of reality—concrete or figurative. The trickery is left unconsummated and exposed, but continuous. No actual three-dimensional substance is ever described, and illusion is established only to be discarded in favor of the painting as painting. By offering two conflicting groups of perceptual data, the artist demands that the painting be seen as a painting first and an illusion of illusion only secondarily, or not at all.

[4] E. H. Gombrich, *Art and Illusion* (Pantheon, 1960), p. 263.

The idea that formal advance was totally contingent upon fidelity to the picture plane had been so broadly accepted by around 1964 that the possibility of approaching geometrical illusionism from a new angle, which occurred simultaneously to younger artists on the East and West Coasts, came as something of a surprise. Larry Bell, Neil Williams, and—in the related area of the "topological" shaped or sculptural canvas—Charles Hinman were among the earliest exponents. The figure-ground ambiguities with strong emphasis on color action of "hard-edge painting" undoubtedly suggested elements to the new art, as it had to Op Art. The shaped canvas, which gained currency around 1963, carried the speeding or diagonal form out of the realm of depicted illusionism into a more concrete area, though still not an entirely literal one, because of its accepted connotations of perspective depth. The favored shapes were, and still are, parallelograms, diamonds, rhomboids, trapezoids, triangles—suggesting speed, streamlined stylization, and perhaps traceable to Pop Art's acceptance and celebration of newness and industrial élan. Dynamic and dramatic—words that had been largely discarded since Abstract Expressionism—apply to much, though by no means all, of the new illusionism, which can hardly be called expressionist since it is keyed to perceptual and conceptual rather than emotional reactions and is as cool in its way as the minimal styles.

Given the pronounced frontality, symmetry, inertia, and antidynamism of the minimal paintings and objects, the perverse perspectives shown here would seem to be a minor aspect of the simultaneous action and reaction between different approaches that has made the New York scene confusing and vital since 1960. The perverse direction can also be seen as a parody of the straitlaced formalism that Frank Stella, one of the major proponents of a new illusionism, was instrumental in instigating. Having exhausted, perhaps temporarily, one aspect of his work, Stella has turned to another that has been latent since around 1962. There is nothing harmonious in the harsh colors and direct oppositions of his recent canvases, unless it is the high degree of control exercised over the contradictory elements. But then, harmony, with its implications of

balance and composition, has never been a concern of Stella's. Now he simply seeks in a more energetic and alogical ambiguity what he previously found in logical stasis. Stravinsky wrote, in 1939: "Nothing forces us to be looking constantly for satisfaction that resides only in repose. . . . Having become an entity in itself dissonance often neither prepares nor anticipates anything. Dissonance is thus no more an agent of disorder than consonance is a guarantee of stability." [5]

Whereas conventional Op Art did introduce chromatic dissonance as the vehicle of eye-rocking vibrations, which destroyed the picture plane, it lacked the substance of a more strongly rooted formal dissonance, which manipulates both color and plasticity. In the perverse idiom, a rectangular shape can be placed against angular forms that slice back into depth and almost define a distinct area behind the surface before the eye is redirected to the plane by some other directional thrust or unanswerable ambiguity. As soon as the eye has established a flat plane as constant, it is led back into schematic depth by devices in which frontal forms veer off into strong diagonals. The effect is one of logical illogicality, or alogic, but not necessarily of absurdity. "The notion of ambiguity must not be confused with that of absurdity. To declare that existence is absurd is to deny that it can ever be given a meaning; to say that it is ambiguous is to assert that its meaning is never fixed, that it must be constantly won." [6] The prime critical problem involved in the evaluation of these works is the distinction between absurd and ambiguous. Success depends on the degree and intelligence of the ambiguity, which must be relevant to vision as an autonomous phenomenon or to painting as a continually developing means of expression. The extent to which the artist is indebted to science will not be evident to the scientifically untrained viewer. Color is the major tool for denying and establishing volumes in space, and when the perspectival ambiguities remain unresolved in terms of color and/or plasticity, the work must be said to fail.

[5] Igor Stravinsky from "Poétique musicale," *Composers on Music,* ed. Sam Morgenstern (Bonanza, 1956), p. 447.

[6] Simone de Beauvoir, *Ethics of Ambiguity* (New York, 1948), p. 129.

Larry Bell was among the first, perhaps the first, to explore this particular kind of anti-illusionist illusionism. His first painting exhibition (at the Ferus Gallery in Los Angeles) was described by John Coplans as shaped canvases based on a "crystallographic form or an isometric projection of a three-dimensional solid. An essentially flat surface was maintained with a highly redundant, bilaterally symmetrical imagery. The rigidity of the format was dissolved and thrown into ambiguity not by the employment of optical flux or coloristic bounce, but by the interaction of the shaped canvas (opposing corners diagonally cut off) and the internal image, which induced an acute turning movement." [7] A very simple and impressive painting of this type was shown at the Tibor de Nagy Gallery's "Shape and Structure" show late in 1964, though by then Bell had taken up mirror boxes which at first demonstrated a similar diagonal distortion operated by slanting ovals and transparencies. In the same exhibition was one of Charles Hinman's little-known early pieces with several angled flat elements and a flat section projecting into space, as well as a large blue-and-yellow checkerboard painting by Will Insley in which a rotative movement accomplished by the placement of four panels around a central aperture and an angled edge of an occasional square intentionally confused the gridlike partition of the surface. Insley occasionally uses similar devices in his current work, such as *Fragment* (reproduced in *Art International,* Vol. X, No. 8, p. 37), where straight rectangular forms reverse direction and lead the eye into paradoxical dead ends.

Ellen Johnson has written of Hinman that "the more one examines his work the more it strikes one that he is giving three-dimensional existence to Cubist implications." [8] This applies to most of the work discussed here, and Hinman's concepts have been taken up by a good many sculptors as well. The manner in which he defines a false silhouette by superimposing a rectangular painted form on a bulging concave or convex surface, allowing the painted image to follow the underlying

[7] John Coplans, "Larry Bell," *Artforum* (June, 1965), p. 29.

[8] Ellen H. Johnson, "Three New Cool, Bright Imagists," *Art News* (Summer, 1965), p. 62.

volume only so far, corresponds to his statement that "there is mystery in geometry." Having taught engineering drawing at one time, he has enough practical knowledge to depart from theory. So does Neil Williams, who is widely read in mathematics and physics and got the idea for his first shaped canvas while reading Heisenberg. His early zigzagged parallelograms were too simple, and the *Transparency Series* (in which a network of white lines intersected planes of bright color within erratically shaped formats) were too hectically complicated to fulfill wholly his good ideas, and his most recent works, manipulating isometric projections, flat parallel bands, and shifting planes within a fairly low-keyed color scheme, are accomplished but still lacking some indefinable directness found in several of Frank Stella's new paintings, which may possibly have been inspired by Williams' propositions.

The center of activity toward integration of art and engineering, physics, and mathematics in New York is the Park Place Gallery, with which Williams has been associated in the past. Initially opposed to the depersonalization and inertia advocated by the structurists, the Park Place group, especially the sculptors, has recently begun to share with them common concerns, if not attitudes. Involved in energy, tautness, "space warp" (a bulging, ambiguous inverse illusionism on flat surfaces), the Park Place painters are, with few exceptions, bogged down in theory; their work tends to the pedantic despite their almost evangelical fervor to impart to their audience a visual breakthrough, with the help of scientific discoveries. "We want to make people realize that what they see has a transcendent nature and a multiplicity and that they themselves are capable of this change inside their own psyches," Dean Fleming has said. "And the experience of that change can be ecstatic." Ed Ruda's "flexible geometry" occasionally endows his tensile distortions with a degree of rigorous dynamism; but the main exception to the rule is Leo Valledor, whose interest in perceptual ambiguity goes back to a group of canvases from around 1962 based on pinpoints of focal perspective on solid color fields. Valledor spent some time diligently formulating theories of his own about space and color effects, but lately he has abandoned the perverse illusionism of directly conflicting works

like *Maryway* or the exotically shaped *Redwing* (in which outer shape and framing borders and inner, or depicted, shape seem only distantly related). Now he is concentrating on a much flatter vertical or horizontal space in which color action provides an unfixed spatial experience while retaining a strong armature to which the tired eye can retire with satisfaction. For the most part, these artists, even those modern *quadratisti* who specialize in specific, known effects, are empirical in their approach to geometry.[9] Sylvia Stone's angled plastic forms are colored and cut intuitively but have a "scientific" appearance to the layman because all diagonals and angular forms imply perspective in their most familiar guise. Nevertheless, this appearance would not hold up if examined conceptually, and sculptor Tony Magar's antiprogrammatic attitude is probably the most common one among artists who study but do not imitate science: "When I read math books, I find myself reinterpreting most of the things, and that, to a mathematician, I'm sure, is outrageous."

The most influential artist to undertake this method has been Frank Stella, whose refusal to adhere to principles of symmetry, inertia, and wholeness that he himself was instrumental in introducing, has been controversial. Yet one never has the impression that Stella has studied science or optics. His irregular formats are real and original shapes rather than geometric combinations, and they seem to emerge from a highly developed formal intelligence rather than from specific knowledge applied. Stella had obviously reached a point of formal exhaustion with his pin-striped "deductive" shapes, the last of

[9] There is another, nongeometric branch of contemporary illusionism that should be mentioned in which opposites are juxtaposed or confronted on a relatively simple scale, whereas the "perverse" artists attack a more complex integration of the limits of conventional perspective and do so more conceptually. This other branch would include Richard Smith's older canvases in which atmospheric veils of color challenge three-dimensional bulk, Stella's tinselly metallic surfaces that subtly undermined the object quality of his heavy stretchers, Robert Mangold's equilibrium between atmospheric haze and a hard thin masonite plane, Lee Lozano's juxtaposition of a shadowy dry flattened arc and a weighty highlighted version of the same form. Poons, Bannard, and Zox are related, too, as are painters concerned with light and structure, such as Ralph Humphrey, Jules Olitski, William Pettet, Robert Irwin, among others.

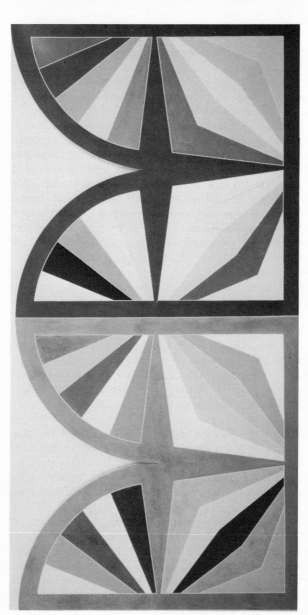

Frank Stella: *Tahkt-I-Sulayman III.* 1967. Fluorescent acrylic on canvas. 120" x 240". Collection of Mr. and Mrs. John Powers. Photograph courtesy of Leo Castelli Gallery, New York.

which were disappointedly decorative in comparison with the great black, aluminum, copper, metallic violet and green canvases of 1959–64. Last year's [1966] "change of style" was not without precedents in his earlier work, which included a two-color day-glo-striped series based on a slightly shifted plans, and a multicolored rectilinear labyrinthine series that dealt in a less acknowledged manner with suggestions of shallow depth. Both have the beveled bands that are so important to the 1966 series, and the last pin-striped paintings were streamlined in silhouette, divided into two- or three-color sections. Stella had always notched the canvases one way or another; now, instead of subtracting from the rectangular support, he adds to it, forming irregular polygonal shapes which verge on gracelessness and bear little resemblance to the taped-edge slickness and banal chromatic elegance of many other painters involved in similar problems.

I don't know what Stella is doing now, but this group of forty-four paintings seems self-contained, and may well have been another of his periodic detours to explore a single aspect of his accomplishments. Despite their return to color, the perverse paintings do not by any stretch of the imagination or admiration constitute a major innovation, and they are by nature more uneven than the rigidly conceptual early work. Their strongest point is the tightly structured, interlocking action achieved primarily by the heavy bands integrating surface and "perspective," frontal and illusionistic, active and passive forms. Stella does not manipulate and compose his shapes so much as he places them; he is still a nonrelational artist. The arrangement of his forms and colors, when they work, has a solid visual justice that is little dependent on logic, though it does depend on a well-considered movement across the surface (not back from the picture plane). What separates Stella from most proponents of this idiom is the way he minimizes the streamlined effect, or the dynamic directionalism. He does not utilize flashily rapid thrusts that are abruptly reversed by other components, but more subtly orients outer form and painted form into a unity that may be ambiguous but is never fragmented. These paintings are dynamic in comparison to the early pin-striped work, but compared to that of Williams, Val-

ledors, and even Ron Davis, Stella's is still more frontal; the bands, despite their beveled edges, hold the eye on surface movement and underplay false perspectives. The single most illusionistic element is the irregular shape of the support, its break—away and out—from the centralized rectangle in unpredictable directions.

The underlying rectangle in the *Chocorua* paintings is not a rectangle; it lacks a corner that can be completed by the willing eye but can also be left incomplete by the eye that does not care about completion. (The same was true of the earlier pin-striped canvases, though there the viewer had less choice since the potentially fulfilled shape was more compelling.) The triangle is not superimposed "pure and simple," and the bands that partially border some edges of triangle and rectangle emphasize the irregularity of the underlying shape by boldly delineating it. Within the context of other work discussed here it is interesting that Stella consistently uses an isoceles triangle, implying speed or dynamism only by its angled placement on the rectangle and avoiding the streamlined cliché in favor of a far more subtle recession that results from the angled, beveled bands that question the right angles from which they emerge. The beveled angles do not reflect any other angles in the painted shapes but perform an independent function, adding to the spatial ambiguity while simultaneously clarifying the surface movement.

The least ambiguous format in Stella's perverse series is the *Conway* group, but even here simple superposition is forgone, partly because of the recessive, movement-filled parallelogram, partly because of the single band at the right (where the left is double) and the open top of the canvas, which provide the directional thrust of the angled figure more area in which potentially to move; and also because the bands never allow the rectangle to establish itself, though the parallelogram is complete in its central area. Here, as in all these works, the diagonals are rigorously contained and not allowed to extend out of the painted plane.

Stella's concern seems to be with an understated ambiguity reduced to a highly subtle action because of its apparent simplicity. What appears to be never is, on perusal, and color is

of course the prime agent of complication. Ron Davis, on the other hand, is more direct about his dependence upon distortion of conventional illusion, but his approach is equally experimental. Davis' fall show at Tibor de Nagy consisted of paintings that resemble broadly foreshortened boxes as they would be seen from above, *were they lying on the floor.* Thus one is confronted by an apparent logic, or correct perceptual clue, which is proved wholly deceptive. The only alternative is to see the painting as a plane despite its implications of depth, to see it as a nonillusionistic, self-sufficient work of art. Photographs of Davis' work really compound the perceptual difficulties, especially if the photographer did not stand directly in front of the painting. The exaggerated illusion (so exaggerated it is no longer an illusion of reality, but a radically unfamiliar form) becomes more "normal" in a photograph. Some of the perspective forms are actually built out from the wall and are therefore both three-dimensional *and* illusions of a third dimension. In addition, Davis' color and surface are highly idiosyncratic. Perpendicular edges are different values and even different colors; the surfaces (fiber glass over paint and sometimes metal flake) are blotchy, though not gestural, belying the elegance inherent in the streamlined silhouettes. Such a surface, like Stella's roughness of execution, insists upon the *painted* quality of a sculpturally evocative idiom. Davis makes no bones about being a romantic (Stella does), but he has channeled his romanticism into a particularly contemporary area, demonstrating that such an attitude need not be obsolete if handled with wit and discretion.

One of the strangest of Davis' newer paintings is *One-Ninth Green,* in which the quasi-diamond-shaped format is sliced at the edges as though to depict a shallow box (the box which most of the other paintings do represent), but the surface is bare; the box implication is left incomplete and must be read as a plane. Then in the "center" (or what would be the center if the illusion were real), is a much smaller reflection of the outer shape that is, this time, completely depicted as a box in near-isometric projection. Not only is the eye frustrated by the incompletion of the outer "box," but the field upon which the central form is laid is a filmy elusive "pearlescence"—gray

Ron Davis: *One-Ninth Green.* 1966. Fiberglass and polyester resin. 6' x 11'. Collection of the Woodward Foundation. Photograph courtesy of the artist.

with brown and purple inflections—highly unsubstantial despite its definitely described perimeter, and almost too weightless to hold the hard bright green floor of the described box. The gray blurs around the edges and the grainy sides are metallic copper and a green gold that compete with the central green again. This is a garish and highly ambitious, even poetic painting which works despite, or because of, its initial unattractiveness and roughness. The application of geometric principles is imprecise but visually acute.

Davis' built-up reliefs and Hinman's voluminous canvases verge on sculpture, and there is a clear and provocative relationship between the reintroduction of illusionism to painting and the reintroduction of color and line into current geometric sculpture. Further discussion falls outside the scope of this essay, but it should be noted that among the earliest examples of "perverse perspective" were Claes Oldenburg's rhomboidal bedroom set and Ping-Pong table. Robert Smithson has explored crystallographic and enantiomorphic form, Di Suvero, Forakis, and other Park Place sculptors have worked on topological variations. If exaggerated shape and depicted perspective endows painting with a claim to an ambiguous third dimension, its effects are still more unexpected and extravagant in sculpture, though emphasis obviously shifts from direct conflict of plane and implied depth to the realm of pure spatial ambiguities. Just as the painter of a monotonal canvas must take pains not to let his work become a relief (if he is primarily concerned with painting), the sculptor concerned with colored planes must guard against depending too greatly upon decorative effects inherent in painting.

Purists may object to Davis' spatial extravagances and may be able to rationalize Stella's, but the fact remains that both of them, and others dealing with contradictory perceptual effects, have abandoned the literalism of the structural painting for a style that is arbitrary, intuitive, frequently romantic, and despite its geometrical or mechanical bases, antiscientific. The sort of intellectual play between reality and unreality, the constant redefinition of these words as well as the experience and realization of them, which until now have lain mainly in the province of figuration (Magritte, Rosenquist) or figurative

references (Johns, Rauschenberg, the assemblagists), is now being carried into total abstraction. The work shown here would seem to present a minor but at least temporarily effective alternative to the unwavering progression of reductive styles. If one has the impression that most of these artists are in a phase that will eventually be considered transitional, that should not destroy all interest in their present attempts to expand the possibilities of painting.

Larry Poons:
The Illusion of Disorder*

No rest, we may be sure, hath been allowed
To bodies of the primal elements,
Since there can be no bottom absolute whereto
They may as 'twere flow down, and there
Remain in quiet rest. Nay, evermore
In ceaseless movement, and from boundless space
Bodies of matter, churning endlessly,
Rise up from depths below.
 LUCRETIUS, *On the Nature of Things*

While Larry Poons's historical background and his processes of conception and execution have been discussed in detail several times since his first show at the Green Gallery in 1963, his attitudes are often misinterpreted. His work has been called painful, uningratiating, inflexible, unlikable, hostile, and aggressive, his intentions likened to those of the more radically disengaged of the structure makers. However, in his rare statements, Poons speaks as a romantic, if that word can be salvaged from its distortions during the fifties. He is still involved in

* Reprinted from *Art International,* Vol. XI, No. 4 (April, 1967).

the sensuous effect of painting and in the risks of painting, and what is more, he admits it. By paring away directional guide-lines and conceptual signposts, by overriding the system he himself constructs, Poons forces a subjective rather than a stereotyped response to his work. Given his concern with totality and wholeness, such an illusion of disorder is partic-ularly challenging.†

Poons's antagonism to the principles of the so-called classi-cists (Judd, Reinhardt, Albers) with whom he has been asso-ciated is manifest in the "interruptions" he poses within the best laid systems. He insists upon the discrepancies and omis-sions that subvert a rational reading of his highly structured initial schemes and instead of imposing some order on the chaos of personal emotions and impressions, as is the usual romantic approach, he begins with a rigorously worked out system and proceeds to depart from it in a wholly intuitive manner. Poons would hardly be interested in having some-one else execute his paintings after diagrams, since "the making is the whole idea of art." [1] He insists upon "the respon-sibility of not knowing, which is one of the most important aspects of making art. If you convince yourself intellectually, you end up with nothing. I believe in ambiguity, but there is a positive and negative side to it. Ambiguity is a feeling. I think a positive ambiguity is worthwhile, but the ambiguity in some of the new sculpture is negative. Maybe it has something to do with failure. If you rule out the possibility of failure in aes-thetic or other ways, you end up with an object with nothing more to it than death. There are guys now trying to rule out

† This paragraph was originally followed by a discussion of the "roman-tic-classic" dichotomy, which now seems so totally absurd that I have omitted it. The term "romantic" was rarely used in the sixties in any but the derogatory sense. I felt, rather romantically, that enough positive meaning adhered to the attitude it denoted (though less so to the obsolete concept of the "classic") to retain it. In 1970, these distinctions seem unim-portant and, in any case, I should prefer "intuitive" and "conceptual," were they not now inextricably attached to a "dematerialized" or "idea" art.

[1] The quotations from the artist are drawn from a conversation with the author, and from notes taken on a radio discussion moderated by Bruce Glaser, WBAI-FM, April 5, 1965.

failure or success, to be neutral. What is important about painting is the contradictions of choices, decisions, believing in choice and allowing yourself to make choices."

Such a commitment to the making of a painting and to the metamorphosis that takes place in the process constitutes more of a tie than most younger artists have to attitudes common in the fifties. The major intermediary was Barnett Newman, whom Poons met in 1959, just after the French and Co. exhibition that brought Newman back into the public eye and proved so influential for a whole generation of younger artists. He recalls having talked to Newman not about painting problems, but about "attitudes." And Newman's attitudes, most recently aired in his *Stations of the Cross* text, are also overtly opposed to the "classic" tendency represented by Reinhardt's rejective "dogmas."

Poons has been quoted as saying that his first color experience was a result of watching the intensity of the red in Newman's *Vir Heroicus Sublimis* diminish as the eye tired, and one might go so far as to say that the notion of the color field itself (not to be confused with a flat color plane) is romantic; its richness and intensity, the implicitly awe-inspiring and expansive surface with hints of shallow depth make possible associations with nature. Newman has written about "the majestic strength of our ties with the earth," echoed in "rich tones of orange to the lowest octave of dark brown," [2] and Poons's titles (*Northeast Grave, Night on Cold Mountain*) do not discourage such implications either, though it is clear that no figurative reference is intended. Poons's fusion of linear pointillism and light has obvious precedents in Impressionism and post-Impressionism, for instance in Cézanne's landscapes, which rejected the "older separateness of form" and by an " 'artistic' intuition of wholeness" built up a "structure which not only plays, simultaneously, over the whole picture field, but which allows objects to come into being only in terms of their relational qualities." [3]

[2] *Revista Belga,* No. 4 (1945) (concerning Tamayo and Gottlieb).
[3] Paul M. Laporte, "Cézanne and the Philosophy of His Time," *trans/formation,* Vol. 1, No. 2 (1951), p. 72.

Poons's painting is essentially immaterial, like the Pollocks of the classic drip period which, as William Rubin has said, achieve a "passionate lyricism—a choreographically rhythmic art capable of an almost Rococo fragility and grace." [4] Poons's canvases are not objects in any sculptural sense; they oppose subtle rhythms, open linear progressions, and pervasive color-light to the physical weight, substance, volume, and strong formal divisions of an expressionist style. He is decidedly concerned with line (though not as a descriptive agent), and line is, with color, all-important to the creation of a unified, but expanding, surface that permits no radical contrasts or contoured forms and is entirely in flux. He conceives of line as "a continuous free-flowing thing with no beginning and no end." A similar function was played in the earlier work by the afterimages which, though Poons did not notice them until a friend pointed them out, did in fact operate as elusive intermediaries between the disks and the field. This same device is used more subtly in the newer work, where at times a "fake afterimage" or low-keyed "shadow" is found near a stronger oval or disk, acting rather like the overtone in music, which minutely alters the note's original function, though in this case such an echo is probably a coincidental result of the basic layout. Still, such intermediaries prevent the viewer's eye from leaping too erratically from point to point and from making too much of the points themselves or the lines they describe.

Poons's space is not as complicated as it might seem. The saturated color—its density constructed of transparencies—provides an infinitesimally shifting plane before which the linear light/movement operates and is guided by color. The lower-valued painted "afterimages" pass just behind the higher-valued ones, whereas the *actual* afterimages in the earlier work jumped off in sparks of light from the surface. In order to communicate such a broad spatial relationship, a relatively large scale seems indicated, though Poons is beginning to re-think his previous conviction that large scale is particularly necessary to his work. Perhaps as sections of an infinitely expanding surface, the paintings' size is irrelevant.

4 William Rubin, "Jackson Pollock and the Modern Tradition," *Artforum*, Vol. 5, No. 6 (February, 1967), p. 15.

What Poons achieves with his inclination to the erratic and irregular is a real disavowal of pattern. The allover concept had, by the late fifties, fallen into an amorphous pattern-making, although it was still influencing the idea of the color field. Poons has departed from the near-geometric regularity of, say, Stella's pin-striped paintings, toward an allover surface that combines both the random appearance and the innate precision of previously divergent directions. His broken surface forgoes the easy wholeness of regularity and attempts a far more complex unity. Only the *sense* or implication of an underlying structural system holds some of the very involved new paintings together. The barely visible grid does help establish a shallow space by halting too ambiguous a recession into depth, in the case of denser color grounds, and in the early work it might have served to connect the far-flung dots and anchor them to the extremely even plane, yet I suspect that the grid is still allowed to show under the thin grounds as much as it does because of its relative insignificance rather than because the artist would like to emphasize system. If anything, Poons now feels freer than before to depart from even the loose system he sets himself. Two years ago he said that he did not allow himself to change the color of a single spot without changing identically the color of every spot in the progression. Today he does not hold himself to this rule and can even conceive of letting accidental modulations occur in the color field. Presence of wrinkles, staples in the pigment, grimy edges was not intended in the new work, but is cheerfully tolerated in direct opposition to any vestige of the "finish fetish."

The progression from order to disorder apparent in his creative process is equally apparent in Poons's evolution as a painter. He began when still a student of composing at the Boston Conservatory of Music, and under the influence of Mondrian and Van Doesburg (both of whom were more or less musically oriented) attempted to transpose musical structures into the visual medium. The first works, like *Art of the Fugue I* of 1958, were self-contained and arrived at a satisfying but relatively conventional finale. As his visual ideas developed, he evidently found the musical framework too confining, and by 1962, in paintings like the beautiful *Night on Cold*

Mountain, and its schematic sequel, *Day on Cold Mountain,* the musical impetus had been absorbed and extended into a purely visual expression.

Poons himself considers analogies with music irrelevant, and his dislike of having them investigated may well be connected with his general disapproval of an overly systematic approach. Music, as the mathematical art, has a conceptual reputation that has distracted some observers from the hugely sensuous facts of the paintings as paintings. Nevertheless, the fact that the grid scheme as well as the shapes of his elements are clearly derived from musical notation and above all the fact that his paintings reveal themselves in conflicting and interacting networks of interval, sequence, tone, accent, which take time to absorb (if not to delight), cannot be totally overlooked. If Poons's art does not force its underlying order upon the audience, and if comprehension of this order is not necessary to aesthetic pleasure, order still provides another dimension to augment the pleasure.

Certainly Poons has no interest in the metaphysical correspondences between music and art that have concerned artists since Augustine's *De Musica* was a handbook for the Gothic architect and the mathematical proportions of music were transposed into geometry. Neither would he seem to be interested in recent discoveries about the mathematical correspondences that may arise between dissimilar vibrations of similar wavelengths in sound and light (color). What may have impressed him at one point is the manner in which the linear movement of music proceeds not in a continuous unbroken line, but depends on silent spaces as well as notes. In Beethoven's late quartets, for example, the rests and even the spaces between many of the notes where no rest is indicated often have as much importance as the notes themselves. "Relations between things, holding them together or separating them, are at heart as real as the things themselves. Their function is real." [5]

Similarly, Poons's line consists not only of chromatic "notes" but also of the spaces which separate, join, and redirect them.

[5] Charles Peirce, quoted in Laporte, *op. cit.,* p. 72.

He has said that what his painting is all about is "space relationship. The edges define but don't confine the painting. I'm trying to open up the space of the canvas and make a painting with a space that explodes instead of going into the painting." Having departed from the confining spatial requirements of a strictly musical structure, Poons now allows his line to go in several directions at once. His newer work denies all limits; the elements fly off into space not only perceptually but conceptually as well. The disks and ovals still present respective degrees of stability and activity, but the overall effect is of a galaxial, multitudinous complexity; the waved, staggered, and conflicting movement drifts rather than proceeding in clearly visible swirls, evoking eddies of water or air more than sections of an initially specific chart or diagram. Although the vertical axes are often minimized, subjected to a highly dispersive space, and their inherent tensions diminished so as not to destroy the surface's wholeness, they are always dominant. This is true of the cream-yellow *Rosewood,* the magnificent purple-black *Knoxville,* and particularly of a new white canvas I saw in the studio, where the color is so pale and evanescent and the format so attenuated (about 8 feet by 2 feet) that the upward floating effect is irresistible.

The character of the vertical/horizontal exchange demonstrates another side of the relationship between system and randomness. Conceptually the paintings are horizontally oriented, as befits their origins in musical notation. The drawings usually read horizontally because of the absence of the transforming color, which acts to mingle, fuse, and confuse. The completed canvases, however, read vertically in a series of twisting vortices that convey in their understated manner all the emotional power of the baroque gesture of reaching, rising to infinity, though if Poons is baroque, he is baroque in the sense that Bach is. It may not be too farfetched to apply further the vertical/horizontal relationship to contrasts between the passive horizontal (system, order, intellectualism) and the active vertical (sensuous, kinesthetic, emotional).

Sidney Tillim is probably correct in calling Poons "Mondrian's 'logical' successor. The effect of Poons's pictures—electric points of color on monochrome fields—is the one Mondrian

probably hoped to achieve ('dynamic equilibrium') in his boogie woogie pictures." [6] Nevertheless, while color vibrations do occur at the intersections of Mondrian's grids in the late paintings, Poons's calm chromatic sensuousness seems closer to Matisse than to anyone else except Newman. He does not limit himself to a doctrinaire palette as the Neoplasticists did; in fact, the color of his new work borders on the pretty, the necessity of its subdued elegance to the floating quality of the configurations becoming obvious only after a certain perusal. He employs no color theory, makes no color notes before the painting itself is begun. "Color is not part of technique," he said in 1965. "Color is painting. Red and blue, blue and green isn't a problem, it's a fact and a fact of no interest. There cannot be a separation between color and form. The color *is* the form. They're inseparable. Now bad painting is coming to the fore in which you can remove the color and still have form. Now it's easy to forget about painting and just make one of these optical things."

As this statement indicates, Poons considered the "Op" element in his work inconsequential, and is opposed to such a "perversion of science. It makes science sound like a fact, but that's applied science. Real scientists are pushing into the void; science is the unknown." Actually, his paintings could serve as analogues to the prophetic verse of the Roman Atomist Lucretius in the first century B.C., and to his equally prophetic universe, where the seminal atoms are constantly moving about in the void. The Atomists saw diversity in nature and assumed that beneath the diversity was order, but unlike most ancient philosophers, they acknowledged the equal importance of order and diversity, stability and change, and in an extremely modern spirit accepted the existence of any number of possibly conflicting explanations of phenomena. As in Poons's paintings, chance had its place in the order of things. [7]

Poons begins with order and achieves an unlikely and pro-

[6] Sidney Tillim, "Op Art—Pending or Ending?" *Arts* (January, 1965), p. 22.

[7] I should like to thank John N. Chandler for calling my attention to the Atomists, and also for considerable assistance in the analytical section below.

vocative disorder. He usually resists, by spatial puns and by
omitting progressive elements necessary for an absolutely
schematic reading, any attempts by the viewer to find the
"key" to the painting. Certain earlier paintings, like *Enforcer*
or *Via Regia,* which are quite tightly knit and regular, can be
decoded, but in the later paintings the system is increasingly
veiled and complicated by color and deliberate conceptual
obscurity. The grid in this context acts as a tantalizing hint at
an order invisible to the viewer, an order that has been re-
placed during the act of painting by more personal choices.
The paradoxical painting, *Stewball,* for instance, illustrates the
conceptual order under the perceptual illusion of a chance
arrangement of seeds in limitless space. I doubt whether this
order could ever be discovered by looking at the finished paint-
ing; certainly the artist does not intend it to be deciphered,
but close study of the working drawing for *Stewball* finally
yields its conceptual plan, as well as demonstrating its highly
intuitive application, and for this reason it is worth investi-
gating as a single example.

The structure of *Stewball* is complex and, like the spiral
staircase, difficult to explain without gestures. Basically tri-
partite, it corresponds to the three shapes of the elements in
the painting. The disk, or dot, is always placed in a small
square, which is the basic spatial element, and is $\frac{1}{450}$th of the
total area of the work. The regular or smaller oval is always
placed in a rhomboid, which is twice the area of the square, and
appears in two variations—one slanted to the right and
one to the left. The larger, or streamlined, oval is always found
in a vertical rectangle, also twice the area of the square and
also dually oriented, having a diagonal cross section slanting
either to left or right, which determines the direction the ovals
themselves slant.

The movement from one of these forms to others is quite in-
volved, but it is always directed from one shape to a different
shape to a third shape; it never goes from one series of squares
to another series of squares, but moves on either to a series of
rhomboids or to a series of rectangles. For example, the move-
ment begins with the disk in the lower right corner (the draw-
ing was originally conceived upside down) and goes in two

Larry Poons: *Stewball*. 1966. Acrylic on canvas. 125″ x 90″.
Collection of David Mirvish. Photograph courtesy of Leo Cas-
telli Gallery, New York.

Larry Poons: *Study for Stewball*. 1966. Pencil on graph paper.
12½" x 9". Collection of Vernon Nikkel. Photograph courtesy
of Leo Castelli Gallery, New York.

directions simultaneously. One line of movement goes up the right side, first to a pair of rhomboids, then to three rectangles, then through a configuration of four reversed rhomboids, to a series of five squares, and on to six rhomboids paralleling the earlier pair. This linear movement curls back into the central area and generates still other lines of motion.

The other movement begins with the same disk in the lower right square, moves to the left to two rectangles, again to the left to three rhomboids at which point it turns upward, and passing through four squares, runs up to five rhomboids, etc. This linear movement is countered by two other basic kinds of movement, only one of which is linear. After the first two linear movements have gone through a series of eight groups, they twist back in upon themselves, starting over again with one element and moving on to two, three, four, etc. The other type of movement exists within the configurations of elements themselves, and may be either clockwise or counterclockwise. The number eight again has a regulating function (and eight is the basis for most of Poons's work, from the "Fugues" on; it is also the module of the graph paper he uses).

In each figure, whether square, rhomboidal, or rectangular, there are eight points where the dot or oval can be placed: the four angles and the midpoints of the lines that join the angles. The position of sequential disks and ovals will be either clockwise or counterclockwise. For example, a series of three squares may have its dots moving clockwise from twelve o'clock to three o'clock; the first oval on the following series of rhomboids would then be found in the lower right-hand corner of the first rhomboid and the next oval would be at six o'clock in the second rhomboid, and so on. Sometimes, as the linear movement changes direction, the movement suddenly shifts from clockwise to counterclockwise. These clockwise and counterclockwise movements can compliment and often cancel the linear movements, that is, though the movement is conceptually clockwise, it may be perceptually a straight line. Because of the line's involutions, it happens sometimes that a single disk or oval becomes a part of both a rising and a descending motion; the lines, if drawn disk to disk, would cross each other at these points. Thus it is possible for a single

point to be part of forward, inverted, clockwise, and counter-clockwise motions simultaneously.

But even within this self-imposed regularity there are arbitrary irregularities; once or twice the ovals fail to move either way but remain where they were in the prior rhomboid, and the members of a configuration are not always contiguous but jump like knights in a chess game to nonadjacent spaces. Even at his most orderly, Poons reserves the right to inconsistency.†

† As this article was being written, Poons was abandoning any rational kind of order for a much looser style, which, by 1970, has become reminiscent of late Abstract Expressionism, and resembles in its intentional lack of formal resolution, the work of Jules Olitski.

Excerpts:
Olitski, Criticism and
Rejective Art, Stella

I *

It has gotten so that Jules Olitski's work cannot be discussed without reference to Michael Fried's criticism. This is not only an unhealthy and rather suspect situation, but it also does the artist a disservice, for the quality and weight of the writing tend to overwhelm that of the art. After seeing Olitski's new paintings at the Poindexter Gallery I could not imagine what would be said in the vein of formalist criticism to support them. I read Mr. Fried's latest exegesis [1] with wholehearted disagreement, and all the more incredulously because his rigorous approach to contemporary American art is usually a model for today's criticism that I greatly respect. Roughly half of his essay is devoted to the exposition of "deductive structure" and goes on to state that Olitski's new work is not deductive. (Ordinarily a reaction against one current concept would not neces-

* Excerpted from "New York Letter" in *Art International,* Vol. X, No. 1 (January, 1966).

[1] "Jules Olitski's New Paintings," *Artforum* (November, 1965); see also his *Three American Painters* catalogue (Cambridge: Fogg Museum, 1965), and Philip Leider's review of it in *Artforum* (October, 1965); also Mr. Fried's reviews of Olitski's work in previous issues of *Art International.*

sitate such elaborate prefacing, but his defensive tone is understandable when one sees the paintings.) The new work is therefore opposed to the structure of "Noland and Stella" —a mixture concocted by Mr. Fried that forces into unholy embrace two painters whose attitudes are, if anything, more unlike than like.† It is undoubtedly true that these paintings are the result of Olitski's feeling the pressure of the reductive drive of these and other colleagues, but it is nonsense to conclude that Olitski's are "almost certainly the first paintings to acknowledge the existence of deductive structure as an achievement the ambitious modernist painter cannot simply ignore." Deductive structure, as well as other kinds of confrontational structure (for this is not the only new thing under the sun, nor is it, alone, such a great virtue), has existed publicly for a good five years. Within that time I would say nearly every aware and developing painter, young or old, has taken it into consideration. As an idea, and at times as a style, it has had tremendous currency and influence.

Mr. Fried's arguments are syllogistic: painting has to be structural to be good; Olitski's painting is good, therefore Olitski's painting is structural. But one look at the paintings themselves—illusionistic evocations of galaxial distances executed by an elaborate stain and multispray technique—shows them to be entirely lacking in structure, and illustrates only too clearly that if "the structure of Olitski's finest recent pictures is vital to their quality and power," then they also lack quality and power. When a critic whose judgments are always painstakingly founded upon the merits of individual paintings does not analyze any one canvas or even name a few of the best,[2] his dilemma is obvious. Mr. Fried likes Olitski's painting but since he is certain that structure is crucial to convincing work and that modernist painting is "a cognitive activity whose aim is knowledge," he cannot, and does not,

† Or were at that time; since Stella's transformation into a decorative color painter, their resemblance is clear.

[2] The only recent painting named is *Hidden Combination,* reproduced on the announcement and the cover of *Artforum,* and it is not discussed, only called an "extraordinary success."

produce one single specific instance, reason, or even indication of what exactly this structure of Olitski's consists.

Like his older work, Olitski's new paintings are essentially fragments of color areas infinitely expandable laterally or in depth. Whereas they used to maintain an equivocal contact with the surface and with image or form, they are now formless, but still not allover or nonrelational. They ignore rather than violate the picture plane, disappearing into a nebulous depth. Far from invalidating the issue of pictorial structure, Olitski has sidestepped it by neither contradicting nor clarifying the nature of the surface. These are great paint-covered windows into infinite Piper-Heidseck-ad space. Their relationship to the framing edges is arbitrary at best. They might have been cut from a gigantic sheet of texture, were it not that their compositions still vaguely imitate their supports; squarish canvases are divisively patterned, vertical canvases vertically, and so on. Mr. Fried avoids this issue as well by declaring that "surface flatness is no longer something an advanced painter had to or perhaps even could establish positively." Yet surface establishment should by definition be inseparable from the premises of deductive structure, which exists in relation to the support. In any case, it is generally taken for granted that illusionism in whatever guise has proved a dead end, perhaps for once and for all.† Spray painting need not be illusionistic; it suggests interesting conflicts of atmosphere and solidity, spatial location, and amorphous depth and has been used structurally by Robert Mangold in highly disciplined paintings that succeed in holding a monochrome surface at the same time that they subtly modify it. Nor do I understand why surface flatness is "an essentially tactile characteristic"— tangible, maybe, but not tactile. Still, the only means by which Olitski attempts to hold the surface (and consequently the framing edges) *is* tactile or, more specifically, textural. The surfaces of these new paintings are momentarily interesting, more so than their formal, or nonformal, characteristics. Such royal opulence of color—theatrically cosmetic and rivaling at

† This is insupportable as a generalization, but it has not been disproved by any of the so-called new illusionisms—abstract or figurative—that have emerged since this was written.

times even Paul Jenkins' lurid excesses—has come to be asso-
ciated with a fluid staining method that identifies pigment and
canvas. Olitski's layered spray is unexpectedly dry, matte, and
grainy, with the individual flecks merging pointillistically in
the eye of the spectator (thus altering when position, focus,
or viewing time is changed). Such dryness gives them a height-
ened density and herein lies the only provocative ambiguity
in these works.

The most successful painting in the show was *Wiles,* which
to some extent retains its surface and is chromatically more
subtle, more subdued, less pretty, less dull than the others.
A warm glow of green at the bottom powders into a brown-
rose-purple mixture that turns a warmer red all the way up
the right side. It has an aura of almost stupefying silence, a
density that resists being swallowed up by depth suggestion,
and consequently confronts more directly than the others both
the viewer and its format. When Fried says the difficulties in
the spray works "cannot be located 'within' the painting," he
is ignoring the many canvases (the most crowded is *Prince
Patutsky Diary*) where a forlorn endeavor is made to reestab-
lish the surface plane by introducing single strokes of pastel
that sit uneasily over the abyss. These accents are the counter-
parts of the little dot or bar details in the older work that gave
scale to the color curtains and oriented the image in terms of
the edge. *Wiles* concedes to such accent only in a wispy tail of
blue-purple disappearing beyond the upper right edge and a
faint blur of dark gray near the upper left. The vertical panels
in which no accent appears are filled by an indeterminate
atmosphere of modulated color—color that evokes a perfumed
cliché of flaming night or sweet dawn that I cannot believe
was intentional. (Fried suggests Northern Lights.) Yet these
modulations are not so subtle or so vital as to provide any new
visual experience. The tones are not uniformly, imperceptibly
applied; each panel is divided into value-contrasting areas.
Olitski often employs an old academic illusionistic device by
which *Hidden Combination,* for example, could even be in-
terpreted as a *trompe l'œil* column by reading the semicircular
glow at the right as a highlight that pushes the surface out in

a convex curve stressed by the shadow in the center, the intense but intermediary field of turquoise at left.

It is significant, and inconceivable, that Rothko is never mentioned in Mr. Fried's article. Surely this is the first name to come to mind in regard to an art of light and color in any recent context, and there are direct reflections of the early Rothko in Olitski's accented paintings. Rothko, one hoped, had made this kind of painted Lumia impossible. Even allowing for obvious differences in intention (and chronology), these works suffer in comparison to Rothko's erection of an original structured concept upon an imprecise luminosity. The way Rothko's rectangles hover in a fixed shallow space represents a phenomenal feat of rigorous control of light-and-color experience that Olitski has not even approached and definitely has not tried to surpass. He seems to have abandoned all pretense of advance, unless this exhibition represents the one step backward in preparation for two steps ahead. If so, the applause is premature. Having given up his own "compositional" mode in reply to Stella's nonrelational challenge, he has lapsed into a retrograde Optical mode that reverts to the achievements of Pollock, Newman, Louis, and Rothko. Olitski presents no legitimate alternative to structural art. His concern with an intuitive expression, spontaneity, and a back-to-nature aesthetic do not per se preclude innovation. These are permanent components of the dialogue of contemporary art and will eventually reappear in some less predictable guise. Olitski's ultra awareness of and intimacy with the most evolved painting being done today bolsters his refusal to throw his own inclinations to the prevailing winds, and as such is admirable. But in the meantime he is the victim of a misguided critical altruism. The campaign on his behalf seems to be killing him off.†

† On the contrary, four years later, Olitski's reputation remains grossly overblown, to the point that his first sculpture show was held at the Metropolitan Museum of Art. A number of younger painters have followed his lead, and a retrograde "Lyrical Abstraction" makes Madison Avenue today look like Tenth Street in 1960. Happily, now as then, this wave of visual Muzak is opposed by a more rigorous tendency.

II *

Wholeness, in a boxlike or modular structure like those of Don Judd or in a painting that looks "empty" like Jo Baer's serenely challenging surfaces, does not preclude complexity or inventiveness. It is a common mistake to assume that simple equals simplistic. On the contrary, there is "complicated art" —intricately detailed, colored, dotted with chance and associative elements—that is far more simplistic, in the sense of witless acceptance of any extraneous materials and experiences. The ideal here is the factual, the specific, because the general has been equated with the romantic, the vague, the confused, in short with expressionism—a genre totally out of favor since the quasi-emotional debacles made spuriously in its name in the late fifties.

The intellectual rigor and detachment of rejective art is a source of annoyance to more conservative, or less singly involved critics, because the great personal commitments of these artists is a commitment to making visual objects, rather than to humanism,† Lawrence Alloway has asserted the need for critics to reintroduce "other experience" into their appraisals of an art steadfastly opposed to personal interpretation, and Hilton Kramer has concluded that the new work is "an art for critics . . . derived mainly from an analysis of critical theory. Their physical and visual realization offers us not the intervention of a sensibility so much as the technical implementation of a theoretical possibility. The very use of a 'system' suggests a flight from sensibility, a conscious evasion of 'other experience.' " He is right about the conscious evasion, but that is in itself indicative of a sensibility little understood by those who simply don't react to this kind of work. With all due respect to Mr. Kramer's opinions, there is no reason that

* Excerpted from "After a Fashion—the Group Show" in *The Hudson Review,* Vol. XIX, No. 4 (Winter, 1966–67), partially devoted to a review of Lawrence Alloway's "Systemic Painting" exhibition at the Guggenheim Museum.

† Humanism in the sense of sentimental illustration, not the "humanism" that is supposed to be lacking in all abstract art.

critical commitment to an art should detract from that art, or in any way suggest that the art derives from the criticism. As a matter of fact, most of the artists in the "Systemic" show do not agree with each other, or with "their" critics, on theoretical or emotional grounds, as is proved by the statements in the catalogue.

The main issue is: Why should critical commitment be interpreted as critical dominance? One reason is the intellectual quality of rejective art; another may be the fact that there has been little American art criticism of note over the last twenty years. As a result, the few good critics (particularly the only author of a sustained critical theory—Clement Greenberg) have been overappreciated. There is no question that one of the problems facing the young or so-called new critics today is, as Mr. Alloway observes, a revaluation and adjustment (not necessarily a devaluation) of Mr. Greenberg's notion of the history of American painting for the last twenty years. Yet even Mr. Greenberg owes the basis of his theories to his acquaintance with the artists themselves and his knowledge of their intentions, problems, and solutions. Given the circumstances of the New York art world today, and the art "world" in many senses *is* New York, it would be most unnatural for critics not to know any artists; those of the same generation are all the more likely to coincide in their viewpoints. The idea that the critic should have nothing in common with the artist is one promulgated by art historians more accustomed to dealing with artists who have been dead for some time. A great majority of the fundamental ideas presented by the new critics comes from the artists, from their works, and from constant dialogues. If the critics spend more time classifying, analyzing, justifying these ideas than the painters whose task is to provide them in visual form, that is not a matter of exerting influence. The best contemporary literature on the Cubists, for example, was produced by friends of the artists, though needless to say all the friends did not make equally valid contributions. All major critics have been partisan. Aesthetic experience can only be so objective. It should hardly be surprising that the more attracted one is to a work or type of work the more one seeks to explore this attraction. Without

some strong commitment, criticism becomes the pedantic, re-
view-oriented, nit-picking, wage-earning esoterica to which
book and art reviewers often succumb.

The new criticism is opposed to the "review syndrome" that
has plagued contemporary art writing with minutiae, poetry,
fanciful journalism, social commentary, and explanations based
on a vague premise of *Zeitgeist*. It is founded on the experi-
ence of looking at art objects and thinking about their achieve-
ments and effects. Ideally the conclusions drawn are readable,
but not necessarily easy to read. Like the art it takes its lead
from, much recent criticism does not aim to entertain or ex-
plain. Yet it is a sad commentary on criticism, and its recep-
tion outside the confines of the art world, that serious and
frequently scholarly commitment to the idioms of the present
is suspiciously interpreted as commercialism, chic, partisan-
ship, academism, or an exercise in boredom. One of the most
depressing facts about writing serious art criticism today is
the extremely limited audience. Artists don't need it,† the
general public is too lazy to plow through it, and knowledge of
the contemporary visual arts among the so-called intelligentsia,
the readers of quarterlies everywhere, is abysmally nonexistent.
There is no reason that visual art should be considered out-
side the intellectual domain. If a certain knowledge of recent
theatre, fiction, film, opera, music are considered de rigueur
for a cultivated person, why shouldn't it also be necessary to
know the recent history and major literature of painting? Yet
museums and galleries are visited for vaguely culture-seeking
motives or not at all. The art world is no more insular than
any other cultural subculture, probably less so, since there is
no language barrier. Supposedly all the arts are experienced
for aesthetic pleasure and discussed in print for intellectual
pleasure or enlightenment. Yet serious art criticism cannot
depend on any outside readership, no matter how "cultivated,"
to know even the most basic names, facts, or categories in-
volved.

† Now I think most artists do need criticism, though their attitude to it
is ambivalent. Writing about art is a large part of the communication of
that art to a broader audience, not to mention the rewards in publicity
form.

By its very restrictiveness, rejective art opens new areas of aesthetic experience. It even tends to be overstimulating. Above all, it has to be looked at. It will not provide instant departures for the familiar picture-finding, landscape-spotting, memory-inducing that often passes for enjoyment of abstract art. Reinhardt's black paintings, for example, must be seen whole, as themselves, without crutches of associative relationship to other objects or sights. So many viewers are lost without this crutch that the new art is often called "boring" or, at the other extreme, it is said to "test the spectator's commitment." The fact is that the process of conquering boredom that makes the pleasure of art fully accessible is a time-consuming one. Most people prefer to stay with boredom, though it does seem, in view of the deluge of recently published comment about boredom in the arts, to be a pretty fascinating boredom. It is ironical that Harold Rosenberg should be one of the most vociferous detractors of "artistic boredom" for, despite his poetic and social insights, he is well known for his frequent inaccuracies of visual observation, his lack of interest in really *looking* at anything.

The exclusion of "lyricism, humanity, and warmth of expression" horrifies Mr. Rosenberg (writing in *Vogue*). Yet do we really turn to painting and sculpture for any of these qualities? Is there any reason why the rarefied atmosphere of aesthetic pleasure should be obscured by everyday emotional and associative obsessions, by definite pasts, presents, and futures, by "human" experience? Overt human content and the need for overt human content in the visual arts in this century is rapidly diminishing; at the moment it rests with photography, film, and the stagnation of figurative art. A painting that is asked to be both a painting and a picture of something else that has nothing to do with painting per se is likely to suffer from its contradictory roles. Visual art is visual. Abstract art objects are made to be seen and not heard, touched, read, entered, interpreted. The expansion of the visual media into other areas has produced many effective results, but they have increasingly less to do with visual art and more to do with a new art of fusion.

Thus the issue of introducing "other experience" into art is,

in the context of rejective styles, and for better or for worse, irrelevant.† Literature, as a verbal medium, demands a verbal response. But advanced music has not been asked to explain itself symbolically or "humanistically" for years. Why should painting and sculpture still be scapegoats?

III *

I have said before, and I shall say again,† that the so-called cult of the new, with which artists and critics are constantly accused of being obsessed, is actually a self-imposed cult of the difficult. And the artist is more often the victim than his commentator or viewer. Success is compromised by acceptance by the wrong people for the wrong reasons, and success in turn can eventually compromise the art. It is extraordinarily difficult to keep on making difficult art when a lapse into the easy can mean the ultimate in fame and fortune: one's picture in *Vogue*, one's name in *Time*, a town house or a country house, now-unneeded grants, artist-in-residences at socially acceptable colleges, lionizing, fur coats, and private schools—the whole bit. These things can be difficult to dismiss for someone accustomed to the beef stew, unheated work/living spaces, and scrounging for materials money that is the lot of most artists in this affluent age. The effort it takes to dismiss them inevitably drains the energy needed to keep working on a difficult art. Aesthetic survivors of what the late Ad Reinhardt called a "howling success" are hard to find. And sour grapes can turn all that lovely new wine to vinegar. The greatest rancor is founded on disillusionment and is reserved for those major figures who succumb not to success but to public relations, or to a self-conscious stance set up by friendly critics.

† Now that the new art of fusion is clarified (see pp. 255–276) I would disagree; its bases are still primarily visual, or sensorial, even when imperceptible, and "other experience" has been successfully introduced into rejective styles in the form of so-called conceptual art.

* Excerpted from "Constellation by Harsh Daylight: The Whitney Annual" in *The Hudson Review*, Vol. XXI, No. 1 (Spring, 1968).

† See pp. 112–119 of this book.

Frank Stella has been in the unfortunate position of being something of a test case. He is virtually the first modern American artist to make it on a really big international scale while still in his early twenties. His very first New York show was in the Museum of Modern Art's "16 Americans" exhibition in the winter of 1959–60. He had graduated from Princeton in 1958, and in the brief interim had painted apartment houses in Astoria, as his wife, the critic Barbara Rose, has recalled in a tribute to Stella's dealer, Leo Castelli. While critical reception was initially either bad or baffled, and one gathers that sales were rare, for an unknown of twenty-three Stella was way ahead of the game; he has remained there ever since. And this success was entirely deserved. In the last three years, however, the work has failed to keep up with the reputation; while this may be simply a personal fact, its relation to the factor of early success makes it worth analyzing. Stella himself must be aware of some change, since he recently broke his long and dignified silence by publishing a letter to the editor of a leading art magazine; such letters are the best indications of insecurity on the current scene, especially when they pick up on petty critical points hardly worth refuting.†

In the 1959 Museum catalogue, Carl Andre wrote of Stella's black-striped paintings: "Art excludes the unnecessary. Frank Stella has found it necessary to paint stripes. There is nothing else in his painting. Frank Stella is not interested in expression or sensitivity. He is interested in the necessities of painting. . . . His stripes are paths of the brush on canvas. These paths lead only to painting." It is hard to explain in simple terms the importance of such sentiments, or antisentiments, at that particular point in American painting. Art for art's sake was not new, nor was fidelity to the medium and exclusion of the unnecessary. Ad Reinhardt had been making solid black paintings for some time and Barnett Newman's single stripes provided another counterpart. Clement Greenberg was influentially demanding a modernist openness and clarity (though he seems to have gotten more than he bargained for), and the trend toward simplicity and intellectual logic, as op-

† I have been told since that this letter was not written by Stella, but by Barbara Rose, "as a joke."

Frank Stella: *Die Fahne Hoch!* 1959. Enamel on canvas. 121½″ x 73″. Collection of Mr. and Mrs. Eugene Schwartz. Photograph courtesy of Leo Castelli Gallery, New York.

posed to Abstract Expressionism's introversion and emotive painterliness, had already been set in motion by Jasper Johns (and by Albers, Kelly, and others). Yet Stella's (and a little later Andre's, Flavin's, Judd's) unequivocal rejections of illogic, illusion, and allusion, his advocacy of symmetry, impersonalism, and repetition, was unique in its impact on younger artists, most of whom were older than Stella himself. He did not write, but his ideas spread through conversations and through criticism.

Stella's "breakthrough" (a favorite American phrase and phenomenon) seemed almost miraculous around 1962–64. It was some time before the obvious sources were mentioned. (For instance, he had been one of the few abstract artists acute enough to recognize the implications of Johns's work and their applicability to abstraction.) The black paintings, and the succeeding aluminum paintings (with notched corners that began the "shaped canvas" boom) were art about art in the highest sense. It seemed that he had looked at painting as it *was* in 1959, brilliantly diagnosed its symptoms, and prescribed the "right" cure; there was in fact more than a touch of righteousness when certain critics, among whom I include myself, began writing about this process. Yet, as Mel Bochner has noted since, "the logic and stringency of Frank Stella's earlier work directly opposed growth. His *completeness* was his insistency." (*Arts,* May, 1966.) Or, as another young and formerly admiring artist has put it: "Stella started out as a genius and ended up as an art student." For he had no development in the usual sense, which was one of the great disadvantages of his intensely rejective position. Partly because he was unknown in 1959, and because he had no public aesthetic past, Stella seemed to have wiped the slate cleaner than any of his predecessors. The metallic copper, purple, green, and flesh-colored paintings continued on the theme of a striped configuration entirely dependent upon (or regulating) the shaped support. Each painting was a single forceful entity—nonrelational instead of traditionally composed with contrasting forms and colors.

By 1965 the striped theme had been diluted into multiple V-shaped forms and two colors. Some of the paintings zig-

zagged across the wall with a dynamism that seemed decadent and incongruously febrile. The 1966 exhibition offered a drastic change in principles, though not so drastic a *style* change as some thought. The new paintings were asymmetrical, illusionistic, illogical, and multicolored in jazzy day-glo tints. The 1967 show was similar, though these paintings were based on a circle instead of a triangle; instead of looking curiously like lesser artists who had been influenced by Stella, they looked like updatings of Frank Kupka's original but pallid and unresolved abstractions, or minor work from the 1930's. Six basic forms were made in three variations each, these being constant in each group. The titles with roman numeral *I* interweave the multibanded edges of the circular forms with a tricky result that is the most impressive of the three possibilities, mainly because it is simpler and therefore more attractively decorative, though the luxurious *entrelac* in large scale is more like a psychedelic poster than the Book of Kells. Titles numbered *II* consist of superposition of the outer shape's components, often rectilinear, over concentrically striped circular elements; they are flat and dull. *III* is the worst, the modern Gothic type, where the circles define themselves by tricky bends in the stripes, and it was one of these that the Whitney chose for the Annual. In this third variation especially, black bands and flashy contrasts are employed to strengthen ideas not inherently strong, and basically good ideas are transformed into empty elegance. The premise is exposed as slippery and exaggerated rather than complex; Stella seems to be grasping for logical straws to justify the merely hedonist approach that was always present in his work but was never before allowed to become paramount. The new paintings must be scrutinized to be formally understood, but initially they are "gorgeous." The fashionable world that was queasy about the implacability of the black work has welcomed the changes. Yet what a fall from grace for someone who had decried the fussiness and archness of just this sort of tricky painting: "All I want anyone to get out of my paintings, and all I ever get out of them is the fact that you can see the whole idea without any confusion. What you see is what you see." (*Art News,* September, 1966.)

The fact that Stella's new work is unconvincing is not in itself of great import. A few more bad paintings won't change American art one way or another. What makes it worth discussion is that these unambitious decorations were painted by a man who is justly considered the major influence and most respected formal intelligence in recent American abstraction, and who is certainly one of the most important painters since 1945. It may take courage to go back on one's own broadly accepted principles this way, though it should also be said that Stella appeared to have no choice but to change. He had good reason to reject his own "minimalism." Not only had he come to a clear and ingratiating dead end with his rejective theme, but the style he had helped invent had become the prevailing mode, and thus "easy art" in its own turn. His most important earlier work is now seen by his greatest admirers on the critical list as an altruistic sacrifice for art in general, a transitional period between painterly expressionism and colorful exoticism. But it is more probable that it is Stella's own art that is in transition; he reached a climax (hopefully not *the* climax) at least five years ago. His dilemma is one which mature painters have always had, but rarely at the age of thirty-two.

The trouble is, artists' crises or transitional periods should, ideally, not be given so much attention as to become public issues; they should be privately resolved and are of interest mainly as historical facts. But given the present star system, the motives are unavoidably public. The system demands that an artist continue to have a show once a year, continue to accept invitations to large group exhibitions (and in Stella's case, even to reproduce his early work for those who can swallow it now and couldn't then). It is customary to blame the dealers for some of these evils, but it is the system itself that is at fault, and indirectly, the artists who allow or are forced to allow it to continue unchanged. A man at the peak of his career in New York is not allowed to retire to the studio for a rethinking session, to come to terms with himself and with the art by others that surrounds him. He loses money; people forget; the next show would be considered a "comeback" and all the more of a disaster if not successful. Only the most power-

ful artists, with moral as well as aesthetic strength, can fight
this system.†

Stella is not the only one in the Whitney Annual whose
predicament is apparent. Larry Poons's entry is entirely recog-
nizable as his own, stylistically if not qualitatively. The yel-
low-green field is spotted by large palely tentative ellipsoids
that float vaguely across or fade into the ground; the familiar
rotating movement has disappeared, or been absorbed into the
rough dry brushwork of the ovals. Occasional drips and
blotches are allowed to remain where they have fallen acci-
dentally. This in itself is not unexpected. Poons has been
associated with composers John Cage and LaMonte Young
and has demonstrated an interest in the laws of chance while
consistently disregarding any purity of approach. Antiminimal
from the beginning, he has been at pains recently to destroy
any reference to the underlying system of serial progressions
that visibly used to regulate his surfaces. Nevertheless, this is
so obviously an inconclusive work that I am surprised the artist
was willing to exhibit it, surprised because his standards up
until now have been so rigorously high.

† Only two years later, this diatribe seems somewhat exaggerated, pri-
marily because the hold of this system on the artist is finally being weak-
ened.

Architectural Revolutions Visualized*

Vision is the primary factor in architecture, not function. If form follows function, then it remains buried in technology. It is the dedication to an abstract content, beyond utilitarian aspects, that blossoms into the physical reality of architecture. Therefore the most important impetus of today's architecture is the vision of a new social content.

FREDERICK KIESLER

An extraordinary exhibition of drawings and prints by three French visionary architects of the late eighteenth century—Boullée, Ledoux, and Lequeu—plus a few works by followers, opened April 15 at the Metropolitan Museum. The character of each artist's work is distinctly different, though the nature of Lequeu's fantasies sets him somewhat apart from the other two; the Kaufmann monograph that groups the three,[1] and the fact that the corpus of Lequeu's lifework rests at the Bibliothèque Nationale, along with that of Boullée and Ledoux,

* Reprinted from *Art International,* Vol. XII, No. 4 (April, 1968).
[1] Emil Kaufmann, "Three Revolutionary Architects, Boullée, Ledoux and Lequeu," *Transactions of the American Philosophical Society, Philadelphia,* xiii, Part 3 (October, 1952).

are obviously responsible for the package deal. While other architects might have offered more historical illumination (Soane, Robert Morris, Gilly, Belanger, or Poyet, for example), for exhibition purposes Lequeu's obsessive assemblages of exotic detail provide the perfect visual foil to the Wagnerian impulses of his colleagues. It is only the inconographical complexity of his drawings that leads me to neglect him in the very generalized discussion that follows.

Aside from the sheer pictorial beauty of the material (the drawings are either large or exquisite and immediately imposing), the initial attraction of such an exhibition for a contemporary critic is its resemblance to contemporary art—primary structures in particular, or, in Lequeu's case, the post-Surrealism of artists like Oldenburg, Westermann, or Conner. On a strictly formal level, this resemblance is superficial. Although Boullée's and Ledoux's projects for towering pyramids, spheres, cones, and blocky cubic masses have large scale, basic geometry, and a reductive aesthetic in common with recent art, stylistic comparisons between architecture on the one hand and painting and sculpture on the other are rarely valid; a two-hundred-year time gap makes them still less promising. Comparisons tend to be made on the basis of our knowledge that few of these projects were realized and that they exist, therefore, primarily as pictorial art. Boullée and Ledoux were both painters before they became architects and their visualizations retained sculptural and painterly qualities—Boullée's black washes in particular, with their dramatic chiaroscuro describing an "architecture of shadows." Lequeu went a step closer to stage design when he designated not only specific landscape settings for his buildings, but scents and textures as well. His work is, finally, more theatrical than architectural, since he was unimpeded by either popular or official esteem and had little chance of constructing anything.

Nevertheless, these drawings for magnificent follies do indisputably have some connection with the equally improbable propositions made today by artists as diverse as Tony Smith, Robert Morris, and Claes Oldenburg, to note three who correspond in general terms to Boullée, Ledoux, and Lequeu. And on the level of intention and motivation it does seem possible

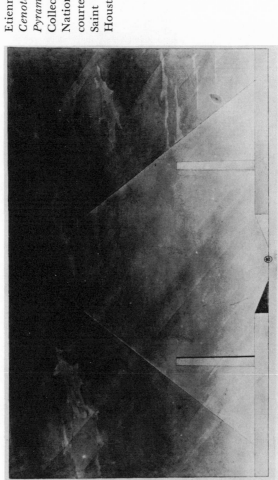

Etienne-Louis Boullée:
Cenotaph in the Shape of a Pyramid. Drawing. 16¼" x 25". Collection of the Bibliothèque Nationale, Paris. Photograph courtesy of the University of Saint Thomas Art Gallery, Houston.

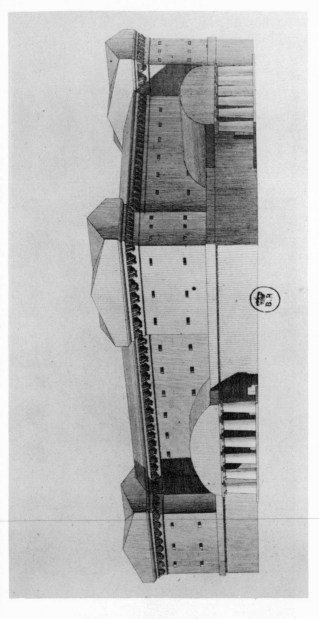

Claude-Nicolas Ledoux: *Prison of Aix-en-Provence.* 1776. Engraving after Ledoux. 11" x 16¼". Photograph courtesy of University of Saint Thomas Art Gallery, Houston.

to make something of these correspondences. A broad primitivism and utopianism emerge as the points of contact, despite the difference in the reasons for such attitudes. As Emil Kaufmann has written: "Any period of extraordinary excitement will easily become a heyday for architectural fantasies . . . architectural fantasies reveal the real trends of an era." [2] The sculptural quality of the architecture in question derives from its primitive sources—from the fact that primitive or archaic architecture is usually more sculptural container than spatially varied envelopment.

Robert Rosenblum, in an endlessly suggestive chapter on the *tabula rasa* [3] desired around 1800, demonstrates the connection between the revolutionary spirit of drastic reform and the inadequacy of models provided by the recent and high classical pasts. The return to an extreme simplicity, a "therapeutic geometry," occurred not only in architecture but in painting (the Davidian "primitifs," among others) and in the drawings by Flaxman *et al.* that emulated the cold hard line of engraving, the flat abstract style of Greek (then called "Etruscan") vase paintings. Robert Goldwater points out that artists around 1800 "had an admiration of the primitive just because it was primitive that cannot be matched again before the twentieth century, even though their art, in the clarity and grace which are its obvious ideals, is essentially archaist rather than primitivist in its feeling." [4] Rosenblum goes on to say that, in fact, "despite the familiar historical claims that Renaissance and Baroque illusionism first began to expire in the 1850's and 1860's with Courbet's and Manet's gradual destruction of traditional perspective systems, the years around 1800, in their fervor for an artistic *tabula rasa,* witnessed a dissolution of postmedieval perspective traditions as radical as anything instigated by Impressionist color patches or by that later nine-

2 Emil Kaufmann, *Architecture in the Age of Reason* (Harvard University Press, 1955), p. 105.

3 Chapter IV of Rosenblum's *Transformations in Late Eighteenth Century Art* (Princeton University Press, 1967). I am particularly indebted to this book, which suggested and provided the support for most of the themes discussed here.

4 Robert Goldwater, *Primitivism in Modern Art* (rev. ed.; New York: Vintage, 1967), p. 54.

teenth-century equivalent of Greek vase painting, the Japanese print." [5]

Thus the relationship of these architects to Cubism and geometric abstraction, the most architectonic strain of modernism, can be followed through to the art of the 1930's, which, in turn, is closest in style to the structural work of the 1960's. Like the 1960's and the 1780's a time of restlessness and aborted political reform sandwiched between wars, the 1920's and 1930's produced a rejective abstraction—Suprematism, Constructivism, De Stijl, the Bauhaus, Purism—as well as a "Surréalisme au service de la Révolution." Ledoux's and Boullée's primitivism included that urge to total abstraction reached by the Suprematists and De Stijl—an abstraction based on primary colors and primary sensations, and on "the belief, typical of so much of twentieth-century art and of so little of the art of the past, that reduction, elimination, simplification are valuable for what they reveal and for themselves." [6] Malevich advocated a "liberating nonobjectivity," and these architects (or the Republicans who adopted their forms and ideas) were attracted to just that liberating quality—a freedom from the involved complexity of Rococo styles and the hated society they represented.

Analogies have already been made between the visionaries and Le Corbusier, Wright, Sullivan, Asplund, Poelzig, Sant'-Elia and others. Buckminster Fuller could be added to the list, though it is necessary to keep in mind that a conscious application of primitive styles to modern art never fails to result in a sophisticated refinement that is "primitive" in intent alone. It has become a truism that the more complicated and chaotic the age, the simpler the art tries to be, though modern emulations of the Noble Savage have been notably unsuccessful.† In the eighteenth century, "primitive" meant anything

[5] Rosenblum, *op. cit.*, p. 189.

[6] Goldwater, *op. cit.*, p. 168.

† The most recent manifestations of this spirit are the earthworks, which closely resemble ancient Indian mounds and the earliest primitive architecture; a similar inclination toward sophisticated tribalism is found in Godard's film, *Weekend,* and there are numerous other instances in other art forms.

from Egypt and China to the Doric temples like Segesta and Paestum, the Vitruvian hut, and a conglomeration of motifs drawn from Gothic, Hindu, Islamic, or Romanesque art. The sculptural or "significant form" approach to the primitive is epitomized by Boullée and Ledoux, and the literary or picturesque approach by Lequeu.

A new proportional system suggested by unexcavated ancient prototypes, like those seen in Piranesi's etchings, inspired primitivist elements like short chunky columns or oppressively weighty domes, which seemed to grow from the earth (as the Doric column was supposed to have grown from the tree) or to be driving down into the earth in a literal demonstration of primeval virility. (Vanbrugh, for example, wanted his architecture to be masculine, as opposed to Rococo femininity.) A similar effect is found in Oldenburg's clearly sexual monument projects, which have been related to the history of man's willful subjugation of nature and the process that transformed earth mound into spire, matriarchy into patriarchy.[7] Nikolaus Pevsner blames the industrial "rape of nature" for the one-hundred-year lag between the immediately potential modernism found in the work of the Revolutionary architects and the modern movement that followed Art Nouveau. The spread of industrial ugliness made people turn away from the present for their aesthetic models and "architecture cannot exist in opposition to society."[8]

Boullée, Ledoux, and Lequeu were clearly romantic in their reformative idealism and architectural historicism, but unlike the true romantic, they did not reject present and future. Their reference, say, to Oriental ornament, was symbolic and restrained rather than regressive. Only Lequeu embraced all the implications of *luxe barbare,* and even his motives were generally forward looking. The emphasis in the mid-eighteenth century was, as it is now, on the new, on novelty, on utopian social and philosophical systems. Baroque hierarchical composition was replaced by what Kaufmann calls "the principle of

[7] Dan Graham, "Oldenburg's Monuments," *Artforum* (January, 1968), p. 31.

[8] Nikolaus Pevsner, *An Outline of European Architecture* (Penguin, 1957), p. 265.

compensation," juxtaposition of strong equal masses. Confrontation replaced envelopment, imposing austerity replaced intimate subtlety. "A new general idea was expressed by the new artistic patterns. The many weaker elements were no longer subjugated by the few stronger ones. And what is more, the elements could form a whole and remain free." [9]

The formal concern of Boullée, Ledoux, and their colleagues in other countries (for this was a distinctly International style) was with the whole. Jacques-François Blondel, Boullée's teacher, taught that anthropomorphic forms were inconsistent. The new compact proportional system derived from archeological sources lent itself to single or independent masses, stark planar walls, and huge scale, the rejection of all but the most integral ornament (to quote Wright), and led to attempts to reintegrate sculpture and architecture as wholes, rather than as auxiliary and host. Robert Morris, a British architect of the early eighteenth century whose prophetic role has been neglected, planned an architecture of cubes. Sounding very much like his twentieth-century namesake, he wrote: "Undecorated Plainness in a well proportioned Building will ever please. . . . Additional embellishments should be rather the Intent of internal rather than external gaiety. . . . [The Building should be made] so as to invite the Beholder to consider the taking in of the whole Scene at one View . . . which should be at such an angle that the Whole may be seen without moving the Eye." [10]

No satisfactory term has been arrived at to describe the essence of the style around 1800 with its over-ismatic incorporation of classicism, romanticism, primitivism, archaism, intellectualism, utopianism, futurism, etc. A twentieth-century invention, "Romantic Classicism," coined "to express the ambiguity of the mode," has been used but never welcomed. H. W. Janson has said that neoclassicism and romanticism are "unevenly matched, like 'quadruped' and 'carnivore.' " [11] Henry

9 Kaufmann, *Architecture in the Age of Reason*, op. cit., p. 175.

10 Robert Morris, *Lectures in Architecture* (London, 1734–36).

11 H. W. Janson, *The History of Art* (New York: Abrams-Prentice Hall, 1962), p. 453.

Russell Hitchcock sees romantic classicism tending "not so much toward the 'Beautiful' in the sense of Aristotle and the eighteenth-century aestheticians as toward what had been distinguished by Edmund Burke in 1756 as the 'sublime.' " [12] This very modern concept has also been applied by Robert Rosenblum, in an art-critical context, to recent American abstraction like that of Still or Rothko, or Newman, whose own historicizing romanticism is manifest in the recent sculpture called *Broken Obelisk*. (See illustration, page 242.)

In any case, it is now generally accepted that the eighteenth-century classical revival was mainly an aspect of the more pervasive romantic movement. "Purity" itself is not so much a classic but a romantically classic notion with utopian overtones. The French Purists, for example, like the Russians and the Bauhaus artists, wanted to contact the broad public by a simple style that would communicate high aesthetic standards directly and painlessly. A similar idea reappears with sculptors in the sixties who would reach the public by overwhelming it with large scale and clarity. Despite the good intentions behind such a trend, the desire to command respect, in both architecture and sculpture, has at times led to vacant grandiosity with a Fascist tinge. For all their idealism, Boullée and Ledoux preferred "forms of withdrawal." "The pyramid and the cone withdraw by their slope from the spectator who stands near the base; the cylinder permits him to be close only to one vertical line, the entire sphere only to one point." [13] While the sphere was recommended by Houet as the perfect shape for revolutionary architecture because "in every instant the sphere is equal only to itself. There is no more perfect emblem for equality," it is also "unnecessarily exclusive, the most intense form, turns everything else *out*." [14]

[12] Henry-Russell Hitchcock, *Architecture of the Nineteenth and Twentieth Centuries* (Penguin, 1963), p. xxvii.

[13] Kaufmann, *Age of Reason*, p. 112.

[14] Tony Smith, in conversation with the author. The sphere has also been seen as a symbol of restlessness, as in Goethe's Altar of Good Fortune in Weimar, where it is set on a cube representing stability. It is its restlessness, the connection with life and movement, that led the most

Such an aggressive isolation is supported by huge size. The proposed architecture for the Revolution anticipated the Napoleonic Empire in size before its style was updated from archaic to Imperial classicism. Though Boullée distinguished between the colossal and the merely gigantic in his writings, his drawings, like Piranesi's prints, dwarf nature and humanity to the point of grotesquerie. Earlier, Blondel had complained about just such a "perennial antagonism of form and purpose." An ironic and hindsighted comment on the future of People's governments is offered in that this style, originally planned for the most elevated purposes—community cultural centers, libraries, civic temples—is in fact best suited to cemeteries, prisons, and fortifications. Boullée regretted that military architecture was considered outside the realm of art (though he succumbed to designing a fort) and Ledoux's prison project for Aix-en-Provence is one of his most successful illustrations of how form follows function. New York's "Tombs" is so called for its "Egyptian" doorways, and Piranesi's prisons, unpopular in the nineteenth century, are sought after now as they were in Paris in the 1790's.

Although there seemed to have been a preoccupation with death in the late eighteenth century, the funerary solemnity of these buildings can also be interpreted as regenerative. Boullée's concept of "sunken architecture" can be read as a womb instead of a bomb shelter. His *Monument Funéraire Caractérisant le Genre d'une Architecture Ensevelie* is a simple but manneristically attenuated form, a pyramid doing the splits, and if part of it is supposedly underground, it would be still more exotic. Its sculptural effect is such that I cannot resist comparing it to the exaggerated extensions into space made in the last few years by people like Robert Grosvenor and Forrest Myers. Similarly, the idea of a hermetic core to the building, and the emphasis on crypts and subterranean spaces, relates to LeWitt's buried cube project, *Morris' Tomb,* Oldenburg's *Underground Drainpipe,* and a good many other contemporary propositions. Frederick Kiesler has also pointed out that the

rigorous of the primary structurists to reject the sphere; the deathlike or entropic stability of the cube makes it their preferred form.

"fortified" appearance of so much recent architecture (e.g., Rudolph's art building and Johnson's geology building at Yale) is the antithesis of the glass boxes of the International style; hermeticism has replaced exhibitionism.[15]

Boullée's intentions were less morbid than they seem. "In designing my funerary monuments," he wrote, "my intention has been to lead man back to virtuous ideas by inspiring him with a horror of death. Newton's Cenotaph was meant as the embodiment of the greatest of all conceptions, that of infinity." Newton's ideas had been introduced to France by Voltaire, and Boullée, not usually given to the hyperbole that characterized Ledoux's literary efforts, was very enthusiastic, dedicating the Cenotaph to Newton's "Sublime Mind! Vast and profound genius! Divine Being!" It was indeed a cosmically ambitious project and only the invention of electric light would have made possible the daytime version, with its huge hanging sun; "night" was produced during the day, by starlike chinks in the dome admitting light.

An urge to the Sublime thus did not preclude an equally strong interest in science and "progress." Ledoux copied entire passages from a scientific treatise in his *Architecture,* and Boullée's theory of "L'essence du corps" echoed contemporary conceptions of the universal metabolism of matter. The artist's idealization of technology and his romantic longing to attain the perfection supposedly available to science is echoed today. Even Lequeu was associated with the geometrician and engineer Monge, and displayed a Rube Goldbergian, or Tinguelyesque fascination with fantastic popular mechanics, making exact drawings of piston pumps, lightning conductors, and imaginary machines. Jacques Guillermé has written of the revotionary period: "In the atmosphere of ideological unrest, all participated emotionally in the progress of the natural sciences, as if, in a time of crisis where everything seemed possible but hardly realizable, they sought to protect themselves from doubt by anchoring their aesthetic doctrines to the landings of scien-

[15] Frederick Kiesler, "The Future: Notes on Architecture as Sculpture," *Art in America* (May–June, 1966), pp. 57–68. The interior of Kiesler's own Shrine of the Book in Jerusalem bears comparison to Boullée and Ledoux.

tific discourse. . . . One finds in all these architects the same naïve adherence to those popular natural philosophers who romanticized matter." [16]

The battle cry of the Rigourists, Italian followers of Carlo Lodoli, whose ideas spread to France, was "Away from Conventional Formality and back to Nature." Nature, presumably, was the Natural Look—unadorned simplicity, fidelity to the nature of materials. The revolutionary vocabulary of forms —cube, pyramid, sphere—are the sublime building blocks of the Neoplatonists. Gothic and classical revivals met in the implications of these "natural" architectural laws. Whereas the English Romantic Classicists and the later Romantics imitated the Gothic in superficial ornamental terms, the French, Soufflot in particular, absorbed it on a structural basis. Boullée refused to admit "the beauty of Gothic buildings" but praised "the artistic methods known and put into practice by the Goths [who made their temples] stunning by raising them to such extraordinary heights that they seem to soar into the clouds." Robert Morris utilized the Pythagorean musical-proportional consonances, as had Palladio, and Ledoux's *"La forme est pure comme celle qui décrit le soleil dans sa course"* refers to the universal geometry that has been exploited for one "religion" after another since its inception.

Today's sophisticated technology disguises the notion of nature as the source of aesthetic law, but artists like Tony Smith, Bladen, and perhaps Grosvenor, are involved in interpreting via modern engineering the dramatic power of such natural events as a cresting wave, a growing crystal. The romantic admiration for nature's random qualities grew out of the classical view of nature's order, and today artists tend to fuse the two. "Nature" is no longer limited to the visible wilds, and its laws now appear to include the fluidity of the baroque as well as the structure of the classic, like Fuller's view of the universe as "nonsimultaneous configurations." The modern knowledge of "natural geometry," of crystallography, tensegrity, molecular structures, permits a visual reference to natural phenomena that in turn resembles pure geometry, making a full circle

16 Jacques Guillermé, "Lequeu et l'invention du mauvais goût," *Gazette des Beaux-Arts* (September, 1965).

back to Platonism. This was out of the reach of the eighteenth century, but the visionaries aspired to it anyway.

Lequeu's medievalism was quite different. It incorporated the visually organic elements in nature, often with specifically sexual results, so that his anatomical-architectural metaphor closely corresponds to Oldenburg's sensuous depiction of common objects. The term *architecture parlante,* invented in 1852 to describe Ledoux's work, is still more applicable to Lequeu. Where Ledoux did make certain very literal propositions (such as an *Oikemas* or Temple of Love, with a phallic plan, visible only from the air, or the circular house for barrel and cask makers) and Boullée's civic buildings, like the projected Bibliothèque Nationale, did combine purpose and character through form, Lequeu's work was often so narrative as to be literary first and architectural only secondarily. His barn in the shape of a Hindu cow, his "Dairy House" with its udder-bedecked door evoking Diana of Ephesus and its bovine "holy family" in a Gothic niche above, the hunting gate with animal heads impaled on obelisks (to be made of a stone that smelled like "cat's urine, rotten eggs, and sulphur"), or the curious tomb for King Porsena, derived from descriptions by Pliny, surpass historicism and belong to the realm of pure imagination. His Sadean section of a Subterranean Labyrinth for a Gothic House is the visual counterpart of the Gothick novels then popular (and recently revived for the paperback mystery market); it was based on the same source as Mozart's *Magic Flute.* If such eccentricities seem incompatible with the more puritanical aspects of Romantic Classicism, one must remember that the bizarre was also a province of the eighteenth-century *philosophes.* Even Ledoux, the most utilitarian of the three, defended such inventiveness: "Don't you know that often quite a bizarre idea, unimportant enough in itself, can contain the germ of an excellent new conception?" From Lequeu's rustic preciosity (and Rousseau's insistence that "so long as men remained content with their rustic huts, . . . they lived free, healthy, honest and happy lives") to the mannered elegance of Art Nouveau and the liberated naturalism of Gaudi's Park Güell was not such a great step.

The prophetic aspects of the drawings at the Metropolitan

are infinite. Formally, Kaufmann has shown that "the most earthbound of all the arts, architecture, was the first to discover the great possibilities of unbalanced composition." Ledoux's Ideal City for the Salt Mines at Chaux, justly his most famous work, some of which was actually constructed, predicts Le Corbusier's Cité Radiale and, theoretically, anticipates the latest ideas of modern city planners. Take, for example, his premise that "one becomes virtuous or vicious as the pebble is rough or polished by the friction of our surroundings," or Boullée's: "I have learnt through my own experience that man's appraisal of himself is related to the space surrounding him." [17]

As for utopianism, our current brand tends to be more subdued and even cynical, but the Enlightenment's belief in the perfectibility of man remains, particularly in the younger generations, an aesthetic force, reflected in such varied areas as the increased involvement in public art (mitigated perhaps by the hopelessness of convincing protest art), books such as Serge Chermayeff's and Christopher Alexander's *Community and Privacy* (subtitled *Toward a New Architecture of Humanism*), and the titles of articles in a special "Margin of Hope" issue of the *Bulletin of the Atomic Scientists:* Gunnar Myrdal on "The Necessity and Difficulty of Planning the Future Society," Gerard Piel on "A World Free of Want—Within the Lifetime of Our Generation," or Michael Michaelis on "How to Improve the *Quality* of Life for All."

[17] Quotations from the architects have been drawn from Helen Rosenau's edition of Boullée's *Treatise on Architecture* (London, 1953), the Boullée and Ledoux selections included in Elizabeth Gilmore Holt's *From the Classicists to the Impressionists* (Doubleday, 1966), and in the rich documentation kindly provided by the University of Saint Thomas, Houston, Texas, where the exhibition was organized by Dominique de Menil.

Beauty
and the Bureaucracy*

With the best of intentions and less than the best advice, Mayor Lindsay's and August Heckscher's names have adorned (as patrons) the labels of some twenty-five sculptures placed around New York City for a month to make up "Sculpture in Environment," the first group exhibition sponsored by a city agency and pretty much the first indication that the city has heard of contemporary art.[1] Total success could not have been hoped for. A more sensible and sensitive approach could have been. The exhibition can be considered optimistically as a Beginning, a Step in the Right Direction, or pessimistically as a howling failure underlining the futility of such shotgun weddings between beauty and the bureaucracy.

The official excuse is the time element. Artists had only twelve weeks to prepare for the show, hardly sufficient to make pieces specifically for the sites they chose themselves. Planned

* Reprinted from *The Hudson Review*, Vol. XX, No. 4 (Winter, 1967–68).

[1] The very first indication, which probably inspired the current show, was the presence of several Tony Smith sculptures in Bryant Park last winter—a far more successful event than its successor. Both shows, however, are welcome signs of awakening, if not yet of Renaissance, at City Hall.

as a "demonstration project" rather than a success—always a poor idea—the exhibition was pushed up to coincide with the Cultural Showcase Festival, an event that could not have made less difference to the men in the street or in the showcase. Why, if it was (as it was) such an important and belated step for New York, was it allowed to be rushed and put out in such a half-assembled fashion? It should be said, however, that the City Department of Recreation and Cultural Affairs is not solely at fault. They spent their money (and the money donated to them) and took the "expert" advice they were offered. It is these "experts," and the artists, who must share the blame.

Aside from the aesthetic qualities of the artists and work selected (I for one think it was about fifty percent a rotten choice), the fundamental problem seems to lie in a lack of conviction about the nature of a public art. One cannot just take a sculpture out of the studio, dump it in the gutter, and call it public art. A good deal of the work so treated looked like nothing so much as evicted furniture. Granted, some people who had never noticed sculpture before noticed it because of this show. But I was disappointed because the present achievement indicates a poverty of resources (both of available art and of its public accessibility) that I know to be untrue.

A public visual art in America would presumably be a democratic art. Most fine art is traditionally private, confined to salons and galleries. Going to a good school does not guarantee any familiarity with the visual arts, neither does living in New York City, at the moment the acknowledged center of international art. Conditions are improving (or degenerating, depending on how you look at it). Museums, which make the same private art semipublic, are full on weekends; they are full of a public that Marshall McLuhan mistakenly considers visually oriented. On the contrary, the American public seems as "primitive" as its more superficially tribal contemporaries. It touches; it has to touch sculpture, even paintings. Art has to be felt up to be seen. The time-honored custom of kicking the tires of a car in fond admiration has apparently been transferred to the aesthetic realm.

From the semipublic exposure of a private art to a truly public art is a big step. Several critics of recent sculpture ex-

hibitions have noted the obvious and discouraging fact that transfer from studio or gallery to public site is usually to the sculpture's disadvantage. The city show compounded this state of affairs by choosing several pieces disastrously unsuitable to their new locations, pieces that had no chance outside of an intimate space. If only small works were available at such short notice, they should have been omitted altogether. Public art cannot be selected simply on the basis of someone liking or disliking an artist's general production. It must be done by people who know the real character of many artists' work very well, and can judge its aptitude for public display.

This is a specialized task. The public at large cannot choose the art to be placed in its cities any more than it can elect presidents of state universities, directors of govenment laboratories, or perhaps the President of the United States. Everyman's taste as evinced in theatre and television will not change the face of the city. The result would be bug-eyed children murals and more macrocephalic Alices in Everyman's Wonderland (see Central Park). The selection should in fact be aristocratic, in the original sense of the word—the best. The placement, not the choice, should be democratic. Obviously the city was defeating its purpose by putting a minor work in the window of Vidal Sassoon's fashionable Madison Avenue beauty salon, or by squeezing a Robert Murray of great effect and high quality (*Athabasca*) into the cramped porch of the Jewish Museum. Most passersby in these areas already have access to plenty of culture. There was one exhibit in Harlem: two small black Calder stabiles in the center of a driveway at the "Devonshire House" in the London Terrace Apartments, virtually invisible from the street. A large red piece, placed in any number of more public locations (the projects around 134th Street and Fifth Avenue, Frawley Circle, Mount Morris Park, to name a few) would at least have been visible, and a Louise Nevelson wall would have been preferable to her two decidedly indoor sculptures placed outside the CBS building.

Art placed in a civic site must be decorative, commanding, easy to take in at a glance, but difficult, stimulating, various enough in receiving light and atmospheric change to provoke continued pleasure, engagement, and surprise. The bulk and

"monumentality" that make it initially visible to a hurried or insensitive urban audience must be retained long enough to engage the viewer's thoughts. To become a landmark rather than an indistinguishable element of the urban collage, a sculpture, like a building, must retain its autonomy, involve its environment enough to augment but not be absorbed by it. The handsome, or decorative, condition is more easily fulfilled than the second, aesthetic condition. At times sculpture of lesser significance but a high degree of decorative éclat comes off better than an excellent piece less suitable to public settings. Lyman Kipp's red-and-yellow archway on the walkway to the Mall in Central Park *looked* better than the David Von Schlegell at the Union Carbide building and the Murray at the Jewish Museum because of its broad planes of color. So did Antoni Milkowski's open notched diamond at Kipps Bay and Bernard Rosenthal's cube balanced on its corner at Astor Place, because their contrast to the city's grids provided the necessary visibility. Such contrast didn't work with the Paul Frasier at City Hall, or the Bernard Kirschenbaum at the Bethesda Fountain Terrace, both white monoliths that owe great debts to other artists. (Someone scrawled "Bob Morris did it better" across the former; Morris is a major sculptor who declined the city's invitation.) In these cases simplicity added up neither to grandeur nor to any new sense of scale or decoration. Looking nice is a matter of design. One hopes for more from art.

The only example of a first-rate work in a first-rate site was Barnett Newman's *Broken Obelisk* in front of the Seagram building. It was notable not only because it was noticeable (a necessary prerequisite of public art) and because it was a major work—not only because of its bright orange-rust surface, its twenty-five-foot height, or its haughty isolation from traffic and buildings—but because these combined to provide an inescapable impact or "presence," an indefinable quality of much recent nonrelational work that Newman's sculpture has inherited from his painting. Yet not even this piece, for all its success, finally contributed any new dimensions to the concept of public sculpture.

While the results are yet to be tested, there is a growing

concern among contemporary artists, especially the young, with the concept of monuments and public art. Several gallery shows last year [1966] included marvelous and currently impossible plans that indicate a departure from the traditional concepts of studio sculpture placed in a "garden" setting. Monuments, conventionally commemorating the past for an indeterminate future, can instead commemorate the present for the present, emphasizing the transitional aspect of modern life. The word monument, like official architecture, calls to mind a commemoration of past styles as well as past events. (Though an early use of the found object in an aesthetic context is the custom of transforming cannons, mines, missiles, and other military leftovers into public art by putting them on pedestals in parks.) Most people admit a certain fondness for the worst of the equestrian statues and "Roman" busts that adorn Central Park. Not that anyone sees them; unless you are looking for them, they are invisible, the green patina of the bronze blending attractively into the leaves or branches of any season. The nostalgia evoked is for a past that is not our own; the fondness is part of the stenographer's dream of Paris, part of the American public's attraction to royalty, to a historical elegance that precedes American history.

In one sense, the contemporary artist's concern with the monument is still more historicizing. Its sources and ideals are largely primitivist. The "presence" of the great blunted cylinder that is a gas or oil drum, a bulbous water tank high over the landscape on a graceful "stem," recalls the minarets, mounds, mastabas, obelisks, ziggurats, menhirs of ancient cultures. Robert Morris, when confronted with a long list of possible influences on his rigorously unified structures (Bauhaus, de Stijl, Constructivism, etc.), denied them all, citing the Egyptian funerary complex of Zoser (*ca.* 2650 B.C.) as his obvious source. Tony Smith, whose ideas on public art are the most fully formed, exhibits his great modular monoliths in a dim, mysterious light so that their archaic quality is intensified by associations with a desolate grandeur.

Much of the new work parallels the late eighteenth-century classicizing romanticism that produced a rather similar visionary primitivism as well as the better-known chinoiserie

and artificial ruins (see Newman's *Broken Obelisk*).† The uto-
pian aspect of the large scale and towering grandeur of much
recent art also reflects an attempt at a new kind of social con-
tact. Art in the 1930's, despite its would-be "proletarian" styles
and subjects, failed to make contact with the working classes.
Today artists may be exploiting the American respect for big-
ness, trying to reach the public by sheer impressiveness, by
overwhelming, awe-inspiring scale, form, and beauty.

Even the *idea* of archeology itself, the hidden or enclosed,
the complex conceptual or intellectual point buried in an
impressive mass of purely physical bulk and monumentality,
seems to appeal to some artists. Carl Andre, Robert Morris,
Walter de Maria, Robert Smithson, among others, have plans
for immense mounds, trenches, pits that would be experienced
rather than optically recognized as wholes. Sol LeWitt has
suggested encasing the Cellini cup in a cube of cement, or
burying a cube sculpture deep underground. For precedent,
one can go back to Plutarch's description of the tomb re-
quested by Archimedes: a cylinder containing a sphere in-
scribed with the figure $\frac{3}{2}$, the ratio of container to contained.
Other modern proposals involve a more visible hermeticism:
Christo's vinyl and rope "packages" allowed hints at the con-
tained, as does his ambition to "package" a skyscraper, perhaps
as an impermanent monument to characterless architecture.
When Tony Smith had an exhibition at the Wadsworth
Atheneum, he "packaged" an obtrusive and unmovable aca-
demic sculpture in the largest room by building a structure of
his own to cover it; the anachronism became contemporary.
This led to the utopian suggestion that Smith "cover" all the
equestrian monuments in Central Park with black planar
forms of his own, or that these statues, which all look alike
when scattered around a park or city, be assembled in a single
field, like toy soldiers in a monumental war game.

The city exhibition actually included two such hermetic, or
ephemeral pieces, both serious and of interest, though not very
appropriate for a "demonstration project" in public art.
Forrest Myers' *Searchin'* employed colored searchlights that

† See page 242 of this book.

stretched approximately a half mile, to be "projected occasionally into the sky over Manhattan." The second, Claes Oldenburg's *Placid Civic Monument,* is described as "108 cubic feet of Central Park surface excavated and reinserted." After proposing a monumental traffic jam, and a scream monument that would echo through the city at 2 A.M., Oldenburg decided on this invisible sculpture—a 6 feet by 6 feet by 3 feet trench between the Metropolitan Museum and Cleopatra's Needle—dug by two union gravediggers under the artist's supervision, and then filled up again. This was a disappointment not because it was something of a blindman's bluff, but because the exhibition's time element did not allow Oldenburg to construct any one of the numerous undeniably important monuments he has projected over the years, among them a soft vinyl drainpipe, a giant hot dog, a fallen hat monument on the spot where Adlai Stevenson fell, and a cement cube at the intersection of Canal and Broadway, supposedly the central bomb target for New York.

All of these plans do not relate to an archaic past alone. They also take into consideration the modern environment itself. If art is to command the same attention that industry and technology do in a materialist world, then it must either compete or work with the nonart surroundings, what Tony Smith calls "an artificial landscape without any cultural precedents." It is ironic that so many artists today are involved with projects that demand huge spaces, surfaces, forms, and that they despair of ever being able to work in the scale they prefer. These shapes and surfaces already exist, in smokestacks, oil drums, building façades, water tanks. A good many artists have already recognized and adopted the vocabulary of the industrial landscape. The New Jersey Turnpike is rich in "abstract" industrial sources for sculpture, as are books of scientific or engineering diagrams. It is the artists' attempts to equal and surpass these sources that have led to the new concern with public art. The situation is made urgent by increasing opportunities to work in large scale, by increasing amounts of industrial money set aside for art, by new materials allowing more ambitious and fantastic conceptions to be attempted. Robert Grosvenor, one of the better sculptors working in

monumental scale, unfortunately planned a piece too expensive for the city to install in its exhibition. Yet a prototypal Grosvenor in a scale wholly inaccessible to him exists in the huge diagonal chute at the East River Drive and Fourteenth Street; backed up by three red, white, and blue-striped Con Ed smokestacks, the scene presents an awesome sculptural experience difficult for art to compete with.† Oldenburg, echoing the Frenchman Arman, conceded this when he considered having his contribution to the show be simply a declaration of Manhattan as a work of art. "Actually," he said, "I feel very modest in the face of New York as a sculptural achievement."

Most artists who plan for public art seem to think in terms of attention-attracting color. It is true that there are areas of the city that are colorless, and others that drastically need broad expanses of good color, though not necessarily more little spots of color. Amid the yellow cabs, red trucks, bright clothes that swarm through the Plaza's plaza, Marisol's feeble attempt at a monument in black with planes of primary color fell flat, and not only because she is an artist with as little sense of scale as Fabergé. The urban environment is colorful to begin with. Poor neighborhoods are often the most colorful. The city does not need color, or mere color, it needs a kind of chromatic depth that only a few fine artists can provide.

A beginning has been made by the city's painting bright primary colors over the tin doors and windows of buildings scheduled for demolition on the Upper West Side.† But think what else could be done with those dismal, moribund neighborhoods about to be replaced by high rent apartments, what could be done by commissioning artists to transform urban eyesores into works of art. What if some (not all) of the smoke-

† Iain Baxter, in Vancouver, has to some extent solved this dilemma by claiming as his own art nonart objects: landscapes, signs, supermarkets, bridges, anything, in short, he considers up to his standards of "visual sensitivity information"; the photograph of the chosen subject is labeled A.C.T., for Aesthetically Claimed Thing. Size is, of course, no object.

† And by "City Walls," an artist-originated project (now finally co-sponsored by the Museum of Modern Art), which paints gigantic abstract murals on blank walls downtown; and by local children and young people doing the same thing on a small and amateur scale in poor neighborhoods, vacant lots, etc.

stacks were decorated by artists or painted solid colors? Hippies could be kept busy for years painting intricate psychedelicacies on such surfaces, as they have on their trucks and cars. Major artists concerned with civic rehabilitation would jump at the chance to have a free hand with a whole neighborhood. Posters are more decorative than gray fences marked Post No Bills, and the List Foundation has made a start in placing its art posters in the subways. Graffiti has its place. If there were blackboards in rest rooms and subways, everyone could have his say, and if it were offensive, anyone could erase or replace it. Art need not be standoffish. Les Levine's *All-Star Cast* at the Time-Life building, four bulging clear plastic forms through which the participating public walks to become the "stars," proved one of the most popular of the city exhibits. A spherical gas tank in Pennsylvania has baseball stitches on it. The Silver Statue of Liberty on top of a building across from Lincoln Center is an improvement on some of the more ponderous culture at the Center itself (which, incidentally, just bought the small David Smith piece included in the city sculpture show, after having sacrificed the chance, several years ago, to make what would have been the only public commission ever received by this most important of American sculptors; they took another Henry Moore, another Calder, another Lippold instead).

What has been done so far is a drop in the bucket. As a whole, New York may be a sculptural achievement, but its parts are less impressive. There are few recent buildings that command engagement and respect. Good sculpture could compensate for some of architecture's lacunae. And sculpture has one major advantage over architecture; it can be moved. Architecture, or anything else placed *in situ* for a long time, is likely to be taken for granted and eventually becomes part of the cement work. The academic sculpture around town has become invisible because its stasis (statute, stature, status quo) is against it. Most people no longer see their environment once it has become familiar. Most of New York's neighborhoods are temporary. We could capitalize on the city's impermanent quality instead of sitting back and deploring it. With build-

ings cavalierly thrown up and mown down, permanent sculpture is often irrelevant. Good sculpture does not become automatically obsolete, but if its setting is changed, it may become unsuitable. One remedy might be for the city to build up a sculpture pool, or bank, by buying, commissioning, or financing large sculpture (and paintings) for specific sites; the artist, while alive, could be consulted on a choice of other suitable sites when his piece was moved. New works could be added to the bank and exchanged with old, which would be moved to new locations. Eventually, the inhabitants of every twenty-block radius could have a chance to live with several sculptures over a period of years. And living with art is really the only way to understand and enjoy it. By this method public interest and curiosity might be kept at the relative intensity sustained by the gallery-going minority.

Escalation in Washington*

Scale is too often considered a synonym for large size. Actually, scale has to do with proportion, and large scale, in sculpture, can be inconstant, a relative factor rather than a fixed duality, dependent not only on its internal proportions, but on those of the space in which it is placed, the distance from which it is seen. Detail, color, and surface—sensuous elements—will also affect its proportions, Robert Morris, among others, has pointed out,[1] as will those factors, such as public or personal association, which can unconsciously diminish or aggrandize the individual viewer's sense of scale. Added to this is the viewer's and the sculptor's own experience. To a man just released from prison, the average living room is vast in scale; those to the manor born might feel closeted. Sculpture that seemed large in scale ten years ago may look small now that we are accustomed to large size, sheer size, mere size.

Most discussions of scale also consider it as a strictly optical experience, the work of art being seen as a whole, or as a small group of objects, a single surface, or a single façade. But a

* Reprinted from *Art International,* Vol. XII, No. 1 (January, 1968).

[1] Quotations from Robert Morris come from his three "Notes on Sculpture" articles in *Artforum* (February, October, 1966, and Summer, 1967).

sense of scale is also a *sense* proper. Scale is *felt,* and cannot be communicated either by photographic reproduction or by description. The sculptor's sense of scale is particularly to be communicated as a "sense of place." This can mean simply that a work is strong enough to dominate its space or environment, or that the work holds aloof from the spectator and makes the spectator just that, an audience. A sculptor's scale is successful in direct proportion to the degree in which it succeeds in holding its own in space. Whereas a painting can *depict* an unlimited scale, its experienced scale remains the same, permanently enclosed in its own spatial framework. Outside space affects it little. (Abstraction that has forgone illusionism must come to terms with its scale or intentions of scale more precisely. Al Held, for one, has attempted to break the bonds of this framework by means of an "inverse" or aggressive, rather than a recessive, illusionism, but the wall plane and the painting's pictorial dimensions remain static.) While a sculpture's actual size also remains the same, its scale is much more vulnerable than that of painting. Truly large sculptural scale is an elusive factor.

I am not sure that any of the three artists in the "Scale as Content" exhibition at the Corcoran Gallery in Washington [2] —Ronald Bladen, Barnett Newman, and Tony Smith—would agree that the show's title strictly applies to his own work. Not only is the word content "virtually useless for criticism," [3] but scale is not any more *the* content of these three sculptures than is color, surface, material, form, or any of the other elements that combine to make them what they are. Though all three sculptors share an open and to some extent anticonceptual approach, and all three sculptors share large size, the group is an extremely heterogeneous one, and the treatment

[2] The event itself, organized by Eleanor Green, who also wrote the catalogue text, is a memorable one since it marks the first time an American museum has financed the construction of such large work without the possibility of permanent acquisition. Mark di Suvero was originally included but his piece could not be brought from its previous site in time. At the close of the exhibition, the works will be returned to the artists and, hopefully, erected elsewhere.

[3] Clement Greenberg, "Complaints of an Art Critic," *Artforum* (October, 1967), p. 39.

of scale varies accordingly. Bladen's *The X* is 22 feet high and 26 feet wide; it has broad surface areas but is not massive in effect. Its size fills space—half of the Corcoran's two-story atrium; its scale is commensurate with, but not out of proportion to, its size. Newman's *Broken Obelisk* is 26 feet high; height and contour are its major formal concerns; outdoor placement helps its scale by imposing no limits on the implied height. Smith's *Smoke* is 24 feet high but 48 feet by 34 feet in its other dimensions. It has no mass, and its infinite flexibility simply bypasses, or transforms, the particularity of scale.

The expanding surfaces of paintings, increasing dimensions of sculpture, have caused much comment recently, as though there were not precedents throughout history for grand (and grandiose) visions. Detractors usually feel that while a good picture story, or monumental excuse, a narrative or representational work of art, can support huge size, abstraction is overblown when it aggrandizes. With the increased availability of stronger and more flexible materials, industrial commissions, and acceptance, at least as a fact, of large size, sculptors are particularly concerned with ways to transcend the object quality of traditional sculpture and to forge a new aesthetic framework within which sculpture would be capable of competing with, but not resembling, architecture and technology. Tony Smith has said that he didn't make his 6-foot cube, *Die,* any larger because he didn't want it to loom over the observer and be a monument, or any smaller because he did not want the observer to see over it like an object. This exchange shouldn't be taken too generally; Smith's answers would have been different had another of his works been in question. Yet it is important in its statement of the two categories between which, or rather beyond which, sculpture is struggling to operate. The monument looms; the object is intimate and can be handled or moved. How can large size be employed without approaching architecture and architectural ornament?

The two indoor pieces—Bladen's and Smith's—necessarily deal with a more specific space, though it should also be noted that the Corcoran's atrium is an interior setting less defined than most; far from a solid container, its walls are open colonnades (Doric downstairs, Ionic above), and the ceiling is a

large skylight, so the pressures of the work on their enclosures, or vice versa, can be minimal. The virtues of the setting are the marvelous overhead light and the viewing prospects offered by the second-floor balcony, which add much to the formal comprehension and pure visual enjoyment of the two sculptures. Both works will, mistakenly, be called "environmental" because they are large and seem to be the only objects in their space. In fact, both Smith and Bladen had conceived of the projects realized here long before the Corcoran space was offered. *Smoke* is quite cavalier about the room space, so that Robert Morris, on hearing it described, called its obstreperousness "being rude to the room." The Bladen, because of its autonomy, is more polite, dividing the space neatly and clearly. Both pieces, however, may have been less "planned for the space" than many gallery exhibitions are. Morris, for example, is probably more occupied with the space in which his work is shown than either Smith or Bladen. His work is regulated by a human scale, the size of the spectator that shares its space, which determines an unchangeably "right" (though not identical) size for his particular shapes, rather like the "ultimate" justice of Ad Reinhardt's decision to make all his later black paintings five feet square. Morris understates scale by making it neither large nor small; he avoids exaggerated height because "large-sized objects exhibit size more specifically as an element" than small-sized objects. He finds, as does Donald Judd, a "certain humanitarian sentimentality" in sculpture that can be walked through or looked up at, and feels that it can "unbalance complex plastic relationship." Bladen, on the other hand, works in consistently large scale and size, while Smith generalizes still more by changing the size of his sculptures almost every time they are shown. Since most of the pieces he shows are mock-ups for ideally immense work not yet cast, the size can be variable depending on exhibition area and funds available.

Clearly the concepts of scale underlying Bladen's planar forms, Smith's unvisualizable structures, Morris' gestalts, and Judd's repeated units, are strongly distinguished and often opposed to each other. Yet all of these men have been periodically annoyed by the fact that their work, like other large or

primary sculpture, is always compared to architecture. This could reflect on the general failure of modern architecture to provide an aesthetic interest, and a scale, commensurate with the twentieth-century dream. Still, even the size of the biggest new sculptures is not architectural, being comparable only to the smallest outbuilding. A large geometric object can "look like" a building in reduced scale, but that has nothing whatsoever to do with being like a building. Even when a sculpture can be entered, it remains sculpture. And architecture can be influenced by sculpture, as I think Philip Johnson's recent monument proposals are influenced by sculpture like Bladen's, Judd's, Smith's, or Morris'. (The one in Dallas, to Kennedy, will be a squadron of seventy-two concrete slabs. The one on Ellis Island will be a huge hollowed-out cylinder with the names of the tired, poor, and huddled masses listed on it— false names for a false monument since so many of the names were "Americanized" or made up by chance on entry; it will actually stand as a monument to the immigration officers' lack of imagination.)

Given the three sculptures at the Corcoran, Newman's offers the most traditional solution. *Broken Obelisk,* a soaring, richly rust-colored tower, consists of an inverted obelisk balanced on the point of a pyramid, its top edge a ragged silhouette, as though violently uprooted and upended. It is a clear example of the use of scale in a classical sense, as harmony or balance (in this case a literal as well as an aesthetic balance). The development of a new and very strong steel alloy—Cor-Ten— made possible its precarious construction, and attention tends to center on this virtuoso aspect, the point-to-point encounter at the sculpture's "waist." Yet the most important detail is the broken edge at the top, which continues the rising silhouette begun by the pyramid, also a rising form, though a classically stable one as well. The pyramid does not function as a base. If anything, it is a substitute for the earth itself, into which the upper spike is being driven. (A real ground line is established by the ripple-edged platform that is a base.)

Altogether, this piece is an unlimited vertical, the only restraint being provided by the downward counterthrust of the

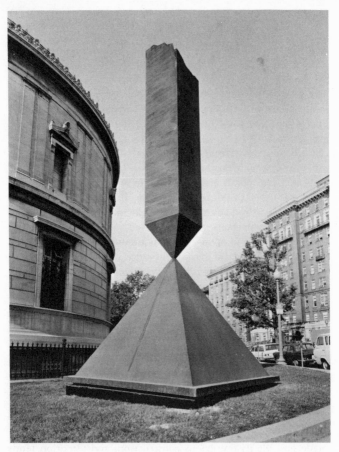

Barnett Newman: *Broken Obelisk*. 1967. Cor-Ten steel. 26′ x 10½′. Photograph courtesy of The Corcoran Gallery of Art, Washington, D.C.

obelisk. Just as the ragged detail line in Newman's painting can be annoying but also sometimes can prove unexpectedly compatible with the breadth of the color-field concept, the rather self-conscious broken edge on the obelisk is held in check by the massive equilibrium of the whole. Its verticality is furthered by an outdoor setting, for a ceiling would pressure and constrain that verticality to some extent. Similarly, its implied height (or scale) was more noticeable in New York, where another cast was exhibited in front of Mies van der Rohe's Seagram building, for there one could estimate how the piece could, theoretically, extend. It seemed to gain support from the surrounding skyscrapers rather than being dwarfed by them. The scale did not seem so monumental outside the Corcoran, where the intention of acting as a "pivotal point" for the curved edge of the two-story building was not altogether successful. It is also worth noting that the symbol in engineering drawing for a greatly expanded but not depicted length is just such a ragged edge, placed a small space away from its counterpart to make a "broken line."

In fact, *Broken Obelisk* illustrates an idea less sculptural than graphic at heart, for contour is its most important visual element. In a 1962 interview, Newman said that he hoped he had "contributed a new way of seeing through drawing. Instead of using outlines, instead of working with the remnants of space, I work with the whole space." [4] Openwork sculpture is often described as "drawing in space." Newman's drawn openness is unlike that of the junk or collage sculpture of the 1950's and before because nothing is enclosed by it. It divides the "whole space" of the outdoors, or the room, as the lines in the canvas divide the implied infinity of the color field. Some years ago, when he isolated as a sculpture the long, thin vertical "stripe" that divides his paintings, Newman admitted in effect, as I have noted before, that the stripe was the unit by which his painting existed, denying the importance of that stripe's placement on the canvas (also denied by his insistence that his is not geometric, but "post-geometric" art).

For sculpture, this idea has its limitations. *Broken Obelisk* is

[4] "Frontiers of Space," *Art in America* (Summer, 1962), p. 87. Interview with Dorothy Seckler.

a monument in several dictionary senses of the word: "a work of enduring value or significance," "a structure surviving from a former period," "a shaft set in the earth to mark a boundary." The boundary marked is that between sculpture as conceived until around 1965 and the transitional area in which we now seem to be. The primary structures tendency, which is broadly accepted at least as an attempted break with the sculptural past, has opened an area of often-desperate exploration for a new conception of sculpture. The Newman refers to an archaic past (as does much recent work) and also to the broken but noble ruins of a nostalgic past, a past grandeur, like that classical past so mourned by the late eighteenth century, also in the form of pyramids and broken columns.

Newman has never made any bones about the metaphysical aspirations of his art, his desire to "express his relation to the Absolute" and to express an exaltation that aspires to the sublime. In 1948 he complained of Mondrian's submission to formalism: "The geometry (perfection) swallowed up his metaphysics (his exaltation)." [5] This complaint might be validly applied to some of Newman's own painting and might bear on such nonformal manifestations as the *Stations of the Cross,* shown at the Guggenheim two years ago [1966], and this sculpture. It now seems ironic that he also complained in 1948 of the European artist who was "nostalgic for the ancient forms, hoping to achieve tragedy by depicting his self-pity over the loss of the elegant column and the beautiful profile." [6] *Broken Obelisk* presents both the elegant column and the beautiful profile.

Newman and Tony Smith have been good friends for some twenty-five years, I believe, years during which Newman's painting has been mature and of major significance to the evolution of nonobjective painting and sculpture. His declaration that "geometry *can* be organic . . . A straight line is an organic thing that can contain feeling" [7] illuminates aspects of

5 "The Sublime is Now," *Tiger's Eye* (December 15, 1948), p. 52.

6 "The Object and the Image," *Tiger's Eye* (March, 1948), p. 111.

7 "Artists' Sessions at Studio 35 (1950)," *Modern Artists in America* (First series [New York: Wittenborn, Schultz, 1951]).

his own work as well as relating to Smith's assertion that his own structures are inspired by nature. Smith matured late, as far as his sculpture is concerned, yet it now seems to be his turn to carry these ideas into an innovatory sculptural area, an area in which Newman, for all his skill in translating these ideas into three dimensions, is less qualified to innovate. Although I was very moved by the Newman, it remains in all its magnificence a sculpture in the traditional sense, an object that has a scale impressive enough to survive in public settings.

"Architecture has to do with space and light," Smith has said, "not with form: that's sculpture." [8] But *Smoke,* at the Corcoran, has to do with space and light and form. It is not architecture, however, because the space it works with is self-generated, not room space, not functional in any sense, but sculptural. Smith has noted the importance of a childhood visit to the pueblos in New Mexico, and the fact that this has been a continuing unconscious reference ever since: "They seemed real to me in a way that buildings of our own society did not." The dim lighting and dramatic settings Smith prefers for his sculpture also refer back to the associations with archaic architecture-sculpture. Robert Morris, when he was asked at a symposium what could be the source of his early plywood structures (a corner pyramid, long beveled floor beam, three-dimensional L) if he denied the obvious modern precedents, replied, simply, logically, the funerary complex of Zoser, *ca.* 2650 B.C. Bladen's "earth drawings" of around 1956, made from black mud, may also have some farfetched bearing on such a primitivizing tendency.

Perhaps this attraction to the public art of ancient sculptures, by no means limited to Smith, Bladen, or Morris, is that it was sculpture as well as architecture. The pyramids, Stonehenge, the Colossus of Rhodes, the Trojan Horse, menhirs, ziggurats, mastabas, obelisks, were often structures with a double function. They enclosed, were gates, tombs, markers, ritual

[8] Quotations from Tony Smith are taken from the catalogue of his exhibitions in Harvard and Philadelphia, 1966; from *Artforum,* December, 1966; and from conversations with the artist.

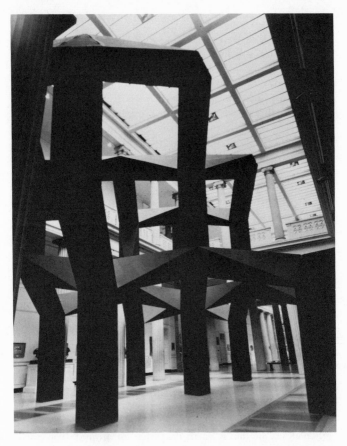

Tony Smith: *Smoke*. 1967. Painted plywood to be made in steel. 24′ x 34′ x 48′. Photograph courtesy of Fischbach Gallery, New York.

sites, sacrificial altars, and they closed out. What was inside of them gradually became less important than their exterior shapes. Beginning as architecture, they became sculpture over the ages, just as leftover cannon (now even missiles) are painted black or gray and mounted on pedestals in parks, to become the first public "ready-mades."

It is in this sense that Bladen's *The X* is so opaque. Its tenuous connection to architecture, or that part of the architectural concept that involves shelter and barrier, should not be made much of. It is, like the pyramids, both public and private. Its effect is elusive, its presence impenetrable, hermetic, self-sufficient. On a literal level it is opaque in that it is concerned with closed forms. From a frontal view, it is open, it rises, but it also has another, more forbidding prospect. From the side, it looms; its slanting black walls can neither be entered nor scaled; they shut out as much as the frontal planes welcome. Its size is thus in proportion, or disproportion, to the spectator in two ways. It is an object still, but a giant one that overrides most conventional sculptural contexts. All of Bladen's free-standing sculpture has seemed expansive by nature, and in this scale the expansion is just so much more liberated. His last two works—*Black Triangle* (now peculiarly squeezed into the Guggenheim International)—and the untitled white box at the Whitney Annual last year [1967] were concerned with a resistance to gravity, a subtle but dangerous denial of equilibrium. The three-dimensional *Triangle* balanced on its apex, and the box tilted slightly, hovering one inch off the floor on its lowest side and six on its highest. Before that, the three massive diagonal slabs in the "Primary Structures" exhibition also defied gravity. *The X* forgoes this aspect in favor of a spread-legged stability. But it too is not as simple as it looks.

To begin with, it is not quite an X. That is, there are four diagonals, not two; the top is offset from the bottom; the 2 *V*'s overlap in the rectangular central core so that the upper angle is slightly wider than the lower one. It is symmetrical when split vertically, but not when split horizontally. Such a device corresponds to Bladen's precise manner of altering angle to his own very personal demands. I wrote elsewhere (*Artforum*,

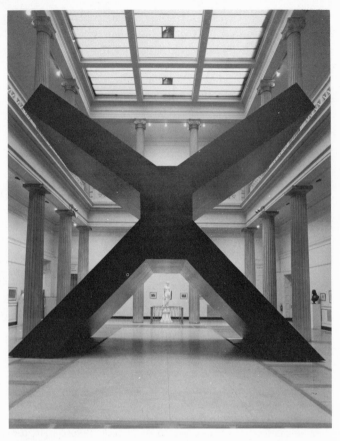

Ronald Bladen: *The X*. 1967. Painted wood. 22′ x 26′ x 14′.
Photograph courtesy of The Corcoran Gallery of Art, Washington, D.C.

March, 1967) of his last two sculptures, and will repeat it in regard to this one, that weight means nothing and everything in his work, and that the uniqueness of his propositions is the particular manner in which the angles operate on the areas. By the first statement I mean that weight is important because the height of the object is overpowering and the initial effect is one of bulk and stability. Weight is finally unimportant, however, because it is not mass and volume that Bladen is after. The big black *X* is not heavy, but open at every joint. It can be walked through, and seen through from its frontal façades. The lower diagonals root it to the ground, but the upper ones spread and lift.

Much of Bladen's work can be seen as two-dimensional figures given a third dimension, transformed into sculpture. They are usually common and easily absorbed figures in two dimensions. The triangle was flat when directly confronted but became a wedge when looked at from the side, sculpturally. The white rectangle became a box. The simple angles of the *X* became a complex series of areas and the slanted upper sides shed a broad shadow over the lower ones. Maybe this has something to do with Bladen's background as a painter. His first show at the Green Gallery in 1962 consisted of planar, "drawn" shapes lifted from their grounds into relief. The *X* form shows up as a rapid orientalizing "earth drawing" made in San Francisco in 1956–57. Now it has been invested with substance, and especially with area. Even the planes provide the remnants of a two-dimensional experience. They are not sensed as volume but are seen and sensed in perspective, as they would be when drawn.

The X has been fortified for its added substance by the addition of a boxlike core that allows upper and lower angles to differ. The breadth of plane and the contingent angle is very carefully regulated, as it is in the rest of Bladen's work. These angles must have been partially decided by the fact that the lower opening could be, and therefore would be, walked through, and by the effect desired of the "corridor" formed by the two base members. Walking through this broad aperture is not an "environmental" experience. It just provides another, admittedly more intimate, way of studying the planes

and angles that are so public from the outside, and allowing one to sense in microcosm the closed effect of the unscalable sides.

X marks the spot. It is a landmark. In algebra (the word comes from the Arabic for "reunion of broken parts"), X is the unknown factor, and while this was surely not the reason for its construction, it does not seem incompatible with the quiet mystery, the rather secretive quality I find in much of Bladen's work. The Corcoran catalogue calls *The X* "in reality two sculptures," the complicated inner structure, which has been photographed, being a "hidden, private sculpture." Bladen did show the unfinished framework of another piece at N.Y.U.'s Loeb Center last year [1967], but these scaffoldings, while certainly interesting in terms of the finished product, obscure the angle-area relationship that is integral to the sculpture's significance. Also, Bladen says that there is nothing unnecessary in the skeleton; if the structure is at all unconventional it is presumably because it was constructed "intuitively," with the benefit only of an original scale drawing of the front (to provide working information about angle and size) and a small mock-up, erected outdoors in Woodstock, where the piece was made. The plywood "skin" was added in Washington, transforming a kind of Bracellian anatomical wonder into an aloof and dignified entity.

There is another way that scale can produce a "sense of place," and it is just beginning to be consciously explored in recent sculpture. That is a use of scale that is not strictly optical, that arises from a size so gigantic that it can only be sensed, a size usually extensive horizontally rather than vertically, to be taken in by parts, or in time. By this I do not mean simply walked through or enclosing, but practically invisible except as the continuous physical experience of a shape. An example is Morris' project for an "endless" mound wall in the desert or plains, which would never be seen as a whole, except by air, but the scale of which could be very strongly experienced or sensed by walking along beside it or coming upon it in a space so vast it loses its specificity.

Such notions might be the sculptural equivalent, finally, of Pollock's allover aesthetic, the endless surface, and structures

that continue or envelop rather than insisting on themselves as isolated forms. The wholeness of Pollock's drip paintings is unity of surface rather than form. Pontus Hultén locates this concept in the Western Hemisphere. Macchu Picchu, the Mayan pyramids, the serpentine Indian mounds in the Midwest, American Indian sand paintings (which may have influenced Pollock), or the Nasca Valley configurations formed by the removal of dark pebbles from a pale, sandy surface [9]—all of these are come upon in sections, taken in as surroundings, rather than as separate parts; their settings do not allow the distance necessary to comprehend them by reasonable, optical perception. Such an approach is opposed to the European habit of considering form as form in a more lucid, rational, optical manner; the American approach can be seen as sensuous, tactile, abstract.

This seems a valid, though obviously not all-inclusive suggestion, so long as it is not oversimplified or perverted into that cliché of the 1950's about big, raw, spontaneous Americanism directly inspired by plains, mountains, and skyscrapers. It does, however, have to do with an openness that in sculpture may offer broader alternatives to the choice between monolith and environment. This is not the openness offered by *The X*, nor is it that offered on a conventional object scale by so-called abstract expressionist sculpture, or by Picasso's and Gonzalez' earlier equivalents. The forms in those works were still contrasted, so that the whole was a composed and therefore unique combination of those parts. The potentially infinite expansion or openness proposed by Sol LeWitt in his cubic grids or by Don Judd in his rows of standing frames, by

[9] Hultén, in conversation; Morris, Andre, Oldenburg, and others are also virtually undermining the idea of monumental height by projecting trenches and shallow pits. Making monuments by subtracting volume rather than adding to it seems to have been typical of the Nasca culture, which also made its pyramids by terracing natural hills. This is perhaps a Western Hemisphere, and very tactile, version of Michelangelo's concept of peeling the stone away from the sculpture to discover the figure hidden inside. It also relates to the enclosure motifs I mentioned in my article on Tony Smith; there are classic Mayan pyramids that are simply built over preclassic temples, and Catholic priests after the Conquest often found that enthusiastic Christianity could be traced to the old idols buried beneath the new altars.

Tony Smith's modular sections of an infinite space-lattice, Dan Gorski's "trellises," and Alan Saret's wire pieces, does relate to Pollock's or Poons's continuous surfaces. Another branch of a similar aesthetic, though not apparently so radical in its possibilities for formal development, is Newman's vertical expansiveness, which has to do with a drawn or implied line upward, forever, like Brancusi's *Endless Column* or Carl Andre's and Bill Bollinger's horizontal linear expansion, or Dan Flavin's structured but immaterial effusions. Similarly, Peter Pinchbeck's large open frameworks, sections of a rectangle, manage to imply a plane in their exposed space as well as the three-dimensional planes and volumes of the rest of the "solid" outlined in space. In still another way, Morris' last exhibition, which changed periodically by a shifting of the sculptural elements, displays a kind of limited openness. This is too big an area to discuss here, but I mention it in order to demonstrate the importance of *Smoke*.

Smith's piece is a kind of contemporary octastyle that has an evident clarity of purpose, but is conceptually decipherable only after lengthy study. Neither an object nor an enclosure, its open lattice form allows space to flow, to suggest a sculptural infinity, a freedom of means not hitherto permitted by geometric sculpture. Unlike a rectangular grid, which would have been too easily comprehended and too easily compared to scaffoldings and architecture, the crystalline structure of *Smoke* is multilaterally symmetrical, a two-story, self-generating vault system of columns and arches. John Chandler has described the piece in intricate structural detail:

> *Smoke* reveals its hexagonal structure both horizontally and vertically since the space is three-dimensional. Each of the eight floor columns is so positioned that it stands at alternate angles of close-packed hexagons. At the top of each column there is a tetrahedral capital whose remaining three sides offer faces to which additional modules are attached. Each continuous pair of columns supports an arch made of two additional identical modules also joined by a tetrahedron (this time necessarily inverted) which can support another vertical module that rises from the re-

maining alternate angles of the hexagons and supports another layer of arches. Each triad of columns supports a hexagonal ring of the same; hence the whole structure reflects a basic generating function; a six-sided figure rising from a three-sided one.

While the modules actually enclose a "solid" known as a rhombic dodecahedron, this is not obvious. Like its namesake, *Smoke* is limited by its container, but, conceivably, more units could be added in all directions ad infinitum. It "grows" organically, as crystals grow, or trees. Once the first module is planted and capped by a tetrahedron, the rest will grow as long as it is fed, or until it runs into a floor, ceiling, or wall.

The column or basic module of *Smoke,* a squat version of which Smith had used three years earlier in *Moondog* has, to my knowledge, appeared nowhere else in art or architecture. It is essentially an octahedron topologically stretched beyond recognition, though retaining the basic and inalterable characteristics of the octahedron: eight triangular faces, six vertices, and twelve edges. The proportional relationship between these parts are those between the parts of a cube: 2 : 1, 3 : 2, and 4 : 3 (coincidentally the ratios of the octave, fifth, and fourth, as discovered by Pythagoras and as used by the Gothic architects who include them in their "true measure").

Another way to visualize this module is as an elongated, three-dimensional hexagram, or Star of David (the hexagram was also the seal and symbol of the Pythagorean school, and "Solomon's Seal" to the medieval mystic). In a hexagram, two equilateral triangles are placed concentrically so that the sites on opposite sides of the center are parallel. To make *Smoke*'s module, these two triangles are drawn apart and six isosceles triangles are extended from the sides of each triangle so that their apexes meet the angles of the opposing equilateral triangles. This module has two interesting characteristics: first, a cross section at its waist would reveal a regular hexagon, any other cross section reveals an irregular hexagon, but at the very top and very bottom is an equilateral triangle. Second, although none of the vertical faces is perpendicular to the horizontal, the column as a whole is; since the triangular ends are concentric, a line extending between

their centers is perpendicular to the parallel planes of the triangles.[10]

The beauty of *Smoke* is that it displays but does not divulge its system. The patterns of space and patterns of linear solids change as one moves through it, but the changes are bewildering only if one insists on analyzing the very complex structure described above. The expected member never appears, and the eye is constantly led away into new configurations. Each new view challenges imagination and perception, opening up new geometrical vistas before the previous group are forgotten, so that one's experience takes on an almost musical dimension. From one angle, the arches line up to form a straight plane; move to the right and they break into hexagons, to the left and they become an angled series of disappearing planes; look up, and the patterns of the second story impose themselves on the first; stand away, and the whole thrusts itself up and out into space while the light picks up rows of tall triangular facets for an added countertheme of transparency.

Chaotic as this may sound, the overall impression is one of organic simplicity, of grace and calm. Smith's work is often, and justly, called baroque because of its emotional intensity, its rotating motion. *Smoke* controls these qualities, and its great size, by lack of volume and columnar equilibrium. Generically it may be closer to the alternating structures of the Banyan tree, but there is an interesting parallel in Islamic architecture. The mosque at Cordova, for instance, was expanded four times without its basic pattern being altered. Like *Smoke* it is an apparently limitless expanse of columns supporting a double layer of arches with great structural and spatial flexibility. H. W. Janson has written that the mosque's spatial "limits are purposely obscured so that we experience it as something fluid, limitless and mysterious." [11] Just as the space between the planets and the space between the molecules is the same space, *Smoke* makes no distinction between inside and outside, void and solid.

[10] From an unpublished manuscript on Tony Smith.
[11] *History of Art* (New York: Abrams-Prentice Hall, 1962), p. 187.

The Dematerialization of Art*

(Written with John Chandler)

During the 1960's, the anti-intellectual, emotional/intuitive processes of art-making characteristic of the last two decades have begun to give way to an ultra-conceptual art that emphasizes the thinking process almost exclusively. As more and more work is designed in the studio but executed elsewhere by professional craftsmen, as the object becomes merely the end product, a number of artists are losing interest in the physical evolution of the work of art. The studio is again becoming a study. Such a trend appears to be provoking a profound dematerialization of art, especially of art as object, and if it continues to prevail, it may result in the object's becoming wholly obsolete.

The visual arts at the moment seem to hover at a crossroad that may well turn out to be two roads to one place, though they appear to have come from two sources: art as idea and art as action. In the first case, matter is denied, as sensation has been converted into concept; in the second case, matter has been transformed into energy and time-motion. If the completely conceptual work of art in which the object is simply

* Reprinted from *Art International*, Vol. XII, No. 2 (February, 1968).

an epilogue to the fully evolved concept seems to exclude the *objet d'art,* so does the primitivizing strain of sensuous identification and envelopment in a work so expanded that it is inseparable from its nonart surroundings. Thus the extremely cool and rejective projects of Judd, LeWitt, and others have a good deal in common with the less evolved but perhaps eventually more fertile synaesthetic ambitions of Robert Whitman, Robert Rauschenberg, and Michael Kirby, or the dance of Yvonne Rainer and Alex Hay, among others. This fact is most clearly illustrated by the work of Robert Morris, who has dealt with idea as idea, idea as object, and idea as performance. In fact, the performance media are becoming a no-man's- or everyman's land in which visual artists whose styles may be completely at variance can meet and even agree.[1] As the time element becomes a focal point for so many experiments in the visual arts, aspects of dance, film, and music become likely adjuncts to painting and sculpture, which in turn are likely to be absorbed in unexpected ways by the performing arts.

Another possibility that permits a combination of art as idea and art as action is the use of a serial scheme, though the recent "Art in Series" exhibition at the Finch College Museum of Art, organized by Mel Bochner, while a good show, indicated that only the most basic tenets of serialism have so far been adapted to the plastic arts. Static by tradition, painting and sculpture have until lately lagged behind music, poetry, and film in the use of serial methods.

Motion is the source of pattern-making, and it might seem that film rather than painting or sculpture would be the visual art most suited to the portrayal of motion and time. But paintings like those of Larry Poons and sculpture such as Sol LeWitt's offer successful means of presenting time-motion without anything actually moving (as, in another way, do Oldenburg's soft sculptures). They are like time exposures in photography, revealing time-space patterns that are invisible to someone seeing them in sequence alone. They are like chords in music, where the pattern is discovered in the vertical and

1 See the *Tulane Drama Review* (Winter, 1965), which includes articles by Cage, Oldenburg, Rainer, Morris, Kaprow, Young, and a good general essay on "The New Theatre" by Michael Kirby.

simultaneous arrangements of the elements rather than horizontally and sequentially, as in melody. Thus these time exposures are double exposures or multiple exposures. Le-Witt's serial projects are made up of parts which, though each part can be seen separately as sculpture, and in sequence, can also be seen simultaneously as one thing. (One of LeWitt's influences, and also one of Duchamp's, was Muybridge.) However, the parts do sometimes call attention to themselves with the unfortunate result that the whole lacks the unity of a chord; it is in the mind, or in the working drawing that sketches all the possibilities, rather than in the eye, that the whole attains its completely realized simplicity and unity. A series is an appropriate vehicle for an ultra-conceptual art, since thinking is ratiocination, or discovering the fixed relations, ratios, and proportions between things, in time as well as in space.

A highly conceptual art, like an extremely rejective art or an apparently random art, upsets detractors because there is "not enough to look at," or rather not enough of what they are accustomed to looking *for*. Monotonal or extremely simple-looking painting and totally "dumb" objects exist in time as well as in space because of two aspects of the viewing experience. First, they demand more participation by the viewer, despite their apparent hostility (which is not hostility so much as aloofness and self-containment). More time must be spent in immediate experience of a detail-less work, for the viewer is used to focusing on details and absorbing an impression of the piece with the help of these details.† Secondly, the time spent looking at an "empty" work, or one with a minimum of action, seems infinitely longer than action-and-detail-filled time. This time element is, of course, psychological, but it allows the artist an alternative to or extension of the serial method. Painter-sculptor Michael Snow's film *Wavelength,* for instance, is tortuously extended within its forty-five-minute span. By the time the camera, zeroing in very slowly from the back of a large loft, reaches a series of windows and finally a photograph of water surface, or waves, between two of them,

† No, not more time, though often equal time. As one painter has put it: "Is less ever any more than more, or is it only *just as good?*"

and by the time that photograph gradually fills the screen, the viewer is aware of an almost unbearable anticipation that seems the result of an equally unbearable length of time stretched out at a less than normal rate of looking; the intensity is reinforced by the sound, which during most of the film is monotonal, moving up in pitch and up in volume until at the end it is a shrill hum, both exciting and painful.

Joseph Schillinger, a minor American Cubist who wrote, over a twenty-five-year period, an often extraordinary book called *The Mathematical Basis of the Arts,* divided the historical evolution of art into five "zones," which replace each other with increasing acceleration: (1) pre-aesthetic, a biological stage of mimicry; (2) traditional-aesthetic, a magic, ritual-religious art; (3) emotional-aesthetic, artistic expression of emotions, self-expression, art for art's sake; (4) rational-aesthetic, characterized by empiricism, experimental art, novel art; (5) scientific, post-aesthetic, which will make possible the manufacture, distribution, and consumption of a perfect art product and will be characterized by a fusion of the art forms and materials, and, finally, a "disintegration of art," the "abstraction and liberation of the idea." [2]

Given this framework, we could now be in a transitional period between the last two phases, though one can hardly conceive of them as literally the last phases the visual arts will go through. After the intuitive process of re-creating aesthetic realities through man's own body, the process of reproduction or imitation, mathematical logic enters into art. (The Bauhaus dictum "Less is More" was anticipated by William of Occam when he wrote: "What can be explained by fewer principles is explained needlessly by more"; Nominalism and Minimalism have more in common than alliteration.) From then on, man became increasingly conscious of the course of his evolution, beginning to create directly from principles without the intercession of reproductive reality. This clearly cor-

[2] Joseph Schillinger, *The Mathematical Basis of the Arts* (New York: Philosophical Library, 1948), p. 17.

responds to the Greenbergian interpretation of Modernism (a word used long before Greenberg, though his disciples insist on attributing it to him). The final "post-aesthetic" phase supersedes this self-conscious, self-critical art that answers other art according to a determinist schedule. Involved with opening up rather than narrowing down, the newer work offers a curious kind of utopianism that should not be confused with nihilism except in that, like all Utopias, it indirectly advocates a *tabula rasa;* like most Utopias, it has no concrete expression.

Dematerialized art is post-aesthetic only in its increasingly nonvisual emphases. The aesthetic of principle is still an aesthetic, as implied by frequent statements by mathematicians and scientists about the *beauty* of an equation, formula, or solution: "Why should an aesthetic criterion be so successful so often? Is it just that it satisfies physicists? I think there is only one answer—nature is inherently beautiful" (physicist Murray Gell-Mann); "In this case, there was a moment when I knew how nature worked. It had elegance and beauty. The goddam thing was gleaming" (Nobel prizewinner Richard Feynman).[3] The more one reads these statements, the more apparent it becomes that the scientist's attempt to discover, perhaps even to impose order and structure on the universe, rests on assumptions that are essentially aesthetic. Order itself, and its implied simplicity and unity, are aesthetic criteria.

The disintegration Schillinger predicted is obviously implicit in the breakup since 1958 or so of traditional media, and in the introduction of electronics, light, sound, and, more important, performance attitudes into painting and sculpture—the so far unrealized intermedia revolution whose prophet is John Cage. It is also implied by the current international obsession with entropy. According to Wylie Sypher, for example: "The future is that in which time becomes effective, and the mark of time is the increasing disorder toward which our system tends. . . . During the course of time, entropy increases. Time can be measured by the loss of structure in our system, its tendency to sink back into that original chaos from which

[3] Quoted in Lee Edson, "Two Men in Search of the Quark," *New York Times Magazine,* October 8, 1967.

it may have emerged. . . . One meaning of time is a drift toward inertia." [4]

Today many artists are interested in an order that incorporates implications of disorder and chance, in a negation of actively ordering parts in favor of the presentation of a whole.[5] Earlier in the twentieth century the announcement of an element of indeterminacy and relativity in the scientific system was a factor in the rise of an irrational abstraction. Plato's anti-art statements, his opposition to imitative and representational art, and his contempt for the products of artists, whom he considered insane, are too familiar to review here, but they are interesting to note again in view of the current trend back to "normalcy," as evidenced by the provocative opening show of the East Village cooperative Lannis Museum of Normal Art, where several of the works discussed here were seen. Actually, the "museum" would be better called the Museum of Adnormal Art, since it pays unobtrusive homage to the late Ad Reinhardt and to his insistence that only "art-as-art" is normal for art. The artist-director, Joseph Kosuth, admits his pedantic tendency, also relatable to Reinhardt's dogmas, in the pun on normal schools.) However, "no idea" was one of Reinhardt's rules and his ideal did not include the ultra-conceptual. When works of art, like words, are signs that convey ideas, they are not things in themselves but symbols or representatives of things. Such a work is a medium rather than an end in itself or "art-as-art." The medium need not be the message, and some ultra-conceptual art seems to declare that the conventional art media are no longer adequate as media to be messages in themselves. The following list, randomly selected from a horde of examples of widely varied kinds of ultra-conceptual or dematerialized art, includes some which have almost entirely eliminated the visual-physical element:

[4] Wylie Sypher, *Loss of Self in Modern Literature and Art* (New York: Vintage, 1962), pp. 73–74. The word has also been applied to differing areas of recent art by Robert Smithson and Piero Gilardi; it appears as the title of a short story by Thomas Pynchon and as a theme of Beckett's, etc.

[5] In the New York art world, the idea seems to have originated with Don Judd.

Robert Rauschenberg: erasure of a de Kooning drawing then exhibited as "erased de Kooning by Robert Rauschenberg."

Yves Klein: "empty gallery" show at Iris Clert, April, 1958; and his smoke, fire, and water sculptures.

Christo: "Temporary Monuments," such as the packaging of the National Gallery of Modern Art in Rome, to take place in March, 1968.

Claes Oldenburg: numerous monument projects, including *Placid City Monument,* a trench dug and filled in again by union gravediggers behind the Metropolitan Museum (accepted by the New York City sculpture exhibition, fall, 1967).

Robert Morris: numerous projects in the early 1960's, including his cross-referenced *Card File,* and his four mirror cubes which disappeared into their reflections; his project for jets of steam as sculpture (refused by New York City sculpture exhibition, 1967), and for a circular low earth wall, to be erected at a Texas airport.

Carl Andre: 120 bricks to be arranged according to their mathematical possibilities; the negative of the first brick show in which empty space was the substance of the forms and the empty space from the first show was filled by bricks (Tibor de Nagy, New York, 1966, and Dwan Gallery, Los Angeles, 1967); scattered ceramic squares; a conical pile of sand in the Museum of Contemporary Crafts monuments exhibition, spring, 1967, formed by gravity when the sand was dropped from the floor above, which would disintegrate at the rate the body buried below would decompose (see Dan Graham, *Arts,* January, 1968).

Sol LeWitt: "nonvisual" serial projects incorporating conceptual logic and visual illogic; exhibition at the Konrad Fischer Gallery, Düsseldorf, January, 1968, of a series of hidden cubes indicated by lines drawn from their bases; project for a buried cube to be interred at a Texas airport.†

Mel Bochner: five negative photostatic panels of a block project for the "Monuments" show noted above, one of which consisted of facsimile quotations (Duchamp, Sartre,

† This was finally buried near the Visser house in Amsterdam.

and "John Daniels") and the dictionary definition of the word "block," spring, 1967.

Joseph Kosuth: painting as idea as idea, a negative photostat on canvas of the dictionary definition of the word "water," etc., 1967; his Lannis Gallery Book Show, consisting of favorite books chosen by a group of artists, many of which were dictionaries, manuals, lists, mathematical works, a leaning sheet of glass.

Christine Kozlov: "Compositions for Audio Structures"; open film can containing a reel of transparent film.

On Kawara: canvas with longitude and latitude of a spot in the Sahara desert painted on it; the date paintings: a canvas a day with dates painted on them (his journal notes one headline from newspaper of the day).

Terry Atkinson and *Michael Baldwin:* conceptual drawings based on various serial and conceptual schemes, among them a map of a thirty-six-square-mile area of the Pacific Ocean west of Oahu, scale three inches to the mile (an empty square); a rectangle with linear depictions of the states of Iowa and Kentucky, titled "Map to not indicate: Canada, James Bay, Ontario, Quebec, St. Lawrence River, New Brunswick . . ." and so on.

Hans Haacke: kinetic sculpture where the "motion" is provided by grass growing on a plexiglass cube; condensation, frost sculptures.

John Van Saun: Falling Fire object.

William Anastasi: exhibition of paintings of the walls on which they are hung in the gallery, slightly smaller scale, Dwan Gallery, New York, 1966.

Walter de Maria: drawing drawing, a white sheet with the word "drawing" lightly penciled in the center, lines in the desert.†

† As soon as this was written, in the autumn of 1967, we were told about other artists who should have been mentioned, and since that time the genre has continued to multiply rapidly. Among those who should have been noted above at that time, or soon after, are: Gene Beery's word paintings from the early sixties, the Rosario group in Argentina, Iain Baxter in Vancouver, Robert Barry, Lawrence Weiner, Douglas Huebler, Luis Camnitzer in New York and environs; Barry Le Va's scatterpieces in Los Angeles, Richard Long and Bruce McLean in England, Jan Dibbets in Amsterdam, etc.

New York Graphic Workshop
(Camnitzer, Castillo, Porter):
First Class Mail Art Exhibition.
1967.

250 METERS OF THICK
CHAIN ACCUMULATED
IN A CUBE OF HEAVY
GLASS, IN ORDER THAT
HALF OF THE SPACE
IS FILLED.

A PRISMATIC BEAM
OF BLUE LIGHT, WITH
A SECTION OF 10
METERS SQUARE, THAT
GOES FROM ONE HOUSE-
FRONT TO THE ONE
ACROSS THE STREET.

A PERFECT CIRCULAR
HORIZON.

A STRAIGHT THICK
LINE THAT RUNS
FROM HERE THROUGH
YOU TO THE END OF
THE ROOM.

A SURROUNDED
SPACE THAT
EXPANDS IN THE
DIRECTION YOU
WALK.

A ROOM WITH THE
CENTER POINT OF
THE CEILING
TOUCHING THE FLOOR.

THIS IS A MIRROR.
YOU ARE A WRITTEN
SENTENCE.

FOUR BRIDGES,
1 KILOMETER LONG,
FORMING A SQUARE
WITHOUT EXIT, OVER
POPULATED AREA.

A TEN STORY BUILDING
WITH STYROFOAM
FLOWING OUT OF THE
WINDOWS.

The following, more aesthetically oriented, are notable for their denial of painting's and sculpture's *expected* substance, or identity:

Dan Flavin: fluorescent light aggregations in which object has both material and immaterial identities.

Robert Ryman: hanging unstretched canvases, 1962; white painting, on paper, attached to the wall with roughly torn masking tape, in order to avoid elegance, slickness, and objectness (1966–67).

Michael Kirby: sculptures "as visual instruments" involving photographs and mirrors; also his performances.

Forrest Myers: searchlight sculpture projected over Tompkins Square Park, fall, 1967; his "lines" stretching between distant points in the streets or landscape.

Robert Smithson: project for mercury pool; map projects; earthworks.

Rick Barthelme: floor-ceiling sculpture of metallic tape in rectilinear U-form on floor, opposite U on ceiling; gift of the artist to the Lannis Museum of Normal Art.

Robert Huot: two-panel "painting," the first panel of unpainted textured nylon through which a muted shadow of the stretcher optically hovers, and next to it an empty stretcher; tape paintings.

And on the more literary side: Dan Graham's concrete poems and his poem-object with sliding letters covered by the word "one" so that all the possible permutations are equally acceptable within the ratio one-as-one-as-one-as-one; Ed Ruscha's books, such as *Various Small Fires and Milk* or *Every Building on Sunset Strip;* Bruce Nauman's unassuming book of his work and his projects in collaboration with William Wiley; Frederick Castle's article "illustrated" by dummy squares with descriptive captions in them; Daniel Spoerri's *Anecdoted Topography of Chance;* George Brecht's "events"; Ray Johnson's "mailings"; and innumerable other books, objects, and projects listed in the Something Else Press's catalogues.

The performance arts and film abound in related material, among them Gustav Metzger's "acid art," Ralph Ortiz's de-

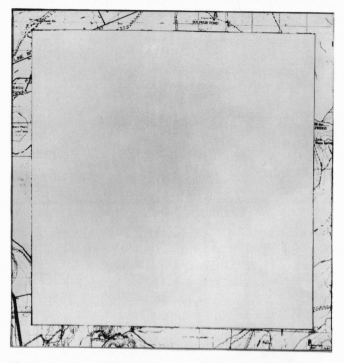

Robert Smithson: *Map for Nonsite—Mono Lake.* 1968. Photograph courtesy of Dwan Gallery, New York.

Edward Ruscha: "1850 S. Thayer Ave." and "2014 S. Beverly Glen Blvd.," two pages from *Some Los Angeles Apartments.* 1965.

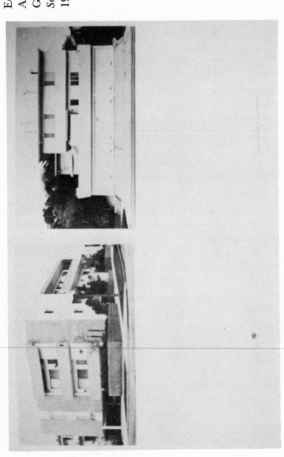

structions, and Elaine Sturtevant's revival of Erik Satie's Dada ballet *Relâche (Cancellation)*, which in its New York performance consisted of a cancellation of the performance.

There is a decided element of humor in most of this work which is by no means to say that it is not serious; the best comedy is always serious art; one would completely misunderstand Aristophanes, Swift, Chaplin, or Beckett if one assumed that they were not serious artists, just as one would misunderstand Democritus if one did not keep in mind that he was known as the "laughing philosopher," or the cynic Menippus if one forgot that he was known as "the secret dog who bites as he laughs" *(ridendo dicere verum)*. The sort of humor these artists are concerned with is really wit, an Anglo-Saxon word that originally meant "mind" or the powers of reasoning and thinking. One of its meanings is "the mental faculties in their normal condition of sanity," as in "to keep one's wits about him," and the word gradually came to designate "the ability to make clever, ironic, or satirical remarks usually by perceiving the incongruous and expressing it in a surprising or epigrammatic manner."

Taking this literary parallel into consideration, it is not surprising that the main twentieth-century sources for a dematerialized art are found in Dada and Surrealism. One can cite the Dada insistence on a *tabula rasa* at the aesthetic as well as the social level, in reaction to the physical emphasis of Cubism which, despite its initial shattering of solid form, aimed at re-creating the object in another, equally physical form. The Dadas adopted the anarchist Bakunin's slogan "Destruction is Creation"; later even Mondrian declared that the destructive element had been neglected in art. Picabia erased a poem as it was written on a blackboard at a Dada demonstration, and his 1913 Amorphist manifesto was illustrated by blank canvases because total opposition of color had canceled out color and total opposition of form had canceled out form; in 1920, Max Ernst made an object with a hatchet attached and spectators paid to take whacks at it; Schwitters hid rather than destroyed the Dada-Expressionist inner core of his first Merzbau by surrounding it with a Stijl-oriented framework. The par-

allels go on and on. But as is so often the case today, one must
return to Marcel Duchamp for the most valid prototype.
Younger artists probably do not consider Duchamp a particu-
lar influence or force as Johns, Dine, and others did around
1960; this is due to the almost total absorption and acceptance
of Duchamp's aesthetics into the art of the present. He is no
longer particular; he is pervasive.

In 1913, Apollinaire described Duchamp as "detached from
aesthetic preoccupations" and "preoccupied with energy."
Duchamp remembers:

> . . . the basis of my own work before coming to America
> in 1915 was a desire to break up forms—to "decompose"
> them much along the lines the Cubists had done. But I
> wanted to go further—much further—in fact in quite an-
> other direction altogether. This was what resulted in
> *Nude Descending a Staircase,* and eventually led to my
> large glass. . . . [*The Nude*] is an organization of kinetic
> elements, an expression of time and space through the ab-
> stract presentation of motion. A painting is, of necessity,
> a juxtaposition of two or more colors on a surface. I pur-
> posely restricted the *Nude* to wood coloring so that the
> question of painting per se might not be raised. There
> are, I admit, many patterns by which this idea could be
> expressed. Art would be a poor muse if there were not.
> But remember, when we consider the motion of form
> through space in a given time, we enter the realm of geom-
> etry and mathematics, just as we do when we build a
> machine for that purpose.[6]

Duchamp did not consider his *Nude* Futurist because for
him Futurism was:

> . . . an impression of the mechanical world. It was strictly
> a continuation of the Impressionist movement. I was not
> interested in that. I wanted to get away from the physical

[6] Marcel Duchamp, *Collection of the Société Anonyme; Museum of
Modern Art 1920* (New Haven: Yale University Art Gallery, 1950), p.
148; and J. J. Sweeney, "Eleven Europeans in America," *Museum of
Modern Art Bulletin,* Vol. 13, Nos. 4–5 (1926); interview with Duchamp.

aspect of painting. . . . I was interested in ideas—not merely in visual products. I wanted to put painting once again at the service of the mind. And my painting was, of course, at once regarded as "intellectual" and "literary" painting. It was true I was endeavoring to establish myself as far as possible from "pleasing" and "attractive" physical paintings. . . . Dada was an extreme protest against the physical side of painting. It was a metaphysical attitude.[7]

Among the issues raised by Duchamp and still valid and continuing today are: his *Dust Breeding,* 1920; his *Hidden Noise* ready-made, 1919; his string installation of the 1942 Surrealist show; his preoccupation in the *Large Glass* with shadows, with perception and the cinematic, with invisible, conceptual structures that connect by association or "electricity" the visible forms; his idea of provisional or temporary color (as in the malic molds that were painted in red lead *"while waiting* for each one to receive its color"); his interest in the transparency and immateriality of air as a medium; a note suggests the expansion of his 1919 *50 cc of Paris Air:* "Establish a society in which the individual has to pay for the air he breathes (air meters; imprisonment and rarified air, in case of nonpayment, simple asphyxiation; if necessary cut off the air)"; (souvenir stores in Maine sell bottles of Maine air). And finally, his preoccupation with definition: "Take a Larousse dictionary and copy all the so-called abstract words, i.e., those that have no concrete reference; substitute for them schematic signs to form the basis of a new alphabet." (The signs were to be arrived at by chance via the method that produced the *Three Standard Stoppages.*) In the *Green Box,*[8] from which these notes were drawn, Duchamp also talked about serial and snapshot effects applicable to art, and about the time element of inscription, such as his plan "for a moment to come (on such a day, such a date, such a minute), to *inscribe* a ready-made. . . . The important thing then is just this matter of timing, this snapshot effect, like a speech delivered on no matter what oc-

7 Duchamp interviewed by Sweeney, *ibid.*

8 *From the Green Box,* translated and introduced by George Heard Hamilton (New Haven: Readymade Press, 1957).

casion but at *such and such an hour*. It is a kind of rendez-vous."

The danger, or fallacy, of an *ultra*-conceptual art is that it will be "appreciated" for the wrong reasons, that it will, like Duchamp's *Bottle Rack* or *Large Glass,* come to be mainly an ingratiating object of aesthetic pleasure instead of the stringently metaphysical vehicle for an idea intended. The idea has to be awfully good to compete with the object, and few of the contemporary ideas listed above are finally that good. Nevertheless, the "thinness," both literal and allusive, of such themes as water, steam, dust, flatness, legibility, temporality, continues the process of ridding art of its object quality. Some of these artists hold that the idea is self-generating and self-conclusive, that building the sculpture or painting the painting is simply the traditional, expected step finally unnecessary to the aesthetic, but very little of their work is really conceptual to the point of excluding the concrete altogether. On the other hand, ideas like Oldenburg's trench or LeWitt's buried cube are both tangible and intangible, simple and complex. They open up art to the intellect without delivering it into any other cultural or transcultural area. Visual art is still visual even when it is invisible or visionary. The shift of emphasis from art as product to art as idea has freed the artist from present limitations—both economic and technical. It may be that works of art that cannot be realized now because of lack of means will at some future date be made concrete. The artist as thinker, subjected to none of the limitations of the artist as maker, can project a visionary and utopian art that is no less art than concrete works. Architecture provides many precedents for this kind of unmaterialized art; Wright's mile-high skyscraper is no less art for not having a concrete expression. Moreover, since dealers cannot sell art-as-idea, economic materialism is denied along with physical materialism.

Nonvisual must not be confused with nonvisible; the conceptual focus may be entirely hidden or unimportant to the success or failure of the work. The concept can determine the means of production without affecting the product itself; conceptual art need not communicate its concepts. The audience

at a Cage concert or a Rainer dance performance will never know what the conceptual framework of the work is. At the other extreme is LeWitt's contention: "Logic may be used to camouflage the real intent of the artist, to lull the viewer into the belief that he understands the work, or to infer a paradoxical situation (such as logic versus illogic). The ideas need not be complex. Most ideas that are successful are ludicrously simple. Successful ideas generally have the appearance of simplicity because they seem inevitable." [9]

Thus the difficulty of abstract conceptual art lies not in the idea but in finding the means of expressing that idea so that it is immediately apparent to the spectator. In math or science, the simpler the explanation or formula, the more satisfying it seems to be, and to reduce the great complexity of the universe to a single simple equation or metaphor is the goal. Even the simple progression of 1, 2, 3, in Dan Flavin's 1963 fluorescent piece *The Nominal Three; To William of Occam,* or the 1, 2, 3, 4 of David Lee's dark hanging plexiglass panels at Finch, are enough to satisfy the initial demands of a rational art. Even the most apparently elaborate schemes, such as Larry Poons's multiple inversions, though they require more deliberation to detect, once found are only slightly more complicated than the simple ones. Perhaps this, or the "camouflage" mentioned by LeWitt, is the reason for the popularity of hermetic motifs today. Hermeticism of one kind or another, manifested as enclosure or monotonality and near invisibility, as an incommunicative blank façade or as excessive duration, helps maintain the desired aloofness in a work confronted by the ordinary or suspiciously avid spectator, while at the same time it satisfies the artist's desire for difficulty and endears itself to the spectator willing to commit himself on a deeper level.

Much recent conceptual art is illustration in a sense, in the form of drawings or models for nearly impossible projects that will probably never be realized, or in many cases, *need* no further development. According to Joseph Kosuth: "All I make are models. The actual works of art are ideas. Rather than

[9] Sol LeWitt, "Paragraphs on Conceptual Art," *Artforum* (Summer, 1967), p. 80.

'ideals,' the models are a visual approximation of a particular art object I have in mind." [10] Mel Bochner's contribution to the Finch serial show—*Sixteen Isomorphs*—is a model after the fact—a model for a piece already executed, and dismantled. Its sixteen modules are serial photographs of a project set up in small black blocks specifically to be photographed.

The interest in rough working drawings, which has become something of a fetish among Primary Structurists, is indicative of a sneaking nostalgia for a certain executionary éclat denied them in the work itself. On the other hand, Bochner's working drawing show at the School of Visual Arts last year [1967], consisting of five identical loose-leaf notebooks filled with Xerox copies of the "exhibits" (including lists, notes, specifications for and bills from fabricators, contributions by poets and architects) brought up another point: the concept of drawing as pseudo-painting was banished and drawing was brought back to its original function as a sketch or medium for working out ideas—visual or intuitive. Nevertheless, the emphasis on diagrams and projects, on models and working drawings rather than the finished pieces, is usually accompanied by the existence of the finished pieces, and these are finally successful only if the idea—original or not—has been successfully translated into visual terms. All of the artists mentioned here were presumably attracted to visual art in order to express something concretely. They began by making work strongly visual in character—conventional painting and sculpture—and they may return to it at any time. Duchamp's example of almost total abstention is not likely to attract many, although certain highly intelligent but formally unoriginal artists will continue to make "art" that is largely an illustration of ideas rather than either visual or ultra-conceptual; their œuvre becomes a veritable Smithsonian of collected fact and invention—technological artifacts. Of course the use of the object of art as a vehicle for ideas is nothing new. In the course of art history it was only in the late nineteenth century that an alternative was offered by the proposal that art is strictly "retinal" or sensuous in effect— a proposition that has come down to us as the formal or mod-

10 *Non-Anthropomorphic Art by Four Young Artists: Four Statements* (Lannis Gallery, February, 1967).

ernist mainstream.[11] Throughout history, art has been not merely descriptive but has been a vehicle for ideas—religious, political, mystical; the object has been taken on faith. What something looks like and what it is about may be complementary but not necessarily (rarely) identical.

Sol LeWitt sees ultra-conceptual art as a "blind man's art" or "nonvisual art" whose logic is conceptual and whose visual appearance is incidental, regulated entirely by the concept rather than by the appearance. "The idea becomes a machine that makes the art," he has said. His most recent projects, like a good deal of other serially based art, are planned entirely conceptually but contain a few visual aspects that make no "sense" to the viewer, such as a shape that must be completely contained in another one and taken on faith rather than seen, or an odd proportion that just doesn't seem to work visually. A "nonvisual structure" is nonvisual because it does not inspire the usual response to art; it does not make compositional sense, just as the nonrelational primary painting or structure disregards compositional balance. In this way it may incorporate the irrational as well as the rational, disorder as well as order.

Some of the most rationally conceived art is visually nonsense. The extent to which rationality is taken can be so obsessive and so personal that rationality is finally subverted and the most conceptual art can take on an aura of the utmost irrationality. Hanne Darboven makes sheets of serial drawings on graph paper—endless permutations based on complex numerical combinations; the more she makes, the more offshoots become possible, and even hundreds of drawings based on a précis of a précis of a précis of one combination only imply the ultimate infinity. Her decisions on which to follow and which to leave are aesthetic. Darboven's is a kind of blind man's art too; the works themselves have analogies with Braille; they pass directly from the intellectual to the sensuous, almost entirely bypassing the visual. The illegible but fundamentally orderly tangle of lines connecting point to point is *felt* by the mathematical layman more than it is understood rationally or visually. Often there is not even a perceptible

11 Duchamp, interviewed by Sweeney, *op. cit.*

pattern. Carl Andre's bricks and metal plaques appear simple but stem from an extremely complex motivation; he offers clastic art as an alternative to plastic art: "Whereas plastic art is a repeated record or process, clastic art provides the particles for an ongoing process." [12] Like Darboven and Andre, and like Eva Hesse in her infinitely repeated identical shapes or rows of curiously exotic but understated forms, many ultra-conceptual artists seem to saturate their outwardly sane and didactic premises with a poetic and condensatory intensity that almost amounts to insanity. How normal is normal art, after all?

These artists are far more "inside of" their work than are others, such as Peter Young in his binary number paintings or Bernar Venet in his faithful copies or blowups of recent scientific diagrams and formulas obtained from Brookhaven Laboratories. Their work represents a simple idea simply put but remains, deliberately, outside—a comment on idea art, as was some pre-Pop work like Dine's or Magritte's. (Johns's number and letter series seems to have more in common with the first group.) Venet's "paintings" are visually simple and even, in spite of his intentions, decorative. They are beyond the intellectual comprehension of the artist himself, who, knowing that his audience is equally uninitiated, provides taped "explanations," which only compound the bewilderment of a spectator demanding "meaning" from the work.

Idea art has been seen as art about criticism rather than art-as-art or even art about art. On the contrary, the dematerialization of the object might eventually lead to the disintegration of criticism as it is known today. The pedantic or didactic or dogmatic basis insisted on by many of these artists is incorporated in the art. It bypasses criticism as such. Judgment of ideas is less interesting than following the ideas through. In the process, one might discover that something is either a good idea, that is, fertile and open enough to suggest infinite possibilities; or a mediocre idea, that is, exhaustible; or a bad idea, that is, already exhausted or with so little

12 Quoted in Dan Graham, "Carl Andre," *Arts* (January, 1968).

substance that it can be taken no further. (The same can be applied to style in the formal sense, and style except as an individual trademark tends to disappear in the path of novelty.) If the object becomes obsolete, objective distance becomes obsolete. Sometime in the near future it may be necessary for the writer to be an artist as well as for the artist to be a writer. There will still be scholars and historians of art, but the contemporary critic may have to choose between a creative originality and explanatory historicism.

Ultra-conceptual art will be thought of by some as "formalist" because of the spareness and austerity it shares with the best of painting and sculpture at the moment. Actually, it is as antiformal as the most amorphous or journalistic expressionism. It represents a suspension of realism, even formal realism, color realism, and all the other "new realisms." However, the idea that art can be experienced in order to extract an idea or underlying intellectual scheme as well as to perceive its formal essence *continues from* the opposing formalist premise that painting and sculpture should be looked at as objects per se rather than as references to other images and representation. As visual art, a highly conceptual work still stands or falls by what it looks like, but the primary, rejective trends in their emphasis on singleness and autonomy have limited the amount of information given, and therefore the amount of formal analysis possible. They have set critic and viewer thinking about what they see rather than simply weighing the formal or emotive impact. Intellectual and aesthetic pleasure can merge in this experience when the work is both visually strong and theoretically complex.

Some thirty years ago, Ortega wrote about the "new art": "The task it sets itself is enormous; it wants to create from nought. Later, I expect, it will be content with less and achieve more." [13] Fully aware of the difficulty of the new art, he would probably not have been surprised to find that a generation or more later the artist has achieved more with less, has continued to make something of "nought" fifty years after Male-

[13] José Ortega y Gasset, *The Dehumanization of Art* (New York: Doubleday, Anchor, 1956), p. 50.

vich's *White on White* seemed to have defined nought for once and for all. We still do not know how much less "nothing" can be. Has an ultimate zero point been arrived at with black paintings, white paintings, light beams, transparent film, silent concerts, invisible sculpture, or any of the other projects mentioned above? It hardly seems likely.

Art Within the Arctic Circle[*]

September 24: From New York to Edmonton, Alberta, with
Lawrence Weiner, artist, to meet Bill Kirby, Director of the
Edmonton Art Gallery and the N. E. Thing Company (Van-
couver artist Iain Baxter and his wife Elaine), and then fly to
somewhere within the Arctic Circle, where Weiner, NETCo.,
and Harry Savage, an artist from Edmonton, will execute
works of art proposed for that location. Virgil Hammock, an
Edmonton journalist and professor, and I will document the
proceedings. The trip is sponsored by the Art Gallery as part
of their "Place and Process" exhibition, which features out-
door and temporary work; the show itself will consist primarily
of film and photographic documentation of works done in
Edmonton and other parts of the world by the participating
artists (places range from the Sahara to the Arctic Circle to
New York, processes from an inane cornflake-spreading piece
to the rather more provocative contributions of artists such as
Richard Long, Dennis Oppenheim, and Robert Morris). The
Arctic expedition arose from Weiner's piece, conceived before

[*] Reprinted from *The Hudson Review,* Vol. XXII, No. 4 (February,
1970), pp. 665–674.

the exhibition: "An abridgement of an abutment to on near or about the arctic circle." [1]

September 25: Spent night in Edmonton and set out on the 1,200-mile flight to Inuvik, Northwest Territory, free passes courtesy of the Pacific Western Airlines. The distances involved are impressive. Edmonton itself is about 2,400 miles from New York, near the fifty-fifth parallel; Inuvik is some 60 miles within the Arctic Circle, almost to the seventieth parallel, in the delta of the great Mackenzie River, main thoroughfare to the North (all provisions go up by barge, or plane, since the gravel highway goes only as far as Yellowknife), and a short distance from Beaufort Sea—the relatively "warm" section of the Arctic Ocean. The land mass of the Canadian North is immense, the barren spaces awesome. The placid geometrically furrowed fields of central Alberta give way to huge forests; halfway through the trip the land begins to crumble into water—innumerable lakes, ponds, and rivers. The first stop, Hay River, on the southern edge of the Great Slave Lake, is bleak but spotted with brilliant yellow birches. Yellowknife, on the northern edge, is blue water, black muskeg bogs, and ledges that are gray from the ground but pinkish from above. In the hour and a half we have there we see the old part of this gold-mining town (dirt roads, shacks, tarpaper and log cabins, Indian children, huge black ravens, and lots of dogs, boats, seaplanes) and Larry does one installment of a work that is being done all over the world: "A natural watercourse diverted, reduced, or displaced"—here a small stone dam across a stream running into the lake.

One more stop at Norman Wells, an oil town set on the broad green-brown river between white mountain ranges, then to Inuvik, the prospect bleaker and bleaker with low, even hills, all alike, dotted with scrub pine, like poles with brief, cold-stunted branches sticking out the sides. These are vestiges of the taiga forest alternating with tundra—spongy hummocks of lichen, mosses, tiny plants, over a layer of perma-

[1] I shall concentrate here on Weiner's work since I recently discussed Baxter's at length (*Artscanada*, June, 1969) and am not acquainted with Savage's outside of that discussed here.

frost (frozen ice and soil) that never melts and extends across the whole Canadian North, making oil leakage particularly dangerous since it would spread across the water table instead of being absorbed into the earth. The landscape is not so exotic as I had expected; it is still not winter here, though temperatures are around 15°; there is some snow, lots of ice, and the ground is frozen. What makes it so impressive, and so uninteresting to describe, is the space, and the infinite sameness of the terrain, the very subtle color range illuminated by a sharp, even light that has a terrible clarity. We arrive at 6:30 P.M. into the eerie red glow of a curiously diffused sunset edged by dense blue skies.

Inuvik is a new town, begun in 1954; it is a new, and deplorable, type of town, owned by the government and oil companies, built as a "showplace" to replace the dying fort towns, or trading posts. In this case it replaced Aklavik, whose native peoples were virtually ordered to move on to Inuvik, though they resisted in part and Aklavik still subsists. As Farley Mowat has pointed out, "Inuvik was designed purely as a white administrative center" in which Indians and Eskimos are on the wrong side of the tracks—off the Utilidor (a sprawling "tin lizard" or metal overground tunnel connecting all the "good" houses in town and providing them with heat, water, and sewers). The result is "one of Canada's newest slums"—West Inuvik, or "Happy Valley," a "transitional area," as a pompous government administrator blithely called it when Larry said he had visited this miserable conglomeration of lean-tos, tents, and shacks. Inuvik is a red-neck town with an overnight population of well-dressed businessmen (many of them German and American) who come in to set up further exploitation plans. It is unexpected to come out of such a trip so preoccupied with social ills. We were in Inuvik thirty-nine and one-half hours. Long enough to get mad. "Why Go North? It's Mostly Because of the Money" reads a headline in the September *McLean's Magazine*. The money is not going to the natives. Canada has done as badly in many respects by her native population as we have. We stay at the misnamed Eskimo Inn, a brand-new, jerry-built plywood structure simulating the last word in North American motel architecture; but the

steps are open, raw wood; the building stands on tall, rough wooden pilings; the main street is mud; it's a sow's ear that refused transformation. ("The Eskimo Inn is not for Eskimos," a young native girl commented bitterly on the night of its Grand Opening, after she and friends had been evicted from the public bathroom.)

September 26: We borrow a truck from the Research Station, buy some wool caps at the Hudson's Bay Company (since fur-trading died out, simply another Sears or Grant's). The N. E. Thing Company sets out on its walking piece, which takes all morning; the rest of us go to the banks of the Mackenzie, not yet ice, though the mud is frozen, cracking eerily over large areas when stepped on. Larry does a second and third installment of "A natural water course diverted reduced or displaced"—a curved channel and a straight one, through which the broad river is indeed diverted—a gesture both absurd and touchingly grand.

Nearby, Harry fills a long strand of clear plastic wiener casings with water and lays it out in a slightly undulating line, about 20'. This "ice worm" begins to freeze immediately. (When we come back later it is almost solid, though some lumber has been unloaded from a barge onto one end of it.) Then Harry lies on a sheet of light-sensitive yellow blueprint paper, and creates a temporary silhouette.

Out to a kind of gravel pit in the bush, where Larry makes "An abridgement of an abutment to on near or about the arctic circle." Using whatever is at hand, in this case a cigarette package, he leans it against a broken pile of dirt. The piece is donated to the Edmonton Art Gallery, received by Bill Kirby, and will be registered as such by a lawyer.

After lunch, the Baxters now holed up in the Canadian National telegraph office, the rest of us go to "Slim" Semmler's general store (antlers over the door, run-down interior crowded with rubbers, long johns, rabbit pelts, canned foods, fur animals, and bead pins, "Eskimo" belts made in Japan). Bill digs out a few pieces of marvelous Eskimo sculpture by an Eastern Arctic Eskimo named Charlie Kooghealook. Back in the bush, Larry creases a rock with several shots of a .22

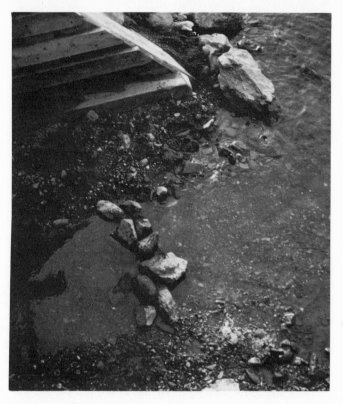

Lawrence Weiner: *A natural water course diverted reduced or displaced.* As executed in Inuvik, N.W.T., September, 1969.

("The Arctic Circle Shattered"). This piece belongs to me and I'm especially excited to see it executed. Harry tries to fly a plastic kite, but the Arctic wind is too strong and it breaks. Larry, exploring, discovers another running watercourse and does a fourth and very beautiful diversion by making a semi-dam of sticks and sheets of ice in a little waterfall. On the way back through town, Harry creates a spontaneous event that is one of the trip's high points. He still has a lot of these long sausage casings, which come rolled up in sticks. He goes over to a ravine where a bunch of children are playing and fiddles around conspicuously with the stick; they ask, of course, what it is, he gives it to them, and they inflate huge lengths of it, wind it around themselves, pull it, throw it, jump over it, and have a general field day while the RCMP (Royal Canadian Mounted Police) watch suspiciously from a car.

To the bar for hot rum. An Indian nearby beckons to Larry and buys him a drink. I go off with Bill and the Baxters. Find out later that the Indian's first, just conversational, question is: "Are you a fucking hippie?" He accepted Larry's "No" and said the priests had warned them against hippies who "would ruin everybody because they don't drink." More drinks and talk led to Larry's being taken by another Indian, a truck driver, to the "settlement" slum. The truck driver wanted to buy his boots. Pointed toes are stylish in Inuvik, where everyone dresses in high style, for the 1950's, but the Indians have wide feet.

On the other side of town with Bill and NETCo. Having spent the morning concentrating on Larry's pieces, I am struck again by the difference between him and Iain. They represent opposite poles of the non-object tendency. They hadn't met before this trip, though knew of each other. Yesterday they were talking about work they have done and have thought about doing and the congruence is strange. Often they have independently hit on similar ideas (a can of paint poured into a hole in the ground; nails driven into the earth; Arctic into Artic). Yet their heads are entirely different, Iain's rapidly alighting on one idea after another, often contradictory, usually well McLuhanized and with far-reaching implications; Larry's working slowly, with total seriousness, within

a clear, self-defined framework, a basically poetic expression, that defines *his* art. The all-embracing, Dada element in Iain disturbs him, as does the idea that art can be entertainment, which he finds debasing and ultimately injurious to art as art, but they get along well.

Baxter is little interested in Art per se and NETCo. has no "style"; different departments deal with different areas of "Visual Sensitivity Information." This trip deals with Arctic V.S.I. and ranges, typically and exuberantly, all over the place; from communications pieces dependent upon electronic technology (see below), to the walking piece (Iain and Elaine circled Inuvik wearing a pedometer and step-counting device —some 3¼ miles, 10,314 steps), which recorded the experience of a town (and a circuitous pun in distance); a piece by a Vancouver friend—George Sawchuk—consisting of the insertion of a padlocked bolt into the northern part of a tree trunk, titled "Locked Up North" (maybe a commentary on Canada's reluctance to deal with her Northern territories), and the works executed that afternoon alone. Elaine did a water exchange between the Seymour River, B.C., and the Mackenzie, adding the first, subtracting the second; we placed a large black-and-white sign reading "You Are Now in the Middle of an N. E. Thing Co. Landscape" in the taiga-tundra; I took a quarter-mile walk due North through the bush, compass in hand; Iain sprayed an East-West white-paint line in the tundra parallel to the latitudes; Elaine sprayed a tiny tree white (early snow) and, having discovered, by comparing the Rand-Mc-Nally Star Chart with the map of Inuvik's few miles of road, that the road to the airport bore the same configuration as that of the constellation Sculptor, NETCo. marked that section of the road with four round mirrors laid concave side up in the bush at the angle turns, simulating the stars.

The day we left, the Baxters did an "ecological" project in which areas of the tundra were turned over (I haven't the details on this). Baxter's interest in ecology predates that of most artists who have picked up on it during the last year or so. As a zoology major in college and later an illustrator of nature books, he became interested in the intricate balances of organisms and their environments and has since plugged this

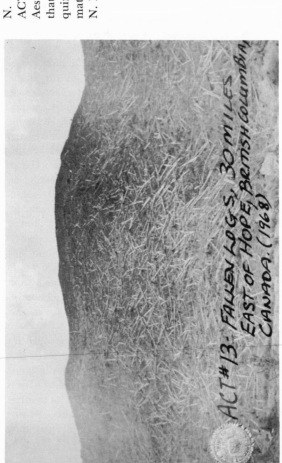

ACT #13. FALLEN LOG-S. 30 MILES EAST OF HOPE, BRITISH COLUMBIA, CANADA. (1968)

N. E. Thing Co. (Iain Baxter). ACT #13. 1968. (ACT: an Aesthetically Claimed Thing that has "met the stringent requirements of sensitivity information as set forth by the N. E. Thing Co.")

into information theory so that many of NETCo.'s pieces quietly draw attention to that relationship (for example—an erosion fountain, slow-motion flow; various ice and snow and skiing pieces in which natural processes are formalized within a small area). As an artist, of course, he also enjoys manipulating that relationship; last year he proposed a controlled grazing project by which concentric squares of different lengths of grass would be formed, and a "formal snow storm" in the Nevada desert where a snow configuration would be retained after the thaw by inset cooling coils. He has projects that deal with grafting of trees, artificially created and controlled oases, change of ecology within an area and then restoration to normal state. The Arctic seems an appropriate place for such studies because its ecology is extraordinarily delicate and vitally important to the future of the area.

Starving, we return to the hotel to find there is no place to eat in town tonight, and we are forced to attend the Eskimo Inn's grand opening to take advantage of pink alcoholic punch and soggy hors d'oeuvres. The whole town was invited and a few natives were there; a band played a fast rhythmic jigging music for Eskimo "step dancing," but few were interested in performing. The bored gentry of the town expected more. One of the overdressed ladies was overheard complaining: "We gave them drinks and now they won't even dance." Indians sat in one area, government and businessmen in another. Some glasses were smashed. Around midnight we go out again to do Harry's last piece. Back into the gravel pit where we light fifty red flares over a large area. Spectacular sights, especially all that hot mobile light set against the clear Arctic stars and pale full moon, made all the more bluish by contrast. We leave before the flares go out and see it from a distance, too. Wonder if anyone else has seen it, then pass an RCMP car going out to the site. Just as they turn in, the last flare flickers out.

September 27: Back on the plane, Larry and I beginning another twenty-four-hour trip back to New York City. Talking it over we are (1) very satisfied with the trip; (2) appalled by our reactions to social conditions in Inuvik; (3) I find that my strongest impression is of the work done, though the Arctic

environment was in part responsible for the art's memorability.

* * *

The kind of space dealt with by Weiner's art and some of Baxter's is not the traditional *occupied* or conquered space in which an object exists. It is a space partially dependent upon the receiver's experience of space and of words, and greatly dependent upon time. Weiner read somewhere about a custom of, I think, the Great Barrens Eskimos, who measure their emotions in actual space/time. When a man is angry he walks the anger out of his system in a straight line, stopping when the anger is gone and planting there an "anger stick," which will for some time bear witness to the length (therefore strength) of that emotion. The physical, aesthetic, and emotional beauty of such a gesture appeals to Weiner, whereas Baxter utilizes the oral tradition within the network of technological media. For example, three of the latter's pieces from the Circle were: a telegram reading "This statement will be is being has been sent from inside to outside the Arctic Circle" (the language a conscious nod to Weiner); a message sent by ham radio from the Arctic to the Antarctic (contact may take six months to be acknowledged and it will be only the second time it has been attempted, according to the Inuvik operator); a piece executed by NETCo. in the Circle and friends in Halifax, Nova Scotia, and Vancouver where each one looked to the North for a certain period of time, thereby "drawing" convergent sight lines in space and forming a triangle.

Before he became a painter, Weiner was a poet. He no longer writes, but his book, *Statements,* published by Seth Siegelaub in 1968, presents his work in a form generally associated with poetry—a single phrase per page, with blank facing page, no punctuation, and such eccentric, nonhyphenated word breaks as *f/rom, st/andard, pressur/e.* The work itself, however, deals essentially with a visual image that, when carried out, attains a poignant and insistent concreteness. As far as Weiner is concerned, the work exists as validly on paper as it would after being made or done; some works are "freehold" or can be "collected" by any "receiver" who cares to own or

execute them during a given period of time. In Siegelaub's semi-immaterial, semi-invisible "January 5–31, 1969" show, the freehold work was "One Standard Air Force Dye Marker Thrown into the Sea." Weiner's catalogue statement read:

1) The artist may construct the piece.
2) The piece may be fabricated.
3) The piece need not be built.
Each being equal and consistent with the intent of the artist, the decision as to condition rests with the receiver upon the occasion of receivership.

Siegelaub's "March" show (which existed as a calendar-catalogue and took place or did not take place all over the world, one piece each day of the month) included Weiner's "An object tossed from one country to another" which NETCo. "extended" by answering, ",and back again." (Baxter later executed this piece and filmed it; the object, tossed from America to Canada, and back again, was the movie camera.) This was a generalized piece, which became specific only when Baxter executed it. Others are more fundamentally specific. For the "Summer" show (these geographically scattered exhibitions have no titles aside from the dates of their duration), Weiner executed the following: "A rubber ball thrown into the american falls niagara falls / A rubber ball thrown into the canadian falls niagara falls." It was photographically documented by filmmaker Hollis Frampton, though for the most part Weiner does not encourage photographs of the works themselves, considering it immaterial (or nobody else's business) whether or not he has actually made the pieces or whether he has just gone to the site and stood around (I suspect they get made).

The pieces made in the Arctic Circle are typical of Weiner's more recent work, about to be published in a second book, in their examination of the relationship between language and act and visual experience. The 1968 pieces were essentially descriptions of possible objects, however dematerialized ("A series of stakes set in the ground at regular intervals to form a rectangle/Twine strung from stake to stake to de-

mark a grid"), or descriptions of acts often resulting in imper-
manent visual residue ("A field cratered by structured simul-
taneous TNT explosions," "One aerosol can of enamel
sprayed to conclusion directly upon the floor"). The more
recent work often focuses on place as material, and action
and place are often delimited by prepositions. Objects thrown
on the sea, in the sea, and at the sea are three different pieces.
He is also concerned with the change inherent in physical
boundaries (several pieces deal with international borders),
theoretical boundaries ("art" and "life"), and, accordingly,
provides his own linguistic boundaries (subtle distinctions in
the wordings of the work that affect or do not affect their phys-
ical presence if executed). The choice of words is very precise
even when the choice of place or materials is wholly open or
arbitrary.

Weiner doesn't like to have to go outside of the situation
for materials; even borrowing a rifle for the shattering piece
was an annoyance. He shares with Carl Andre and others a
distant and perhaps unwitting debt to Duchamp's aesthetic
of the found object, the temporary act. But Weiner is above
all a purist in that he is interested in art, art alone, art that
is "received" by people but not necessarily possessed by them.
He and several other unfortunately dubbed "conceptual" art-
ists seem to be fusing what once appeared to be the two
diametrically opposed mainstreams of modern art: the ac-
ceptive and the rejective, or Dada-Surrealist and abstract-
formalist, life and art, messy and clean aspects. They share
with the so-called Minimalists a dislike of the extraneous and
the anecdotal; but they have taken an additional step toward
divorcing art from luxury decoration by abolishing or at least
deemphasizing its object aspect. Many of Weiner's pieces con-
cern "removal," an idea explored in 1960 with a "cratering
piece" in Mill Valley, California, and in later niched, mono-
tonal canvases. His visible contribution to the January show
was a "36″ × 36″ Removal to the lathing or support wall of
plaster or wallboard from a wall." He disavows interest in the
"process" (a fashionable concept in the art world at the mo-
ment) of removal, but finds "the idea of removal is just as—if
not more—interesting than the intrusion of a fabricated ob-

ject into a space, as sculpture is." He also refuses to be called a "materialist," which "implies a primary involvement in materials, but I am primarily concerned with art. One could say the subject matter is materials, but its reason to be goes way beyond the materials to something else, that something else being art. . . . If I were to choose the condition of the piece [fabrication or nonfabrication], that would be an art decision which would lend unnecessary and unjustified weight to what amounts to presentation—and that has very little to do with art." [2]

Though Weiner showed paintings in 1964 and 1965, the wandering, impermanent, and geographical basis of much of his current work has its roots in years spent hitchhiking across the country, herding sheep, working with a forest ranger, with explosives, on the docks, at sea, when he would make sculptures in the woods or fields and simply leave them there to be found or not found by a chance "receiver." At the moment he is following up his particular affinity for the North by a trip to the Norwegian Arctic to make a glacier piece. Northern spaces are grand, bleak, infinite, and reject autonomous, manmade objects almost by definition. Vilhjálmur Stefánsson has written of scale-deception in the Arctic:

> One sees things under circumstances that give one no idea of the distance, and consequently one has no scale for comparison. The marmot at twenty yards occupies as large a visual angle as a grizzly bear at several hundred, and if you suppose the marmot to be several hundred yards away you naturally take him for a bear. There is, under certain conditions of hazy Arctic light, nothing to give you a measure of the distance, nothing to furnish a scale to determine size by comparison.[3]

Under such conditions, imposed somewhat differently by the endless rolling tundra and a flat snow landscape, a work of art has no scale, or rather no relative scale, and does not com-

[2] Interview by Arthur Rose, *Arts Magazine*, Vol. 43, No. 4 (February, 1969).

[3] Vilhjálmur Stefánsson, *My Life with the Eskimo* (New York: Macmillan, 1962).

pete with nature, partly because few people will see it, partly
because it need be compared to no other art, partly because it
is impermanent anyway. The natural watercourses were di-
verted, displaced, or reduced only temporarily. The rock
creased by bullets resulting from "The Arctic Circle Shattered"
is an artifact but it is not the work of art. I may own it on
paper but the residents of Inuvik who come to the gravel pit
in the tundra where the rock is located "own" the artifact,
the five people who were present at its execution are "re-
ceivers" of the act, and anyone who reads it is an equally di-
rect recipient. The property values accruing to most art are
absent, and the work itself either reverts to a primitive, pre-
ownership natural state or else is available as a post-capitalist,
communally owned work of art.

It is not wholly coincidental that Weiner's aesthetic agrees
with that of the Eskimos who were once the masters of the
land where Inuvik stands.[4] The Eskimo language contains
no words for measurement of space or time. The fact that in
the winter the arctic landscape is constantly changing under
the influence of storms and temperature alterations, and his
nomadic life-style, give the Eskimo a curious (for us) attitude
toward property, toward form, toward permanence. "Where
we think of art as possession, and possession to us means con-
trol, means to do with as we like, art to them is a way of
revealing". (Carpenter) "The Eskimo conception of individ-
uality belongs in the same category of conceptions as that of
unity and entirety, the whole and the all; and the distinction
between spirit in general and individual spirit possesses not
nearly so much power over their minds as over ours." (Ries-
man) Their language contains no verb "to be" but all words
(there is little distinction between verb and noun) are forms
of "to be":

4 Here I depend heavily on the following articles and books: Edmund
Carpenter, "Image Making in Arctic Art" and Paul Riesman, "The Eskimo
Discovery of Man's Place in the Universe," both in Gyorgy Kepes, ed.,
Sign, Image, Symbol (New York: Braziller, 1966); Farley Mowat, *Canada
North* (Toronto: Little, Brown, 1968), and *People of the Deer* (New York:
Little, Brown, 1952); Vilhjálmur Stefánsson, *My Life with the Eskimo*
(New York: Macmillan, 1962).

Eskimo is not a nominal language; it does not simply name things which already exist, but rather brings both things and actions (nouns and verbs) into being as it goes along. . . . To Western minds, the "monotony" of snow, ice and darkness can often be depressing, even frightening. Nothing in particular stands out; there is no scenery in the sense that we use the term. But the Eskimos are not interested in scenery, but in action, existence. . . . Theirs is a world which has to be conquered with each act and statement. . . . Man is the force that reveals form. He is the force which ultimately cancels nothingness.

(Carpenter)

The eye is subservient to the ear, and possessions, even their own art of ivory carving, are treated carelessly, as acts like songs rather than objects to be coveted:

The essential feature of sound is not its location, but that it *be,* that it fill space. . . . Auditory space has no favored focus. It is a sphere without fixed boundaries, space made by the thing itself, not space containing the thing. It is not pictorial space, boxed in, but dynamic, always in flux, creating its own dimensions, moment by moment. It has no fixed boundaries. The eye focuses, pinpoints, abstracts, locating each object in physical space, against a background; the ear favors sound from any direction.

(Carpenter)

Weiner has done his best work since he moved out of the pictorial boundaries of painting and the static boundaries of sculpture into the extremely complex realm of the indeterminate in relation to the determinate. His pieces are highly abstract because they can be "made" with whatever "materials" the reader-receiver "has in mind" or any materials the receiver-executor has in reach. While they are eminently out there in "life," to be experienced almost at random when they exist outside of museum-gallery-collection circumstances, they are also very much art—nonfunctional, expressive, sensorially stimulating, raising new questions *in situ* or out of sight.

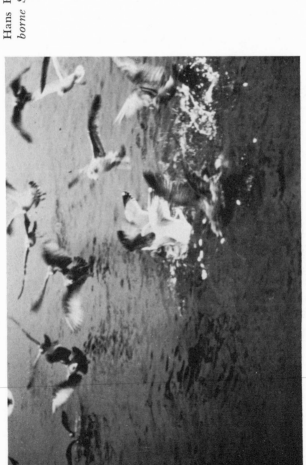

Hans Haacke: *Random Airborne Systems.* 1968.

Jan Dibbets: *TV as a Fireplace.* 1969. Twenty-four minutes of pure fire, transforming the television set into an electronic fireplace; transmitted on West German TV, December 24–31, 1969.

Douglas Huebler: One photograph from *Duration Piece #5*.
New York, April, 1969. "During a ten-minute period of time
on March 17, 1969 ten photographs were made, each docu-
menting the location in Central Park where an individually
distinguished birdcall was heard. Each photograph was made
with the camera pointed in the direction of the sound. That
direction was then walked toward by the auditor until the
instant that the next call was heard, at which time the next
photograph was made and the next direction taken. The ten
photographs join with this statement to constitute the form of
this piece." Collection of Lucy R. Lippard.

AT PAULA COOPER 96/100 PRINCE STREET

TWO BLUE WALLS
(PRATT & LAMBERT #5020 ALKYD)

SANDED FLOOR
COATED WITH POLYURETHANE

SHADOWS CAST BY
ARCHITECTURAL DETAIL AND FIXTURES
USING AVAILABLE LIGHT

Robert Huot: Exhibition at Paula Cooper Gallery, New York, March–April, 1969.

Joseph Kosuth: *VI. Physical Properties (Art as Idea as Idea)*.
1968. Published in *New York* magazine, 1969.

**ALL THE THINGS I KNOW
BUT OF WHICH I AM NOT
AT THE MOMENT THINKING—
1:36 PM; JUNE 15, 1969**

Robert Barry

On Kawara: *I Got Up*. Approximately three months of daily postcards, 1969–70; one example of a series begun two years earlier.

A$_1$ b$_2$ s$_{19}$ e$_5$ n$_{14}$ t$_{20}$ e$_5$ e$_5$
I$_9$ n$_{14}$ f$_6$ o$_{15}$ r$_{18}$ m$_{13}$ a$_1$ t$_{20}$ i$_9$ o$_{15}$ n$_{14}$
a$_1$ n$_{14}$ d$_4$ o$_{15}$ r$_{18}$
C$_3$ r$_{18}$ i$_9$ t$_{20}$ i$_9$ c$_3$ i$_9$ s$_{19}$ m$_{13}$ [*][†]

ABSENCE: (1) withdrawal, nonexistence, nonresidence, non-presence, nonattendance, disappearance, dispersion. (2) emptiness, void, vacuum, vacuity, vacancy, depletion, exhaustion, exemption, blank, clean slate, *tabula rasa*. (3) absentee, truant. (4) nobody, no body, nobody present, nobody on earth, not

[*] Reprinted from Kynaston McShine (ed.), *Information* (New York: Museum of Modern Art, 1970), pp. 74–81.

[†] The following instructions were sent to Kynaston McShine in lieu of an Index to the *Information* catalogue, for which the necessary information did not arrive in time. When I realized it would not, I decided to substitute some absentee information arrived at by chance. I opened a paperback edition of Roget's Thesaurus to "absence," hoping to get some ideas. The book had been given to me, secondhand, by a friend in December, 1969; I had not opened it until this point (Wednesday, April 15, 1970, 3:30 P.M., in Carboneras, Spain). When I did so, I found not only the entry above (now cut and revised) but two red tickets, unused, inscribed as follows: Museum of Modern Art, FILM RESERVATION Wednesday Afternoon 3:00 P.M. Showing NOT FOR SALE Keller Printing Co. New York; the numbers on them were 296160 and 296159. These tickets determined the initial framework for the following situation/text. Quotations from and debts or references to the works of the following persons are included in it: Art Workers Coalition, David Askevold, Gaston Bachelard, Robert Barry, Frederick Barthelme, D. E. Berlyne, Mel Bochner, John Cage, Marcel Duchamp, Dan Graham, Latvan Greene, Douglas Huebler, William James, On Kawara, Joseph Kosuth, R. D. Laing, Sol LeWitt, Marshall McLuhan, Ad Reinhardt, Saint-Beuve. (L.R.L.)

a soul, nary a soul, nobody under the sun, nary one, no one, no man, never a one.

Be absent, absent oneself, go away, stay away, keep away, keep out of the way, slip away, slip off, slip out, hold aloof, vacate. *Colloq.* hooky, cut, not show up, not show, French Leave, Spanish Pox, make oneself scarce. *Slang,* go A.W.O.L., jump, skip.

(1) absent, away, missing, missing in action, lost, wanting, omitted, nowhere to be found, out of sight, gone, lacking, away from home. Absent Without Official Leave, abroad, overseas, overlooked, overseen, on vacation. *Colloq.* minus. (2) empty, vacant, void, vacuous, untenanted, unoccupied, uninhabited, uninhibited, tenantless, deserted, abandoned, devoid, forsaken, bare, hollow, blank, clear, dry, free from, drained. *Colloq.* Godforsaken.

Nowhere, elsewhere, neither here nor there, somewhere else, not here. *Dial.* nowheres. Without, wanting, lacking, less minus, *sans.*

SEE ALSO PRESENCE

Games are situations contrived to permit simultaneous participation of many people in some significant pattern of their own corporate lives. 1311819811212 13312218114

PART I

A. For each artist in the exhibition whose name begins with a vowel, proceed as follows: go to the Museum of Modern Art Library and look under the artist's name in the general card catalogue. From the first book or article entered under his last name (whether or not it is his own name), transcribe the twenty-fourth sentence $(2 + 9 + 6 + 1 + 6 + 0 = 24)$. If there is nothing under that name, take the first name occurring in the catalogue that begins the same way and has the most beginning letters in common with

the artist's name (e.g., for Barthelme: Barthelm, Barthel, Barthe, Barth, Bart, Bar, Ba, B, in that order).

For each artist in the exhibition whose name begins with a consonant, follow the same procedure taking the thirty-second sentence $(2 + 9 + 6 + 1 + 5 + 9 = 32)$ of the first book or article occurring in the most recent full volume of the *Art Index*. If in any case there is no text, or no twenty-fourth or thirty-second sentence, reproduce in its place the eighth picture or the picture on page eight or the picture one-eighth of the way through the reference $(8 = $ common denominator of $24/32)$.

B. Make an alphabetical list of these artists, each name followed by the quotation arrived at above, with full bibliographical source (i.e., author, title of book, publisher, place published, date, page number; or, in the case of an article: author, title, magazine, volume number, date, page number).[1]

Acconci, Vito (Accardi, Carla)
 "Die erste Einzelausstellung in Deutschland findet im September 1966 in der Galerie M.E. Thelen in Essen statt."
 Galerie M. E. Thelen, Essen. *Carla Accardi.* Essen: The Gallery, 1966, p. 3.

Andre, Carl
 "An astronaut who slips out of his capsule in space has lost his environment, any living organism has an environment."
 The Hague, Gemeentemusem. *Carl Andre.* The Hague: The Museum, 1969, p. 5.

Armajani, Siah (Arman)
 "Thus, for example, round objects will by their nature make curved marks when dipped in colour and rolled across a surface."
 Jones, Peter. "Arman and the Magic Power of Ob-

[1] The directions for Part I were executed for the catalogue by the library staff of The Museum of Modern Art; the results follow.

jects." *Art International,* Vol. VII, No. 3 (March 25, 1963), p. 41.

Arnatt, Keith (Arnatt, Ray)
"It is rather like the poet and the sunset."
Arnatt, Ray. "A View of Opposites." *Ark,* No. 28 (December, 1960), p. 31.

Art & Project (Artaria, Paul)
"Ein richtig gebautes Holzhaus ist im Sommer kühl, im Winter wird es rasch warm und hält auch die Wärme."
Artaria, Paul. *Schweizer Holzhäuser aus den Jahren 1920–40.* Basel: B. Wepf, 1942, p. 11.

Artschwager, Richard (Arup, Ove)
"In another way his achievement is built on a broad basis: he is not just an engineer, or an architect, or a contractor and constructor, but all three rolled into one."
Arup, Ove. Foreword to Faber, Colin, *Candela/The Shell Builder.* New York: Reinhold, 1968, p. 7.

Askevold, David (Askeland, Jan)
"I Paris suget han til seg av de maleriske nyvinninger de franske malerne hadde frembragt, i Tyskland synes det derimot først og fremst å vaere de filosofisklitteraere ideene som fanget hans interesse."
Askeland, Jan. *Profiler I. Norsk Grafikk* . . . Oslo: Dreyers Forlag, 1958, p. 8.

Atkinson, Terry (Atkinson, Tracy)
"A variety of this substance later became the 'celluloid' now little used but well known to our grandfathers in forms as diverse as billiard-balls and shirt collars."
Atkinson, Tracy. Introduction to Milwaukee, Art Center. *A Plastic Presence.* Milwaukee: The Center, 1969, p. 5.

Bainbridge, David (Baines, George Grenfell)
"As primary and secondary school costs are partly met out of local authority rates, a second interest in maintaining ceiling levels is created, though it does seem that final costs which are known to the local authority are not as well known in the Ministry unless a flagrant breach occurs."

Baines, George Grenfell. "Cost Ceilings—Curse or Blessing?" *Journal of the Royal Institute of British Architects,* Vol. 76, No. 4 (April, 1969), p. 160.

Baldessari, John
See illustration.
Baldessari, John. "Solving Each Problem." *Art News,* Vol. 67, No. 8 (December, 1968), p. 7.

Baldwin, Michael (Baldwin, Arthur Mervyn)
"Neben Diversion und Grundlastigkeit, als Prinzipien der New Sculpture, tritt damit die Gesetzmässigkeit der 'Syntax': der Bezug zwischen den formalen Setzungen ist wichtiger als ihre monolithische Einzelpräsenz."
Kudielka, Robert. "New English Sculpture—Abschied vom Objekt." *Kunstwerk,* Vol. 22, No. 1–2 (October–November, 1968), p. 19.

Barrio (Barrios, Gregg)
"A menacing young bitch uses a sharp knife to cut a defenseless victim's jeans."
Barrios, Gregg. "Naming Names: the Films of Carl Linder." *Film Quarterly,* Vol. 22, No. 1 (Fall, 1968), p. 42.

Barry, Robert
"Also in the show will be a room filled with ultrasonic sound."
Rose, Arthur. "Four Interviews with Barry, Huebler, Kosuth and Weiner." *Arts,* Vol. 43, No. 4 (February, 1969), p. 22.

Barthelme, Frederick (Barth, Bradi)
See illustration.
Arts, Vol. 43, No. 2 (November, 1968), p. 8.

Becher, Bernhard and Hilla (Bechtel, Edwin De Turck)
"They illustrate."
Bechtel, Edwin De Turck. "Illustrated Books of the Sixties: a Reminder of a Great Period in Illustration." *Print,* Vol. 23, No. 3 (May, 1969), p. 21.

Beuys, Joseph
"Richard Serra se souvient de Pollock, et même de Motherwell; mais où son originalité éclate, non sans

quelque afféterie, c'est lorsque, alognant sur un mur neuf harnais de caoutchouc découpés en lanières aux belles inflexions décoratives, il souligne le mouvement de l'un d'entre eux d'une nonchalante arabesque de néon."

Pierre, José. "Les Grandes Vacances de L'Art Moderne." *L'Oeil,* No. 173 (May, 1969), p. 13.

Bochner, Mel (Boers, Dieter)

"Die künstlerische Arbeit erweist sich am überzeugendsten dort, wo entgegen aller Irritierung trotzdem eine autonome ästhetische Gestalt gefunden wird."

Boers, Dieter. "Deutsche Kunst: eine neue Generation II." *Kunstwerk,* Vol. 22, Nos. 9–10 (June–July, 1969), p. 4.

Bollinger, Bill

"Now the dross is almost all gone, for the natural history and the techni-poetry was returned to Europe on his recent trip there."

B[runelle], A[l]. "Bill Bollinger." *Art News,* Vol. 67, No. 9 (January, 1969), p. 17.

Brecht, George (Breeze, Claude)

"Breeze's heartless examination of the conflict between the sexes is forcefully scientific, actual, physical."

Simmins, Richard. "Claude Breeze: Recent Paintings and Drawings." *Artscanada,* Vol. XXVI, No. 128/129 (February, 1969), p. 37.

Broegger, Stig (Broek, Johannes H. Van Den, and Bakema, J. B.)

"L'ensemble repose sur quatre piliers implantés dans une pièce d'eau."

———. "Pavillon Néerlandais: Van Den Broek et Bakema C. Weeber, Ingénieur." *L'Architecture d'Aujourdhui,* No. 143 (April–May, 1969), p. 15.

Brouwn, Stanley (Brown, Bill)

"You might just be right about the corn pone but, then, you're probably not."

Williams, Jonathan. "Of Brown and Penland." *Craft Horizons,* Vol. 29, No. 3 (May–June, 1969), p. 47.

Buren, Daniel
 "The beholder will have had no more than the illusion of communication."
 Claura, M. "Paris Commentary." *Studio,* Vol. 177, No. 907 (January, 1969), p. 47.

Burgin, Victor
 "Cage is hopeful in claiming, 'We are getting rid of ownership, substituting use;' [3] attitudes towards materials in art are still informed largely by the laws of conspicuous consumption, and aesthetic commodity hardwear continues to pile while utilitarian objects, whose beauty might once have been taken as conclusive proof of the existence of God, spill in inconceivable profusion from the cybernated cornucopias of industry."
 Burgin, Victor. "Situational Aesthetics." *Studio,* No. 178 (October, 1969), p. 119.

Burgy, Donald
 "Thus the art system has maintained its vitality by constantly reaching outside of itself for data."
 Burnham, Jack. "Real Time Systems." *Artforum,* Vol. 8, No. 1 (September, 1969), p. 50.

Burn, Ian and Ramsden, Mel (Burnett, Calvin)
 "Adele Serronde, who channeled city 'Summerthing Project' funds into scaffolding, paint and fees of $500 per mural, stresses the impact of these two artists as role-models: 'The main thing is to get the younger boys interested', she says, 'to have them see somebody as an artist who isn't feminine, who's virile and, well, strident.'"
 Kay, Jane Holtz, "Artists as Social Reformers." *Art in America,* Vol. 57, No. 1 (January, 1969), p. 45.

Byars, James Lee
 "This theory diminishes the value of further verbal communication between people which presumably only distorts the reality of the original meeting."
 Barnitz, Jacqueline. "Six One Word Plays." *Arts,* Vol. 43, No. 1 (September/October, 1968), p. 19.

Carballa, Jorge (Cabianca, Vincenzo)
"Non è quindi possibile, di fatto associare in una stessa riunione le centinaia di invenzioni feconde del mondo dell'architettura cariche spesso di indicazioni di stupendi è validi traguardi con le pochissime opere che tale validità riescono a mantenere sino al livello attuativo dopo essersi misurate e scontrate con le difficoltà del sistema."

Cabianca, Vincenzo. "I Premi Nazionali e Regionali IN/ARCH 1966." *Architettura*, Vol. 13, No. 157 (November, 1968), p. 499.

Cook, Christopher (Cook, Brian F.)
"Its right arm is missing from just above the elbow, and in the left hand is an object of irregular shape that appears to be a liver."

Cook, Brian F. "Two Etruscan Bronze Statuettes." *Metropolitan Museum Journal*, Vol. 1 (1968), p. 170.

Cutforth, Roger (Cutler, Anthony)
"The martyr's face has ears set almost at right angles to his head, like the saint in the north soffit of the Garda arch, and the contours of his face are defined by similar contrasts between highlight and shadow."

Cutler, Anthony. "Garda, Källunge, and the Byzantine Tradition on Gotland." *The Art Bulletin*, Vol. 51, No. 3 (September, 1969), p. 258.

D'Alessio, Carlos (Daley, William)
"These are not cups as such but are *about* cups: the spirit of cups, cups reincarnated, cups purified by removal of function."

———. "Exhibitions." *Craft Horizons*, Vol. XXIX, No. 2 (March/April, 1969), p. 43.

Darboven, Hanne (Darbourne and Darke)
See illustration.

———. "Housing, Pimlico London." *Architectural Review*, Vol. 145, No. 866 (April, 1969), p. 286.

De Maria, Walter
"They saw nature as a protective refuge against the dehumanizing industrial age."

Shirey, David L. "Impossible Art—What It Is: Earth-

works." *Art in America,* Vol. 57, No. 3 (May–June, 1969), p. 34.

Dibbets, Jan

"Vieles von dieser Gesellschafts-Anti-Form, auf der einen Seite der Hang zur Kontemplation und anderseits die von der Verherrlichung des physischen und schöpferischen Ichs getragene Aktion, ist in diese neue Kunst eingeflossen."

Ammann, Jean-Christophe. "Schweizer Brief." *Art International,* Vol. 13, No. 5 (May 20, 1969), p. 48.

Ferguson, Gerald

"In a world of rapid change and new invention, radical departures have come to be expected."

Ferguson, Gerald. "Jim Leedy. Anna Leonowens Gallery. Nova Scotia College of Art, February, 1969." *Artscanada,* Vol. XXVI, No. 2 (April, 1969), p. 45.

Ferrer, Rafael

"The organizers of the show, Marcia Tucker and James Monte, had arranged things such that this splendid desecration was the first thing one saw upon entering the exhibition area."

Schjeldahl, Peter. "New York Letter." *Art International,* Vol. 13, No. 7 (September, 1969), p. 70.

Flanagan, Barry

"Kandinsky worked in total isolation at Neuilly, fired by the hope that he might live on into a brighter future."

Glueck, Grace. "Open Season. New York Gallery Notes." *Art in America,* Vol. 57, No. 5 (September/October, 1969), p. 117.

Fulton, Hamish (Fuller, Richard Buckminster)

"L'intellect aussi dépend de ce principe des contraires: il aspire à la métaphysique, mais ramène le désordre à l'ordre; il développe des idées de complexité croissante, mais simplifie les moyens d'expression."

Ryser, Judith. "RIBA '68: Londres. Remise de la Médaille D'Or Royale d'Architecture à Richard Buckminster Fuller." *Werk,* Vol. 55, No. 9 (September, 1968), p. 624.

Gilbert and George (Gilbert, Gerry)
"Unidentified flying objects are unidentified falling objects."
Gilbert, Gerry. "1000 Words on Lee-Nova." *Arts-canada,* Vol. XXVI, No. 2 (April, 1969), p. 15.

Giorno Poetry Systems
"Reason: too much taped obscenity."
"Telephone's Hot Breath: Poet Giorno's Dial-a-Poem." *The Architectural Forum,* Vol. 131, No. 1 (July/August, 1969), pp. 43f.

Graham, Dan (Graham, Robert)
"Most of them are sprawled, sound asleep, on diminutive beds."
Graham, Robert. "In the Galleries." *Arts Magazine,* Vol. 43, No. 7 (May, 1969), p. 64.

Group Frontera (Frost Associates)
"An inventive scheme breaks out of the traditional city-block, link-fenced playground mold, and steps clustered units across the hilly, irregular terrain."
————. "P.S. 36 Is Scaled for Very Small Pupils—and a Highly Urban Setting." *Architectural Record,* Vol. 144, No. 5 (November, 1968), p. 152.

Haacke, Hans
"Our age—it is one of science, mechanism, of power and death."
Glueck, Grace. " 'Tis the Month before Christmas . . . New York Gallery Notes." *Art in America,* Vol. 57, No. 6 (November/December, 1969), p. 154.

Haber, Ira Joel (Haas, Felix)
"Younger architects like Rosselli, 4 (house at Lake Maggiore, 1958), Ungers, 5 (Students' Hostel at Lindenthal, near Cologne, 1958), and Chasmann, 6 (model of house at Tzaala, near Tel-Aviv, 1965), build to strike hard, to shock—in short to do what the dadaists did."
Haas, Felix. "Dada and Architecture." *The Architectural Review,* Vol. 145, No. 866 (April, 1969), p. 288.

Hardy, Randy (Hardy, Hugh)
"It requires that the performer move to be understood, and it emphasizes the actions of his body."

Hardy, Hugh. "An Architecture of Awareness for the Performing Arts." *Architectural Record,* Vol. 145, No. 3 (March, 1969), p. 118.

Heizer, Michael
"The Downs are hills covered with a natural lawn."
Hutchinson, Peter. "Earth in Upheaval. Earth Works and Landscapes." *Arts Magazine,* Vol. 43, No. 2 (November, 1968), p. 19.

Hollein, Hans
See illustration.
L'Architecture d'Aujourd'hui, No. 140 (October, 1968), p. xxiii.

Huebler, Douglas
"Barry."
Rose, Arthur R. "Four Interviews with Barry, Huebler, Kosuth, Weiner." *Arts Magazine,* Vol. 43, No. 4 (February, 1969), p. 22.

Huot, Robert
" 'Stella, Noland, & Olitski' sounds like the name of a slightly seedy law firm but is, of course, the still-reigning triumvirate of what Clement Greenberg dubbed Post-Painterly Abstraction."
Schjeldahl, Peter. "New York Letter." *Art International,* Vol. 13, No. 6 (Summer, 1969), p. 64.

Hutchinson, Peter
"The Downs are hills covered with a natural lawn."
Hutchinson, Peter. "Earth in Upheaval. Earth Works and Landscapes." *Arts Magazine,* Vol. 43, No. 2 (November, 1968), p. 19.

Jarden, Richards (Jaray, Tess)
"The observer can detect the subliminally enclosed nature of the work only by productively associating in the artistic process."
Kudielka, Robert. "Tess Jaray: New Paintings." *Art International,* Vol. 13, No. 6 (Summer, 1969), p. 41.

Kaltenbach, Stephen
"In another work, he seems to prop a lead picture rectangle against the wall by means of a pipe wedged

diagonally from the floor."

> Kozloff, Max. "9 in a Warehouse. An 'Attack on the Status of the Object.'" *Artforum,* Vol. 7, No. 6 (February, 1969), p. 41.

Kawara, On (Kawashima)

"These are subtle and intense paintings that somehow achieve serenity and energy at the same time."

> "Reviews and Previews." *Art News,* Vol. 68, No. 6 (October, 1969), p. 13.

Kosuth, Joseph

"Barry."

> Rose, Arthur R. "Four Interviews with Barry, Huebler, Kosuth, Weiner." *Arts Magazine,* Vol. 43, No. 4 (February, 1969), p. 22.

Kozlov, Christine (Kozloff, Max)

"As for those spectators who have preferred the beauty of that splendid car, the Bugatti Royale, to any of the mere works of art in the show, this is as literalistic a mistake as preferring a beautiful woman to the incomparably different beauty of the object which is her portrait."

> Kozloff, Max. ". . . Art Negotiates with the Machine as the Central and Most Unavoidable Presence of Its Time." *Artforum,* Vol. 7, No. 6 (February, 1969), p. 23.

Latham, John

See illustration.

> Harrison, Charles. "Against Precedents." *Studio International,* Vol. 178, No. 914 (September, 1969), p. 90.

Le Va, Barry

"By spring, there were only a few stakes with bags of hardened grey powder and a few thin crusts of cement to remind us of the distribution."

> Rosing, Larry. "Barry Le Va and the Non-Descript Distribution." *Art News,* Vol. 68 (September, 1969), p. 52.

LeWitt, Sol
"Nevertheless, his paintings and drawings can easily be broken down to their art-historical components—Art Nouveau, Surrealism, and Informal."

Sommer, Ed. "Prospect 68 and Kunstmarkt 68." *Art International,* Vol. 13, No. 2 (February 20, 1969), p. 32.

Lippard, Lucy
"Perhaps there is some not merely personal significance in the fact that they all deal with landscape or with implications of an extensive space."

Lippard, Lucy. "Notes in Review of Canadian Artists '68." *Artscanada,* Vol. XXVI, No. 128/129 (February, 1969), p. 25.

Long, Richard (Longhi, Pietro)
"Later, with the exception of *L'Elefante* (Salom Collection), an animal which had been seen in Venice in 1774, the *Contadini Che Giocano A Carte* of 1775 (Paulucci Collection), the mention of a *Confessione* exhibited at the Fiera della Sensa by Longhi in 1779, the only references are to portraits."

Cailleux, Jean. "The Literature of Art. The Art of Pietro Longhi." *The Burlington Magazine,* Vol. III, No. 798 (September, 1969), pp. 567–568.

McLean, Bruce
"The sculpture department at St. Martin's has never accepted a *status quo;* deep commitment to the possibilities of sculpture and to the need for development has ensured a constant questioning of ideas which are are in danger of hardening into attitudes."

Harrison, C. "Some Recent Sculpture in Britain." *Studio,* No. 177 (January, 1969), p. 27.

McShine, Kynaston (Mac Taggart, William)
"These portraits are really the beginning of his emergence from the cave."

———. "Recent Museum Acquisitions." *The Burlington Magazine,* Vol. CXI, No. 790 (January, 1969), p. 32.

Meirelles, Cildo (Meisel, Alan R.)

"Surely there is no other place in the U.S. with as many shops selling local crafts as Santa Fe, and time was available for browsing and purchasing Indian rugs, jewelry, pottery, basketry, and kachina dolls."

Meisel, Alan R. "U.S.A.: Focus on Albuquerque." *Craft Horizons,* No. 29 (September, 1969), p. 47.

Minujin, Marta

"And when the object is precious, ownership becomes a responsibility that is more important than the experience of the object."

Margolies, J. S. "TV—the New Medium." *Art in America,* No. 57 (September, 1969), p. 50.

Morris, Robert

"One of Edward Kienholz's Tableaus entitled 'After the Ball' contains the following first-novel prose: 'In the kitchen, sitting at a table, under an unshaded light bulb is the father, tired, rigid, menacing.'"

Plagens, P. "557,087 at the Seattle Art Museum." *Artforum,* No. 8 (November, 1969), p. 66.

Nauman, Bruce

"X's legacy to posterity will consist largely of some legends, a mass of photographic documentation, a few items little more than souvenirs, and a handful of traumatized first-class critical minds."

Schjeldahl, P. "Anti-Illusion: Procedures/Material." *Art International,* No. 13 (September, 1969), p. 70.

N.E. Thing Co. (Neuburg, Hans)

"The world's first great poster museum in the Polish capital bears witness to this fact."

Neuburg, Hans. "Second International Poster Biennale in Warsaw." *Graphis,* Vol. 24, No. 137 (1968), p. 242.

New York Graphic Studio Workshop (Graphics, Studiographic)

"In principle, no doubt, purpose and beauty walk hand in hand."

Banks, C. and Miles, J. *Studio,* No. 175 (April, 1968), p. 215.

Newspaper (Newman, Robert)
"In fact, these prints were neckties, works of art staking out a strong position in still rather alien territory."
Newman, Robert. "Exhibition at Gain Ground Gallery." *Art News,* No. 67 (September, 1969), p. 18.

Group Oho (Ohquist, Johannes)
"Er malt die 'Alte Frau mit dem Korbe' (Bild S. 50), den Fischer 'Auf dem Meere' (Bild S. 52), die grosse Kinderszene 'Im Luxembourggarten' (Bild S. 51) und die 'Bäuerinnen vor der Kirchhofsmauer in Ruokolaks' (Bild S. 54) mit einer Leuchtkraft der Farbe und einer Schärfe der Charakteristik, die damals verblüffend wirkten."
Ohquist, Johannes. *Neuere Bildende Kunst in Finnland.* Helsingfors: Akademische Buchhandlung, 1930, p. 5.

Oiticica, Helio (Oka, Hideyuki)
"This is indeed regrettable, for it seems to me that we are thereby losing one of the simpler amenities of life, but I see no way of reversing the trend without a deliberate effort to preserve what now amounts to a dying art."
Oka, Hideyuki. *How to Wrap Five Eggs: Japanese Design in Traditional Packaging.* New York: Harper & Row, 1967, p. 10.

Ono, Yoko
"Place the canvas where the west light comes in."
Cox, Anthony. "Instructive Auto-Destruction." *Art and Artists,* Vol. 1, No. 5 (August, 1966), p. 17.

Oppenheim, Dennis (Oppenheim, Meret)
"Meret Oppenheim. T.V. Form med hjälm. Gipsrelief. 1954."
Thollander, Leif. "Meret Oppenheim." *KONSTrevy,* Vol. XXXVI, No. 2 (March–April, 1960), p. 77.

Panamarenko
"The spacecraft would continue in flight for four years or be stopped in several hours; thus even the exploration of certain stars would become a possibility."

Exhibition at Gibson Gallery. *Arts,* No. 43 (May, 1969), p. 67.

Paolini, Giulio (Paolo Di Giovanni Fei)
"In both these paintings the Virgin is frontal, an unusually severe pose when one recalls the numerous Trecento Sienese paintings in which the Madonna fondly and wistfully inclines her head toward the Child."
Mallory, M. "Lost Madonna del Latte by Ambrogio Lorenzetti." *Art Bulletin,* No. 51 (March, 1969), p. 42.

Pechter, Paul (Pechstein, Max)
" 'It's a Hopper,' Hirshhorn said."
Jacobs, J. "Collector: Joseph H. Hirshhorn." *Art in America,* No. 57 (July, 1969), p. 69.

Penone, Giuseppe (Penni, Luca)
"Dans un milieu extrêmement fécond où l'on voit plusieurs graveurs travailler de manières très voisines, les chances d'erreur sont élevées."
Zerner, H. "Les eaux-fortes de Jean Mignon." *L'Oeil,* No. 171 (March, 1969), p. 9.

Piper, Adrian (Piper, David Warren)
"Since World War II, demand for handcrafts has been given a new lease on life."
Piper, David Warren. "Canada: Dimensions 1969." *Craft Horizons,* No. 29 (September, 1969), p. 71.

Pistoletto, Michelangelo
"Any other choice would have been as good or bad; 'not to saw at all does not solve anything either, and besides, Engels likes sawing.' "
Blok, C. "Letter from Holland." *Art International,* No. 13 (May, 1969), p. 51.

Prini, Emilio
"Se, infatti, alcune de queste operazioni (come quelle di Zorio, di Anselmo, di Merz, di Pistoletto) riescono o sono riuscite, altrettanto non si può dire per molte altre."
Dorfles, G. "Arte Concettuale o Arte Povera?" *Art International,* No. 13 (March, 1969), p. 37.

Puente, Alejandro
"Sobre una mesa de enorme tamaño, colocó una serie de espejos rectangulares, pertenecientes a celdas penitenciarias."
> Whitelow, G. "Carta de Buenos Aires." *Art International,* No. 13 (May, 1969), p. 28.

Raetz, Markus
" 'Vieles von dieser Gesellschafts-Anti-Form, auf der einen Seite der Hang zur Kontemplation und anderseits die von der Verherrlichung des physischen und schöpferischen sich getragene Aktion, ist in diese neue Kunst eingeflossen.' "
> Ammann, J. C. "Schweizer Brief." *Art International,* No. 13 (May, 1969), p. 48.

Rainer, Yvonne (Rainer, Arnulf)
See illustration.
> Sotriffer, K. "Ausstellung, Museum des 20. Jahrhunderts." *Kunstwerk,* No. 22 (February, 1969), p. 8.

Rinke, Klaus
"Its 'art' is depersonalized, calculable, multiplyable, transformable, very close to industrial design, a grammar of form that can be technologically applied towards shaping one's environment."
> Bonin, W. von. "Baden-Baden: a New Method of Exhibiting." *Arts,* No. 44 (September, 1969), p. 53.

Ruscha, Edward
See illustration.
> *Art News,* No. 68 (October, 1969), p. 9.

Sanejouand, J. M. (Sandle, Michael)
"In der Referenz vor Philipp King (geb. 1934) aber ist man sich allgemein einig: ob bereits äusserlich die bekannten Lehnformen ('L-shapes') seinen Einfluss ausweisen, wie bei Tony Benjamin und Derrich Woodham, oder eine prinzipielle Gemeinsamkeit vorliegt (Evans, Hall)—die Renaissance der grundlastigen Plastik durch King ist die wirkungsträchtigste Tat in der Geschichte dieser Bewegung gewesen."
> Kudielka, R. "New English Sculpture, Abschied vom Objekt." *Kunstwerk,* No. 22 (October, 1968), p. 19.

Sladden, Richard (Slade, Roy)

"Many salaries are low, particularly outside richer universities."

Slade, R. "Up the American Vanishing Point." *Studio,* No. 176 (November, 1968), p. 174.

Smithson, Robert

"The thousand-square-foot expanse was 'salt of the earth' triumphing over the new technologies."

"Earthworks." *Art in America,* No. 57 (May, 1969), p. 34.

Sonnier, Keith

"As had been the case with each successive wave of new sensibility, especially since the triumph of Rauschenberg in 1963, the more daring German dealers have endorsed young American artists by creating platforms for them, often long before their being widely shown in this country."

Pincus-Witten, Robert. "Keith Sonnier." *Artforum,* Vol. VIII, No. 2 (October, 1969), p. 40.

Sottsass, Ettore, Jr. (Soto, Jesus Raphael)

"Its ceaseless visual whirring concentrates the mind and eye in a curious way:"

Peppiatt, Michael. "Paris Letter." *Art International,* Vol. 13, No. 7 (September, 1969), p. 75.

Thygesen, Erik (Thornton, Richard S.)

"He also learns the 51 *katakana* and 51 *hiragana* characters, plus the 26 Roman letters and the Arabic numbers."

Thornton, Richard S. "Japanese Design Education." *Graphis,* Vol. 24, No. 138/139 (1968), p. 320.

Van Saun, John

"A good glass of beer is better than a good piece of sculpture."

Sharp, Willoughby. "Place and Process." *Artforum,* Vol. 8, No. 3 (November, 1969), p. 48.

Vaz, Guilherme Magalhäes (Vass, Gene)

"But the principal motifs were geometric circles and squares."

Mellow, James R. "New York Letter." *Art International,* Vol. 13, No. 2 (February 20, 1969), p. 46.

Venet, Bernar (Venetien, Jean)
"Wang, a Zen calligrapher and teacher at the University of Massachusetts, uses tongue-in-cheek titles to underscore this disparity."
"Reviews and Previews." *Art News,* Vol. 68, No. 1 (March, 1969), p. 71.

Wall, Jeffrey (Wallach, Alan)
"It was this dialectic between theory and first-hand experience that drove his art forward."
Wallach, Alan. "Thomas Cole." *Artforum,* Vol. 8, No. 2 (October, 1969), p. 47.

Weiner, Lawrence
"WEINER. Materials."
Rose, Arthur R. "Four Interviews with Barry, Huebler, Kosuth, Weiner." *Arts Magazine,* Vol. 43, No. 4 (February, 1969), p. 23.

Wilson, Ian (Wilson, William)
"If at any point a Kienholz is resold or given away for tax deduction, a percentage of the then current market value of the piece reverts to the artist or his heirs."
Wilson, William, with Peter Selz. "Los Angeles—A View from the Studios." *Art in America,* Vol. 57, No. 6 (November–December, 1969), p. 146.

PART II

A. If it is true that the artist possesses the means of anticipating and avoiding the consequences of technological trauma, what then are we to think of the world and bureaucracy of "art appreciation"? Would it not seem suddenly to be a conspiracy to make the artist a frill, a fribble, or a Miltown? 13312218114 171914

 . . . The logic of the photograph is neither verbal nor syntactical, a condition which renders literary culture quite helpless to cope with the photograph. . . . For most

people, their own ego image seems to have been typographically conditioned, so that the electric age with its return to inclusive experience threatens their idea of self. 9294

For art as either action or idea, memory, or the absorption of some referent to an artwork or an art idea into the observer's consciousness, is instrumental. By memory, I mean less the retentive, the fact-storage faculty, than the associative faculty. From the arts we are learning to make connections, jumps, through cues and clues that come to us in fragments. 1212022114 71855145

It is not so much for you, my friend, who never saw this place, and had you visited it, could not now feel the impressions and colors I feel, that I have gone over it in such detail, for which I must excuse myself. Nor should you try to see it as a result of what I have said; let the image float inside you; pass lightly; the slightest idea of it will suffice for you. 19191420–2521225

A good third of our psychic life consists of these rapid premonitory perspective views of schemes of thought not yet articulate. 23912129113 10113519

Philosophy makes us ripen quickly, and crystallizes us in a state of maturity. How, then, without "dephilosophizing" ourselves, may we hope to experience new images, shocks, which are always the phenomena of youthful being? 7119201514 21385121184

Fragmentation can be a highly effective artistic or critical approach to much new art. It is closer to direct communication than the traditionally unified or literary approach, in which all sorts of superfluous transitional materials are introduced. Interpretation, analysis, anecdote, judgment, tend to clog the processes of mental or physiological reaction with irrelevant information, rather than allow-

ing a direct response to the basic information. 71855145, 1516. 3920

We think we want creative children, but what do we want them to create? 18.4. 1219147

No one will take No for an answer. 14 1859148118420

Chance brings us closer to nature in her manner of operation. 1015814 3175

It is, in fact, quite possible that before the next one hundred years are up our thought processes will have led to our extinction, in a way that would be quite impossible for lower animals that are incapable of thinking. 4.5. 25181225145

B. Provide errata sheets in the exhibition space where visitors can correct any inaccurate information, spelling, etc., in the material on view or in the catalogue. Edit out facetious comments and publish as a review of the exhibition in an art magazine.

Emile Durkheim long ago expressed the idea that the specialized task always escaped the action of the social conscience. 13312218114 171914

PART III

A. Match the name of each artist in the exhibition who is or will be in New York or environs with that of a Trustee of the Museum of Modern Art whose last name begins with the same letter (use procedure similar to that in Part IA, going to the next letter in the alphabet if still incomplete); ask each trustee to spend at least eight hours talking to that artist about art, artist's rights, the relationship of the Museum to society at large, or any other subject agreed upon by the two of them. This should be

executed within six months of the opening of the exhibition and can be applied to foreign artists if individual travel plans are known far enough in advance.

B. On the first afternoon after the opening of the exhibition (preferably a Wednesday) that this is statistically possible, give the holders of film tickets numbered 296160 and 296159 lifetime free-admission passes to the Museum (valid any day of the week). If the holder is Black, Puerto Rican, female, or a working artist without a gallery affiliation, give him/her in addition a free Xerox copy of any piece or pieces in the Information exhibition utilizing Roget's Thesaurus; if there aren't any, or if the artist refuses, give a free copy of the catalogue of the Museum's permanent collection.

C. Show no films glorifying war.
 Ask the American artists in the exhibition to join those willing on the Museum staff in compiling and signing a letter that states the necessity to go A.W.O.L. from the unconstitutional war in Vietnam and Cambodia; send it to 592,319 (296160 + 296159) men at armed forces based in each state of the U.S.A. (If this is impossible, to fifty-six major newspapers.)

D. Purchase one work by those artists in the exhibition whose names appear first, second, fifth, sixth, ninth, nineteenth, and sixtieth (if it goes that far) in the alphabetical list of exhibitors; donate one each to seven (or six) independent museums all over the world which are located in low-income areas, outside of major cities.

E. Xerox and publish as an insert to the catalogue of the Information exhibition, all available information on any extant proposed reforms concerning artist's rights, such as rental fees, contracts, profit-sharing, artists' control over works sold, shown, etc.